T1 TorinoTriennaleTremusei

THE PANTAGRUEL
SYNDROME

Francesco Bonami
Carolyn Christov-Bakargiev

T1 TorinoTriennaleTremusei
2005

Cover
From the DVD *Pianeta Blu.*
Oceani e Abissi
The Blue Planet
© BBC Worldwide 2001
Copyright © 2003 Cinehollywood
Italian Edition and DVD project

First published in Italy in 2005 by
Skira Editore S.p.A.
Palazzo Casati Stampa
via Torino 61
20123 Milano
Italy
www.skira.net

© 2005 by Skira editore
© 2005 Castello di Rivoli Museo
d'Arte Contemporanea
© 2005 Fondazione Sandretto Re
Rebaudengo
© 2005 Fondazione Torino Musei /
GAM - Galleria Civica d'Arte Moderna
e Contemporanea
© The artists for their artworks
© The authors for the texts

Printed and bound in Italy. First
edition

ISBN-13: 978-88-7624-631-9
ISBN-10: 88-7624-631-2

Distributed in North America by
Rizzoli International Publications,
Inc., 300 Park Avenue South, New
York, NY 10010.
Distributed elsewhere in the world by
Thames and Hudson Ltd., 181a High
Holborn, London WC1V 7QX, United
Kingdom.

T1 TorinoTriennaleTremusei

The Pantagruel Syndrome
November, 9 2005
March, 19 2006

CITTÀ DI TORINO
PROVINCIA DI TORINO
REGIONE PIEMONTE
COMPAGNIA DI SAN PAOLO
FONDAZIONE CRT

Organization
Castello di Rivoli Museo d'Arte
Contemporanea, Rivoli-Torino
Fondazione Sandretto Re
Rebaudengo, Torino
GAM - Galleria Civica d'Arte
Moderna e Contemporanea, Torino

Exhibition Venues
Castello di Rivoli Museo d'Arte
Contemporanea, Rivoli-Torino
Fondazione Sandretto Re
Rebaudengo, Torino
GAM - Galleria Civica d'Arte
Moderna e Contemporanea, Torino
"PalaFuksas", Torino
Fondazione Merz, Torino
Casa del Conte Verde, Rivoli-Torino
Chiesa di Santa Croce, Rivoli-
Torino

Exhibition curated by
Francesco Bonami and
Carolyn Christov-Bakargiev

Curatorial Assistance
Ilaria Bonacossa
Ruggero Penone
Camilla Pignatti Morano

General Coordination
Alessandro Bianchi

General Assistance
Carlotta Canella
Karin Gavassa
Veronica Liotti
Maria Vittoria Martini
Chiara Oliveri Bertola
Ilaria Porotto

Promotion
Lara Facco

Press Office
Angiola Maria Gili
Daniela Matteu
Massimo Melotti
Helen Weaver

Catalog edited by
Carolyn Christov-Bakargiev

Editorial Assistance
Chiara Oliveri Bertola

Catalog entries
Ilaria Bonacossa (IB)
Maria Vittoria Martini (MVM)
Chiara Oliveri Bertola (COB)
Ruggero Penone (RP)
Camilla Pignatti Morano (CPM)
Andrea Viliani (AV)

Translations
Ros Schwartz Translations, London
Judith Landry, Caroline Beamish
(Catalog entries) Luisa Nitrato-Izzo
(Forewords) Terry Riley
(Translations Coordinator)

Editing Melissa Larner

Editing Michele Abate

Graphic Design
New Collectivism, Ljubljana

Acknowledgments

*For the exhibition of Takashi
Murakami*
Tim Blum, Jeff Poe, Silke
Taprogge, Alexandra Gaty, Mark
Hagen, Blum & Poe, Los Angeles;
Emmanuel Perrotin, Peggy
Lebeouf, Nathalie Brambilla,
Etsuko Nakajima, Galerie
Emmanuel Perrotin, Paris - Miami;
Jun Tagawa, Yuko Sakata, Joshua
Weeks, Tomoko Sugimoto, Kaikai
& Kiki Co., New York - Tokyo;
Collection of Eileen Harris Norton
and Peter Norton, Santa Monica;
The Dakis Joannou Collection,
Athens;
Linda and Bob Gersh, Los Angeles;
Tina Kim Fine Art;
Kukje Gallery, Seoul;
Collection of Angela and Massimo
Lauro;
Adam Lindermann Collection;
Collection David Teiger;
Collection Villalonga, London;

For the exhibition of Doris Salcedo
Sir Nicholas Serota, Jan Debbaut,
Tate, London;
Madeleine Grynsztejn, SFMOMA
San Francisco Museum of Modern
Art;
Carolyn Alexander, Ted Bonin,
Alexander and Bonin Gallery, New
York;
Jay Jopling, Paula Feldmann,
White Cube, London;
Tom Eccles, Marcia Acita, Center
for Curatorial Studies, Bard
College, Annandale-on-Hudson,
New York;
Joshua Mack, New York;
Lisa Miller, San Francisco;
Azriel Bibliowicz, Bogotá;
Marco della Torre;
Carlos Granada, Joaquin Sanabria,
Jorge Suarez, Diego Suarez, Javier
Monroy, Felipe Bermudez, Oscar
Sanabria;
William Ahumada, Alfonso Amaya,

Felipe Acevedo, Alexander Bravo, Andrea Cano, Soraida Gaviria, Edilson Rios, Jairo Suarez, Isabella Huertas, Yul Hans Castillo; Rodolfo Florez, German Florez, Jovanny Becerra, Leonardo Rivillas, Juan Carlos Rodriguez, Efraìn Rojas, Olga Perez, Edwin Amaya, Jaime David Valderrama, Carlos Rodriguez, Alberto Lozano, Eduardo Rodriguez, Alejandro Machete, Angel Farias, Miguel Bernardo Bolivar, Jose Mendoza;

For the Pantagruelisms
Silvia Alfei; Carlo Alban, Atrealban, Mussolente (VI); Chiara Ambrogio;
Diana Baldon; Emma Bedford, IZIKO, The South Africa National Gallery, Cape Town; Simone Berti; Rebeca Blanchard, Nogueras Blanchard; Anita Bonvini; Bose Pacia; Adela Bravo Sauras; Federico Campbell; Marie Blanche Carlier, Ulrich Gebauer, Bèatrice Dallot, carlier|gebauer, Berlino; Alejandra Carrillo; Christian Schoen, Center for Icelandic Art, Reykjavik; Michael Curren; Saleem Dhamee; Sara De Bondt; Massimo De Carlo, Milan; Rodolfo Dìaz; Ben Donald, BBC, London; Vito Donatini; Daniela Edburg; Ezio Fissore, Europainting, Mondovì; Linda Fregni Nagler; Jose Freire; Barbara Thumm, Ute Proellochs, Galerie Barbara Thumm; Chantal Crousel, Niklas Crousel, Elodie Collin, Galerie Chantal Crousel, Paris; Galleria Francesca Kaufmann, Milan; Galleria Maze, Turin; Galleria Raucci / Santamaria, Naples; Gallery Barcelona and Martha Hummer Bradley; Annet Gelink Gallery, Amsterdam; Simona Giovanardi; Sara Gómez and Christian Maci; Ivars Gravlejs; Greenberg Van Doren Gallery, New York; Simone Griva; Giampiero Bottazzi and Domenico Regis, GTT - Gruppo Torinese Trasporti; Guelman Gallery; Anthony Hubermann; IDA; Israel National Lottery, Council For The Arts; Miriam Katzeff; Bernadette Kerrigan; Julia Kissina; Johann König, Berlin; Klosterfelde Gallery, Berlin; Josè Kuri, Cristian Manzutto, Monica Manzutto, Gaby de la O, Manola Samaniego, Kurimanzutto Gallery, Mexico City; Kim Jeong Yeon; George Lindemann Jr.; Patricia Lok; Lea Freid, Jane Lombard, Cristian Alexa, Lombard Fried Gallery, New York; Ulrich Loock; Michele Maccarone, New York; Brendan Majewski; Adam Frank, Sara Meltzer Gallery, New York; Jimena Mendoza; Viktor Misiano; Mizuma Art Gallery, Tokyo; Monitor video&contemporary art, Rome; Thomas and Amanda Mulcaire; Margaret Murray, Janice Guy, Murray Guy, New York; Peter Nagy; Carlos Narro; Marco Noire, Marco Noire Contemporary Art, Turin; Hans Ulrich Obrist; Kirsty Ogg; Fulvio Zendrin, Giuseppe Messina, Nico Cartei, Piaggio, Pontedera (PI); Cesare Pietroiusti; Roberto Piva; Jonathan Rabagliati; roslyn oxley9 gallery, Sydney; Nasser Rabbat; Marek Raczkowski; Michal Kaczynski, Lukasz Gorczyca, Raster Gallery, Warsaw; Edward Reno; Gabriel Renz; Octavio Serra; Maciek Sienkiewicz; Thea Slotover and Llyr Williams; Kathryn Smith; Alessandra Sofia; Store London; Spencer Brownstone Gallery, New York; The Aga Khan Program for Islamic Architecture, MIT; Andrea Viliani; Ivan Volovsek; Aurelie Voltz; Toby Webster and The Modern Institute, Glasgow; Max Wigram Gallery, London; Connie Wirtz and Stephen Wirtz Gallery, San Francisco; Paolo Zani, ZERO, Milan.

Furthermore we would like to thank
Gianni Bussolati, Dipartimento di Scienze Biomediche e Oncologia Umana, Università di Torino for the performance by Araya Rasdjarmrearnsook

and our correspondents
Gridthiya Gaweewong, Sofia Hernandez, Chong Cuy, Raimundas Malasauskas, Francesco Manacorda, Ana Matveyeva, Pi Li, Ralph Rugoff, Kathryn Smith, Trevor Smith, Adam Szymczyk

CONTENTS

ARTISTS

PANTAGRUELISMS

FOREWORD

Contemporary art is one of the major strengths of the "new" Turin. The city has two public art museums – the Castello di Rivoli Museo d'Arte Contemporanea and the GAM Galleria Civica d'Arte Moderna e Contemporanea of Turin; and two Foundations open to the public – the Fondazione Sandretto Re Rebaudengo and the Fondazione Merz. Each year, Turin holds *Artissima*, the only art fair in Italy dedicated exclusively to contemporary art, and a major appointment for collectors and art lovers alike. The city's private galleries also play an important role, liaising with each other to open new shows on the same date, and creating a tide of visitors who flow from one gallery to another, filling the streets with comment and discussion. Thanks to the *Luci d'Artista* project, and the monumental works installed along the *passante ferroviario* (city rail link) and elsewhere, Turin has also brought contemporary art out of the museums and galleries and into direct contact with the city and its people. For many years, Turin has also been organizing group exhibitions and workshops for young artists.

People now talk of the "Turin system for contemporary art:" a difficult concept to define, as a system cannot be formed out of a simple collection of objects which are more or less related, but requires interaction, mutual exchange and collaboration. The city has begun to weave something of a web between the various strands of the artistic community: for example, the curatorial committee of *Luci d'Artista* is made up of the directors of the Castello di Rivoli and of the GAM; private galleries work together to choose the artists who take part in *ManifesTO*, Turin's open-air art event where every corner of the city is redecorated with giant street posters which suggest advertising billboards; many key points of *Artissima* are organized by other people within the "system"; and so on. Until now, the one element still missing was a periodical event of international standing.

Now, this gap has been filled: Turin's three foremost art institutions (Castello di Rivoli, GAM and the Fondazione Sandretto) have collaborated to produce *T1*

– the city's new triennal of contemporary art. Although organized by three different institutions, it will be presented as one umbrella event – something that we believe to be unique within the art world. Three museums all with a similar focus, which instead of competing against each other have joined forces to create an international art event that will enrich the Piedmont region and has all the hallmarks of an event destined to join the select ranks of the most important art events. *T1* will also highlight our commitment to contemporary art during the 2006 Winter Olympics: after the first phase of the event which will begin on 9 November, a few days after the opening of the eighth *Luci d'Artista* and a day before the twelfth *Artissima* contemporary art fair, a second phase is scheduled to coincide with the Olympics and Paralympics.

The Piedmont region has already hosted important artistic events such as the Biennale dei Giovani Artisti del Mediterraneo of 1997 (the Biennial of Young Mediterranean Artists) and two editions of Biennale Internazionale Giovani events (BIG) in 2000 and 2002. *T1* will build on these experiences by showcasing major international artists, bringing them together to explore themes chosen for their importance both on a general and critical level.

We hope that with this new initiative, our "system of contemporary art" will be strengthened and enhanced, integrating its wide range of purpose and meaning. Anyone interested in seeing how contemporary art can help a city to transform itself, should make the effort to come to Turin.

Gianni Oliva
Assessore alla Cultura, Patrimonio Linguistico e Minoranze Linguistiche, Politiche Giovanili,
Museo Regionale di Scienze Naturali, Piedmont Region

Valter Giuliano
Assessore alla Cultura, Protezione della Natura, Parchi e Aree Protette, Province of Turin

Fiorenzo Alfieri
Assessore alle Risorse e allo Sviluppo della Cultura, City of Turin

FOREWORD

The Piedmont region, with Turin at its heart, is currently one of the liveliest areas on the international art scene, thanks to the combined forces of its museums, galleries and other arts institutions, as well as to the wide range of temporary exhibitions it mounts, the installations created by major artists which have become part of the urban fabric, the presence of established artists who live in the city and the arrival of new, young artists who have adopted Turin as their home. With the first *T1 TorinoTriennaleTremusei* event, Turin has added an important date to the international art calendar: a project that aims to present the most recent developments within the visual arts through a number of exhibitions which also are experimental in terms of curatorial practice. The Triennale is organized by three art institutions: the Castello di Rivoli Museo d'Arte Contemporanea, the Fondazione Sandretto Re Rebaudengo and the GAM Galleria Civica d'Arte Moderna e Contemporanea of Turin. Their successful collaboration reflects Turin and the Piedmont region's general enthusiasm and ability to find new ways of working together on a cultural basis.

Two major curators, Francesco Bonami and Carolyn Christov-Bakargiev, were invited to conceive and develop the new Triennale; both are experts in international contemporary art and both are "at home" in Turin. Their departure point was the idea that our era is characterized by different forms of megalomania and "gigantism," which filter into all aspects of life. This led to the exhibition's intriguing title, *The Pantagruel Syndrome*, after François Rabelais' strange literary creation of the sixteenth century: the grotesque Pantagruel, perennial traveller, a creature of gigantic proportions, incredible strength and voracious appetites.

The event is in two parts: the first, *Pantagruelisms*, presents new and experimental works by seventy-five young artists from around the world; the second pays homage to two established artists, Doris Salcedo of Colombia, and Takashi Murakami of Japan, with two solo exhibitions. The artworks and performances

wind their way through and around Turin, forming a "Pantagruelic" spiral of exhibition spaces: at the Castello di Rivoli Museo d'Arte Contemporanea, the Fondazione Sandretto Re Rebaudengo and the GAM Galleria Civica d'Arte Moderna e Contemporanea of Turin, but also at the Fondazione Merz, the new "PalaFuksas" of Porta Palazzo market square, at the University of Turin's Department of Anatomical Pathology, at the Casa del Conte Verde and the Church of Santa Croce, Rivoli.

In an era of increasing globalization, it is important for a periodical event like the new Triennale to recognize that the art world has also "gone global:" from Berlin to Mexico City, Cape Town to Bangkok, New York to Sydney and Shanghai, the people and places of the art world create a localized, dynamic, ever-shifting, multi-event network. The Triennale must be able to fit into this system of relationships between artists, curators, galleries and experimental art spaces. For this reason, the Triennale's two curators interacted with their own network of ten international "correspondents," young curators hailing from all four corners of the globe, who work either independently or within international art institutions: Sofia Hernández Chong Cuy, Gridthiya Gaweewong, Raimundas Malasauskas, Francesco Manacorda, Anna Matveyeva, Pi Li, Ralph Rugoff, Kathryn Smith, Trevor Smith, and Adam Szymczyk – our thanks are due to them all.

Finally, we must also express our sincere thanks towards the Compagnia di San Paolo and to the Fondazione CRT, which supported the Triennale initiative with major contributions, working together with the Comune di Torino, the Provincia di Torino and the Regione Piemonte to ensure the success of a project that is truly Pantagruelic in scope.

<div align="right">

Giovanna Cattaneo Incisa
Chairman, Fondazione Torino Musei

Ida Gianelli
Director, Castello di Rivoli Museo d'Arte Contemporanea

Patrizia Sandretto Re Rebaudengo,
Chairman, Fondazione Sandretto Re Rebaudengo

</div>

FOREWORD

Over the past years, the Compagnia di San Paolo has made contemporary art one of its prime focuses. This reflects our ongoing commitment to supporting world-class exhibitions, as well as initiatives that promote artistic creativity, especially among young artists.

With the first edition of *T TorinoTriennaleTremusei*, the city of Turin has added an important date to the international art calendar: an exhibition of the most recent developments within the visual arts. It is thanks to the close collaboration of the triennial's organizers – the Castello di Rivoli Museo d'Arte Contemporanea, the Fondazione Sandretto Re Rebaudengo and the GAM Galleria Civica d'Arte Moderna e Contemporanea – that the city has been able to achieve such a high-level event.

The Piedmont region, with Turin at its heart, is currently one of the liveliest areas on the Italian and international art map thanks to the combined support of its museums, galleries and other arts institutions and as a result of the wide range of temporary exhibitions it mounts, the installations it has commissioned from major artists and which have become part of the urban fabric, an art fair dedicated exclusively to contemporary art, and now this new triennial. We hope that the cooperation and commitment expressed by the sponsors and organizers of *T1* will continue into the future, and help to consolidate Turin's image as a dynamic and international center for contemporary art.

<div align="right">

Franzo Grande Stevens
Chairman Compagnia di San Paolo

</div>

FOREWORD

The Fondazione CRT is proud to support the new *T1 TorinoTriennaleTremusei* project as part of our ongoing, strategic commitment to the metropolitan system of contemporary art.

T1 offers new space... and new spaces to young artists' creativity. The Fondazione CRT also contributes a significant proportion of its resources to young people, including a series of specifically youth-orientated projects, in the firm belief that the younger generation can be both a driving force for social development and instrumental in bringing about the most significant changes.

T1 is also part of the rich seam of contemporary arts initiatives that continue to thrive in Turin – a sphere we feel the city excels in, and to which the Fondazione CRT has given substantial support.

The Fondazione CRT makes regular, ongoing contributions to Turin's major museums, and for six years has been involved in a project whose aim is to enhance the permanent collections of the two main contemporary art institutions: the Castello di Rivoli and the GAM. To date, the Fondazione CRT has acquired approximately 150 works of art for the two museums while in the last five years the Turin-based foundation has donated almost 25 million Euros to contemporary art.

I wish the new *T1* event all the success it deserves.

Andrea Comba
Chairman, Fondazione CRT

THE NON-EXISTENT CURATOR

Francesco Bonami

"Not another Triennale?," you might ask. But this is not "another" Triennale, it is this Triennale, which will be called *T*, and which will be different. It could have been another exhibition entirely, had the host city not been Turin, but Bologna; it could have been a biennale, and it could have been called B. In fact, it is called T, for Turin, Triennale and Three museums. So, it will be a triennale and it will be held for the first time in Turin. Its most important feature is not how often it occurs, but its structure. Exhibitions differ from one another by virtue of their structure, which defines their parameters and their success. The structure of this triennal is born of a contradiction implied by its title, *The Pantagruel Syndrome*, which would seem to suggest something sprawling, omnivorous, unfocused. In point of fact, it was conceived with very particular rules, with proteins limiting its size and appetites. Every three years *T* will present, and digest, the work of seventy-five core artists, no more, no less: this number marks its limits, and its strengths. *T* will also be centered around two cardinal points, two additional artists who have reached the mid-course of their lives, and who will each be celebrated with a one-person show, with the work of other, less well-known artists revolving round them. This year the cardinal points are the south of the planet, with Doris Salcedo from Colombia, and the east, with Takashi Murakami from Japan. We believe that it is always interesting to open up a dialogue between different and contradictory artistic viewpoints: between two ways of seeing art that reflect two different perspectives on the history of the world, brought into convergence, very briefly, purely through the unnatural situation contrived by this event. We believe that dialogue between these two extremely divergent ways of looking at each other, and at the world, will provide an opportunity for some hard thinking about the state of contemporary society and culture.

This convergence of viewpoints also suggests an initial explanation for the title of the first *T The Pantagruel Syndrome* – that is, the convergence of many languages within the belly of the exhibition, "sampled" in the city's three main museums: the GAM, the Castello di Rivoli and the Fondazione Sandretto Re Rebaudengo. These three bodies will devour seventy-five artists, each metabolising them in its own way. Though perhaps it would be more accurate to say that the body that metabolizes the exhibition is Turin itself, a city that has always had an up-to-the-minute syndrome, often synonymous with a Pantagruelian hunger, because to be contemporary means eating the present, devouring the moment, and Turin, possibly alone among Italian cities, has always been characterized by its immense voracity. The city opens its jaws to gobble up all the artists who visit it with their ideas, some indigestible, others delectable, only a very few inedible. It has three mouths to do this gobbling up, this absorbing and fermenting: GAM, Rivoli and Re Rebaudengo. Turin is like Gurdulu, groom to Italo Calvino's Non-existent Knight, who not only has a Pantagruelian appetite, but is also up-to-the-minute, chameleon-like, taking on the look of everything he comes upon. A city that hopes to be of its time must indeed be all-devouring, but must also be able to cloak itself in every idea that comes its way, challenging its identity. Cities that guard their own identity at all costs are destined to die, becoming first anorexic, then skeletal. Turin is not such a city: it has always laid its own identity on the line, welcoming immigrants from the south, becoming one huge workshop, a place of clashes, first social, then ethnic. Turin and Piedmont gave house-room to the heretical Valdensians; they devoured Italy by creating it; they have always looked fairly and squarely at their own identity, knowing that only by digesting their past and their culture, together with other cultures, would it be possible to imagine their own future. It was this spirit that spawned the idea for *T*: not as the umpteenth biennale, triennale or quadriennale, but rather as a challenge to its contemporary identity, in the hope of forging another, stronger and even more contemporary one: the fruit of an insatiable appetite, dangerous and compelling.

But where there is a Gurdulu, there must also be a Non-existent Knight. And indeed, the triennial has a Non-existent Curator of its own, or rather two. What do

we mean by Non-existent? How can an exhibition be curated by two non-existent cura-
tors? We live in an age where curators, too, are Pantegruelian, and this exhibition is
an opportunity for them to go on a diet, to think more carefully about the dishes on
their plate. In Calvino's novel the knight boasts a magnificent suit of armour – with
no one inside it but a voice. Here the armour I am speaking of is Turin, and inside
it are not two curators, but many voices, which include those of the curators, but are
mainly those of the artists, who, like all the other characters in the story, do actual-
ly exist. Only the curators do not exist, because their physical presence is not really
necessary – all we need is the spirit with which they have managed to fashion their
own armour, which, if it is to be effective, is also destined to become that of many
others.

Our age has been laid waste by the Pantagruel syndrome: the world is covered in
a crust of images that hide it from us, and on which image upon image continues to
pile up. The more images pile up, the more speedily we swallow, digest and expel
them. We have reached a point of no return, or so it seems. Our civilization is obese.
Violence, too, has become one foodstuff among others. We are stuffed with violence
and beauty, fundamentalism and immortality; we wolf down the lot. We cannot con-
tain ourselves, for fear of going hungry. Art, too, is a form of intemperance, but it
may also be the best diet for the regaining of control over the body of our society. The
artists invited to this first *T* are collectively presented as one among many possible
diets, but not as savourless, "low-fat" artists, "no-sodium" artists or "no-sugar" artists.
These artists are the natural fibres of a possible new cultural biology with which a
city – in this case, Turin – has decided to experiment. There may be side effects, but
the hope is that the body of reality with which we are working will assimilate the
transformation; that uncontrollable hunger will be replaced by the pleasures of a new
appetite, an insatiable desire to receive the best of the present, so that we may serve
it up on the table of the near future.

THE PANTAGRUEL SYNDROME

Carolyn Christov-Bakargiev

When, in 1817, the French writer Stendhal (1783–1842) travelled to Italy, he visited the Santa Croce Church in Florence. Upon leaving, he found that: "I had attained to that supreme degree of sensibility where the divine intimations of art merge with the impassioned sensuality of emotion. As I emerged from the porch of Santa Croce, I was seized with a fierce palpitation of the heart (that same symptom which, in Berlin, is referred to as an attack of nerves); the well-spring of life was dried up within me, and I walked in constant fear of falling to the ground."[1]

This phenomenon – fainting due to an excess of aesthetic stimuli – is commonly known as the Stendhal Syndrome. Entitled "The Pantagruel Syndrome" this exhibition feeds off and incorporates that notion, as well as taking its inspiration from the character of Pantagruel, the grotesque protagonist who features in the novels of another French writer, François Rabelais (1484–1553.)

Pantagruel, son of Gargantua, is a creature of gigantic proportions, voracious appetites and incredible strength, He is also a great lover of wine and its effects on the mind and body. An absurd and burlesque hero for a civilization in transition from the Middle Ages to the Renaissance, he is an ideal character who rediscovers the empirical world through the direct experience of his adventures. His name, a combination of learned etymology (in Greek *panta* means "all") and childish neologism ("gruel" is suggestive of digestion,) alludes to an omnivorous appetite for knowledge. Yet Pantagruel, who eats, drinks and travels incessantly, occasionally falls ill.

We live in an age of exaltation and frenzy, where stark contrasts and powerful

[1] Stendhal, *Rome, Naples and Florence*, John Calder, London, 1959, p. 304 (Translated by Richard N. Coe. First edition in French, 1826.)

emotions are our daily experience. Globalization is characterized by extremes – extreme progress, extreme scientific research, but also extreme pain and extreme injustice. In art, too, our epoch is defined by large-scale exhibitions, mega shows celebrated in the rituals of international biennials on every continent. Our syndrome, our cultural illness so to speak, is a form of gigantism. This tendency, however, is accompanied by great fragility and precariousness; collapse, self-destruction and break-down are potentially everywhere, at the first large storm.

This "Pantagruel Syndrome" becomes the point of departure for the first edition of a new Triennial, an exhibition that is intended to reflect on the exhibiting frenzy and cognitive gigantism of our times, proposing playful, fanciful, dreamy and adventurous works, whose poetics, like the texts of Rabelais, are stratified and complex. It enacts and expresses our voracious tendency towards exploration and excess, yet at the same time brings our contemporary illness to the fore. It attempts to "work through" (*durch gehen*, as Freud put it) our contemporary syndrome via a group show featuring artworks by seventy-five artists from around the world, and two solo exhibitions dedicated to a pair of extremely different artists – Doris Salcedo from Colombia and Takashi Murakami from Japan.

Murakami takes the syndrome by the horns, tackling it in his sculptures, installations, public projects, paintings and wallpapers through a re-enactment and transformation both of contemporary Pop culture and traditional Japanese civilization. Salcedo, however, is a Cassandra for our modern era, who creates poignant and painstakingly laborious sculptures and installations that refer to loss, death, and, more recently, confinement. In our world of apparently easy travel and communication, she reveals that for many, the globalized world means only the suspension and loss of freedom, represented by prisons, cages and detention centres.

The contemporary era is characterized by a tension between change and fear, between a healthy voracity for knowledge and a sense of an imminent explosion. On the one hand this is manifested as a form of megalomania, tied to the presumption that we have the technology to put all utopias into action, as well as to train and shape the human body. In genetic research, for example, the "Genome Project" attempts

the total mapping of the human genome structure, while biogenetics aim to alter organisms, or clone new ones from stem cells. We are even endeavouring to control the climate, and digital technologies have radically modified the "body" of global communications. The very term "globalization" represents an omniscient point of view, an external vision of a spherical body. At the same time, however, this is an era filled with insecurity, where a proliferation of visions of terror are manifested as the destruction of the addicted, omniverous and globalized body.

Throughout history, collective human fears have been expressed in the form of images of the destruction of parts of the self. During the Enlightenment, for example, with its emphasis on rational thought, fear manifested itself in the ritual of beheading, while in the Romantic age of colonialism and exoticism the greatest fear was loss of blood by the sword and thus of the heart (and the emotional system,) represented by the infinite circulation of the blood. Now we fear a deflagration from within, caused by an explosion or "big bang," the image embodied by the kamikaze terrorist or suicide bomber; a Self that is destroyed through over-ingurgitation.[2]

Cultural gigantism was born in the 1990s, when numerous large-scale exhibitions were staged, both through already established international shows such as Documenta in Kassel, or through the multiplication of new biennials in various parts of the world (Johannesburg, 1995, 1997; Gwangju, 1996; Yokohama, 2001; Istanbul, 2001, 2003.) A broad and multifaceted view of the most diverse manifestations of cultural creativity – including art, architecture, urban planning and science – as well as themes tied to centre/periphery relationships and cultural identity have characterized most of these exhibitions. In the worst cases, where they have been curatorial import/export devices, with little critique, the "Biennale syndrome" represents a new phase of cultural consumerism and tourism, a sick Pantagruel. In the best cases, instead, it represents a healthy de-centralization of culture, which breaks Western cultural hegemony, introducing complexity and energy into art.

[2] The Italian artist Emilio Fantin has explored this vision of the kamikaze/Pantagruel in conversation with the author.

As a gargantuan triennial of contemporary art, this project is intended to act like a vaccination, injecting a drop of the disease itself in order to build up antibodies. This first edition, *T1*, reflects on the syndrome through the presentation of drawings, videos, installations, sculptural and photographic works, performances, sound pieces, collective and anonymous projects. As in a large newspaper or television network, we set up a team of ten "correspondents" – a core of young curators, independent or tied to a diverse range of international art centres, from the artist-run or alternative space to the museum. Rooted in every continent, from Europe to Asia, America, Africa and Australia, they contributed to the exhibition by sending in suggestions, names of artists and reports on contemporary art from their perspective, which have been integrated into the exhibition. Their presence denies a centralized and hierarchical view of art and exhibition-making.

The show itself, located throughout the city of Turin, is Pantagruelian in its themes. For example, the works of artists are found dotted throughout the 140-metre long, intestinal tract of the Manica Lunga gallery which is transformed into a digestive apparatus. In the spaces of the Castello di Rivoli, the Casa del Conte Verde and Santa Croce Church in Rivoli, and in downtown Turin, at the Fondazione Sandretto and the GAM – Galleria Civica d'Arte Moderna e Contemporanea, carousel and fair-like installations inflate and deflate, grow organically, twirl like tops, ring alarmingly or shoot out human canon-balls across borders, while other radical artworks dialogue with the spiralling art of Mario Merz at the Merz Foundation and insinuate themselves at the new market on Piazza della Repubblica.

In Chapter Eight of *Pantagruel*, Gargantua writes Pantagruel a letter in which he reminds him of all the disciplines that a good student must study – Greek, Hebrew, Latin, Law, Science, the Medicine of the Greeks and Arabs, and the Holy Books, so that he might become "an abyss of knowledge." In Chapter Nine, however, Pantagruel and his friends come across Panurge, a poor-looking man of noble nature. He immediately begins to converse with him, asking: "Who are you? Where are you from? Where are you going? Whom are you looking for? And what is your name?" And yet, for all his knowledge, when Panurge answers in Old German, Pantagruel

cannot understand him. Pantagruel persists in his questioning, and Panurge answers in a variety of languages, some invented by Rabelais, but most of them in use in Europe at the time. On each occasion, Pantagruel fails to understand, until finally, after many attempts and exhausted by the lack of communication, Panurge exclaims in Old French that he is simply hungry. Could the complexities of today also boil down to just as vital, and as simple, a question?

SOURCES

PANTAGRUEL

François Rabelais

The Origin and Antiquity of the Great Pantagruel

[...] It's appropriate to point out how, at the beginning of the world (I speak here of distant things, more than forty forties of nights gone by – if we count the way the old Druids used to,) not long after Abel was killed by his brother, Cain, the earth soaked with that righteous blood became so prodigiously fertile in all the fruits the soil offers us (and especially the medlar apple) that everyone ever after has always called it the year of the giant medlar apples, because it took three of them to make a bushel. [...]

[...] You'd better believe that everyone gladly ate those apples, because they were lovely to look at and they tasted delicious. But just as Noah, that saintly man (to whom we owe so much, and are so bound, since it was he who planted for us that glorious vine from which we get that nectarous, fragrant, precious, heavenly, joyous, godlike drink we call wine,) was misled when he drank, because he forgot just how powerful wine is, and what it can do, so too the men and women of that time ate that beautiful huge fruit with great pleasure.

And then all sort of disasters began to occur. Every single one of them suffered horrible swelling all over their bodies, but in different places. Some puffed out at the belly, and their stomach rounded out like a great cask, because of which it is written, *Ventrum omnipotentum*, O Almighty Belly – and these were all wags and punsters, from which race sprang Saint Fatbelly and Fat Tuesday, or Mardi Gras.

Others swelled along the shoulders, and got to be so humpbacked that they were called Manmountains, or Mountain Carriers, and you still see them, all over the world, male and female, noble folk and commoners. Their race gave us Aesop, whose wonderful words and good deeds we have in writing.

Still others swelled along that part we call nature's digging tool, so that it got to be magnificently long, and large, hard, and thick all around, and proud as a peacock, the way it used to be in the old days, so men used it as a belt, tying it around their waists

five or even six times. And if it was really feeling its oats and the wind was in its sails, well, you'd have to say, seeing such men, that they were carrying their spears at the ready, all of them on their way to target practice. And this race is extinct, according to the ladies, because they're always complaining that

Those great big ones are gone, gone, gone –
you know how the song goes.

Still others swelled up in the balls – so enormously that three filled a large barrel. From them we have the race who live in Lorraine, whose balls never stay in their codpieces but are always hanging down to the bottom of their breeches.

And others got huge in the legs and feet, so that if you saw them you'd say they were cranes or flamingos, or even men walking on stilts. And little schoolboys, studying grammar and versification, called them Metermen.

Still others grew such immense noses that they looked like the long beak of a flask, but speckled, as sprinkled with pimples as the sky is filled with stars, swelling up everywhere, purple and blotched, flecked all over with eruptions, decorated with red – and you've seen them, if you've ever seen Canon Fatgut or Doctor Woodfoot of Angiers. Not many of this race were crazy about barley water or tea: they were all of them lovers and guzzlers of wine. Publius Ovidius Naso, better known these days as Ovid, came from this race – of whom we write, *Ne reminiscaris*, Don't remember my sins, though what we really mean is, Forget about my nose.

Others grew big ears, so big you could make a jacket out of just one of them, plus a pair of breeches and even a scarf to tie around your head, and a Spanish cape from the other one. It's said that this race still exists, in Bourbonnais somewhere, which is why we talk about Bourbon ears.

Other grew immense bodies. From them, finally, came the race of giants, from whom, ultimately, Pantagruel was born. [...]

Pantagruel's Childhood

[...] I won't bother to tell you how at each of his meals [Pantagruel] drank the milk of four thousand six hundred cows, and how, to make him a saucepan for boiling that milk, they called up all the pot makers of Saumer, in Anjou, and Villedieu, in Normandy, and Bramont, in Lorraine, and how they poured that boiled milk into a huge wooden trough (which still exists, in Bourges, near the palace) – and his teeth were already so big and so strong that he broke a big chunk right out of that trough, as you can see for yourself if you go take a look.

One day, toward morning, when they wanted him to suckle from one of those cows (because they were the only nurses he had, the histories tell us.) he got one of his arms out of the straps that kept him in his cradle, and got a good grip on the cow, just under the knees, and ate both her udders and half her stomach, and her liver and kidneys, and would have eaten all the rest of her if she hadn't bellowed and roared, and they thought wolves had gotten at her, and they all came rushing up and pulled her away from Pantagruel. But they didn't manage it very well and the knee joint was still in his grip, and he chewed on it nicely, as you might bite on a fresh sausage. And when they wanted him to let go of the bone, he bolted it right down, like a seagull with a little fish, after which he began to cry out, "Good! good! good!" – because he still couldn't talk well and wanted them to understand that he'd thoroughly enjoyed his snack and they should certainly let him have more. [...]

How Pantagruel, at Paris, Received a Letter from His Father, Gargantua,
with a Copy of That Letter

My very dear son,

[...] For now all courses of study have been restored, and the acquisition of languages has become supremely honourable: Greek, without which it is shameful for any man to be called a scholar; Hebrew; Chaldean; Latin. And in my time we have learned how to produce wonderfully elegant and accurate printed books, just as, on the other hand we have also learned (by diabolic suggestion) how to make cannons and other

such fearful weapons. The world is full of scholars, of learned teachers, of well-stocked libraries, so that in my opinion study has never been easier, not Plato's time, or Cicero's, or Papinian's. From this day forward no one will dare appear anywhere, or in any company, who has not been well and properly taught in the wisdom of Minerva. Thieves and highwaymen, hangmen and executioners, common foot soldiers, grooms and stableboys, are now more learned than the scholars and preachers of my day. What should I say? Even women and girls have come to aspire to this marvellous, this heavenly manna of solid learning. Old as I am, I have felt obliged to learn Greek, though I had not despised it, as Cato did: I simply had no leisure for it, when I was young. And how exceedingly glad I am, as I await the hour when it may please God, my Creator, to call me to leave this earth, to read Plutarch's Morals, *Plato's beautiful* Dialogues, *Pausanias' Monuments and Athenaeus'* Antiquities.*

Which is why, my son, I strongly advise you not to waste your youth, but to make full use of it for the acquisition of knowledge and virtue. You are in Paris, you have your tutor, Epistemon: you can learn from them, by listening and speaking, by all the noble examples held up in front of your eyes.*

It is my clear desire that you learn languages perfectly, first Greek as Quintilian decreed, and then Latin. And after that Hebrew, for the Holy Bible, and similarly Chaldean and Arabic. I wish you to form your literary style both on the Greek, following Plato, and on the Latin, following Cicero. Let there be nothing in all of history that is not clear and vivid in your mind, a task in which geographical texts will be of much assistance.

I gave you some awareness of the liberal arts – geometry, arithmetic, and music – when you were still a child of five and six. Follow them further, and learn all the rules of astronomy. Ignore astrology and its prophecies, and all the hunt for philosopher's stone which occupied Ramon Lull – leave all those errors and vanities alone.

As for the civil law, I wish you to know by heart all the worthy texts: deal with them and philosophy side by side.

I wish you to carefully devote yourself to the natural world. Let there be no sea, river, or book whose fish you do not know. Nothing should be unknown to you – all the birds

of the air, each and every tree and bush and shrub in the forests, every plant that grows from the earth, all the metals hidden deep in the abyss, all the gems of the Orient and the Middle East – nothing.

Then carefully reread all the books of the Greek physicians, and the Arabs and Romans, without turning your back on the talmudic scholars or those who have written on the Cabala. Make free use of anatomical dissection and acquire a perfect knowledge of that other world which is man himself. Spend several hours each day considering the holy Gospels, first the New Testament and the Apostles' letters, in Greek and then the Old Testament, in Hebrew.

In short, plumb all knowledge to the very depths, because when you are a grown man you will be obliged to leave the peace and tranquillity of learning, and acquire the arts of chivalry and warfare, in order to defend my house and lands and come to the aid of our friends if in any way they are attacked by evildoers. [...]

Your father,

GARGANTUA

How Pantagruel Found Panurge ("He Who Is Good at Everything")
and Loved Him All the Rest of His Life

One day, as Pantagruel was walking outside the city, headed for the Cistercian abbey of Saint-Anthony, chatting and debating with the members of his household and a number of other students, he met a tall, elegantly handsome man, but pitifully wounded all over his body, and in such a state of disarray that he seemed to have just escaped from a pack of furious dogs – or, better still, he looked like the proverbial raggle-taggle apple picker from Perche.

Seeing him in the distance, Pantagruel said to his companions:

"See that man coming along the Charenton Bridge road? By my faith, it's only fortune that's made him poor, because I swear that nature made him in some rich and noble mould, and the bad luck that often befalls people with curious minds has reduced him to such beggary."

And soon as he'd come right up to them, Pantagruel asked him:

"My friend, let me ask you, please, to stop a moment and answer a few questions. You won't regret it, I assure you, for I feel a great urge to help you in any way I can, seeing the disaster you have plainly experienced. I feel an immense pity for you. So tell me, my friend: Who are you? Where do you come from? Where are you going? What are you hunting? And what is your name?"

The man answered him in German:

"*Junker, Gott geb euch Glück unnd hail. Zuvor, lieber juncker, ich las euch wissen, das da ihr mich von fragt, ist ein arm unnd erbarmglich Ding, unnd wer vil darvon zu sagen, welches euch verdruslich zu hoeren, unnd mir zu erzelen wer, wie vol die Poeten unnd Orators vorzeiten haben gesagt in iren Sprüchen und Sentenzen, das die Gedechtnus des Ellends unnd Armuot vorlangst erlitten ist ain grosser Lust.*"

("My lord, May God grant you happiness and prosperity. My dear sir, I must tell you that what you ask of me is a sad and pitiful thing, and that what must be said, on that subject, would be full of matters it would tire you to hear, and weary me to relate. On the other hand, as the ancient poets and rhetoricians have declared in their maxims and other words of wisdom, the memory of pain and poverty is a great joy.")

To which Pantagruel answered:

"My friend, I don't understand a word of that gibberish. If you want to be understood, please speak in some other tongue."

So the man answered him:

"*Al barildim gotfano dech min brin alabo dordin falbroth ringuam albaras. Nin porth zadilkim almucathin milko prim al elmin enthoth dal heben ensouim: kuth im al dim alkatim nim broth dechoth porth min michas im endoth, pruch dal marsouim hol moth dansrikim lupaldas im voldemoth. Nim hur diavolth mnarbothim dal gousch pal frapin duch im scoth pruch galeth dal chinon, min foulthrich al conin butbathen doth dal prim.*"[1]

"Do you understand any of that?" Pantagruel asked his companions.

To which Epistemon answered:

[1] Spoken in an imaginary language, meaning nothing.

"It might be the languages of Upside-down Land. The devil himself would break his teeth on it."

So Pantagruel said:

"Friend, I don't know if the walls understand you, but we don't, not a word."

And so the man said:

"*Signor mio, voi vedete per exemplo che la cornamusa non suona mai s'ela non à il ventre pieno. Così io parimenti non vi saprei contare le mie fortune, se prima il tribulato ventre non à la solita refectione. Al quale è adviso che le mani et li denti abbui perso il loro ordine naturale et del tutto annichillati.*"

(In Italian: "My lord, you know from experience that a bagpipe can't make a sound unless its belly is full. And so too with me: I wouldn't know how to tell you what has happened to me unless my unhappy belly first got what it's used to. My stomach feels as if my hands and my teeth have lost their natural abilities – been quite annihilated.")

To which Epistemon answered:

"It's six of one and half a dozen of the other."

And Panurge said:

"*Lard, ghest tholh be sua virtiuss be intelligence ass yi body schall biss be naturall relvtht, tholb suld of me pety have, for nature hass ulss egually maide; bot fortune sum exaltit hess, an oyis deprevit. Non ye less viois mou virtius deprevit and virtiuss men discrivis, for, anen ye lad end, iss non gud.*"

(In Scots: "My lord, if you are as noteworthy for intelligence as you are, in your own person, elevated in form, you ought to have pity on me, because nature has indeed made us equal, but chance raises some and lowers others. Nonetheless, virtue is often looked down on and virtuous men despised, since after all it's true that, before the final end, no one is truly good.")

"Still less," answered Pantagruel.

So Panurge said:

"*Jona andie, guaussa goussyetan behar da er remedio beharde versela ysser lan da. Anbates oyto y es nausu eyn essassu gour ray proposian ordine den. Nonyssena bayta fascheria egabe, genherassy badia sadassu noura assia. Aran hondovan gualde cydassu*"

nay dassuna. Estou oussye eguinan soury hin, er darstura eguy harm, Genicoa plasar vadu."

(In Basque: "Great lord, there is a remedy for every evil. What's really hard is to do the right thing. I've already asked you, over and over! Let us have things settled. We'll get to that, and in pleasant style, if you'll let me satisfy my hunger. After that, ask me whatever you like. And it wouldn't be a bad idea to fork up enough for two, may God be willing.")

"Are you there?" answered Epistemon. "Hey! Genicoa!"

And Carpalim (meaning in Greek, "Quickman") said:

"By Saint Trinian, you're Scots, or I haven't understood a word!"

And Panurge answered:

"Prug frest strinst sorgamand strochdt drhds pag brledand Gravoi Chavigny Pomardière rusth pkallhdracg Devinière pres Nays. Bcuille kalmuch monach drupp delmeupplistrincq dlrnd dodelb up drent loch minc stzrinquald de vins ders Cordelis hur jocststzampenards."[2]

To which Epistemon said:

"Are you speaking some Christian tongue, my friend, or jabbering the way they do in Maître Patelin's farce? Ah, no: it must be the language of Lanternland."

And Panurge said:

"Heere, ie en spreke anders gheen taele, dan kersten taele: mi dunct nochtans, al en seg ie u niet een woordt mynen nood verklaart ghenonch wat ie berglere; gheest my uyt bermherticheyt yet waer un ie ghevoed magh zung."

(In Dutch: "I speak none but Christian tongues. However, it seems to me that, without my saying a single word, the rags I'm wearing would show you well enough what I wish. Be sufficiently charitable, please, to give me that which will nourish and restore me.")

To which Pantagruel answered:

"And that's more of the same."

[2] Another imaginary language, sprinkled with occasional French words and place-names.

And Panurge said:

"*Seignor, de tanto hablar yo soy cansado. Por que suplico a Vuestra Reverencia que mire a los preceptos evangelicos, para que ellos movent Vuestra Reverencia a lo que es de consciencia; y si ellos non bastarent para mover Vuestra Revenerencia a piedad, yo supplico que mire a la pieded natural, la qual yo creo que le movra como es de razon, y con esto non digo mas.*"

(In Spanish: "My lord, I grow tired of too much talking. Which is why I beg Your Reverence to consider the Bible's precepts, so they may move Your Reverence to act according to the dictates of conscience; and if those precepts are not enough to move Your Reverence to pity, I beg you to consider natural piety, which I believe will move you, as it is right it should. And having said that, I have nothing else to say.")

To which Pantagruel said:

"Certainly, my friend, I haven't the slightest doubt that you can talk all sorts of languages. But tell us, please, in some language we can understand, what it is you want."

And Panurge said:

"*Myn Herre, endog, jeg med inghen tunge ta lede, lygeson boeen, ocq uskuulig creatner! Myne Kleebon och my ne legoms magerhed udviser alligue klalig huuad tyng meg meest behoff girered somder sandeligh mad och drycke: hvuarpor forbarme teg omsyder offuermeg; oc befarlat gyffuc meg noguethi: aff hvylket ieg kand styre myne groeendes magher lygeruff son man Cerbero en soppe forsetthr. Soa shal tuloeffue lenge och lycksaligth.*"

(In Danish: "Sir, even were this a situation where, like children or animals, I spoke no language at all, my clothes and the bony, half-starved nature of my body should clearly show you what I need: that is, to eat and drink: so have pity on me and give me that which will subdue my howling stomach, just as one puts a sop in front of Cerberus. And may you live long and happily.")

"I believe," said Eusthenes (meaning in Greek, "Strongman,") "that the Goths talked like this. And if God wanted us to talk through our assholes, we'd talk that way, too."

So Panurge said:

"Adoni, scholom lecha: im ischar harob hal habdeca, bemeherah thithen li kikar lehem, chancatbub: Laab al Adonia chonenral."

(In Hebrew: "Lord, greetings to you: if you care to help your servant, give me, right away, a bit of bread: as it is written, he who has pity on a poor man says a prayer to God.")

To which Epistemon answered:

"Now I've understood him, because this time he spoke in Hebrew, most eloquently pronounced."

And Panurge said:

"Despota tinyn panagathe, diati sy mi uc artodotis? horas gar limo analiscomenon eme athlios. Ce en to metaxy eme uc eleis udamos, zetis de par emu ha u chre, ce homos philologi pantes homologusi tote logus te kerhemata peritta hyparchin, opote pragma afto pasi delon esti. Entha gar anankei monon logi isin, hina pragmata (hon peri amphisbetumen) me phosphoros epiphenete."

(In classical Greek: "Dear master, why, why don't you give me some bread? You see me virtually dying of hunger, and you have no pity for me, none at all, and you ask me improper questions. Yet all those who love learning agree that words are superfluous when the facts are obvious to everyone. Words are necessary only when the things we discuss don't clearly reveal themselves.")

"What!" said Carpalim, Pantagruel's servant. "That's Greek, I understood that. How come? Have you lived in Greece?"

And Panurge said:

"Agonou dont oussys vou denaguez algarou, nou den farou zamist vou mariston ulbrou, fousquez vou brol tam bredaguez-moupreton den goul houst, daguez daguez nou croupys fost bardou noflist nou grou. Agou paston tol nalprissys hourtou los echatonous, prou dhouquys brol panygou den bascrou no dous cagnous goukfren goul oust troppassou."[3]

"I understand that," said Pantagruel. "Or at least I seem to, because it's the language we speak in Utopia – or at least it sounds a lot like it."

[3] Yet another imaginary language, with a few real words to season the mixture.

And then, as Pantagruel was about to go on, Panurge said:

"*Jam toties vos, per sacra, perque deos deasque omnis obtestatus sum, ut, si qua vos pietas permovet, egestatem meam solaremini, nec hilum proficio clamans et ejulans. Sinite, queso, sinite, viri impii, Quo me fata vocant abire, nec ultra vanis vestris interpellationibus obtundatis, memores veteris illius adagii, quo venter famelicus auriculis carere dicitur.*"

(In Latin: "I have already conjured you, and several times, by the holiest of objects, by the gods and by the goddesses themselves, that if any pity stirs in you, you might relieve my poverty, but my cries and lamentations have been useless. Give it up, I beg you – give it up, O hard-hearted men, and let me go wherever my destiny calls me. Nor weary me any more with your empty interpolations, but remind yourselves of the old adage that a famished belly has no ears.")

"Truly, my friends," said Pantagruel, "don't you know how to speak French?"

"Very well indeed, my lord," answered Panurge, "and God be thanked for it. French is my native tongue, and my mother tongue, for I was born and nourished in the very garden of France: that is, in Touraine."

"And so," said Pantagruel, "tell me your name and where you're going, because – by my faith! – I've taken such a liking to you that, if you're willing, I'll never let you leave my company, and you and I will make a new pair of friends to rival Aeneas and Achates."

"My lord," was the answer, "my true and proper baptismal name is Panurge, and I have just come from Turkey, where I was taken prisoner when, in an evil hour of us, we tried to take Mytilene. And I'll gladly tell you everything that's happened to me, which is more marvellous than the adventures of Ulysses. But since it pleases you to keep me with you (and I cheerfully accept your offer, and declare I will never leave you but follow you, if you like, straight to the devil,) there will be more convenient times, and more leisure, to tell you everything, because right now I have a singularly urgent need to eat. My teeth are sharp, my belly is empty, my throat is dry, my appetite is eating me alive: everything's ready. If you'd like to see me get to work, it will please you to watch me put it away. By God, just give the order."

Then Pantagruel commanded that Panurge be led to his lodgings and that food be brought to him at once. This was done, and that night Panurge ate very well indeed, and then fell asleep like a chicken, and slept until it was dinner time the next day, so that all it took him to get from his bed to the table was three steps and a jump. [...]

How Pantagruel Got Sick, and How He Was Cured

Not long after, my good Pantagruel fell sick and had so much difficulty with his stomach that he could neither drink nor eat. And since sicknesses never come singly, he was tormented by a burning piss that tortured him almost beyond belief. But his doctors were able to help him, and they did a fine job, with the assistance of lots of sedatives and diuretics, so that soon he was able to piss away his illness.

But his urine was so burning hot that from that day to this it has never cooled down, and we have a number of such places right here in France, depending on how the urine happened to flow away. And these are the hot baths of Cauterets, Limoux, Dax, Balaruc-les-Bains, near Montpellier, Néris, Bourbon-Lancy, and others. And in Italy there are: Montegrotto, Abano, San Pietro Montagnone, Santa Elena Battaglia, Casa Nova and San Bartolomeo. And in Bologna: at Porretta – and a thousand other places.

And that crowd of stupid doctors (and would-be philosophers) absolutely astonish me, wasting time debating where each of these hot baths might come from, whether perhaps borax might have caused them, or sulfur, or alum, or saltpeter from a mine. Because all they're doing is playing games: they'd do better rubbing their asses on a spike thistle than making so much empty noise about something they don't understand at all. Because the answer is simple, and there's no need to look any farther for it. These hot baths are hot because they began as our friend Pantagruel's hot piss.

Now, to tell you how he was cured of his principal ailment, let me just note that he took a diuretic sedative, in a dosage of four hundredweights of colophonic resin, a hundred and thirty-eight wagonloads of cassia, eleven thousand nine hundred pounds of rhubarb, not to mention other items.

You must realize that, according to the doctors' best opinions, it was decided that they had to get rid of whatever was upsetting his stomach. To accomplish this, they

made seventeen great copper balls, bigger than those you see at Rome, on Virgil's Needle. Each of these balls opened in the middle and could be closed by a spring. One of his men climbed into the first great ball, carrying a lantern and burning torch, and was lowered down into Pantagruel as if he'd been a tiny pill. Five good-sized fellows, each carrying a pick, got into five other balls, and three peasants got into three more, each of them with a shovel on his back. Seven strong porters got into seven other balls, each of them with a big basket on his back, and they, too, were lowered down like pills.

When they got into his stomach, they unhooked the springs and left their cabins, headed by the man with a lantern, and thus they groped their way for more than a mile, across a ghastly chasm, fouler and more stinking than the fumes of Mephitis, or the Swamp of Camerina, or the fetid Lake of Serbonis that Strabo wrote about. If they had not been protected by the heart, the stomach, and that wine pot we call the head, they would surely have been suffocated to death by those horrible vapours. Oh what a perfume, oh what a scent, to foul the delicate masks of whores and sluts!

And then, feeling their way and sniffing as they went, they located and drew near the fecal matter and corrupt essences, until finally they reached a small mountain of shit. The pick carriers smashed at it, to break it into smaller chunks, and then the men with shovels loaded it into their baskets, and when everything was thoroughly cleaned up, they all got back into their balls. And then Pantagruel obligingly threw up, and they were back out again in a moment, and it made no more difference to his throat than a belch would to yours. They jumped out of their balls happily – it made me think of the Greeks jumping out of the wooden horse, in Troy – and thus Pantagruel was cured and put back on the road to good health.

And one of these bronze balls can be seen, to this day, in Orléans, on the bell tower of the church of the Holy Cross.

From: *Gargantua and Pantagruel* by François Rabelais, translated by Burton Raffel. Copyright © 1990 by W.W. Nortons & Company, Inc. Used by permission of W.W. Norton & Company, Inc., New York, 1991, pp. 135-137, 143-144, 156-159, 160-164, 233-234, [First French edition 1542.]

ROME, NAPLES AND FLORENCE

Stendhal

Florence, 22nd January 1817. The day before yesterday, as I descended upon Florence from the high ridges of the Apennine, my heart was leaping wildly within me. What utterly childish excitement! At long last, at a sudden bend in the road, my gaze plunged downward into the heart of the plain, and there, in the far distance, like some darkling mass, I could distinguish the sombre pile of *Santa Maria del Fiore* with its famous Dome, the masterpiece of Brunelleschi.

"Behold the home of Dante, of Michelangelo, of Leonardo da Vinci," I mused within my heart. "Behold then this noble city, the Queen of mediaeval Europe! Here, within these walls, the civilization of mankind was born anew; here it was, that Lorenzo de' Medici so brilliantly sustained the part of Kingship, and established a Court at which, for the first time since the reign of Augustus, military prowess was reduced to a secondary role." As the minutes passed, so these memories came crowding and jostling one against the other within my soul, and soon I found myself grown incapable of rational thought, but rather surrendered to the sweet turbulence of fancy, as in the presence of some beloved object. Upon approaching the *San-Gallo* gate, with its unbeautiful Triumphal Arch, I could gladly have embraced the first inhabitants of Florence whom I encountered.

At the risk of losing all that multitude of personal belongings which a man accumulates about him on his travels, immediately the ceremony of the *passport* had, with fitting ritual, been observed, I abandoned my conveyance. So often have I studied views of Florence, that I was familiar with the city before I ever set foot within its walls; I found that I could thread my way through the streets without a guide. Turning to the left, I passed before a bookseller's shop, where I bought a couple of descriptive surveys of the town guides. Twice only was I forced to enquire my way to passers-by,

who answered me with a politeness which was wholly French and with a most singular accent; and at last I found myself before the façade of *Santa Croce*.

Within, upon the right of the doorway, rises the tomb of Michelangelo; beyond, lo! there stands Canova's effigy of Alfieri; I needed no *cicerone* to recognize the features of the great Italian writer. Further still, I discovered the tomb of Machiavelli; while facing Michelangelo lies Galileo. What a race of men! And to these already named, Tuscany might further add Dante, Boccaccio and Petrarch. What a fantastic gathering! The tide of emotion which overwhelmed me flowed so deep that it scarce was to be distinguished from religious awe. The mystic dimness which filled the church, its plain, timbered roof, its unfinished façade – all these things spoke volumes to my soul. Ah! could I but forget...! A Friar moved silently towards me; and I, in the place of that sense of revulsion all but bordering on physical horror which usually possesses me in such circumstances, discovered in my heart a feeling which was almost friendship. Was not he likewise a Friar, Fra Bartolomeo di San Marco, that great painter who invented the art of *chiaroscuro*, and showed it to Raphael, and was the forefather of Correggio? I spoke to my tonsured acquaintance, and found in him an exquisite degree of politeness. Indeed, he was delighted to meet a Frenchman. I begged him to unlock for me the chapel in the north-east corner of the church, where are preserved the frescoes of Volterrano. He introduced me to the place, then left me to my own devices. There, seated upon the step of a faldstool, with my head thrown back to rest upon the desk, so that I might let my gaze dwell on the ceiling, I underwent, through the medium of Volterrano's *Sybils*, the profoundest experience of ecstasy that, as far as I am aware, I ever encountered through the painter's art. My soul, affected by the very notion of being in Florence, and by the proximity of those great men whose tombs I had just beheld, was already in a state of trance. Absorbed in the contemplation of *sublime beauty*, I could perceive its very essence close at hand; I could, as it were, feel the stuff of it beneath my fingertips. I had attained to that supreme degree of sensibility where the *divine intimations* of art merge with the impassioned sensuality of emotion. As I emerged from the porch of *Santa Croce*, I was seized with a fierce palpitation of the heart (that same symptom which, in Berlin, is

referred to as an *attack of nerves*); the well-spring of life was dried up within me, and I walked in constant fear of falling to the ground.

From: Stendhal, *Rome, Naples and Florence*, John Calder, London, 1959, pp. 300-304 [Translated by Richard N. Coe, First French edition 1826.]

CORRESPONDENTS

Gridthiya Gaweewong

BANGKOK DIARY # 1

June 4, 2005. Thanks for giving me an opportunity to do this report, and to be part of *T1 The Pantagruel Syndrome.* I'd like to respond to your question about what I 'feel is important in contemporary art today and why, as well as give my thoughts on "Pantagruel".' These are good questions, but hard to answer. Everything is important and worth considering in contemporary art. The most significant point is context.

With the fluxes of biennials and triennials around the globe, be they in Eastern European countries, Asia, Latin America or Africa, the Anglo- or Eurocentric has gradually been debunked to the periphery. The art world has been obliged to use the invention of hi-speed internet and the instant cultural format of biennial or triennial, which allows any city or country to enter the international art landscape. The mega cities or underdog cities whose politicians and citizens wish to change their image or to be part of the "international art world" have tended to use this event as their strategy. Cities like Tirana, Istanbul, Johannesburg, Luanda, Ho Chi Minh City and Guangzhou started to be discussed at the dinner tables of art elites on the other side of the world. But it seemed as if the art world was no longer offering any choice, no alternative strategy to do something different from what others were doing.

There must be some alternative format, tool or strategy for the art world to offer something different from the tailor-made art event. It would be great to see something like this happening. There is hope. I can see something starting to change, in the Triennale format, like yours, or in Hou Hanru's and Hans Ulrich Obrist's Guangzho Triennale and the Luanda Triennale in Angola, which are altering formats and strategies from merely being an "exhibition" to something like *T1*, where you work with many people around the globe, and activate this network to be more vibrant by integrating "us" into the process of both the exhibition and production itself.

What about Bangkok ? Where are we now, within this kind of trend? We might get there, someday, with a different approach. We have started to question ourselves, looking for a new strategy to appropriate these cultural activities in this country, where infrastructures have been constructed due to the needs and demand of its art community. Today is the first time in our political history that people's voices can instigate and formulate the institution of the Ministry of Culture, and its Office of Contemporary Art and Culture (OCAC.) Thailand has started to shift its position from being a country that mostly depends on outside grants to a self-supporting country through its own public and private advocacy. Two years ago, the OCAC brought Thai artists to the Venice Biennale. This year, we have our own pavilion, presenting the two leading artists from Thailand, Montien Boonma and Araya Rasdjarmrearnsook.

What happens to those who have "been there, done that?" Instead of heading to the center, many artists and art projects are happening here, within their own locality and playing with their own contexts. They are moving away from site-specific, and object-based works, to project-based works, with the community, the environment and the context as a new challenge and catalyst. Spearheaded by Rirkrit Tiravanija and Kamin Lertchaprasert with *The Land Foundation* project in Chiangmai and by Navin Rawanchaikul's *Fly with Me to Another World* in Lamphun, artists' initiative projects have demonstrated an attempt to relocate the arts activism from mainstream and urban issues to rural and community levels. At the same time, urban artists and professionals in Bangkok have begun to get together and work with a resurrected Bangkok Art and Culture Center, which had aborted five years ago. With the approval of a new governor, this project will be realized and is scheduled to finish around the end of December 2006. We still keep our fingers crossed. Meanwhile, the Thailand Creative and Design Center is on its way to opening an exhibition at the end of this year. Bangkok's vibe is back to its hyper rhythm, just like it was in 1997, the year after the economic crash.

On a regional level, Southeast Asia has become the place for various types of experimental projects, especially "community based programs." With its complex cultural and political situation, laid-back attitudes, and its clash and co-existence between

old and new, many international art projects have started to explore this area as an important site. Ironically, however, they are mostly subsidised by some powerful funding bodies from New York.

Here we get quite a broad picture of the current situation in Thailand. There will be some projects happening throughout the year, of which I will write to you later. We do not have any major debates or discussions or major identity crises about post-colonialism, as in our neighbouring countries. The source of our inspiration or creativity comes from everywhere, and nowhere. Within this kind of chaotic frame, nobody knows what is going to happen with our Southern problem, our political future over the next ten years, but we live our lives according to Murphy's law: we make fun of it, and let it go. Maybe this kind of attitude, at some point, can link in with your *Pantagruel Syndrome*.

For the frenzied, playful, fanciful part they play, I'd like to propose Michael Shaowanasai (b. 1964,) Wit Pimkanchanapong and Porntaweesak Rimsakul (both born in the late 1970s and early 1980s.) They all work with a humourous, satirical, quirky, yet critical approach to our society. And of course, also interesting is Araya Rasdjarmrearnsook– who's working with dead bodies and the body of death.

More depressive and self-orientated works by a young female artist would be those by Jibby Vanchit Yunibandhu (b. 1975.) For more information visit our website at www.project304.org, and click on our archive for 2000, when we staged her first solo, *Life As a Box of Chocolate.*

Apichatpong Weerasethakul's video and film works are adventurous and very poetic. He's currently busy with his new film project, about the inspiration of Mozart. I'm currently preparing a group show of southeast Asian artists in Berlin with a new work, a collaboration with Christelle Lheureux about the tsunami, entitled *Ghost of Asia.*

I hope you have great weekend.

BANGKOK DIARY # 2

July 27, 2005. When Pantagruel went to study in Paris, his father sent him a terrific letter saying, "I wish you to carefully devote yourself to the natural world. Let there be no sea, river, or book whose fish you do not know. Nothing should be unknown to you [...] all the metals hidden deep in the abyss, all the gems of the Orient and the Middle East – nothing."[1] In response to his father's will, Pantagruel demonstrated his ability to be open, to learn something new, to make an attempt to communicate with unknown cultures and languages, capable of constructing his imaginative language to communicate with people within his own utopia.

Pantagruel's attitude is totally opposite to today's society and mentality. Because of globalization and its backlash, we've tried to explore our own cultural coasts, and play with the past to negotiate our future. When the world tried to merge us together, we started to back off and detach ourselves from one another by means of the reinforcement of our own individual, identities of nation/state. Perhaps the idea of unity, standardization and globalization doesn't really work. And here we reach a dead end.

In today's art world, the Pantagruel spirit can be seen in international art circles. Participants in this event, be it curators, artists and artworks, are part of this system. They have functioned like Gargantua's letter to his son. They have cited, documented, analyzed and critiqued their own times, just as all artists do with their own contemporary culture. These people are a new tribe in today's world, a tribe that has no real home, but relies on cyberspace, virtual reality, as its base, and uses email as its sole means of contact. For the members of this tribe, it is a strange experience to be

[1] From Chapter Eight, 'How Pantagruel, at Paris, Received a Letter from His Father, Gargantua, with a copy of That Letter.'

in their own cities for more than two consecutive months. Later, nobody really counts them as part of their own "community," because they are always away, treating their base as a stopover, or a transit zone.

"Hot" curators around the world, legendary Thai artists like Rirkrit Tiravanija, Surasi Kusolwong, and Apichatpong Weerasethakul, are part of this tribe, nomads with their own mission impossible: to express themselves to the world, to communicate with an unknown territory, to challenge traditions and to provoke audiences' minds. Today's world needs this kind of tribe, to break open our stereotypical perceptions of one another. But not all cities in the world can tolerate them.

Fortunately, in a transitional city like Bangkok, they are more than welcomed. Their presence, energies and practices have always excited and stimulated us. As I wrote in my first report, the energy of the Bangkok art scene is back to how it was in the mid-1990s. This month, many nomadic curators and artists are heading to Bangkok to recruit artists for their upcoming biennials and triennials. Representatives from the Sydney Biennale, Yokohama Triennial, Berlin Museums, the Asia Society, New York, are storming the city either in person or through emails to solicit advice and to sneak a peek at young artists' studios, looking for fresh, young artists to participate in their events.

I wonder how frequently we can nurture and produce young artists to feed the enthusiastic international art world.

Bangkok rainy day

Gridthiya Gaweewong lives and works in Bangkok. She is an independent curator and a co-founder of Project 304, a non-site/non-profit art organization based in Bangkok, focusing on multidisciplinary cross-cultural art projects by local and international artists. Her curatorial works include *Bangkok Experimental Film Festival* (1997 – present,) *Sorry for the Inconvenience*, Bangkok, and *Under Construction*, Japan Foundation and Open City Gallery, Tokyo, Japan (2003,) - + - *negative plus negative*, Earl Lu Gallery, Singapore, and a retrospective of Rirkrit Tiravanija and Kamin Lertchaiprasert, Chiangmai University Art Museum, Chiangmai (2004.) She is currently preparing a group show of Southeast Asian contemporary artists for the Haus der Kulturen der Welt in Berlin (2005.)

Sofía Hernández Chong Cuy

T1 REPORT # 1

April 18, 2005. I am writing from New York City. There is an evident polarization here between so-called topical art and formal art, where the topical generally sides with politics and formalism with the market – at least discursively. This is not to say that it is an either/or relationship, or that these are mutually exclusive categories, nor that it is symptomatic of this city alone. This polarization also exists to different levels of intensity elsewhere. In any case, it is important to look at the sides of this contextual split; at what is generated or emerging in the midst of this divide.

A sense of anxiety is one of the things that surfaces, particularly towards the diverse and critical interpretation of art, artistic practices and exhibition-making.

Since an amnesiac relationship to history is characteristic here, timely discursive forums, such as magazines, journals and blogs, can secure the necessary address to references and sources, and cite the relevance of both making and approaching – even of not understanding – contemporary art. It is important to find ways of critically *intervening* in established discourses as well as discursive forums, rather than necessarily *creating* spaces that might increasingly segregate an already divided community.

Considering the figure of Pantagruel is interesting and timely. What types of parameters will be created so that the address to such a figure is not one based only on allegory or category? I ask this since the description you give us of this figure shares similarities with the typical characteristics given to capitalism. Most likely this is not a coincidence. But I find that the political transitions that are currently taking place are not so much strictly tied to an either/or type of economy, but to a lack of knowledge and thus reconciliation of the beliefs embedded or perhaps lacking in any of its systems. What is questionable are the motivations of transitions, and the processes that enable, deter and complicate them. I am sceptical about how a figure or a sys-

tem itself can shed light on or explain motivations or forces, political or aesthetic. It is often a series of seemingly unrelated events that does so. Having said this, the most exciting characteristic of the Pantragruelic is the intensity of its impulses. But its intensity is measured here in a literal way (e.g. in terms of height: gigantic; in terms of length: a traveller; in terms of appetite: insatiable, suggesting infinite depth.) What other ways will intensity (e.g. as intention, as a force) be addressed in your curatorial approach?

I recommend a group of young artists, some of them relatively unknown. In most cases, their work tends to be concept-driven, and therefore their aesthetic strategies change according to the given project on which they are working.

The work of Ruben Ortiz Torres, a Mexican artist based in Los Angeles since the early 1990s, is rarely known in the mainstream art circuit. He is one of those artists who has had an impact in specific circuits (e.g. he was recently included in the remarkable group exhibition, *The Interventionists*, and was invited to do a residency at the Fabric Workshop in Philadelphia,) but who is entirely left out of the international art exhibition scene, such as biennials, triennials and so on. To create his work, Ruben generally addresses the aesthetics or "inventions" (either of objects or myths) of immigrant communities. His work is robust, complex, sometimes kitsch and always purposefully "over the top." I met him at *inSITE97* (Tijuana/San Diego, 1997,) and worked with him recently at Art in General (New York, 2004.)

I have worked closely with Jennifer Allora & Guillermo Calzadilla (based in Puerto Rico,) who are perhaps the best known from this group of artists I am suggesting. I also feel strongly about the work of Mario Garcia Torres (Mexico City/Los Angeles) and Yoshua Okon (Mexico City/Los Angeles.) In New York City, I am in dialogue or have recently begun conversations with a number of New York-based artists such as Alejandro Cesarco (Uruguay,) Sharon Hayes (USA,) Michael Rakowitz (USA,) Melissa Martin (USA,) Patrick Killoran (USA,) Ignacio Lang (Puerto Rico) and Daniel Bozhkov (Bulgaria.) With the exception of Bozhkov, who is in this mid-forties, all these artists are relatively young (in their early thirties.) Killoran is currently working on a project-based work on his own initiative that incorporates a mask with open mouth;

its material is coated vinyl foam, as in the cushioned masks used by boxers. His intention is to produce dozens, perhaps hundreds of these masks and to organize an event (yet to be determined) with various people wearing them.

I also have a particular interest in artists' groups and collectives. Two groups that I'm currently working with are LTTR (a.k.a. Lesbians to the Rescue) and Bernadette Corporation. LTTR is a group of radical young artists (most of them in their early twenties.) They publish a journal and organize multi-media events, exhibitions, performances and other cultural activities. One of its members, the artist K8 Hardy, is particularly special; she works primarily in video and performance. Bernadette Corporation does everything from fashion shows to magazines to feature-length videos to novels. It is primarily formed by three members, an artist based in Berlin, a writer based in New York (John Kelsey,) and an artist living in Paris.

Many of the artists I have suggested live in NYC. During the time of your visit, Michael Rakowitz will be having an exhibition at Lombard Freid Fine Arts; Daniel Bozhkov at Andrew Kreps. I didn't initially suggest Javier Tellez (Venezuela,) an artist based in New York City, too. For some reason, I thought he would have been suggested by someone else.

You might also want to know that there are some interesting international artists doing the ISCP residency, such as Marko Lulic (Vienna) and Jonas Dahlberg (Sweden.)

Also, Andreja Kuluncic from Zagreb, Croatia is doing the residency at Art in General. She was included in *Manifesta 4*, *Documenta 11*, and other international shows, but she has not had a major solo show.

T1 REPORT # 2

September 5, 2005. I am writing from Brooklyn, after devouring repulsive realities described in articles, graphs and images in the newspapers, wandering in pointless search engines, downloading music soundtracks from films I've seen in the last

month, or haven't, repeatedly listening to some, deleting most, thinking about stopping, stepping out, taking pleasure in the daylight or the evening, but remaining, still here, convincing myself that lingering in this mediocre incarceration is most comfortable, that sitting is better than a walk, emailing better than a call, and I continue enjoying the nicety of detachment, consuming the pettiness of nothingness, eluding a succinct response to the romanticized notion of this adopted or assumed bourgeois life.

In a trip into self-consciousness, while people drift in rivers of rain and rising founts of piss and shit, is how I embarrassingly meet Pantagruel. It happens in a liminal space where it is neither possible to forget nor articulate. It is far from where Stendhal dwells, but not too distant from a place that would profoundly provoke him – or anyone.

Uniquely sublime, considering its unreal proportions, is what living and working in this fucking country is all about. A loaded space filled with promises and prophecies that generate nothing but ideal scenarios that are at once packed and vacant, and yet forever dirty as tripe. Silent goes the protest. Bulimic goes the night.

And I remember an early video by artist Dave McKenzie. A single shot, torso up. A microphone stuck on his mouth. Him mumbling. His arms and hands gesturing sign language: "I am talking to you." And I remember another video, of a decade ago. This one by Marina Abramović. A single head shot of her obstinately eating an onion as if it were an apple, mumbling, sniffing, tearing. The sound of her thoughts: "I am tired ... I want..." And I finally decide to go out of my home, myself. I visit Melissa Martin, and find her chewing and spitting gum, one after a hundred others, sculpting it into meat cuts shaped after a dissected body belonging to her father, packing them up in styrofoam and plastic. And I leave, compulsively eating another day, awake, throwing it up.

Sofía Hernández Chong Cuy is curator and programs manager at Art in General, a non-profit gallery in New York City that organizes exhibitions of contemporary art and that hosts an international artist in residence programme. She is also one of the three curators of the forthcoming *IX Baltic Triennial*,

 to take place in Fall 2005 at the Centre for Contemporary Art in Vilnius, Lithuania and the Institute of Contemporary Art, London, UK. Other curatorial projects include *Puerto Rican Light*, a solo-exhibition of artists Jennifer Allora & Guillermo Calzadilla, which was presented at The Americas Society, New York, and the first monograph of visual artist Paul Ramirez Jonas, published by Ikon Gallery, Birmingham, UK. Sofía obtained a Licenciatura en Artes at the Universidad de Monterrey, Mexico, and received a graduate degree at the Center for Curatorial Studies, Bard College, New York.

Raimundas Malasauskas

FROM A NON-EXISTENT WEBLOG

April 19, 2005. Last week, together with Rene Gabri, we were walking along the shore of lake Garda in Salò, where Pasolini shot *120 Days of Sodom.* Driven by the idea of making a TV version of Pasolini's film for a contemporary audience, we were trying to recruit people (mostly kids) for the upcoming production. We did not ask them about Fascism becoming a part of cultural tourism, we rather talked about reality TV and their denim jeans. The conversations were shot on video. The first and perhaps the last episode of the series on Salò will follow on CAC TV. One important thing that didn't make it into the video was our conversation with Rene about art. Its synopsis is as follows: the most simple way to betray art is to define it. As soon as you define what art is, it is dead. Please keep it undefined.

So in that sense I think it's important to reinvent your own practice, objectives and methodology. "Every program is a pilot, every program is the last episode" is the slogan of the CAC TV programme, www.cac.lt/tv, that we have been running in Vilnius. With each episode we try to reinvent our own identity in a fluid collaboration with artists. Escape a fixed definition. This keeps us in a limbo between Bart Simpson, who says "My job is to repeat," and Maurice Blanchot, who says "The writer never is, the writer always becomes." So the idea is not to be, but to become. It is a state of a continuous pilotism.

Forget seriality. Invent formula for variety. Forget it.

The adventure of reinvention is an element that might constitute a contemporary figure of Pantagruel. Wouldn't you like to show the 16 mm film of Gordon Matta Clark about his Food restaurant? Food was always a way of reinventing and following the realm of the senses. Maybe I should make an interview with Roger Welch who edited the original film? I am going to NYC next week and would love to meet him for a coffee there.

When adventure is massive and collective it's called "revolution." "The revolution is already here, it's just unevenly distributed," claimed William Gibson. How does one distribute revolution evenly? By changing the whole system of distribution or by changing the logic of the system? Can art be a mediating link between different systems of distribution? A node whose function is to link and mediate? Perhaps Google has an answer. More soon.

Suggested artists in random order:
Bubu (Jesus Cruz Negron,) Puerto Rico
Ulrike Mueller, NY
Ana Prvacki, Singapore/NY
Rene Gabri, NY
Pablo Leon de la Barra, London
Hubert Czerepok, Poland
Gints Gabrans, Riga, Latvia
Melvin Motti, Rotterdam
Mariana Deball, Berlin/Amsterdam
Will Kwan, NY/Maastricht
Laurel Nakadate, NY
Laura Stasiulyte, Vilnius
Maaike Gottschal, Amsterdam
Darius Miksys, Vilnius
Kiwa, Tallinn, Estonia
Chemi Rosado Seijo, Puerto Rico
Tobias Wang, NY
Juozas Laivys, Vilnius
Hope Ginsburg, NY
Yane Calovski, Skopje, Macedonia
David Kuenzi, Zurich
Kobe Mathys, Brussels

Sven Augustijnen, Brussels

Lina Issa, Maastricht/Beirut

Gabriel Lester, Brussels/NY

Mindaugas Lukosaitis, Vilnius

REPORT #2 FROM THE NON-EXISTENT WEBLOG

July 28, 2005. And the next thing I remember is the cab that took us to the cinema. We arrived carrying the plates of food and drinks that had accompanied our earlier conversation about sex, poverty and death in front of the CAC Hotel. "If I become old and deprived of anything, like you are," I said to Stefa, the oldest of the homeless guys that we were hanging out with, "I'll commit suicide." "Stupid," Stefa disagreed, "They won't accept you in the cemetery." "Bingo!" I forgot any other words. Stefa's statement made it clear that the function of the cemetery is a gate for joining normal society posthumously, even after years of existing outside of it. Seemingly suicide, the ultimate choice of freedom, deprives you of the right to enter the cemetery and thus the right to remain inside the community. Stefa knew that, and yet didn't manage to join us at the cinema because she collapsed after another couple of shots of a window-washing liquid (which one could get in the nearest bodega, according to her.) We left her lying on the grass. "Suicide is an art that takes life to learn," Vale remembered Foucault while Margarita and Ben chewed sausage. Soon we reached the cinema, which was meant as a surprise for those who had not followed its repertoire for years. *Batman* was not there yet.

Before he started training as a fighter in Himalaya, our companion started a different fight: Ben hit Margarita a couple of times ("because the film was absolute crap," he said the following day.) Then they both fell asleep ("due to politeness as they didn't want to leave the film and make us sad," Vale commented) and we've left them in their seats. Perhaps the choice of film was no better than the KGB museum in

Vilnius, which was our next destination. Nevertheless, the walls of the torture chambers were not thick enough to block the signal of the call of a friend, who had turned his place into a cruise boat "for the whole family" and was looking for company while demonstrating a beard made of shaving foam. The trip continued at the highest speed of non-thinking, which afterwards made me think about Harald Szeemann's idea that exhibitions should be organized like a poem.

Perhaps they could be organized like music as well. Or a blog: the exhibition as a blog that mediates, organizes and facilitates the experience while linking it to similar attempts by others. A blog that functions as a tool of subjectivity and gets updated through a palm-held device (or by organs in the body) while you sleep. A blog that connects remote destinations as an open loophole. A blog that is always with you even if you are with someone else. A blog that is unblogged. A blog that is always offline and online at the same time. A blog that is updated from the side of no-dates where all times co-exist and all sides are inside and outside at the same time. From the zone the same time is always another time and Stefa is putting honey into tea.

"Do you agree that notebooks, by definition, are more interesting than books?" I asked Vale.

Raimundas Malasauskas is Curator at the Centre of Contemporary Art, Vilnius (www.cac.lt.) He grad-
uated from the Curatorial Training Program at the De Appel Stichting, Amsterdam. Co-producer of
CAC TV program (www.cac.lt/tv) and So-Called Records (www.socalledrecords.com,) he has made
interviews with Robert Barry, Seth Siegelaub, Rammelzee and Tino Sehgal, as well as a psychic inter-
view with George Maciunas, founder of Fluxus ("Looking for Mr Fluxus: In the Footsteps of George
Maciunas," 2002,) and forwarded a telepathic message from Robert Barry to Jonathan Monk during

 the exhibition *The Gallery will be Open* (Jan Mot Gallery, Brussels, 2003.)
He has curated various exhibitions, including *24/7 Wilno – Nueva York*
(CAC Vilnius, 2003); *PR 04 (A Tribute to the Messenger,)* Puerto Rico
(2004,) *Elektrodienos: Unidentified Audio Object* (CAC Vilnius, 2004,) the
series of events *Bi-Fi* (various venues, New York City 2001-03,) and *Out Trip
Out West, Pierre Bismuth & Jonathan Monk* (CAC Vilnius, 2001.) He is cur-
rently working on the 9th Baltic Triennial of International Art, co-curated
with Sofía Hernández Chong Cuy (NYC) and Alexis Vaillant (Paris,) which
is being held at the CAC in Vilnius and the ICA in London.

Francesco Manacorda

THE ARTIST AS OMNIVORE. ON CONCEPTUAL CLOSED SYSTEMS AND GROTESQUE BRICOLAGES

April 14, 2005. An opposition, originating in a historically well-bred lineage, has recently taken an unusual shape in artistic practices emerging in London and in continental Europe. On the one side there is an easily identifiable revival of conceptual precision, operative in the conception of the work as a "closed system" in which production of the work is dependent on a conceptual formula reiterating the work's concerns (represented in my selection by the artists Armando Andrade Tudela, Simon Popper and Jamie Shovlin.) On the other hand there is a side that conflates Nietzche's notion of the Dionysiac, Bataille, Bakhtin and the concept of the uncanny, which has assumed a new performative shape tending towards the carnivalesque and the grotesque (elaborated particularly in the work of Lali Chetwynd, Richard Hughes and Francis Upritchard.)

Concerning this latter excessive and expressionistic side, there is an aspect of British artistic production that indulges in the old-fashioned, awkward or eccentric, traceable also in the work of Mark Leckey or in Jeremy Deller's parades. Degradation as a strategy, and formal reductionism as a credo seem to be crucial elements at work. They are aimed at anchoring various high-culture references to a material, low culture level (see in particular Lali Chetwynd.) The voracity with which available cultural materials (films, art, books, theory, music) are gathered, processed and recombined suggests a comparison between this kind of practice and the febrile activity of essay-writing, a contemporary version of the Levi-Straussian notion of "the science of the concrete." By this term the French anthropologist tried to draw the line between science and mythical thought. This latter is intended as a *bricolage* activity that generates a new cultural artefact by combining meanings and concrete signs floating in the

creator's cultural discursive field.[2] (I am thinking of the works of Lali Chetwynd, Armando Andrade Tudela, Tobias Buche, Simon Popper and Ryan Gander.)

In the second type of artistic strategy, there are conceptually precise works whose formulae correspond to a complex interactive dynamics, which is itself the subject of the artistic practice. Any work based on a "closed system" has its peak in the pre-production phase rather than in the final object. Peculiar to this tendency is the gesture of delimiting a portion of the world and constructing a set of rules for its combination. Such an algorithm is consistent with the material investigated and becomes the structure producing an object through the combination of chosen cultural references. (In this tendency we can see Armando Andrade Tudela, Olivier Foulon, Ryan Gander, Elisabeth McAlpine, Jamie Shovlin and Simon Popper.) This second type of work – traceable to the practice of such diverse artists as Cerith Wyn Evans and Simon Starling – consists of a set of procedures whose boundaries are defined and whose functioning combines together the ingredients of the formula. This operation activates the process of production, while representing the work itself. The internal coherence of the references involved in the work, and the limited interaction with elements not included in the formula, makes of the result a thermodynamic closed system, exchanging energy with its exterior but not with matter. Mikhail Bakhtin opposes such a classic impenetrable construct to the open and abject propensity for the grotesque of carnival boundlessness.[3]

[2] Levi-Strauss explains: 'mythical thought, that *bricoleur*, builds up structures by fitting together events, or rather the remains of events, while science, "in operation" simply by virtue of coming into being, creates its means and results in the form of events, thanks to the structures that it is constantly elaborating and which are its hypotheses and theories.' Claude Levi-Strauss, *The Savage Mind*, University of Chicago Press, Chicago, 1969 (*La pensée sauvage*, Plon, Paris, 1962,) p. 22.

[3] See Mikhail Bakhtin, *Rabelais and his World*, Indiana University Press, Bloomington and Indianapolis, 1994, p. 25. Bakhtin opposes to the grotesque, monstrous and hideous aesthetics what he calls 'the "classic" aesthetics of the ready-made and the completed,' by which he means the smooth impenetrability that characterises the idea of the closed system: 'they are contrary to the classic images of the finished, completed man, cleansed, as it were, of all the scoriae of birth and development' (p. 25.) On the other hand, 'contrary to modern canons, the grotesque body is not separated from the rest of the world. It is not a closed completed unit; it is unfinished, outgrows itself, transgresses its own limits' (p. 26.)

Both omnivorous and combinatory, these two tendencies seem to evoke the image of Pantagruel devouring, digesting and spitting out. In the present artistic syndrome it is visual, textual, historical and conceptual information that gets processed and delivered back to the world. The references drawn into the platform of the "artwork composed as an essay" operate in the construction of a combination of images and signs that aspire to delineate a space of suggested connections.

Suggested artists:

Liz McAlpine (UK)

Tobias Buche (Germany)

Francis Upritchard (UK)

Laly Chetwind (UK)

Armando Andrade Tudela (Perù/Netherlands)

Simon Popper (UK)

Richard Hughes (UK)

Jamie Shovlin (UK)

Ryan Gander (UK)

Olivier Foulon (Belgium)

Tue Greenfort (Germany)

THE OPEN MOUTH: I WANT TO EAT EVERYTHING

July 31, 2005. Reflecting on the most irreducible feature that would encapsulate Pantagruel's drive, I am tempted to leave aside for a moment the classic figures of quantity, excess and extension. I believe that "assimilation" is what makes its paradigmatic character a metaphor relevant for the "google era," in which nothing exists outside what stays in the all-devouring database. Assimilation seems the most impor-

tant aspect of the voracious appetite metaphor (for food, information and culture) since ingestion without the retention of crucial elements results in an impoverished diet. The open mouth is not the only image of the Rabelasian body, but just an entrance, the liminal opening between the inside and outside that allows Pantagruel joyfully to introduce the world into his body and make it part of himself.

There are nonetheless different ways of devouring both food and knowledge, which symbolically perform different functions and are motivated by diverse impulses. Some people hoover up anything that might interest them without elaborating their implications, enjoying the devouring impulse itself rather than its consequences; others color the incorporation with an exploitative twist and are interested in the return they get from such an action; others even perform a ritual aimed anthropophagically to incorporate enemies through symbolic ingestion ... The curiosity that underpins any "Pantagruel syndrome" is perhaps the motor of the best cultural and artistic results, but it can risk being unproductive when hasty digestion leaves the material unprocessed. Assimilation is necessary to transform the syndrome from a compulsive pathology to a cultural strategy. The system grows only if it can process the ingested food or information before delivering it back to the world as mere waste.

It is unclear to me what or whom in *TI* impersonates the figure of Rabelais' giant. Certainly at the beginning I thought that the artists invited could be affected by the "syndrome" in different ways and develop it towards different targets. I thought many artists working today could be seen as producers and consumers of a vast quantity of information, cultural references and visual materials. But then the model of the biennial itself is an even better example of a gigantic ingesting mechanism easily devouring even the cultural practices that criticize it. The art system is perhaps the quickest apparatus to consume voices that reject its institutional agenda, and biennials are its most efficient digestive tract.

Ultimately, perhaps the most paradigmatic heir of Pantagruel in the field of visual culture is not the artist but the curator, constantly processing and consuming cultural information; filtering through his or her visual digestion mechanism a vast quantity of "food" that he or she extensively guzzles in all parts of the world, endlessly

ingesting new material and seeking stimulating flavours. Like Pantagruel's banquets, the curator's proficiency seems increasingly to be based on his/her ability to hyperbolically open the confines between the individual and the world by swallowing the latter and thus determining his or her encounter with the new and undiscovered. Recently, the artist Scott Miles opened a solo show in his gallery in Glasgow borrowing a sentence from a renowned curator for its title: "HUO: I want to know everything."

MA Graduate of the Royal College of Art in London, Francesco Manacorda regularly contributes to *Flash Art*, *Metropolis M* and *Domus*. In conjunction with the last edition of the Frieze Art Fair in London, he participated in *Pilot 1. A Unique Show Case for Emerging Visual Artists and Independent Curators*. He curated an exhibition on the impact of media images *The Mythological Machine* (2004) at the Warwick Art Center and programmed the symposium *Ecology and Artistic Practices* (2005) at the Royal Society of Arts, London. He is currently preparing the exhibition *A Certain Tendency in Representation* on the fascinations of the cinematic apparatus. He has written catalog essays on Simon Starling, Rainer Ganahl and recently (with Claire Bishop) on Phil Collins for the Milton Keynes Gallery.

Ana Matveyeva

PANTAGRUEL I

April 7, 2005. Let us not be hypocritical: a theme or topic means next to nothing for a project. No-no-no, of course it does mean a lot, but, applying a certain skill, you can make so many different contents (excluding some ultimate, obvious misfits) fit into the required theme. A theme for a show – or for a conversation, for a meditation – is so flexible, it can involve almost anything. And this all-inclusive scheme seems to be the default attitude for any project – not only an art project – for today. Today's mind patterns itself on a panopticum: a milieu that is designed to contain ALL. The panopticum is an idea of a Pantagruelian epoch, and Rabelais's Pantagruel is the Panopticum Man: a roaming body that happens to be everywhere, a roaming eye that sees everything, a roaming mind that contains everything.

This is exactly what we have now, and today's Pantagruel is the mass media: we have too much information; we have information on virtually everything (and what we do not have information on, hardly exists) and since we have too little time to structure or select the information, we are forced to be all-accepting. We still have to introduce new instruments that will enable us to cope with this vast, flat field of information, of phenomena without comparative value. Art now is one such instrument, and its mission is to convert an impersonal phenomenon into a personal experience – and after that, to convey that personal experience from the artist and his inner life to you and your own private inner life, to make you incorporate the very personal meaning the artist has given to his or her subject. This is why I am especially interested in art that dwells on patterns, information and images borrowed from the mass media: this makes the impersonal and structureless panopticum focus on something that seems absolutely unjustified and private, and then it proves that this private focus finds a response in your own soul and can become a center of that part of your mind that was

lacking a system. In that case, you are still Pantagruel – but already capable of tackling all the data, all the contents and impressions you have received.

The list of artists I recommend is as follows:

Kerim Ragimov, photorealist painter, especially his *Human Project*, based on images borrowed from newspapers and magazines, from news to fashion ads – see www.ragimov.ru; Vitaly Pushnitsky – see www.pushnitsky.ru – painter, maker of objects, graphic artist, especially his series "TV" (lightboxes with "TV noise") and "Brides," based on images from high-society chronicles in tabloids; Alexey Garev, see www.alekseygarev.narod.ru, photo-based panels with the basic image borrowed from newspaper illustrations. Garev takes the newspaper image, enlarges it many times (so that one can see the printing raster or the scanning pattern,) prints it out and tints it, and then "adds" to the image with scratches or words. What I would especially like to recommend is the series "Subtitles," part of which we exhibited at Moscow Biennale in January 2005 (see www.ncca-spb.ru/human/artists/garev_e.)

PANTAGRUEL II

July 29, 2005. I am late with the reply. I've been sitting at my desk for a week or so, wasting the precious sunny days, so few in Saint Petersburg, reading again the Pantagruelian correspondence sent to me by Carolyn. I was getting urgent messages from Turin by e-mail, prompting me to hurry with my second contribution. I've been honestly trying to spot some common mood valid for all the discrete contributions that could form a basis for a reaction or a dialog. I felt that was a futile and boring attempt. The variety of messages from a dozen people – some I know in person, some I have heard of, and some who are new to me – from different places, with different interests and backgrounds, writing about things utterly different, even the Pantagruelian reference being used as a metaphor to refer to different contents hardly linked to each other. This – after the week of efforts to combine the contributions

in one united statement – seemed to be the only positive way to view the whole business: to stop looking for a common ground and to dumbly accept, as the ground, the heterogeneity of interests and attitudes, forming, in some Rabelaisian way again, a panopticum: a kind of a mosaic vision without much focus.

However, I still believe that art is about struggling with this taxonomy of equal-value contents (which we are subject to but which no one can get accustomed to) and offering some focal points and hierarchic projects, introducing values or changing them, marking some experience or image as valuable and thus altering the world's (and our minds') structure of preference. Because it is not just some new information or experience that is attractive and challenging and sexy for us, but only such information or experience that changes our value structure, and this is what art can do better and more exquisitely than any other instrument. This capacity of introducing special value in things that did not possess that value before makes art magic, and this is, by the way, the reason for high prices for art – it is the magic that one buys, the very reason that one once donated a lot of money to the church. This is also why we curators and critics get plenty of moral satisfaction out of tackling art, in spite of being poorly paid and hardly ever needed by anybody but our narrow circle.

Actually, I would love to make an exhibition based on this correspondence only. And that exhibition would hardly include art, or art would not be the major part of the exhibition's content. I wish I could exhibit – beyond artworks – the messages, portraits, documents, postcards, things belonging to those contributing to this correspondence or loved by them; excerpts from movies run in cinemas in the places the contributors come from; I would show TV commercials from their local channels, the books they read, the clothes they wear or the clothes they would like to buy; the books considered fashionable in their communities, Live journal entries, food shop prices, home porn and statements by local politicians. That would be a great impersonal show, in which each of us would be a conductor of all the cobwebs of circumstance and ideas active at one's place, thus re-evaluating the personal through the impersonal and vice versa – most honestly representing oneself as only one of the numerous symptoms of one's time and place. Such a show could also be done on the mate-

rial of other people, not even (and even better) related to art, but making the ordinary circumstances of everyday life appear as evidence of a certain unique way that things are – and of certain aesthetics too! This is more thrilling for me than pictures and videos – and, though we are speaking about other things now, I catch a glimpse of such an attitude in this whole correspondence, and I hope it will convey this feeling and this flavour in its final version in the catalog.

An art critic and curator, Ana Matveyeva writes regularly for the *Moscow Art Magazine*, *Artchronika*, and *Time Out St. Petersburg*, and she contributes to the national daily newspaper *Izvestia*. She co-curated the exhibition *The Human Project*, which was part of the first Moscow Biennial (January 2005.) The exhibition was organized by the National Center for Contemporary Art network and involved the collaboration of five curators.

Pi Li

EVERYONE HAS THEIR OWN STORY

July 8, 2005. In Asia, the impact of globalization is most obvious in the trend towards urbanization. Within the process of urbanization, commercial and popular aesthetics have become increasingly prominent in contemporary culture. At the same time, urbanization has given rise to new styles of living and communication. This has brought increasing opportunities for visual representation centered around mass media; contemporary culture engenders a strong tendency towards theatrical performance and action, enshrining the goal of newness or freshness as well as the shock factor. It also embodies a desire for instant success or impact. All of these elements demand that within contemporary culture, visual representations occur on an increasingly grand scale. From the perspective of culture, most of the entertainment for the masses takes the form of visual stimulus. Contemporary culture is increasingly being reduced to a passive act of looking and listening. However, under its auspices, culture is becoming more and more democratic.

But from another perspective, a culture based on "looking and listening" is totally different from one grounded on "reading and writing." The latter gives space for the individual to emerge and grow, and for the audience to engage in a dialog with the text/subject. Looking and listening carries with it a speed of recognizing and understanding what is being seen or heard. Within the process of looking and listening, no provision is made and no demand put forth for understanding and filtering the content. Moreover, faced with this type of culture, people increasingly put aside their own emotional response, or experience a "false" initial, instant reaction (devoid of wider context.) In such a situation, the perception of what is "real" becomes veiled. The fundamental origin of this "look and listen" culture is the com-

bination of political and economic trends, directives and goals. The beautiful exterior of this culture is wrapped around an inner pressure placed upon the viewer to absorb, to purchase and to acquire. That these images, or a "look and listen" culture, can have risen to occupy such a prominent position in contemporary society is because they are based on a narrative tradition. Within a narrative tradition, the image becomes subject or vulnerable to specific political and commercial ideologies. At the same time, narrative has a long history within the field of high art.

Within the history of art, the tradition of narrative is found in all cultures: wherever art is bent to religious or political use, narrative is present. The real function of narrative in art is to imbue it with a higher aim. So, the use of narrative at times denies the creative or spiritual development of pure art. In the West, beginning in the nineteenth century, science and technology experienced great development, and the notion of the self, the individual, became paramount. Against this background, Western art underwent a period of modernism characterized by formalism. The continual exploration of form through creativity served to emphasize the individual self. The result of this exploration was to introduce an artist's personal experience as a major element of art. This evolved as an equation of individual invention and personal experience, upon which enormous importance was placed. To substantiate this approach, critics and arts writers such as Clement Greenberg initiated a defining line between the avant-garde and popular, mass culture. This led to a crisis within Western art in the 1970s, between the art that was being produced and the audience's ability to view and comprehend it with ease. From this time onward, formalism, or individual invention, has been subject to constant debate and criticism. However, few people have attempted to examine exactly at which point the artists' individual experience can be made public, and be publicly accepted. Although contemporary art has turned to dealing with social issues and social/popular images, there remain numerous barriers between art and society, and art and audience. On the other hand, within contemporary society, technique, science and reason have become increasingly impor-

tant, pushing out human faith and beliefs, which have as a result diminished in significance. Although the situation is presently thus, is it possible that we can control the relationship in art between desire and reality, the individual and society, the individual and the individual?

The rapid development of Asia means that these kinds of questions have become increasingly obvious. For myriad historical reasons, Asians have not experienced a natural release of the "self." So the narrative tradition, to greater and lesser extents, remains an element of contemporary art in Asia. Under the influence of specific political circumstances, narrative is wholly equated with the political notion of the collective. In the wake of this, portions of the art world have adopted a curious attitude towards narrative, making light of it, "playing" with it if you like. A second group views narrative as an ugly birthmark on contemporary Asian art. If we say that the kind of mass and commercial culture that has appeared in Asian nations is the result of globalization, then we have to consider the notion that in this context, narrative in art is untouched by globalization. This thesis takes its cue from the position of narrative as a framework within which to explore globalization.

Thus I would like to place the narrative as a certain key perspective to explore art creation, especially in Asian countries, because I think this might present the overlapping ground between individual experience, individual creativity and social images, and explore art and society and culture against the background of globalization. This perspective has three main aims:

Within contemporary culture, is it possible to reform the notion of narrative? Against the background of globalization, can narrative offer new creative approaches? With narrative as the base, is it possible to seek a new dialog between art and audience, art and society, taking the language of daily life to return art to daily life?

With narrative as the point of entry, can we explore the culture of "looking and listening" that is the result of globalization? Can we examine the difference or relationship between the visual art image and mass-culture images, between the truth of

the image and the audience's individual experience, and also explore the impact of the overflow of such images on a contemporary value system?

It is hoped that via the above two points, via specific artworks and artists, we can define a specifically Asian art, cultural approach and set of human values.

Suggested artists:

LIU, Wei (Beijing, born 1973)

CHEN, XiaoYun (Hangzhou, born 1971)

JIANG Zhi (Shenzhen, born 1973)

KAN, Xuan (Beijing/ Amsterdam, born 1972)

CHEN, Wenbo (Beijing, born 1969)

www.chenwenbo.com

CHEN, Shaoxiong (Guangzhou, born 1962)

WANG, Gongxing (Beijing, born 1960)

LIN, Tianmiao (Beijing, born 1961)

www.courtyard-gallery.com

T1 #2 "CHINESE PEOPLE EAT EVERYTHING ..."

September 1, 2005, Beijing. When I was working on my second correspondence related to *The Pantagruel Syndrome*, a sentence from a joke suddenly came into my mind. During the opening of the *Under Construction* exhibition in Tokyo, 2003, Mami Kataoka, a very nice curator and colleague from Tokyo Opera City gallery at that time, joked: "Chinese people eat everything." Yes, Chinese people do eat everything: snakes, mice, cockroaches. But the remark was made in the context of the recently reported news that, Zhu Yu, a young Chinese artist had eaten a human body in one of his works.

How can this happen at the beginning of the twenty-first century? Does it prove the energy of Chinese contemporary art, or is it just mad behaviour? If we want to come close to the answer, we must explore the context of this behaviour. What are the precursors for this both in art history and society? What do we eat in art and how do we digest it? No doubt this artist was influenced by the YBAs and their *Sensation* exhibition. But how could it lead to such radical results in China and not in any other place in the world that has also been influenced by the YBAs? Does the Pantagruel of Chinese contemporary art have a special digestive system?

More and more exhibitions of Chinese contemporary art are taking place on an official level in the big Western museums, but few of them are happening in China. The main function of such exhibitions is economic benefit. The international contemporary art exhibitions that are allowed to take place in China have the same motive. Until recently, there was no effective channel in China with which to import external information. Any information about Western contemporary art was not learned in schools, or introduced objectively in the mass media, or acquired by students studying abroad. It was passed from mouth to mouth, or was seen in catalogs brought back to China by artists travelling abroad. Upon seeing a new issue of a foreign art magazine, young artists could only glean information from pictures a few centimeters in size – most were unable to read the text. Prior to creating any work that

might be construed as contemporary art, Chinese artists had scarcely any opportunity to view an original work. In such a situation, young artists who have no understanding of the original work are squandering the worthless "freedom" that the mass media propounds.

Ever since the twentieth century, all the choices made when borrowing from foreign cultures have been partial and snobbish. China accepted Expressionism but not analytical abstract art. It accepted Surrealism but not Structuralism, as it accepted Pop art but not Minimalism. The one-sided practice came from the utilitarianism latent in the Realist art established by the Communist ideology. This utilitarianism is implanted in every artist's mind through academic education, the mass media and other channels. Cultural snobbism points to China's status as a third-world country, so that whatever China has done in the political, economic or cultural spheres is judged by foreign standards.

During the first half of the 1990s, the main medium of experimental art in China was painting. However, since 1995, video and photography have found their way on an unprecedented scale into a number of exhibitions in Beijing. Although efforts in this respect had begun in the early 1990s, it was only in the mid-1990s that such artworks prospered. To a certain extent this phenomenon reflected the young artists' dissatisfaction with an art system guided by the singular goal of selling their works. Perhaps what fascinated young artists was that there were few norms surrounding video art and at the same time it was not restricted by the "export-oriented" art system, i.e., based on collection and sales. The expansion of media was the most profound change in the 1990s. Within a short period of time, Chinese contemporary art was unexpectedly catalyzed. Experiments in the use of new media made up for what Chinese contemporary art had missed. Video Art first emerged in the work of Zhang Peili, an artist in Hangzhou. His students Qiu Zhijie and Wu Meichun spread and popularized this medium by organizing a large exhibition of Chinese video, *Image and Phenomena* (1996, Central National Academy gallery.) Only a few Beijing artists participated in this exhibition because few were engaged in an exploration of the medium in Beijing at that time. Due to China's special historical and social background,

ever since the early twentieth century, it has adopted a utilitarian attitude towards art. The Enlightenment movement in avant-garde art in the 1980s purported to reverse this social phenomenon, but after 1989, post-colonial reality and the available channels to the outside world turned Socialist utilitarian art into post-colonialist utilitarian art. In the political and cultural center, Beijing, the search for a new art language ceased. New art languages are, to a limited extent, being used by a small number of artists in southern cities. Almost simultaneous to the extension of media, controversy within experimental artists' circles occurred. The debate on "meaning" in 1996 made manifest the young artists' reflections on the relationship between Realism, contemporary art and utilitarianism.

Some young artists as represented by Qiu Zhijie, put forward the proposition that "art cannot help us approach truth," "art is just for fun," or in more "academic" terms, "art is just pre-thinking, a preparation for process, but it refuses to become thought. It does not lead us to any standpoint, but helps us to *withdraw* from any definite position." Their original intention was to reverse the tendency of non-art within contemporary art and the tendency of "vulgar sociology," which was hindering the development of contemporary art. They also wished to dispose of the pro-Western nature of Cynical Realism, Political Pop and Gaudy Art. Qiu's view and explorations were largely carried out by artists from the south. It had a fundamental affinity with the Enlightenment movement begun in the 1980s, but had been totally eclipsed by a strong political trend after 1989.

These kinds of opinions led directly to the famous Human Body phenomenon at the beginning of the twenty-first century. There are already many arguments about this phenomenon in China, not only in contemporary art but also between the contemporary art critics and the official art critics. But it is noticeable that people talk more about the motives behind the work than about its quality and methodology. There is no tradition of reasoning and analysis within contemporary Chinese art. So young artists believe that searching for a new art language means discovering original motifs. They regard the relationship between art and society as antagonistic. In Beijing, where there is no academic atmosphere but much blind impulse, this view

has been understood as a modernist cliché. Thus art becomes an Olympic game of technical innovations. This misconception has led to anti-human, extremist activities. The use of human bodies reflects the influence of modernism and postmodernism within the context of post-colonialism, as well as the real effect of a thirst for action, novelties, stimulation and new sensations in contemporary Chinese art. The exhibitions *Post-Sense Sensibility* (1999) and *Infatuated with Injury* (2000) markedly demonstrated the bad effect of the "export-oriented" art system. That it attracted international attention again displayed the power of "export-oriented" art, guided by curious international journalists and curators.

This is the special digestive system of Chinese contemporary art. It was brought into being by a freakish context, but with luck it will be maintained by some unknown strength.

Pi Li was born in 1974. He is an independent curator of visual arts, and has been a lecturer in Curatorial Studies for the Art Administration Department of the Central Academy of Fine Arts, Beijing, since 2001. The exhibitions he has curated include *Future Hope* (Tsingtao Sculpture Museum, 2000,) *Fantasia* (Donga Ilbo Art Museum, Seoul, 2001, Eastern Modern Art Centre, Beijing, 2002,) *Moist: Asia-Pacific Multi-Media* (Millennium Museum, Beijing, 2002) and *Image is Power* (He Xiangning Art Museum, 2002.) He was the assistant curator of the Chinese Pavilion of São Paulo Biennale (2002,) Shanghai Biennale (2002) and *Alors, la Chine?* (Centre Georges

Pompidou, France, 2003.) His published books include *Sculpture in Postmodernist Times* (Jiangsu Fine Arts Publishing House, 1999) and *The Curators* (Jiangsu Fine Arts Publishing House, 2003.) He is also the founder of the web-site Art Union (arts.tom.com,) chief editor of *Contemporary Art Magazine* and director of the Chinese Contemporary Art Awards, 2001. In 2004, he founded the Debo Films Project, together with Wang Xiaoshuai, which supports independent films and young Chinese directors. *Shanghai Dreams* (directed by Wang Xiangshui, 2005) is their most recent production.

Ralph Rugoff

WHAT IS IMPORTANT IN CONTEMPORARY ART TODAY

April 15, 2005. The world is getting flatter as globalization advances the cause of cultural homogeneity. Significant contemporary art counters this tendency by offering models of dimensional thinking, providing conceptual lift-off through suggesting chains of unsuspected associations and fresh networks of connections, whether these be primarily aesthetic, social or economic in nature. It inserts into our public discourses a missing dimension of idiosyncratic thought and desire, incongruity and wit. Embracing the dynamics of emotion, pathos, narrative or humour, it playfully (and even poetically) engages with vernacular and everyday experience.

Instead of making pronouncements or declarations addressed to a universal spectator, the most interesting art today explores the terms of its use, and the social and psychological logistics of the specific situations through which it encounters different viewers. And regardless of what forms it takes, it embodies a sense of the mutability of cultural artifacts. Thus many of the most compelling works today have an unfinished aspect, suggesting works-in-progress. In this way they also remind us that cultural artifacts never exist in isolation as definitive statements, but belong to ongoing social debates, cultural rituals through which groups of people define common frameworks of value.

And in one way or another, what is important today is that contemporary art has an obscene aspect. This is not the obscenity of yesterday, but something more like an obscene generosity that challenges and unsettles. In an era of ever-narrowing specialization, it spreads promiscuously across discursive fields, drawing on disciplines and genres and histories of every kind, creating a space for re-framing and re-mixing the ways in which we go about understanding and looking at our cultural and social

encounters. In doing so it denatures the illusory flatness of our everyday reality, and restores the sense of an opening, a space of openness in which there is room for innovative thought and action.

Some suggested Pantegruelian artists: Simon Evans, Steven Shearer, Case Calkins, Anthony Burdin, Taft Greene, Mindy Shapero, Sean Duffy, Tobias Putrih, Artemio, Peng Yu and Sun Yuan, Lara Favaretto, Won Ju Lim.

PANTAGRUELIAN IMPERATIVES

July 28, 2005. When I think again about the conceptual starting points for *The Pantagruel Syndrome*, Rabelais on one hand and Stendhal's aesthetic swoon on the other, it strikes me that rather than relating to situations in current art, this arranged marriage sums up a contemporary curatorial dilemma: namely, how to reconcile the intensities of connoisseurship (Stendhal) with the desire for democratic and global forms of art and research (Pantagruel.) This might appear simplistically as a question of reconciling pleasure and virtuousness, but I think it is really more about finding bridges between different kinds of knowledge. In any case, as a principle, rather than a theme, for an exhibition, Pantagruel certainly brings into play attitudes about acquiring knowledge. In Gargantua's letter to his son (Chapter Eight,) he describes the new information age ushered in by the technology of printing, and exhorts Pantagruel to "plum all knowledge to the very depths." And so I agree with Ana Matveyeva's suggestion that Pantagruel has something to do with the mass media. Perhaps his legacy includes the omnivorous Google, that tool and emblem of our desire to know everything without necessarily understanding anything.

Distance and disconnection characterize our media society, what Pi Li calls our culture of "looking and listening," which privileges the speed of recognition over conversation and comprehension. I think of Pantagruel, however, in very different terms: as someone who engages his world in a direct, even intimate fashion. His obscene acts

of consumption and expulsion are spectacular, but ultimately social in nature; they reveal to us an identity grounded in its material and social exchanges. And as Trevor Smith points out, it is through this figure of excess that Rabelais also keeps "truth," that most asocial invention inasmuch as it precludes debate and dialog, at arm's length. In Pantagruel, then, we find a refreshingly unidealistic model of sociality, which, in this moment of fashionable Utopianism, is just what our exhibition-making practices need.

Director of the CCA Wattis Institute for Contemporary Arts, San Francisco and co-director of the MA Program in Curatorial Practice, Ralph Rugoff acted as curatorial advisor to the 2002 Sydney Biennial. He was the curator of *Four Projects: Roni Horn, Ann Veronica Janssens, Mike Kelley and Mike Nelson*, 2003, and co-curator of *Baja to Vancouver: Contemporary Art and the West Coast*, 2003. His projects as an independent curator include *Scene of the Crime* at the Armand Hammer Museum in Los Angeles, and (with Lisa Corrin,) *The Greenhouse Effect* at the Serpentine Gallery and at the Museum of Natural History in London. Rugoff writes regularly for *Artforum* and other publications.

Kathryn Smith

T1 THE PANTAGRUEL SYNDROME

April 16, 2005. Talking about contemporary art from a South African point of view is to speak from a position of conflict, complexity and celebration. When reading around the metaphor of Pantagruel as a framing device for this project, it struck me that the satirical narrative of this Renaissance monster, who ends his epic journey by producing an enormous turd, may not be very far from the experiences of artists, curators and critics working from within the contemporary South African context, or artists for whom recent South African history cannot fail to be a factor in their emotional landscapes.

The historical and intellectual context of the Renaissance that birthed Pantagruel represents a seismic shift in our perceptions of the world. As Pantagruel represents everything that is antithetical to Western master narratives (centralization, rationalism, utilitarianism and so on,) it speaks to contexts of intellectual and creative production that have historically been seen as "peripheral," as well as to the richly complex terrain of getting local logics to interface with accepted professional practices of the Euro-American artworlds. Pantagruel represents unstable excess, which can double-back on itself, consuming itself as much as everything else.

Speaking from the position of being an artist who is also identified as a critic as well as a curator (this approach is not uncommon here, sometimes more a survival mechanism than a conscious choice,) my own work flirts perversely with the fraught terrain of violent private narratives and personal histories, and where or how these experiences become the stuff of public spectacle. I take the scientific discipline of forensic investigation as a metaphor for processes of reclamation, whether historical, biographical or personal. This approach might seem idiosyncratic in the face of oversubscribed postcolonially influenced visual rhetorics of crises of identity and

memory, but the development of new visual grammars or syntax, visual languages that can encourage the development of new critical parameters from within a previously "peripheral" context rather than from beyond it, underpins my work.

I am not interested in being identified as a South African artist, but rather, as an artist who lives and works mostly in South Africa. The distinction may seem slight, but the imposition of an artistic identity that is informed by one's technical nationality (especially if this is tied to a country that has experienced radical political transformation) disallows a certain imaginative freedom in how one's work is interpreted. Of course certain tropes will rise to the top of the pile. In South Africa, post-democracy was coeval with a wave of conceptualism, the effects of which are still felt in the work of young artists. This grew out of a politically-motivated "resistance" art, and it feels as if some are still trying to work with the debris from these tendencies to come up with a fresh set of visual and critical strategies – an art of ambition in the face of processes of globalization that seems to repeat some of the deeply problematic strategies of colonialism.

Suggested artists:

Ed Young

Christian Nerf

Zen Marie

Zanele Muholi

Mikhael Subotzky

Nandipha Mntambo

Frances Goodman

Alison Kearney

Gerhard Marx

Thando Mama

Churchill Madikida

Kathryn Smith (b. 1975, Durban) is a Johannesburg-based artist, curator and critic, who is currently reading for a PhD in Fine Arts while serving as a co-curator on the Kebble art awards with Clive van den Berg. In 2003 she selected the short-listed artists for the MTN New Contemporaries award (MuseuMAfricA, Johannesburg.) Her writing on art has been widely published in South Africa and abroad, most recently in *10 Years, 100 Artists: Art in a Democratic South Africa* (Bell-Roberts/Struik, 2004.) and *Over Here: International Perspectives on Art and Culture*, edited by Gerardo Mosquera and Jean Fisher (New Museum of Contemporary Art /MIT Press, 2004.) She is a regular contributor to *Art South Africa* magazine and served as Gauteng editor for www.artthrob.co.za for several years. She

was the recipient of the Standard Bank Young Artist Award for visual art in 2004, and her work is shown and collected locally and internationally. As a founding director of the *Trinity Session* artists' collective (2000-04,) she participated in *Transmediale.03* (Berlin,) *Video Art Plastique* (Centre d'Art Contemporain, Normandy); and the *Big Torino Biennale of Young Art* (Turin.) In 2003, she compiled *In No Particular Order*, an anthology of South African video art, and undertook research into the arts and crafts industries in the SADC region, commissioned by the International Labour Office, Geneva.

Trevor Smith

REPORT #1

May 9, 2005. Reading and re-reading Pantagruel, Rabelais's text reads like a cat-alog of contemporary artistic tropes: abjection, scatology, archiving, listmaking, etc. While this provocative coincidence certainly complicates the notion of what it might mean to be avant-garde or even contemporary, to my mind this is not the most impor-tant thing about it.

Over the last several years there has been a reassessment of the role of narrative in contemporary art. Documentary tradition and styles have once again come to the fore and have been re-validated on both ethical and aesthetic grounds. Yet in the broader culture, documentary and its close relation, journalism, are being under-mined by a culture of infotainment in which "reality TV" has come to stand in for reality, and the bear-baiting culture of political punditry effaces any sense of com-plexity or moral ambiguities.

An old adage has it that those who do not know their history are condemned to repeat it. In this light, documentary practices remain a kind of useful counter-tradition, shoring up a zone where complex political discussion might be contin-ued.

Yet, it could equally be said that those who are too concerned with historical "facts" are also condemned to repeat them because it becomes impossible to think beyond them. This is where Pantagruel seems most interesting to me. While it is steeped in historical and classical references, Rabelais is also engaged in a parodic and excessive play that allows for new possibilities to emerge. His text is built around the importance of storytelling, of an evident joy in inflation, infelicities, conflation, confusion, misreadings, mistranslations and out and out bullshit. While Rabelais reflected on contemporary society, his absurdity calls attention to itself, and unlike a pundit, he does not masquerade his story as truths held to be self-evident. A charged

relationship between an unreliable narrator and contested social ground is fruitful for exploration, I think.

I will propose a range of artists, not all of whom exactly fit the text above but nonetheless whom I somehow think fit the spirit of the project. It will do as a start.

Marko Lulic

Marcel van Eeden

Markus Schinwald – particularly his *Children's Crusade* video

Richard Grayson – his rearrangement of Handel's *Messiah* for a country band. Strange juxtapositions of high art and vernacular culture. The grandeur became pathos but nonetheless "authentic" or "emotive."

Alex Villar

Kerry Tribe

Steven Shearer

Nikolay Oleynikov – the Russian artist whom we saw in Moscow, who had the opera singer in the shopping mall singing an aria made up of brand name

Angela de la Cruz

REPORT #2

July 31, 2005. Even as Sofía Hernández Chong Cuy's first correspondence warns against the use of Pantagruel as a mere metaphor, I am struck by how the different voices of the correspondents might link with the many languages spoken by Panurge on his first meeting with Pantagruel (published elsewhere in this volume.) At this first encounter, Panurge parades his extensive academic knowledge of foreign languages. Pantagruel dissuades him from this pretence in favor of a voice no less clever but one clarified and refreshed by vernacular expression.

The correspondents speak in many voices but are not omnivorous nor omniscient beings. Gridthiya Gaweewong suggests "context is everything" and it is clear that individual positions emerge out of a confrontation with particular experiences and ver-

nacular circumstances. Such polyphony – both harmonic and discordant – cannot be more distinct from a situation that demands a single, and therefore impoverished, opinion that must be agreed upon as a collective. This is the spirit of debate after all, not the necessary codification of law. As Raimundas Malasauskas might put it, our difference of opinion allows us to "keep it undefined" (but not unargued) and therefore alive.

As it has been for all generations, keeping it alive is the most important task before us. Even as the story of Pantagruel is hundreds of years old, our contemporary readings, or – pace Harold Bloom – misreadings, bring it alive again in the minds of a new generation of readers. In this sense, I am not concerned whether *The Pantagruel Syndrome* represents something "new" or not. The "new," in the sense of novel, is after all one of the most overvalued commodities in contemporary art today. What a project like *The Pantagruel Syndrome* reminds me is that anywhere is a good place to start: a place close to home or a text hundreds of years old that still provokes a response. "Begin at the beginning," as the mad hatter might say. What remains important is intelligence, integrity and intensity. It seems a little insular to be responding only to my fellow correspondents, but one cannot respond to an exhibition that has not yet occurred. Very shortly we will be in Turin with you and the artists and conversations can develop in new and always unexpected ways.

Trevor Smith is currently Curator at the New Museum in New York, where he recently co-organized the exhibition *Adaptive Behavior*, a show of international artists whose works explore the collapsing space between private communication and public performance today. In 2005 he is scheduled to curate, with Paola Morsiani, curator of the Contemporary Arts Museum, Houston, a survey exhibition of the work of Andrea Zittel. Before moving to New York, Smith was director of the Canberra Contemporary Art Space in Canberra, Australia, from 1994-97, where in 1997 he curated the exhibition *Archives and the Everyday*. Also in 1997 he became Curator of Contemporary Art at the Art Gallery of Western Australia, Perth, where he organized the exhibition *The Divine Comedy: Francisco Goya, Buster Keaton, William Kentridge*.

Adam Szymczyk

THE LOOPHOLE IN CIESZYN

July 25, 2005. Two days ago I arrived in Cieszyn, a small town divided by the Polish-Czech border along the river Olsa. A film festival has taken place here for two years, attracting a huge and mixed crowd of very young film and art aficionados. They come mostly from Warsaw and other big cities in Poland, where in the course of economic transformation cinemas have been replaced by multiplexes appealing to a mass audience. This year, screenings of over 200 films from all over the world took place in the course of one week in some ten movie theatres scattered around the town, including the Czech part, Cesky Tesin.

There are many remarkable things about Cieszyn/Tesin: in cherishing the town's Habsburgian past, it modestly declares itself a "Little Vienna," and it has its own Little Venice, a charming densely built area with a canal. The town looks out onto the world and during the opening of the festival the mayor told me that the greatness of Cieszyn always lay in the fact that it was shaped by foreigners, who were hospitably welcomed by the local folk, in anticipation of yet another novelty. The Cieszynians are also big on traveling. "I'm going to Finland tomorrow," the taxi-driver who brought me to town on Sunday evening told me. "Why Finland?" I asked absent-mindedly. "Why not?" was the answer.

This openness to impulses coming from elsewhere remains a strong part of the town's identity even today. This year, architect François Roche and his office R&Sien (an acronym to be read, among other things, as *hérésien*, the heretic,) was commissioned to build a pedestrian bridge over the river connecting the Polish and Czech banks. Roche's project is a skeletal, biomorphic steel construction. The bridge is called "The Loophole" since it swirls in the center, arousing the pedestrians' alertness and making the passage a sophisticated, reflexive exercise. To be

built in 2006-07, it will become the most advanced piece of architecture in Poland to date.

Cieszyn is all avant-garde, and it is no coincidence that before World War II the local printing house published *From the Heights*, a collection of Julian Przybos's revolutionary poems set in Wladyslaw Strzeminski's radical post-constructivist typography. And at the end of the eighteenth century, when the former Jesuit Leopold Jan Szersznik moved to Cieszyn from Prague, the ideas of the Enlightenment revolutionized the consciousness of the local literati. Szersznik's appetite for knowledge was insatiable. In the years he spent in Cieszyn, he collected an enormous and valuable library of books on art, history, mineralogy, chiromancy and the like, which is preserved in its entirety as a monument, the books standing on the original, state-of-the-art shelves, still intact, in the newly built glass vault, and available to the general public. The library proudly represents the liberal and curious spirit of Cieszyn. Sitting in the reading room, I found at least one German, and three French editions of Rabelais's *Gargantua and Pantagruel*, including the one published in 1870, a year before the events of the Paris Commune, by the Librairie de Firmin Didot Fréres, Fils et Cie. Delving into Pantagruel, I realize again that the need for a change of speed and style, and the hope for a better future, are not modern inventions, but essential parts of our lives and driving forces in art.

Some of the artists whom I think could be interesting in the context of Pantagruel Syndrome are:

Cezary Bodzianowski

Agnieszka Brzeżańska

Roberto Cuoghi

Kate Davis

Oskar Dawicki

Anna Niesterowicz

THE DEADLOCK IN VIENNA

August 31, 2005. I arrived in Vienna today on the early morning flight from Basel. The taxi from the airport brought me to the hotel at 9 am. The room was not ready and it would not be until 2 pm, the lady at the hotel reception told me apologetically. I sensed something was going wrong, and indeed, having called my host, I learned that the meeting was between 6 and 10 pm and not, as I thought, between 10 am and 6 pm. It was a mechanical error I had made while reading the schedule sent to me months ago. I must have taken it for granted that meetings of this kind take place during the day and ignored the information provided in black and white. On top of it all, they booked me on this 7 am flight, perfectly within the logic of my thinking, but in fact without any apparent reason.

In this way I earned an unexpected eight hours in Vienna without a schedule and I decided to use it. First of all, I realized that the second text for the Pantagruel project was still pending. Second, it struck me that my first one had dealt with a small town in Poland that has often been called Little Vienna. Sipping a double espresso and looking at the towering grey elevation of MUMOK, I thought that at first sight present day Vienna has little do with Cieszyn and decided to search deeper, in pursuit of a fearful symmetry. The museum opened at 10.

The lift took me to the many floors, each station equalling one show. There were three larger exhibitions on view: a ride across *Nouveau Réalisme,*where I spotted an amazingly beautiful black and white piece by Martial Raysse featuring what I imagined to be the two famous actors in Godard's *Breathless*, the Sammlung EVN show, where I revisited two long unseen pieces by Pawel Althamer, a self-portrait consisting of the artist's clothes, cut hair and personal belongings sealed between two layers of plastic foil, and a small wooden self-portrait resembling a voodoo doll, both totemically powerful. The third exhibition was an accumulation of various pieces from the 1970s, brought together under the heading of "Realism," including Gerhard Richter's large horizontal painting of several connected panels with a view of a dark empty park, which almost automatically made me think of Antonioni's *Blow-Up*.

Nothing of which, save for some obvious cinematic references, resonated with Cieszyn.

The last show was in the basement, I went all the way down and there I found it.

In Bruce Nauman's *Audio-Video Underground Chamber*, designed in 1972 and first realized two years later at the Wide White Space in Antwerp, a small black and white monitor shows a live transmission from a concrete, coffin-sized chamber buried somewhere in the vicinity of the museum. A surveillance camera is directed at the microphone installed inside the box. The piece is not exactly silent because the microphone records some technical noise, but no sound from the outside of the box can be heard. The camera is fixed and it shows no more than a section of wall and the microphone in the center, pointed at the camera. Nor is the piece exactly still, since some white noise occasionally flickers down the screen. But in the end it can only be perceived as a silent still from an unknown and inaccessible place, an ultimate exercise in sensory detachment, played out in the museum's unconscious zone, the basement.

The library of Szersznik in Cieszyn is a hermeneutic monument of the Enlightenment, containing discorsive knowledge in the form of books on many subjects, available to further understanding and interpretation. Nauman's dully lit *Underground Chamber* in Vienna demonstrated the final withdrawal from the emancipatory concept of knowledge at the end of the twentieth century. It made me speechless and, in line with what Nauman said in the catalog interview, it left me looking and waiting to see what happens next, if anything at all.

From 1997 to 2003, Adam Szymczyk was the founder and curator of the Foksal Gallery Foundation in Warsaw. He curated projects with artists such as Pawel Althamer, Douglas Gordon, Susan Hiller, Job Koelewijn, Edward Krasinski, Claudia and Julia Mueller, Gregor Schneider, Piotr Uklanski and Krzysztof Wodiczko. The group shows he has curated include *Roundabout*, CCA Warsaw, 1998; *Amateur*, co-curated with Mark Kremer and Charles Esche, Kunstmuseum Göteborg, 2000; *Painters Competition*, Galeria Bielska BWA, Bielsko-Biala, 2001; and *Hidden In a Daylight*, co-curated with Joanna Mytkowska and Andrzej Przywara, Hotel pod Brunatnym Jeleniem, Cieszyn, 2003. Currently he is the Director of the Basel Kunsthalle.

ARTISTS

Takashi Murakami

Little Boy and Fat Man

Do not believe that the concept of a "panta-gruelic" culture is known in Japan but if there were an award given, Japanese society would certainly deserve the gold medal. Pantagruel is the famous character of Rabelais' masterpiece "Gargantua and Pantagruel," a book that bridges the Middle Ages and Renaissance periods. Pantagruel is voracious by nature and has an insatiable appetite. Of course, the Japanese are not known to eat enormous quantities of food, but their society has a very peculiar appetite both for its own past and future and, at the same time, for western culture. Japan shut itself out from the west until the mid-nineteenth century when, with Commodore Perry's opening of the Port of Yokohama, the world flooded the country and Japanese culture started to leak outside. Takashi Murakami could be looked at as the Rabelais or, better yet, the Gargantua (Pantagruel's father) of Japan, capable of bridging the past into the subculture of the future, of unifying tradition with childhood and popular culture with fine art (a word unknown in the Japanese language until 1868 when the Meiji Restoration allowed the country to mingle with the west.) Murakami's theory of the "Superflat," which refers both to the formal flatness of Japanese painting and the flat line in which high and low Japanese culture equally co-exist, has been given less credit than it deserves and it has been so far linked only to Japan. The "Superflat" theory can be applied, with the necessary variations, to the current state of our global society, a round world that has become flat thanks to the internet and digital technology. Murakami's innovative style and imagery has the refreshing power of the early Mickey Mouse and Disney characters that had a huge influence on Japanese imagery of the 60's and the 70's, yet also has the subtle delicacy and mysterious atmosphere of the art of the Edo period (1603-1868) and old masters like Katsushika Hokusai, Otagawa Hiroshige and Kano Eitoku. Murakami eats history as well as the immediate present with a voracity that is mesmerizing. On his imaginary working

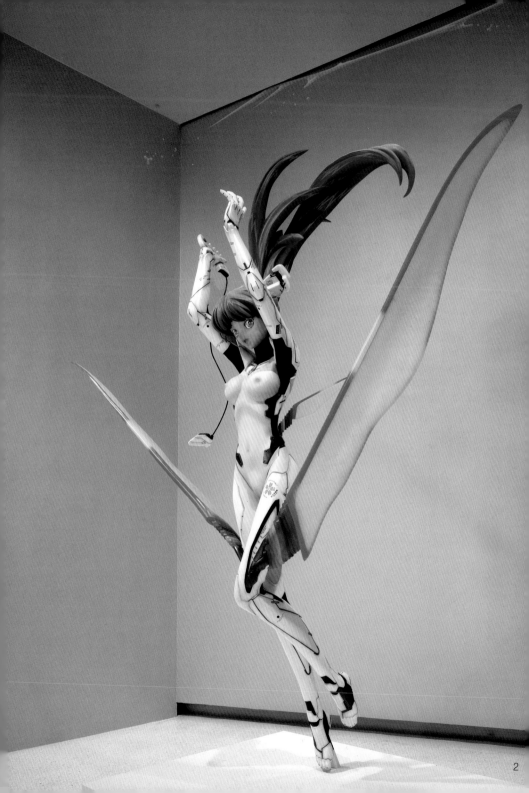

3

map we can see Japanese history laid flat. Murakami fuses the influences of ancient mytholo-gy, Chinese and Japanese painterly traditions, pop culture from his youth ("anime" films and Hello Kitty market branding) all with his unique characters resulting in an utterly contemporary mythology that has no equal in the world. Two elements are pivotal in his grammar: the "otaku" and "kawaii." "Otaku" (roughly translates into "nerd") people are obsessed with the minutiae of many and various subcultures including characters from "manga" comics and *anime* and are usually male.

On the opposite side of the subcultural spectrum we find the idea of "kawaii," which means "cuteness" and which is related more to young females. We could easily say that *otaku* and *kawaii* are the yin and yang of the superflat reality. Murakami believes that maintaining a child-ish attitude toward reality allows people to stay free. But it would be dismissive to consider Murakami's art childish, as it is more a reflection on the reality of a society traumatized by the disaster of World War II and its dramatic apotheosis with the two atomic bombs dropped over Hiroshima and Nagasaki (code named "Little Boy" and "Fat Man".) As articulated so suc-cinctly in the exhibition of the same name (Murakami's third part of the "Superflat" trilogy of exhibitions he has curated over the last five years,) for Murakami "Little Boy" is also the men-

7

tal state of Japanese society today, a society that recovered from the war's trauma almost obliviously, developing a dark side which was manifested most recently in the Aum Shinrikyo cult that gassed the Tokyo subway in the mid-nineties. It is hard to say that Murakami sculptures and paintings are optimistic, but it's hard as well to say that that they are like Warhol's work – a reflection on the surface and the superficiality of society. While Warhol lacked any spiri-tuality in a blunt or honest way, in Murakami's case a sort of

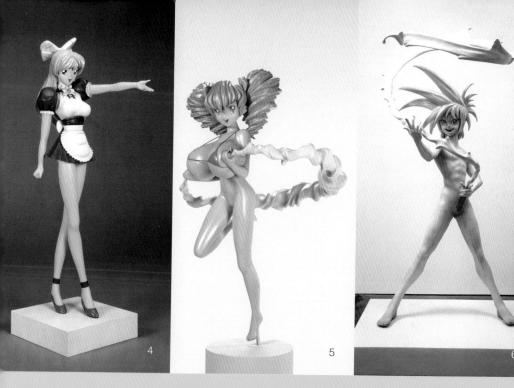

4 5 6

sci-fi spirituality is present. His work has a kind of epic taste that comes at the same time from an ancient and recent past, but does not belong to our present. It seems to share something, even if esthetically completely different, with the Star Wars saga and its search for a clear-cut definition of good and evil. To say that evil is totally absent from Murakami's imagery would be a dangerous oversight, but where evil is hiding in most of his paintings and sculptures is really difficult to say. Perhaps Murakami is suggesting that evil is the absence of consciousness, the lack of profundity, or true happiness missing. Murakami's characters live in a fluid atmosphere but also in an undetectable melancholia. In the painting exhibition I curated at the 2003 Venice Biennale I placed Takashi Murakami at the end of a trajectory that began with Robert Rauschenberg paintings. Rauschenberg transformed painting from a flat surface into a screen where reality was dragged over and passed by the eye of the beholder without stopping in front of it. I felt that this transformation had a revolutionary edge. In the same way, I felt that Murakami was revolutionizing both sculpture and painting by creating neither a surface nor a screen but an utterly contemporary space, not hierarchical and not linear, but fluid like the less and less physical world in which we live and communicate with each other. Murakami's world is a Füssli nightmare transformed into a wet dream, a fairy tale transformed into a luminous hallucination, a world where fear and anxiety have become oblivious of one another. To present the work of Takashi Murakami for the first time in an expanded way to an Italian audience and within the framework of the new triennial T, is an important task to accomplish and offers to the viewer the opportunity for deep reflection on the state of our contemporary society and culture.

Franceso Bonami

8

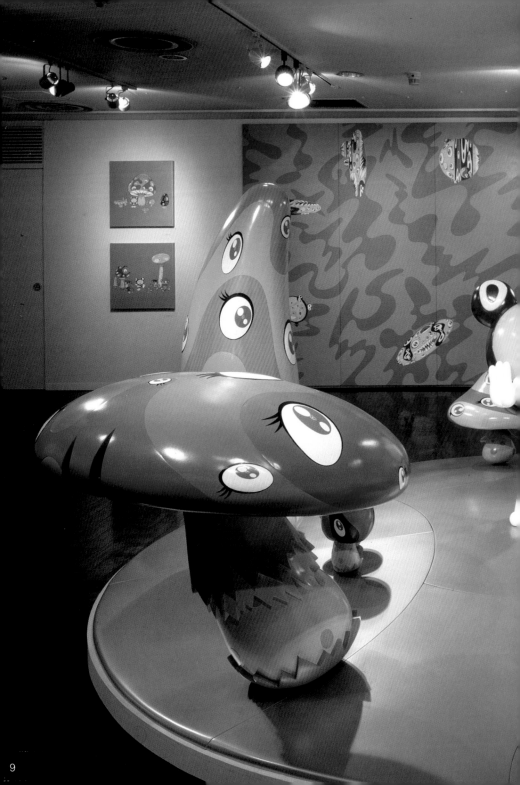

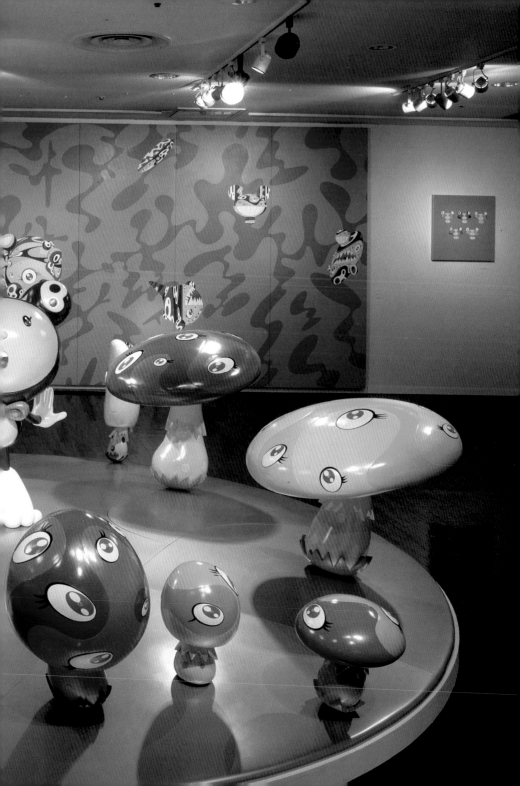

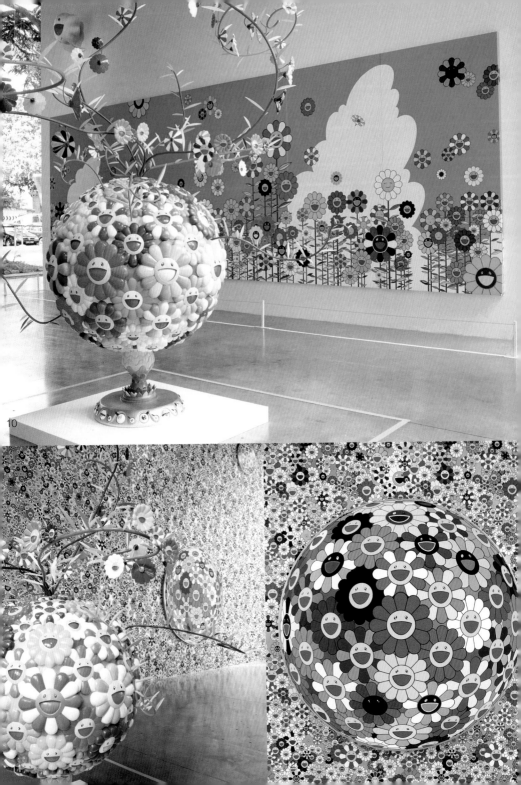

10

11

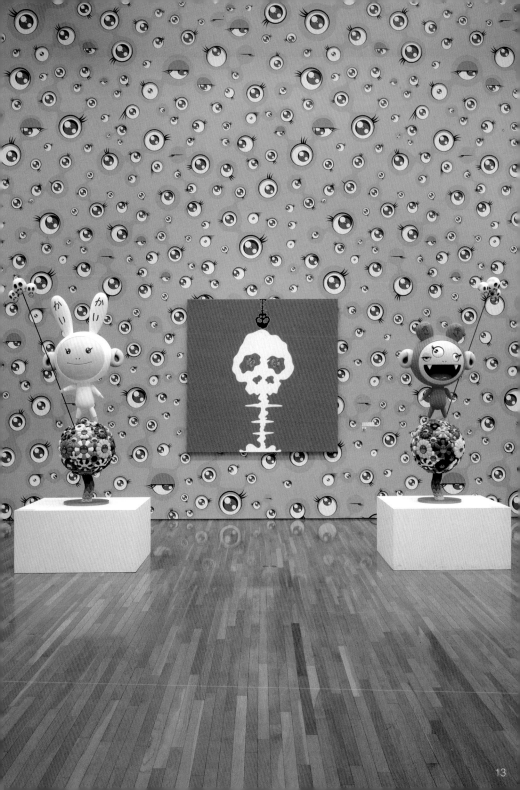

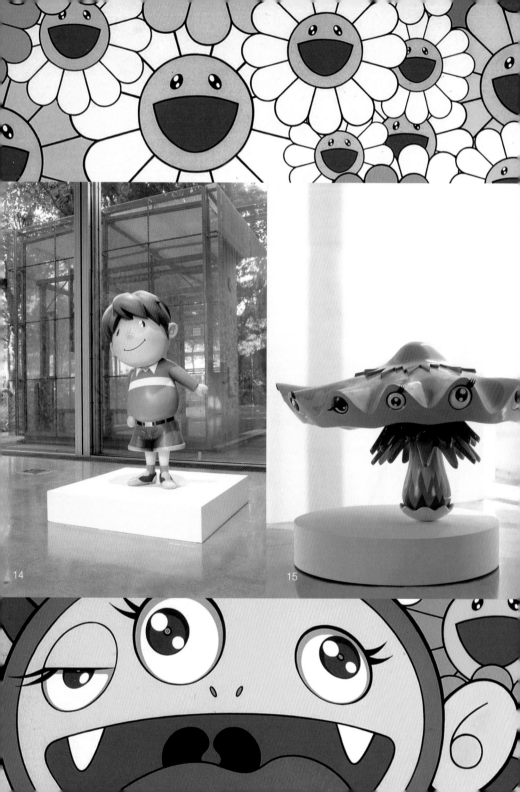

14

15

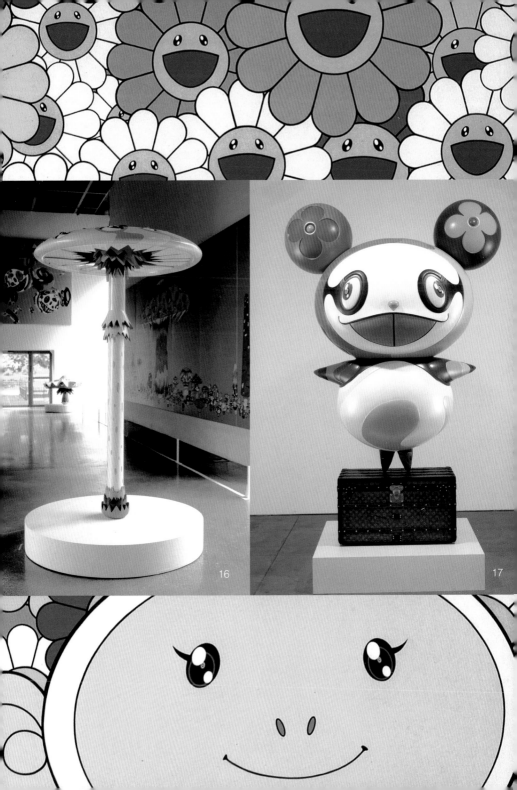

16

17

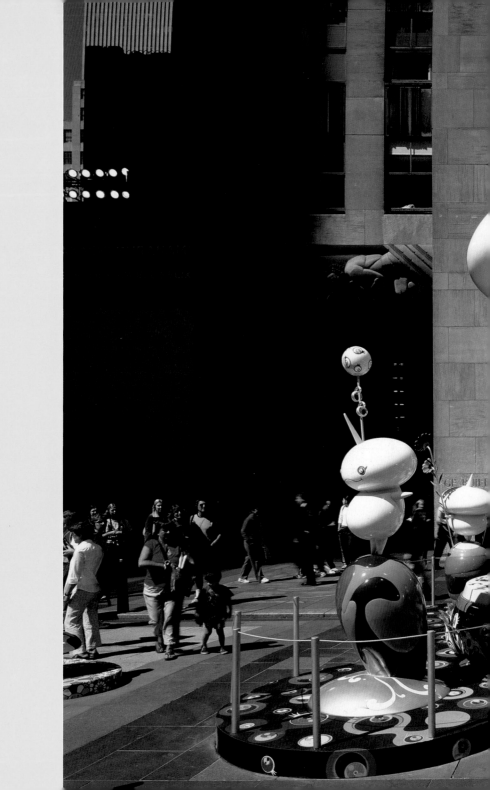

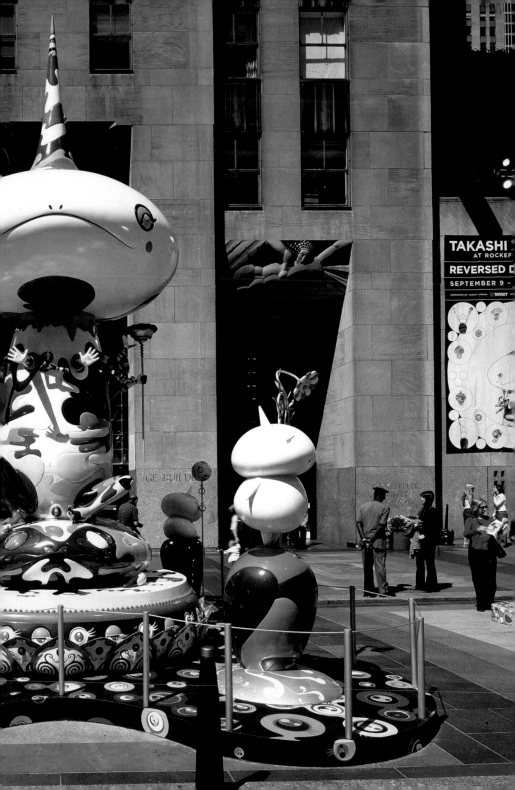

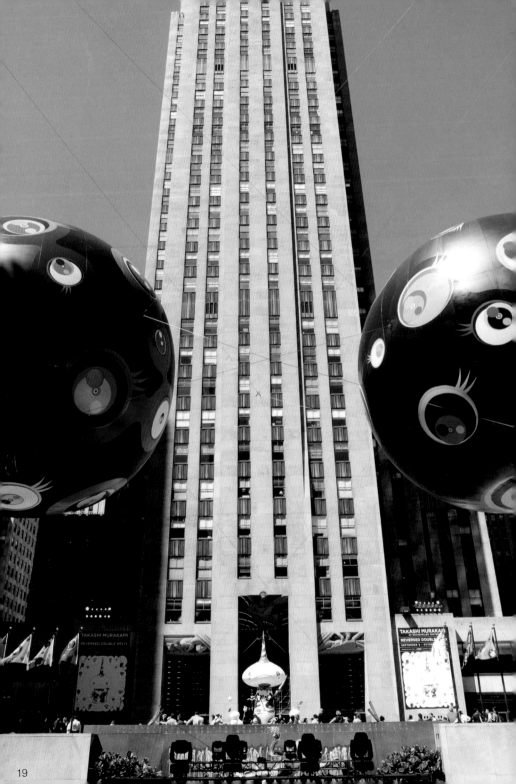

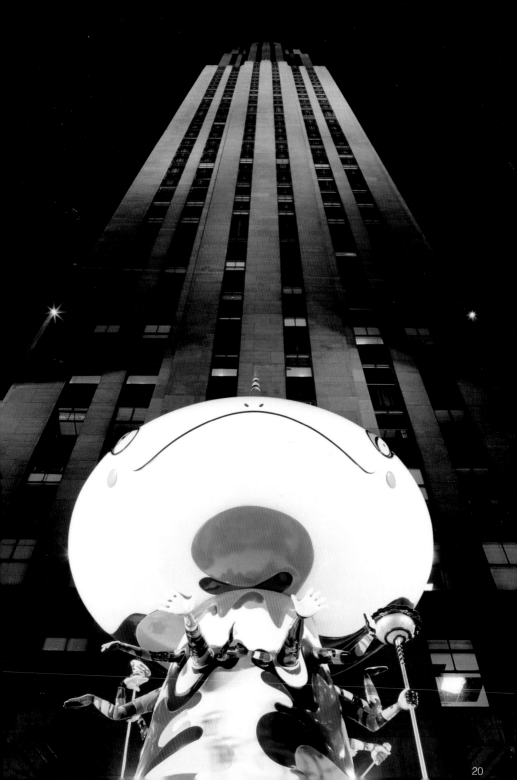

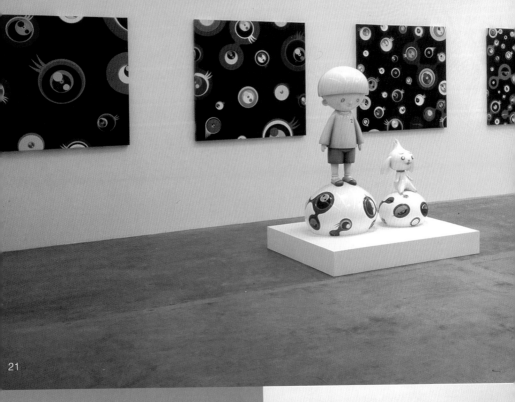

21

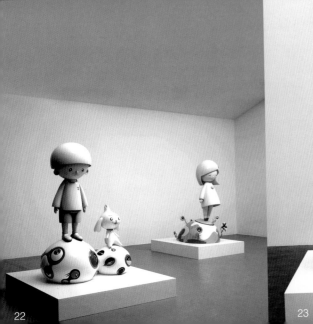

22

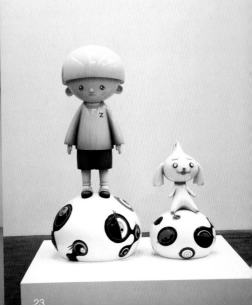

23

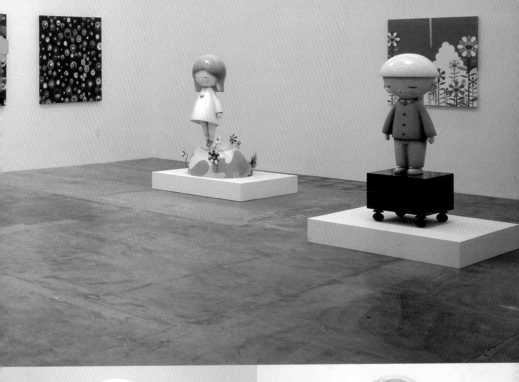

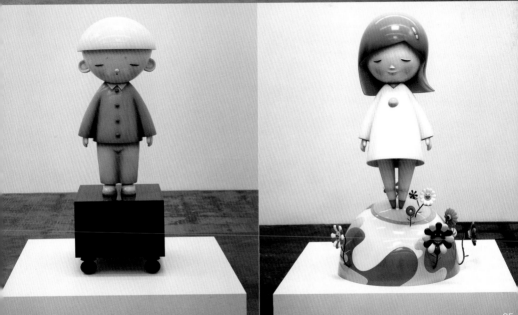

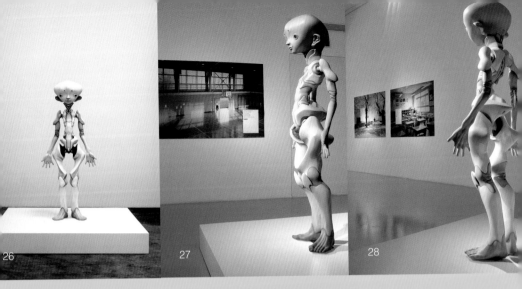

26

27

28

frontispiece: Detail from *Jellyfish Eyes – Max & Shimon in the Strange Forest*, 2004
Courtesy Blum & Poe, Los Angeles
© 2004 Takashi Murakami/Kaikai Kiki Co., Ltd. All Rights Reserved

1 *Polyrhythm*, 1991
Courtesy Shiraishi Contemporary Art Inc., Tokyo
© 1991 Takashi Murakami/Kaikai Kiki Co., Ltd. All Rights Reserved

2 *Second Mission Project Ko² (human type)*, 1999
Courtesy Blum & Poe, Los Angeles
© 1998 Takashi Murakami/Kaikai Kiki Co., Ltd. All Rights Reserved

3 *Mr. DOB*, 1994
© 1994 Takashi Murakami/Kaikai Kiki Co., Ltd. All Rights Reserved

4 *Miss Ko²*, 1997
Courtesy Marianne Boesky Gallery, New York
© 1997 Takashi Murakami/Kaikai Kiki Co., Ltd. All Rights Reserved

5 *Hiropon*, 1997
Courtesy Blum & Poe, Los Angeles
© 1997 Takashi Murakami/Kaikai Kiki Co., Ltd. All Rights Reserved

6 *My Lonesome Cowboy*, 1998
Courtesy Blum & Poe, Los Angeles
© 1998 Takashi Murakami/Kaikai Kiki Co., Ltd. All Rights Reserved

7 *Physical Pie*, 1992
© 1992 Takashi Murakami/Kaikai Kiki Co., Ltd. All Rights Reserved

8 *Dobozite Dobozite Oshamanbe*, 1993
Courtesy Gallery Cellar, Nagoya
© 1993 Takashi Murakami/Kaikai Kiki Co., Ltd. All Rights Reserved

9 *DOB in the Strange Forest*, 1999
Courtesy Marianne Boesky Gallery, New York
© 1999 Takashi Murakami/Kaikai Kiki Co., Ltd. All Rights Reserved

10 *Flower Matango*, 2001
Courtesy Galerie Emmanuel Perrotin, Paris
Photo André Morin
© 2001 Takashi Murakami/Kaikai Kiki Co., Ltd. All Rights Reserved

11 *Flower Matango*, 2001
Courtesy Galerie Emmanuel Perrotin, Paris
Photo André Morin
© 2001 Takashi Murakami/Kaikai Kiki Co., Ltd. All Rights Reserved

12 *Flower Ball (3D)*, 2002
Courtesy Galerie Emmanuel Perrotin, Paris
© 2002 Takashi Murakami/Kaikai Kiki Co., Ltd. All Rights Reserved

13 *Kaikai & Kiki*, 2000
Courtesy Galerie Emmanuel Perrotin, Paris
Photo Norihiro Ueno
© 2000 Takashi Murakami/Kaikai Kiki Co., Ltd. All Rights Reserved

background pp. 126-127: Detail from *Kaikai Kiki News*, 2002

Courtesy Galerie Emmanuel Perrotin, Paris
© 2000 Takashi Murakami/Kaikai Kiki Co., Ltd. All Rights Reserved

14 *Kitagawa-kun*, 2002-2003
Courtesy Marianne Boesky Gallery, New York
Photo André Morin
© 2002-2003 Takashi Murakami/Kaikai Kiki Co., Ltd. All Rights Reserved

15 *Scarlet Heart*, 2002
Courtesy Galerie Emmanuel Perrotin, Paris
© 2002 Takashi Murakami/Kaikai Kiki Co., Ltd. All Rights Reserved

16 *Troll's Umbrella*, 2002
Courtesy Galerie Emmanuel Perrotin, Paris
© 2002 Takashi Murakami/Kaikai Kiki Co., Ltd. All Rights Reserved

17 *Panda*, 2003
Courtesy Marianne Boesky Gallery, New York
© 2003 Takashi Murakami/Kaikai Kiki Co., Ltd. All Rights Reserved

18 *Reversed Double Helix*, 2003
Rockefeller Center, New York
Courtesy Marianne Boesky Gallery, New York
Photo Tom Powel Images
© 2003 Takashi Murakami/Kaikai Kiki Co., Ltd. All Rights Reserved

19 *Reversed Double Helix*, 2003
Rockefeller Center, New York

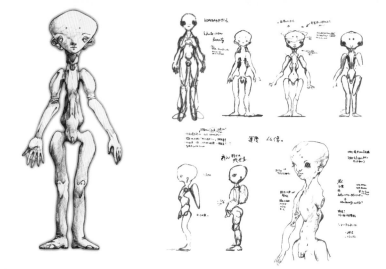

Courtesy Marianne Boesky Gallery,
New York
Photo Hal Tomioka
© 2003 Takashi Murakami/Kaikai Kiki
Co., Ltd. All Rights Reserved

20 *Reversed Double Helix*, 2003
Rockefeller Center, New York
Courtesy Marianne Boesky Gallery,
New York
Photo Hal Tomioka
© 2003 Takashi Murakami/Kaikai Kiki
Co., Ltd. All Rights Reserved

21 *Inochi*, 2004
Installation view, Blum & Poe, Los
Angeles, 2004
Courtesy Blum & Poe, Los Angeles
Photo Joshua White
© 2004 Takashi Murakami/Kaikai Kiki
Co., Ltd. All Rights Reserved

22 *Jellyfish Eyes - Max & Shimon and
Saki*, 2004
Installation view, Liverpool Biennial
Courtesy Marianne Boesky Gallery,
New York
Photo David Lambert, Rod Tidnam
© 2004 Takashi Murakami/Kaikai Kiki
Co., Ltd. All Rights Reserved

23 *Jellyfish Eyes - Max & Shimon*,
2004
Courtesy Blum & Poe, Los Angeles
© 2004 Takashi Murakami/Kaikai Kiki
Co., Ltd. All Rights Reserved

24 *Jellyfish Eyes - Tatsuya*, 2004
Courtesy Blum & Poe, Los Angeles
© 2004 Takashi Murakami/Kaikai Kiki
Co., Ltd. All Rights Reserved

25 *Jellyfish Eyes - Saki*, 2004
Courtesy Blum & Poe, Los Angeles
© 2004 Takashi Murakami/Kaikai Kiki
Co., Ltd. All Rights Reserved

26 *Inochi*, 2004
Courtesy Blum & Poe, Los Angeles
© 2004 Takashi Murakami/Kaikai Kiki
Co., Ltd. All Rights Reserved

27 *Inochi*, 2004
Installation view, DESTE Foundation
for Contemporary Art, Psychico,
Athens
Courtesy Blum & Poe, Los Angeles
Photo Fanis Vlastaras & Rebecca
Constantopoulou
© 2004 Takashi Murakami/Kaikai Kiki
Co., Ltd. All Rights Reserved

28 *Inochi*, 2004
Installation view, DESTE Foundation
for Contemporary Art, Psychico,
Athens
Courtesy Blum & Poe, Los Angeles
Photo Fanis Vlastaras, Rebecca
Constantopoulou
© 2004 Takashi Murakami/Kaikai Kiki
Co., Ltd. All Rights Reserved

29 Drawing for *Inochi*, 2001
© 2001 Takashi Murakami/Kaikai Kiki
Co., Ltd. All Rights Reserved

Selected Solo Exhibitions

Reversed Double Helix, Rockefeller Center, New York, September 9 – October 12, 2003.
Kaikai Kiki: Takashi Murakami, Fondation Cartier pour l'art contemporain, Paris, June 27 – October 27, 2002; Serpentine Gallery, London, November 12, 2002 – January 26, 2003.
Summon monsters? Open the door? Heal? Or die?, Museum of Contemporary Art, Tokyo, August 25 – November 4, 2001.
Takashi Murakami: Made in Japan, Museum of Fine Arts, Boston, April 25 – September 3, 2001.
The Meaning of the Nonsense of Meaning, Center for Curatorial Studies Museum – Bard College, Annandale-on-Hudson, June 25 – September 12, 1999.

Selected Group Exhibitions

Ecstasy: In and About Altered States, Museum of Contemporary Art, Los Angeles, October, 9 2005 – February 20, 2006.
Collection Exhibitions, Walker Art Center, Minneapolis, April 17 – August 3, 2005.
Pittura/Painting: Rauschenberg to Murakami, 1964-2003, L Esposizione Internazionale d'Arte. La Biennale di Venezia, Museo Correr, Venice, June 15 – November 2, 2003.
Drawing Now: Eight Propositions, MoMA The Museum of Modern Art, New York, October 17, 2002 – January 6, 2003.
Carnegie International 1999/2000, Carnegie Institute, Pittsburgh, November 6, 1999 – March 26, 2000.

Selected Bibliography

A. Lubow, "The Murakami Method", *The New York Times Magazine*, New York, April 3, 2005, pp. 48-57, 64, 76-79.
F. Prose, "Tokyo Godfather", *Black Book*, New York, Fall 2004, pp. 184-189.
K. Siegel, "Art Review", *Art Review*, New York/London, November 2003, pp. 46-53.
J. Howe, "The Two Faces of Takashi Murakami", *WIRED*, San Francisco, November 2003, pp. 180-185.
Painting at the Edge of the World, Walker Art Center, Minneapolis, 2001. Texts by D. Fogle, "The Trouble with Painting," pp. 9-25; M. Matsui, "New Openings in Japanese Painting: Three Faces of Minority," pp. 46-77; T. Murakami, "A Theory of Super Flat Japanese Art," pp. 187-205.

TAKASHI MURAKAMI

Tokyo, 1962
Lives and works in Tokyo and New York

List of Exhibited Works

Hiropon, 1997
Oil, fiberglass, acrylic, iron
88 x 40 $^{15}/_{16}$ x 48 $^{1}/_{16}$ in.
Private Collection, Belgium
Courtesy Blum & Poe, Los Angeles
Copyright Takashi Murakami/Kaikai Kiki Co., Ltd./All Rights Reserved

Miss Ko2 (Project Ko2), 1997
Oil, acrylic, fiberglass, iron
73 $^{1}/_{4}$ x 26 $^{3}/_{4}$ x 25 $^{9}/_{16}$ in.
Private Collection, Belgium
Copyright Takashi Murakami/Kaikai Kiki Co., Ltd./All Rights Reserved

Cream, 1998
Acrylic on linen
91 $^{3}/_{4}$ x 191 $^{3}/_{4}$ in.
Collections Eileen Harris Norton and Peter Norton, Santa Monica
Copyright Takashi Murakami/ Kaikai Kiki Co., Ltd./All Rights Reserved

Milk, 1998
Acrylic on linen on board
95 $^{11}/_{16}$ x 191 $^{3}/_{4}$ in.
Collections Eileen Harris Norton and Peter Norton, Santa Monica
Courtesy of Blum & Poe, Los Angeles
Copyright Takashi Murakami/ Kaikai Kiki Co., Ltd./All Rights Reserved

My Lonesome Cowboy, 1998
Oil, acrylic, fiberglass, iron
100 x 46 x 35 $^{13}/_{16}$ in.
Private Collection, Belgium
Courtesy Blum & Poe, Los Angeles
Copyright Takashi Murakami/Kaikai Kiki Co., Ltd./All Rights Reserved

DOB in the Strange Forest, 1999
FPR, resin, fiberglass, acrylic
60 x 119 $^{15}/_{16}$ in.
Collection Adam Lindemann, New York
Copyright Takashi Murakami/Kaikai Kiki Co., Ltd./All Rights Reserved

Second mission Project Ko2 (Ga-Walk Type), 1999
Oil, acrylic, synthetic resins, fiberglass, iron
88 $^{3}/_{8}$ x 69 $^{5}/_{8}$ x 51 $^{3}/_{4}$ in.
Private Collection, Belgium
Courtesy Blum & Poe, Los Angeles
Copyright Takashi Murakami/Kaikai Kiki Co., Ltd./All Rights Reserved

Second Mission Project Ko2 (Human Type), 1999
Oil, acrylic, synthetic resins, fiberglass, iron
108 $^{1}/_{4}$ x 99 $^{3}/_{16}$ x 55 $^{1}/_{8}$ in.
Private Collection, Belgium
Courtesy Blum & Poe, Los Angeles

*Second Mission Project Ko²
(Jet Airplane Type)*, 1999
Oil, acrylic, synthetic resins,
fiberglass, iron
21 5/8 x 76 x 73 1/4 in.
Private Collection, Belgium
Courtesy Blum & Poe, Los Angeles

Kaikai, 2001
Oil paint, acrylic synthetic resins,
fiberglass, iron
71 7/16 x 27 15/16 x 21 5/8 in.
Courtesy Galerie Emmanuel Perrotin,
Paris/Miami

Kiki, 2001
Oil paint, acrylic synthetic resins,
fiberglass, iron
63 x 27 15/16 x 42 15/16 in.
Courtesy Galerie Emmanuel Perrotin,
Paris/Miami

Napping, 2002
Fabric, aluminium, blower, oil paint
196 7/8 x 118 1/8 x 157 1/2 in.
Collection Angela and Massimo
Lauro, Italy
Courtesy Galerie Emmanuel Perrotin,
Paris/Miami

Time Bokan (sexual violet), 2002
Acrylic on canvas over panel
70 7/8 x 70 7/8 in.
Private Collection, United States
Courtesy Tomio Koyama Gallery,
Tokyo

Jellyfish Eyes – Max & Shimon, 2004
FRP, steel, acrylic, lacquer
Max, 21 7/16 x 10 7/8 x 10 7/8 in.;
Shimon, 11 7/8 x 6 15/16 x 6 15/16 in.;
Pedestal, 21 11/16 x 21 1/16 x 2 15/16 in.
Private Collection
Courtesy Blum & Poe, Los Angeles /
Galerie Emmanuel Perrotin,
Paris/Miami

Jellyfish Eyes – Saki, 2004
FRP, steel, acrylic, lacquer
14 3/16 x 26 x 39 in.
Private Collection
Courtesy Blum & Poe, Los Angeles /

Galerie Emmanuel Perrotin,
Paris/Miami

Jellyfish Eyes – Tatsuya, 2004
FRP, steel, acrylic, lacquer
53 7/16 x 75 1/2 x 6 15/16 in.
Private Collection
Courtesy Blum & Poe, Los Angeles /
Galerie Emmanuel Perrotin,
Paris/Miami

Eyeball (Wall) 1 – White, 2004
FRP, steel
3 1/2 x 3 3/16 in.
Collection David Teiger, New Jersey
Courtesy Blum & Poe, Los Angeles

Eyeball (Wall) 2 – Platinum, 2004
FRP, steel
3 1/2 x 3 3/16 in.
Collection David Teiger, New Jersey
Courtesy Blum & Poe, Los Angeles

Eyeball (Wall) 3, 2004
FRP, steel
3 1/2 x 3 3/16 in.
Private Collection, United States
Courtesy the artist and Blum & Poe,
Los Angeles

Kumo – Kun (Mr Cloud), 2004
Oil paint, acrylic, synthetic resins,
fiberglass and iron
31 1/2 x 31 1/2 x 9 13/16 in.
Villalonga Collection
Courtesy Villalonga Collection,
London and Galerie Emmanuel
Perrotin, Paris/Miami

Rice Cake 1 – White, 2004
FRP
body, 10 x 9 5/8 x 8 in.; cushion,
11 x 12 3/16 x 2 in.
Collection Linda and Bob Gersh,
Los Angeles
Courtesy Blum & Poe, Los Angeles

Rice Cake 2, 2004
FRP
body, 10 x 9 5/8 x 8 in.; cushion,
11 x 12 3/16 x 2 in.;
Courtesy of the artist and Blum &
Poe, Los Angeles

Galerie Emmanuel Perrotin,
Paris/Miami

Inochi Installation:

Inochi, 2004
Fiberglass, resin, iron
55 1/8 x 24 5/8 x 14 3/8 in.
Collection The Dakis Joannou
Collection, Athens
Courtesy Blum & Poe, Los Angeles

Inochi Poster (Classroom), 2004
Inkjet print
40 1/2 x 57 5/16 in.
Collection The Dakis Joannou
Collection, Athens
Courtesy Blum & Poe, Los Angeles

Inochi Poster (Gym), 2004
Inkjet print
40 1/2 x 57 1/4 in.
Collection The Dakis Joannou
Collection, Athens
Courtesy Blum & Poe, Los Angeles

Inochi Poster (Trees in Bloom), 2004
Inkjet print
40 1/2 x 57 1/4 in.
Collection The Dakis Joannou
Collection, Athens
Courtesy Blum & Poe, Los Angeles

Thumpity, Thump, Milk, Sha-la-la,
2004
35 mm film transferred to DVD, 5' 28''
Collection The Dakis Joannou
Collection, Athens
Courtesy Blum & Poe, Los Angeles

*Inochi Mannequin, Clothing and
Shoes*, 2005
Fiberglass, fabric, leather, metal
55 1/8 x 24 5/8 x 14 3/8 in.
Collection The Dakis Joannou
Collection, Athens
Courtesy of Blum & Poe, Los Angeles

The Emperor's New Clothes, 2005
Fiberglass, resin, oil paint, lacquer,
acrylic plates, fabric, iron, wood
73 1/4 x 26 3/4 x 25 9/16 in.
Courtesy of the artist and Galerie
Emmanuel Perrotin, Paris/Miami

Doris Salcedo

Torino 2005

Abyss: Notes on the Art of Doris Salcedo

It is difficult
to get the news from poems
yet men die miserably every day
for lack
of what is found there.
William Carlos Williams

Noviembre 6 y 7, 2003
Installation view, Palace of Justice,
Bogotá, 2003
Photo courtesy Alexander and
Bonin, New York

The art of Doris Salcedo is a form of spatial poetry, at once elegiac and epic, ordinary and monumental. It is intended to evoke intense emotions that will raise consciousness in the viewer, so that the pain and human suffering that she acutely perceives in the world, a principle source for her art, will not be in vain. Aesthetic emotion is for Salcedo deeply related to the political – it *is* the political, and art is the terrain on which the personal and intimate meet the collective and the public. Her art retrieves removed histories, "works through" them, sounds the complexity and depth of memory in order to enrich the surface and the present. This is achieved both on the level of the content (the narratives of loss and injustice that are evoked by, and embedded in, her sculptures and installations) as well as on the level of their materiality (their tactile qualities, labour-intensive manipulation and the subtlety of their surfaces) so that the viewer is grounded in an experience of reality that is at once specific and unique, universal and abstract.

Salcedo's exhibition for the Castello di Rivoli is rigorously structured along a divide between inside and outside, full and empty, past and present, power and powerlessness, freedom and confinement. She identifies, explores, heightens and, finally, reverses and transforms this boundary, allowing the experience of the work to be a form of hovering around this divide, this space of the chasm.

On the one hand, the artist presents a *full* space, a pristine "white cube" exhibition gallery where a group of her untitled furniture sculptures made between 1989 and 2001 is installed. This series was created over a period of years by casting concrete into pieces of old furniture – tables, chairs, dressers, closets, even beds. These works are dense and heavy; they carry the traces and the burden of past lives through references to the absent bodies they once harboured. They suggest layers of experience, the weight of loss and

the density of life. The gallery in which these untitled sculptures are installed evokes emptiness, loss, solitude and a longing sense of absence, as if – substituted through a metonymic process of reversal by the furniture with which they once lived – the missing are now present only as negative casts, their souls entombed in the cement from which only traces emerge.

On the other hand, however, in an adjacent space characterized by its high, brick-vaulted dome, Salcedo creates a stunning new architectural installation, *Abyss*, working rigorously along its perimeter and leaving the centre of the vast room empty. Salcedo's intervention does not deny the existing architecture; it underlines, heightens and renders it extreme. As the artist herself has explained, *Abyss* "emphasizes both the form and the character of this grand space. It is not a distortion of it, it is rather a reinforcement of the specific aspects the space."[1]

In *Abyss*, Salcedo transforms the apparently neutral and lofty exhibition space, enhancing "the ungraspable nature of this dome, located somewhere between a political hegemony and a transcendental idea."

The 14 x 14 meter gallery was once a venue for receptions when the Castle was a center of political power under the Savoia monarchy. By extending the eighteenth-century brick vault so that it descends down to 1.20 meters above floor level, almost obscuring the four white walls of the room, but leaving a small portion visible along the bottom so that the viewers might still perceive and imagine the original architectural space, Salcedo suggests a vertiginous void, abysmal and unfathomable, a space of exclusion by enclosure. *Abyss* is awe-inspiring, silent, heavy and mysterious. The brick walls transform the already oppressive dome above into something even more powerful, even more dominating. The vault now weighs down over and around us, as if suspended at the moment before completion, when it will finally immure us all.[2]

For the artist, *Abyss* "is a tool to decode or read the history and nature of this impressive and at times unapproachable space. It is clearly a space of political practice, not a space of human habitation, and the social practices inherent to the spatial form of this room remain present today, more than a century and a half after it ceased to be a center of power."

In 1985, Salcedo witnessed the dramatic events in her native city of Bogotá, Colombia, when rebels seized the supreme court building on 6 November and were subsequently besieged by government forces, who repressed the rebellion in blood the next day, with over 100 fatalities. Salcedo had just returned to Bogotá from New York, where she had

[1] Doris Salcedo, Statement, June 28, 2005. All further quotes, unless otherwise noted, are from this statement of intent.

[2] Salcedo is obliquely referring in this piece to the imprisonment of King Vittorio Amedeo II by his son Carlo Emanuele III in the Castello di Rivoli in 1731. To keep him from escaping, a moat was built around the castle and bars were installed on the windows. Some windows were almost completely walled up with bricks, to a point where only the minimum of light and air could filter into the room. Leaving red bricks visible is also a traditional decorative element in Piedmontese architecture, as can be seen in many notable buildings in downtown Turin.

been an art student, and she held her first solo exhibition that same year, "Nuevos Nombres," at the Casa de Moneda in Bogotá. It was thus also a seminal moment in her development as an artist. The violence of the event became the subject matter for a number of artworks over the years, including *Noviembre 6* (2001,) *Tenebrae: Noviembre 7, 1985* (1999–2000) and a unique performance event in 2002, *Noviembre 6 y 7*, when she lowered 280 chairs from the roof and down the external walls of the supreme court building, a piece that lasted for the same duration as the original events themselves – a public sculpture, a sculpture of time, a commemoration.

Chairs (as substitutes for people) and walls (as metaphors of the contested terrain of conflict) continued to appear in Salcedo's art, and for the Istanbul Biennial the next year she filled a vacant (and contested) lot in the city with 1,550 wooden chairs, carefully joined together and compacted so that they created a perfectly flat and dense surface (again a wall) flush with the buildings on its two sides, a temporary installation that would evoke the masses of displaced persons behind the *façade* of globalization.

The tortured materiality of walls and boundaries, representing the violence and division of people in the globalized world, continued with Salcedo's installation *Neither* at White Cube in London in 2004. For this project, she activated and transformed the neutral walls of the exhibition site (the modernist "white cube") into a space of enclosure and confinement, by entrenching, crushing and forcing wire mesh into plaster panels.[3] The effect was reminiscent of cages, prisons, echoing the horrendous and recent images of the Guantanamo Bay camps.

Salcedo's labour-intensive artworks are conceived after extensive research and dialogs. They are subsequently made with the collaboration of a community of people – engineers, architects and numerous assistants. They are *extreme* endeavours, and follow few rules of cost-effectiveness, almost as though she were pushing economics to a paradoxical state where capitalist logics of production fall away. They are therefore, even in their production process, radical and new proposals of *work*, forms of labour disjoined from the practical issues of production costs and profit. "I work with gestures *ad absurdum*," the artist has explained, "until they acquire an inhuman character. The processes go beyond me, beyond my very limited capacity, whether because one single person couldn't possibly have made the work [...] or because of the brutality and massiveness of the act [...] or because it is inhuman to handle certain materials."[4] Through these processes Salcedo repeats and symbolically reverses the extreme conditions of manual labour in many parts of the world today.

Walls are the membranes between spaces, materials, places, universes, or between people. They are not clear cut; they are transitional zones, zones of conflict, desire, escape. In their titles, too, *Abyss* and *Neither* suggest conflict, and even a sense of thwarted escape: etymologically "abyss" comes from the Latin *ab abimes*, where the prefix *ab* (from) expresses that we are not in the *abimes* (depth,) and thus only able to gaze

[3] 1000 tons per square meter were needed to crush the mesh wire into the plasterboard.

[4] D. Salcedo, "Carlos Basualdo in conversation with Doris Salcedo," in C. Basualdo, A. Huyssen, C. Merewether, *Doris Salcedo*, Phaidon Press, London, p. 21.

into it from without. Similarly, *Neither* suggests the impossibility of any choice, the negation of "either."

In our "globalized" world, the media tend to make one believe that movement, flexibility and freedom are increasing thanks to swifter and easier interconnectedness and communication systems. Behind this image of apparent fluidity and mobility, however, lies a different story, one of disparity, impossibility of travel and even incarceration. Salcedo has explained that "*Abyss* addresses the sheer extra weight the powerful ones exert over disenfranchised populations. It is an attempt to address the irreconcilable disparity that prevails in the social practices of our time. This piece is the result of long-term research on the fact that immigration has become nothing but a problem in the First World. Opinion polls show that there is consensus among the majority of the population in Europe and Australia, identifying immigrants as the perpetrators of an inexplicable wrong, as the source of all the problems they are enduring. The rejection of the immigrant as a human being, and the erasure of their status as political refugees or even as workers, makes evident the fact that they are the object of an unquenchable hatred. This general trend towards separation, disintegration and racism, is marked by the new space that *Abyss* intends to delineate, a space that not only contains but dominates the bodies it shelters." Bricks – small portions of red earth baked to become so resistant that they can withstand thousands of years without crumbling, cemented together into walls that enclose, that divide, that disconnect, that isolate and immure, that infinitely suspend and dilate time and transform space into an unfathomable abyss: the gallery, only apparently left empty by the artist, has been transformed, metamorphosed into a space that expresses this oppressive and crushing weight, and its ability to enclose human beings, and remove their freedom altogether through erasure and enclosure. It is thus a tremendously full space, full of the bodies caught in its transaction of power.

Carolyn Christov-Bakargiev

following pages:
Project for *Abyss*, Castello di Rivoli Museo d'Arte Contemporanea, Rivoli-Torino, 2005
Courtesy Alexander and Bonin, New York and White Cube, London
Photo courtesy the artist, digital Photoshop Martín López

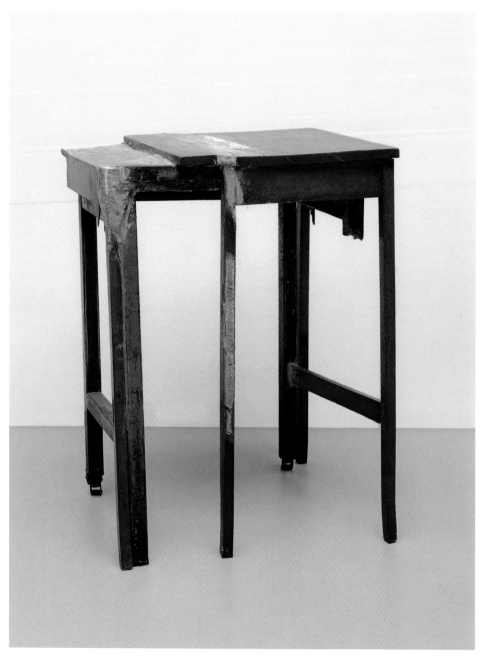

Untitled, 1990
Collection of the artist

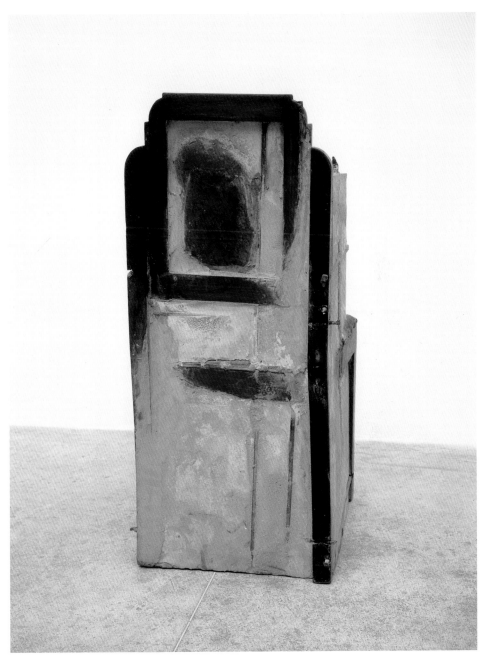

Untitled, 1995
Private collection

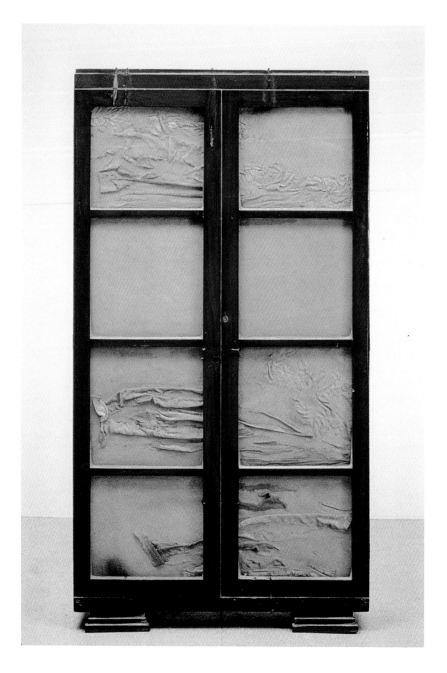

Untitled, 1998
San Francisco Museum of Modern Art
Fractional Gift of Lisa and John Miller

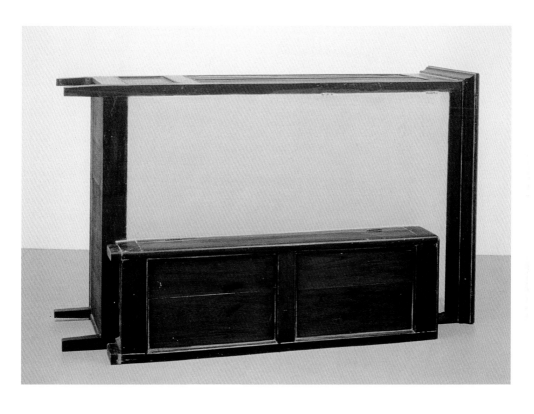

Untitled, 1998
Collection National Gallery of Canada, Ottawa
Purchased 1999

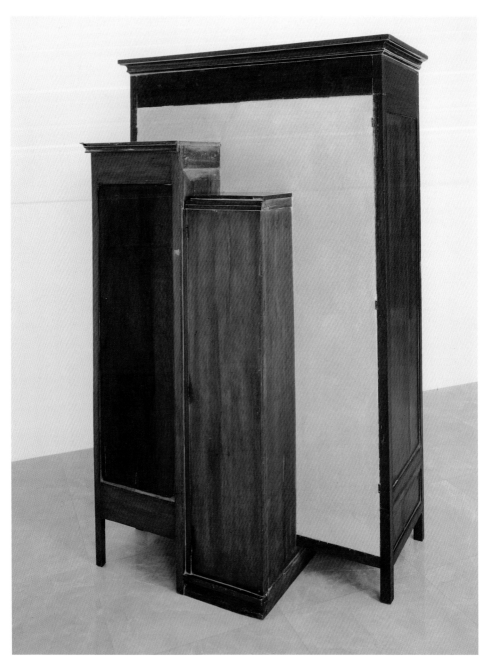

Untitled, 1998
Private collection
Photo Teresa Diehl

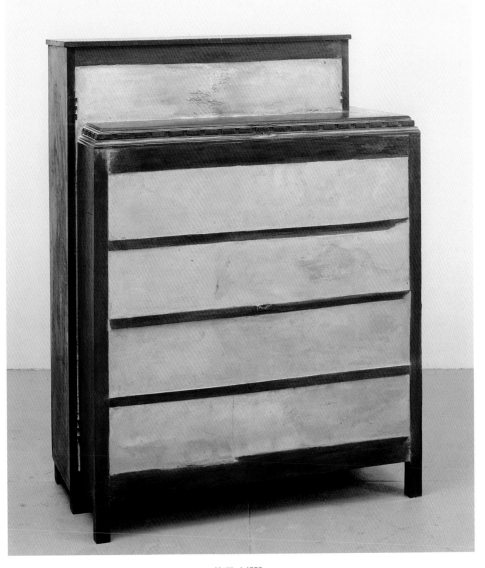

Untitled, 1998
Private collection
Photo David Heald

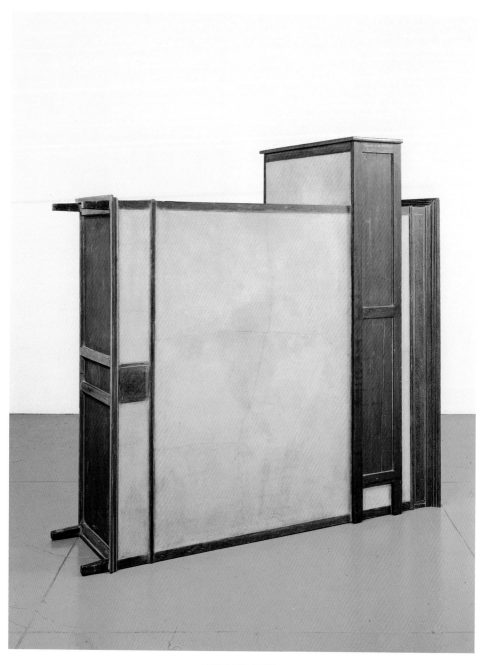

*Untitled*Untitled, 2001
Marieluise Hessel Collection on permanent loan to the Center for Curatorial Studies, Bard College,
Annandale-on-Hudson, New York
Photo David Heald

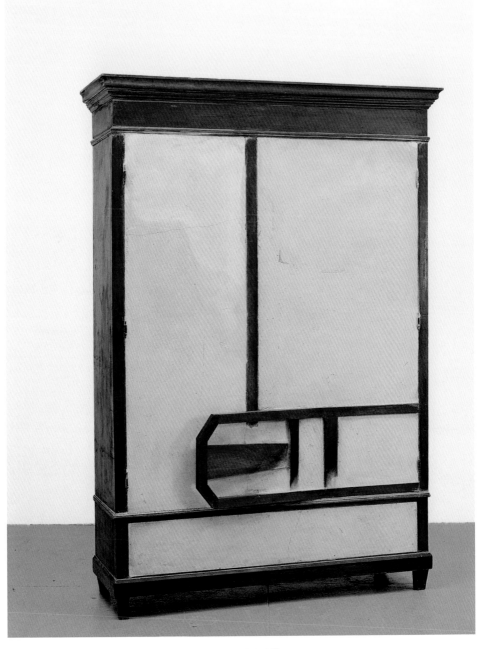

*Untitled*Untitled, 1998
Tate, presented by the American Fund for the Tate Gallery, 1999
Photo David Heald

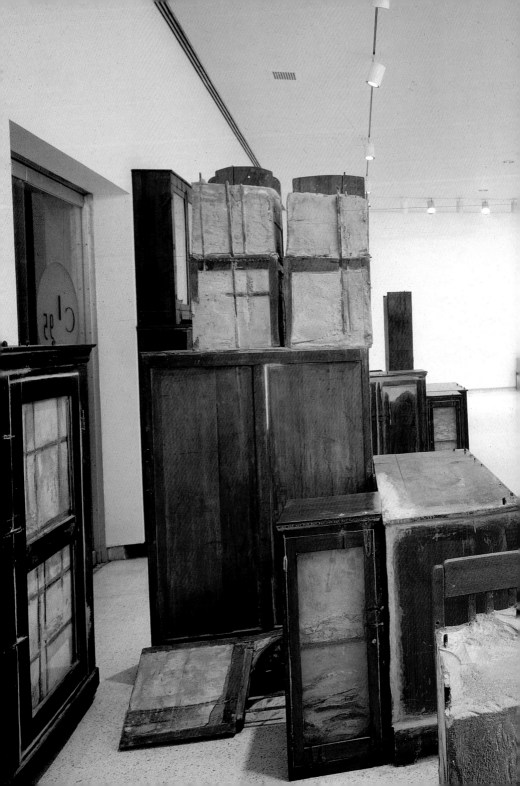

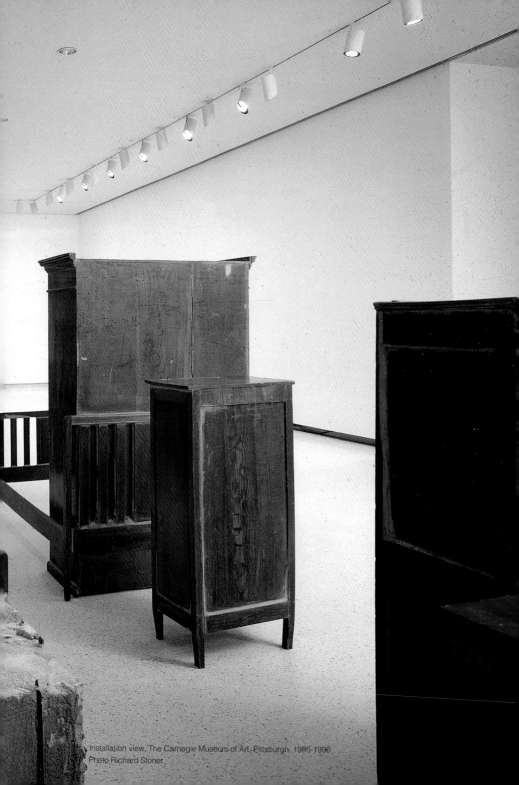

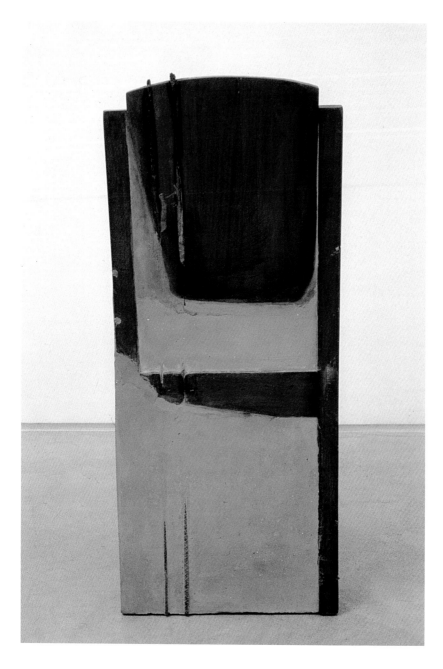

Untitled, 1997-1999
Private Collection
Photo Orcutt & Van Der Putten

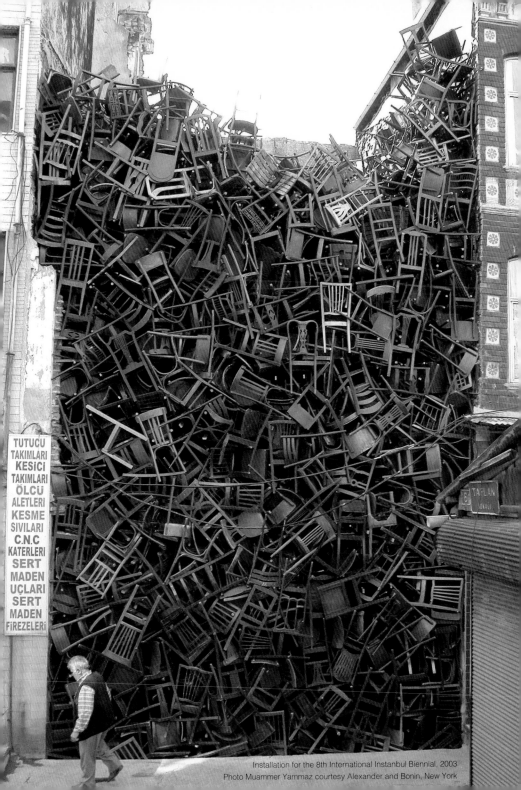

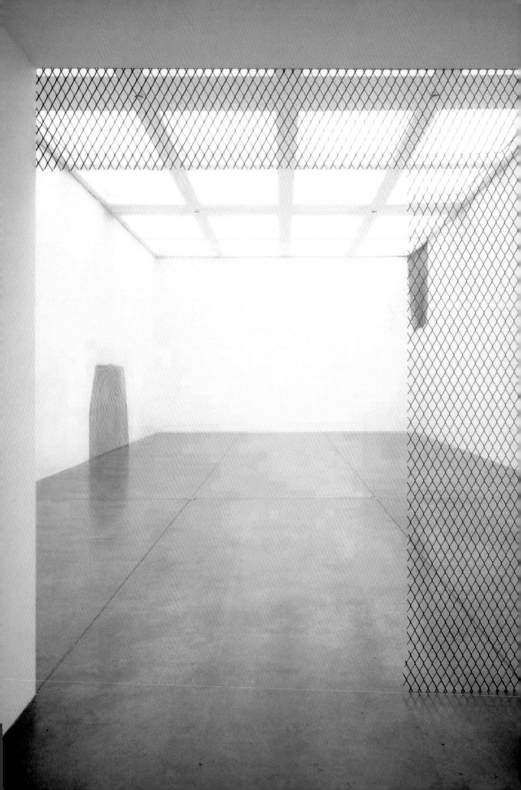

DORIS SALCEDO

Bogotá, 1958
Lives and works in Bogotá

Selected Solo Exhibitions

*Neithe*r, White Cube, London, September 10 –
October 17, 2004.
Doris Salcedo, Camden Arts Centre, London,
September 14 – November 11, 2001.
Doris Salcedo, Tenebrae: Noviembre 7, 1985,
Alexander and Bonin, New York, October 24 –
November 25, 2000.
Unland / Doris Salcedo, The New Museum of
Contemporary Art, New York, March 19 –
May 31, 1998; SITE Santa Fe, Santa Fe,
August 15 – October 18, 1998.
Doris Salcedo, Le Creux de L'Enfer, Thiers,
April 21 – June 16, 1996.

Selected Group Exhibitions

8th International Istanbul Biennale, Istanbul,
September 20 – November 16, 2003.
Documenta 11, Kassel, 8 June – 15 September
2002.
Carnegie International 1995, Carnegie Institute,
Pittsburgh, November 5, 1995 – February 18,
1996.
Cocido y Crudo, Museo Nacional Centro de
Arte Reina Sofía, Madrid, December 14, 1994 –
March 6, 1995.
Aperto 93, XLV Esposizione Internazionale
d'Arte. La Biennale di Venezia, Corderie
dell'Arsenale, Venice, June 13 – October 10,
1993

Selected Bibliography

Doris Salcedo: Neither, Jay Jopling / White
Cube, London, 2004. Texts by R. Mengham,
pp. 9-11; C. Basualdo, pp. 30-33.
Doris Salcedo, Phaidon Press, London, 2000.
Texts by C. Basualdo, pp. 8-35; N. Princenthal,
pp. 40-89; A. Huyssen, pp. 92-102.
Doris Salcedo, The New Museum of
Contemporary Art, New York 1998. Texts by D.
Cameron, pp. 9-14; C. Merewether, pp. 16-24.
C. Jiménez, "Los Duelos ocultos del silencio,"
Lapiz, Madrid, No. 174, June 2001, pp. 18-25.
R. Anastas, "Doris Salcedo: A Tour of the
Borderland of Unland," *Art Nexus*, Bogotá,
No. 29, August – October 1998, pp. 104-105.

preceding pages:
Neither, installation view, White Cube, London, 2004
Photo Stephen White

– 160 –

List of Exhibited Works

Untitled, 1995
Wood, concrete, steel, vinyl
38 $\frac{1}{2}$ x 16 $\frac{3}{4}$ x 22 $\frac{1}{2}$ in.
Private collection
Courtesy White Cube, London
p. 147

Untitled, 1997-1999
Wood, concrete, metal
32 x 15 x 16 $\frac{1}{2}$ in.
Private collection
Courtesy Alexander and Bonin, New York
p. 156

Untitled, 1998
Wood, concrete, glass, fabric, metal
79 x 49 x 20 $\frac{1}{4}$ in.
San Francisco Museum of Modern Art
Fractional Gift of Lisa and John Miller
p. 148

Untitled, 1998
Wood, concrete, metal
78 $\frac{3}{2}$ x 51 x 39 $\frac{1}{3}$ in.
Private collection
Courtesy White Cube, London
p. 149

Untitled, 1998
Wood, concrete, metal
59 $\frac{2}{3}$ x 45 $\frac{1}{2}$ x 22 $\frac{3}{8}$ in.
Private collection
Courtesy White Cube, London
p. 150

Untitled, 1998
Wood, concrete, metal
84 $\frac{1}{4}$ x 59 x 21 $\frac{1}{2}$ in.
Tate, presented by the American Fund for the
Tate Gallery, 1999
p. 151

Untitled, 2000
Wood, concrete, metal
32 x 16 $\frac{1}{8}$ x 16 $\frac{1}{8}$ in.
Private collection, Bogotá

Untitled, 2001
Wood, concrete
79 x 39 $\frac{1}{2}$ x 81 in.
Marieluise Hessel Collection on permanent
loan to the Center for Curatorial Studies, Bard
College, Annandale-on-Hudson, New York
p. 152

Abyss, 2005
Bricks, metal, concrete
173 $\frac{2}{3}$ x 545 $\frac{2}{3}$ x 639 $\frac{3}{8}$ in.
Courtesy Alexander and Bonin, New York and
White Cube/Jay Jopling, London
p. 144

PANTAGRUELISMS

Using sounds, texts, sculptures and images, Saâdane Afif's installations are so many reflections on the figure of the contemporary artist. The installation *Laffs in the Dark* (2005), made for this exhibition, is centered around a monumental piece of writing through which the public is obliged to pass. To enter, visitors must walk through the letter O, made from a revolving barrel, which causes them to stumble. The installation reproduces the façade of a house of horrors. As viewers walk around inside it, in the dark, they are surprised and alarmed by various childish and silly special effects. By appropriating an object taken from the world of popular entertainment, Afif recreates the impression of constant loss of balance suggested by contemporary art. Linked to fear of the dark, fun-fair amusements and excess, his installation also points out the resemblance between everyday life and the experience of a house of horrors, with all the scary situations that it entails. (*IB*)

b. 1970, Vendôme, France
Lives and works in Paris

Solo Exhibitions
Lyrics, Palais de Tokyo, site de création contemporaine, Paris, October 8 – November 20, 2005
One Million BPM, Cimaise et Portique, Albi, July 2 – October 30, 2005

Group Exhibitions
Experiencing Duration. Biennale d'Art Contemporain de Lyon 2005, La Sucrière, Lyon, September 14 – December 31, 2005
Dialectics of hope. 1ˢᵗ Moscow Biennale of Contemporary Art, Former Lenin Museum, Revolution Square 2/3, Moscow, January 28 – February 28, 2005

Bibliography
F. Piron, J. Beagles et al., *Jeunesse Youth / part 1*, Le Collège / Frac Champagne-Ardenne en coédition avec la Galerie Michel Rein, Paris / La Villa Arson, Centre national d'art contemporain, Nice / Le Creux de l'Enfer, Centre d'art contemporain, Thiers /L'école des Beaux-arts, Tours / Zoo Galerie, Nantes, 2003
T. Morton, "Saâdane Afif," *Frieze*, No. 85, London, September 2004, p. 104

p. 165: *Laocoon*, 2005, photo Marc Boyer, *Pop (Laocoon)*, 2005, lyrics commissioned by the artist to Mick Peter for the exhibition *One Million BPM*; music: Julien Perez
p. 166: *The Sphinx*, 2004, *Pop (The Sphinx)*, 2004, lyrics commissioned by the artist to Tiziano Lamberti for the exhibition *Vorticanti*, Galleria Maze, Turin, music: Tiziano Lamberti
Courtesy Galerie Michel Rein, Paris
p. 167: *Blue Time*, 2004 *Pop (Blue Time)*, 2004, lyrics commissioned by the artist to Lili Reynaud-Dewar for the exhibition *Melancholic Beat*; music: Tujiko Noriko, Port Radium

Pop (Laocoon)

Whatever the shipwreck in the salon
it's always a delight
for the vultures
and makes the best scream
of this grimness campaign

Wherever there's a landscape
with a curtain of black hair waving in front of it
I'll lie crumpled and ignorant on this raft
without the fluency and wit
of the hissing, streaking rain

Three holes in the hat brim
where bullets past
though where's the harm
when you possess something
and it's made beautiful again?

Mick Peter

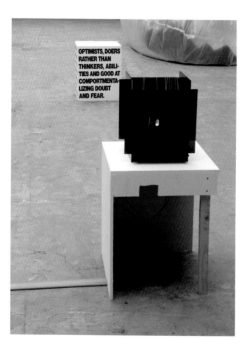

The sphinx

Verse:
 Every lizard, every cloud
 Every sunset in the south
 Every weekend in the sand

 Love is flying above the ground
 Better brief than never found
 Anytime that will be mine

Chorus:
 tu tu tu tu tu tu tu
 tu tu tu tu tu tu tu
 tu tu tu tu tu tu tu

 tu tu tu tu tu tu tu
 tu tu tu tu tu tu tu
 tu tu tu tu tu tu tu

(repeat all as a canon)

Tiziano Lamberti

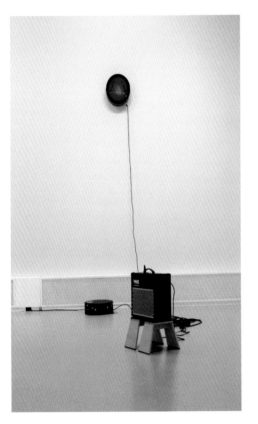

Pop (Blue Time)

I've been waitin' for the producers For the PRs,
for the designers For any kinda success maker
I've been writin' songs, musicals, operas, I played
Honky Tonk, blues, bluegrass, Freejazz, funk,
rock'n roll, salsas Twists and even modern
chachas

I played in bars, hotels, parties,
So many birthdays, funerals, weddings So many
unplugged, so many gigs, So many women with
no name None of my nights have been the same
I've been waitin' for recognition So far no one
had the intuition That all my songs were to be
big I left home when I was a kid To accomplish
my destiny I've been on the road indefinitly
Weeks, years, it seems a century
I played in bars, hotels, parties, So many birth-
days, funerals, weddings So many unplugged, so
many gigs, So many women with no name None
of the Lights have been the same
Oh I've been waitin' for days It feels cool in this
haze Weeks, years, it seems a century But
there's no need to worry Cos waitin' has to be
my duty No I'm not scared of infinity Infinity's
the heavy duty Of a songwriter like me

Lili Reynaud-Dewar

The works of Jennifer Allora and Guillermo Calzadilla often take puns and humour as their starting point, which the artists see as a radical intellectual and aesthetic act. Exploring the psychological, political, social and cultural geographies of contemporary global culture, their theoretical investigations and artistic procedures have led them to develop videos, installations and actions that illustrate – not without a certain irony – the *détournement* (re-routing) of objects and situations, reminiscent of a certain strand of Dadaism. Examples of their artistic exploits include *Returning a Sound* (2004), in which a bugle is soldered to the silencer of a scooter, and *Hope Hippo* (2005), which features a large mud hippopotamus on which people take turns to read the newspaper. For this exhibition Allora & Calzadilla have created *Ruin* (2005), an ironic and formalist-looking sculpture made by "digesting" and assembling discarded parts of machines found in Puerto Rico. The audience can interact with the sculpture – folding, altering, re-shaping it at will. (*RP*)

b. 1974, Philadelphia, United States
b. 1971, Havana, Cuba
Live and work in San Juan, Puerto Rico

Solo Exhibitions
Ciclonismo, Galerie Chantal Crousel, Paris, March 20 – May 29, 2004
Allora & Calzadilla, Chalk, Seventh Annual ICA /Vita Brevis Project, ICA The Institute of Contemporary Art, Boston, July 2 – 4, 2004

Group Exhibitions
Always a Little Further, LI Esposizione Internazionale d'Arte. La Biennale di Venezia, Arsenale, Venice, June 12 – November 6, 2005
Common Wealth, Tate Modern, London,October 22 – December 28, 2003

Bibliography
S. McKinlay, *Jennifer Allora and Guillermo Calzadilla*, in *Common Wealth*, Tate Modern, London, 2003, pp. 83-94
Y. Mckee, *Common Sense*, ICA The Institute of Contemporary Art, Boston, 2004, p. 42

pp. 169-171: Drawing by Allora & Calzadilla, text by Yates Mckee

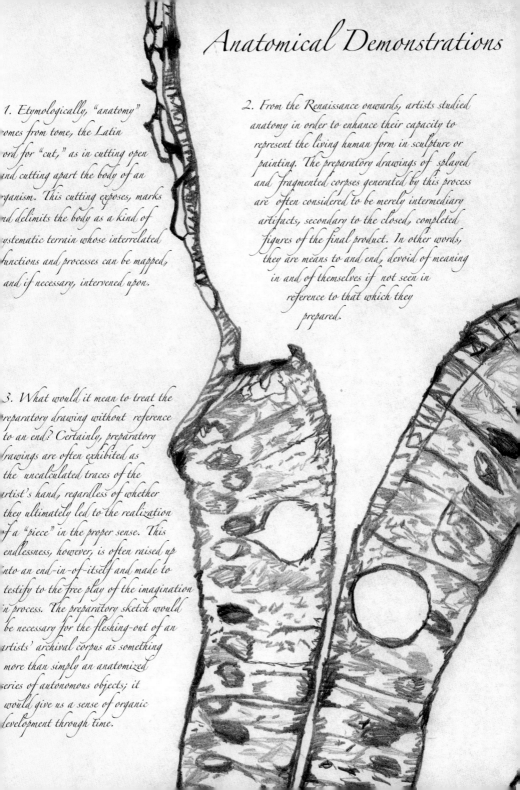

1. Etymologically, "anatomy" omes from tome, the Latin ord for "cut," as in cutting open nd cutting apart the body of an rganism. This cutting exposes, marks nd delimits the body as a kind of ystematic terrain whose interrelated unctions and processes can be mapped, and if necessary, intervened upon.

2. From the Renaissance onwards, artists studied anatomy in order to enhance their capacity to represent the living human form in sculpture or painting. The preparatory drawings of splayed and fragmented corpses generated by this process are often considered to be merely intermediary artifacts, secondary to the closed, completed figures of the final product. In other words, they are means to and end, devoid of meaning in and of themselves if not seen in reference to that which they prepared.

3. What would it mean to treat the reparatory drawing without reference to an end? Certainly, preparatory drawings are often exhibited as the uncalculated traces of the rtist's hand, regardless of whether they ultimately led to the realization f a "piece" in the proper sense. This endlessness, however, is often raised up into an end-in-of-itself and made to testify to the free play of the imagination in process. The preparatory sketch would be necessary for the fleshing-out of an rtists' archival corpus as something more than simply an anatomized eries of autonomous objects; it would give us a sense of organic evelopment through time.

The preparatory drawing also comes to
from the conventions of architecture;
as a painter might prepare the ground
rendering of human form, so does the
ner sketch out the morphological contours,
structural coordinates and circulatory
orks of a building or a city before
eeding into the realm of physical construction.
aratory drawing is thus typically bound up
h an organizational teleology, which is to say,
subordination of an organism's means to the
alization of its
er ends or
ctions.

5. In so far as it formalizes the future, the preparatory drawing ceases to be preparatory in any meaningful sense; since in principle what comes is already known, it can be planned for and calculated, despite any empirical obstacles or imperfections. A true preparatory drawing would thus involve a fidelity to that which ruins preparation; it would somehow attest to this ruination in its very form, which is to say, it would become formless, a means subordinated to no end, not even its own.

6. Needless to say, such a drawing would be an

impossible drawing, and the organism it would trace
out could no longer be called an organism in the
normal sense of a life-form — whether an
artwork, a body or a city — that
 its own operational destiny
carries it, prior to the media that
within supplement its realisation
would preparatory
(such as a
drawing for
instance).

7. But in sketching out this impossible drawing, in preparing ourselves for its
incalculable arrival, we should be clear: becoming-form less remains foreign to
that which we would identify as merely amorphous, pure materiality (hyle)
lacking a definite shape in which everything blurs entropically into everything else. A better
term to mark this event might be morpho-illogical, which inhabits and alters the horizons of
 morphology itself, whether understood on a biological, linguistic, architectural, or art
 -historical register.

. Rather than deliberately abolish form altogether, a morpho-illogical practice would attend to what George Bataille referred to as "the deviations of nature." These "monsters" are not mere exceptions to the commonality and regularity of form; they testify, rather, to the ever-present possibility within a design or matrix of a future that would be something other than an extension of the present. Needless to say, this morpho-monstrosity cannot be posited as a good-in-of-itself, nor captured as an artistic or political theme. It can only come as a demonstration provided we understand this morpheme in light of its etymological connection to the Latin monstrare ('to show') and in turn monstrum, a divine portent that warns or reminds of a danger that has always already befallen us, a danger for which we can never fully prepare.

. The danger comes to us today in many forms, including advanced technoscientific capacities to engineer living material, human and otherwise. This complicates romantic organicism in art and architecture, in which biomorphic structures were thought to extend an essentially natural process of preformation and realization. Biotechnology posits life as a textual structure to be decoded and reprogrammed according to human designs. The danger is not that this violates an organic nature, but that the ends to which the means are put will themselves be naturalized as the unfolding of freedom itself. The double imperative is to question dominant interpretations of the meaning of biotechnology, and the imbrication of those interpretations in specific regimes of corporate and state power. With a few important exceptions, artists and designers have either resorted to nostalgia for an organic body, or uncritically embraced the rhetoric of bio-industrial complex, including the substitution of bioethical dramaturgy for biopolitical conflict. Invoking the morpho-illogical bodies of Gargantua and Pantraguel rather than the anatomical correctness of modern morphology, Hardt and Negri provide an important corrective when they write: "Today we need giants and new monsters that bring together nature and history, labor and politics, art and invention in order to demonstrate the new power…the multitude provides to humanity. We need a new Rabelais or, really, several."

CARLOS AMORALES

The works of Carlos Amorales range from performance to video, drawings to sculpture and installation. They combine mystery, irony and meditations on form, philosophy and psychology to reflect current definitions of our contemporary identity in all its many manifestations. In his double-video projection *Dark Mirror* (2005), one side of the screen shows the pianist José María Serralde performing the piece he composed especially for this work. The other half contains animation taken from Amorales's digital drawings: silhouettes of birds and aircraft traversing blood-spattered surfaces in an atmosphere of increasing loss of control. Media images of the airborne attacks of 11 September are also incorporated, and these, along with the subsequent trauma left lingering in the memory, are lent a dreamlike quality, poised between reality and unreality, consciousness and unconsciousness, resignation and incredulity, like reflections in a mirror. (AV)

b. 1970, Mexico City, Mexico
Lives and works in Mexico City and Amsterdam

Solo Exhibitions
¿Por Qué Tener Miedo al Futuro? / Why to Fear the Future, Casa de América, Madrid, February 8 – March 27, 2005
Cabaret Amorales, Migros Museum Für Gegenwartskunst, Zürich, June 1 – August 12, 2001

Group Exhibitions
We are the World, Dutch pavillion, L Esposizione Internazionale d'Arte. La Biennale di Venezia, Giardini, Venice, June 15 – November 2, 2003
Mexico City: an Exhibition About the Exchange Rates Of Bodies and Values, P.S.1 Contemporary Art Center, Long Island City-New York, June 30 – September 2, 2002

Bibliography
J. Allen, "Review in Madrid. Carlos Amorales. Casa de América," *Artforum*, Vol. XLIII, No. 10, New York, Summer 2005, p. 333
C. Amorales, *Flames*, in *2 Berlin Biennale 2001*, Oktagon Verlag, Köln, 2001, pp. 50-51, 464-467

pp. 173-175: *Liquid Archive*, 1999-2005, work in progress

Armando Andrade Tudela's work brings together aspects of American conceptual photography and the South American constructivism of the Sixties, analyzing the way in which contemporary and modernist culture have come together in Peru. Essentially documentary, his series of photographs *Camion* (*Trucks*, 2004) surveys the works painted on the coachwork of their trucks by Peruvian truck-drivers, with their pure colors and abstract designs. *Billboards* (2005) photographs various blank billboards, transformed into so many "found" sculptures. For Armando Andrade Tudela, they are the bearers of a dialog of forms, vernacular and decorative, which may be both critical and playful. (*RP*)

b. 1975, Lima, Perù
Lives and works in St. Etienne

Solo Exhibitions
Camion, Counter Gallery, London, May 6 – June 5, 2004
Armando Andrade Tudela, Annet Gelink Gallery: The Bakery, Amsterdam, April 5 – May 10, 2003

Group Exhibitions
InSite_05: Farsites. Urban Crisis and Domestic Symptoms in Recent Contemporary Art, San Diego Museum of Arts, San Diego: Centro Cultural, Tijuana, August 27 – November 13, 2005
Tropical Abstraction, Stedelijk Museum Bureau, Amsterdam, July 10 – August 21, 2005

Bibliografia
R. Gortzak, "Armando Andrade Tudela," *Metropolis M*, Year 27, No. 3, Utrecht, June-July 2005, pp. 76-85
M. Godfrey, "Image Structures: Mark Godfrey on photography and sculpture," *Artforum*, Vol. XLIII, No. 6, New York, February 2005, pp. 146-153

pp. 177-179: *Banda en pedazos* (*Dismembered Band*)

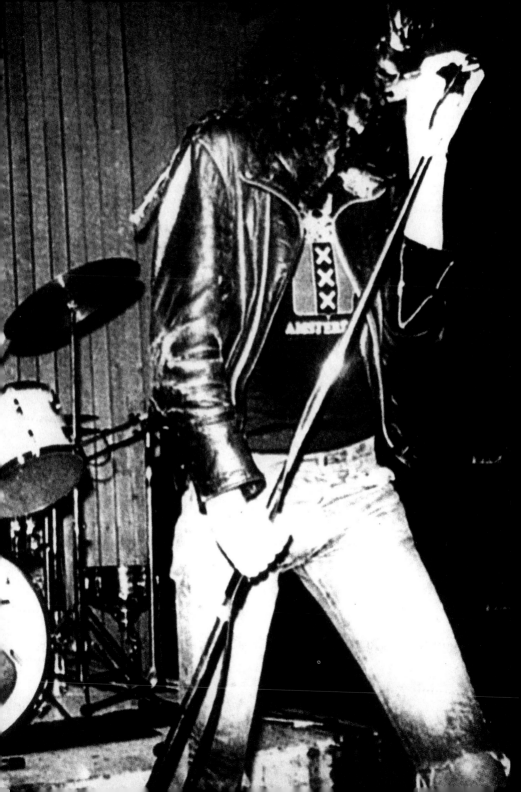

ANDREONI_FORTUGNO

The photographic research carried out by Luca Andreoni and Antonio Fortugno – who, since 1994, have been signing their work Andreoni_Fortugno – is centered on the theme of the contemporary living space, the everyday normality of everyday territory. The series of photographs entitled *IMHO – Manifesti elettorali (IMHO – Electoral Posters)*, an abbreviation of 'In My Humble Opinion', was made during the Italian electoral campaign of 2004, and presents the faces of various lesser-known politicians as they chose to present themselves to the voters on posters. Through these images, Andreoni_Fortugno consider the amateurish and declamatory use to which portrait photography has been put, and the current state of political communication. (*IB*)

b. 1961, Sesto San Giovanni-Milan, Italy
b. 1963, Novi Ligure-Alessandria, Italy
Live and work in Milan

Solo Exhibitions
Tracce, Galleria Dryphoto, Prato, October 13 – November 28, 2001

Group Exhibitions
Modena per la fotografia edizione 2003: L'idea di paesaggio nella fotografia italiana dal 1850 ad oggi, Galleria Civica, Modena, November 23, 2003 – January 25, 2004
Exit. Nuove geografie della creatività italiana, Fondazione Sandretto Re Rebaudengo, Turin, September 21, 2002 – January 6, 2003

Bibliography
F. Maggia, *Très belle*, in *Modena per la fotografia edizione 2003: L'idea di paesaggio nella fotografia italiana dal 1850 ad oggi*, Galleria Civica, Modena; Silvana Editoriale, Cinisello Balsamo-Milan, 2003, pp. 212-213, 218-219, 233
F. Maggia, in *Camera Austria*, No. 83, Graz, September 2003, pp. 60-61

pp. 181-183: *Untitled*, Courtesy Nepente Art Gallery, Milan

IMHO\im-hō\abbrev.
Abbreviation of 'In My Humble Opinion'.
One of the many abbreviations current on the web, particularly in the context of discussions
and newsgroups. Variants include IMNSHO (In My Not-So-Humble-Opinion) and IMAO (In My
Arrogant Opinion).

IMHO
Electoral posters

Strongly influenced by Icelandic culture and a close relationship with virtually untamed nature, the works of Magnús Árnason recreate the mystical and magical moods of ancient pagan rituals. A protagonist who appears in his works, whether video, performance or installation, is Benedikt, a mysterious figure who is made to perform sometimes violent actions – such as plucking feathers off birds – which verge on the macabre and the grotesque, and which seem to feed on elements of some archaic set of symbols. These hellish atmospheres, born of nightmares and all manner of unconscious fears, are evoked in cryptic works, always ringed by a halo of mystery. An example is an enormous ice cube, apparently imprisoning a man, which, as it slowly melts, turns out to reveal nothing more alarming than some male clothing. (*COB*)

b. 1977, Reykjavík, Iceland
Lives and works in Reykjavík

Solo Exhibitions
Sjúkleiki Benedikts (Sickness of Benedikt), Kling and Bang Gallery, Reykjavík, February 5 – 27, 2005
Sveinbjörn Jónsson, Gallery Nema Hvad, Reykjavík, March 2003

Group Exhibitions
Grasroots 2003, Living Art Museum, Reykjavík, September 20 – October 12, 2003
Finsternis (Darkness), Gallery Priestor, Bratislava, November 2002

Bibliography
C. Schoen, "Magnús Árnason," *LIST – Icelandic Art News* (online), No. 2, Reykjavík, June 2005, www.cia.is/news/june05/magnus

pp. 185-187: *Hamskipti Benedikts (Benedikt Metamorphosis)*, performative installation, Reykjavik, 2005

Artemio's work makes use of the Situationist practice of appropriation through remakes and adaptations, which, taken out of their original contexts, become charged with symbolic contents and suggest a form of conspiracy against the world of the spectator. His videos are a comment on, and critique of, the contemporary means of communication under whose influence he grew up. Through the montage and manipulation of images, Artemio creates tragi-comic characters who stir the public's political conscience and serve as so many ironic representations of the shifts in contemporary taste, fusing the global with the local, and cynicism with Utopia. His works seek to show how ideologies infiltrate one another and distort the myths and stories which inspire the world of show business; and how this world in its turn influences the course of political strategies in the real world. (*IB*)

b. 1976, Mexico City, Mexico
Lives and works in Mexico City

Solo Exhibitions
Compendios Filosóficos, SAPS-ENG (Sala de Arte Público Siqueiros), Mexico City, September 22 – November 6, 2005
Full Metal Racket, OPA (Oficina Para Proyectos de Arte A.C.), Guadalajara, March 7 – April 17, 2003

Group Exhibitions
Monuments for the USA, CCA Wattis Institute for Contemporary Arts, San Francisco, April 7 – May 21, 2005
White Noise, Gallery at REDCAT, Los Angeles, USA, September 9 – October 31, 2004

Bibliography
L. M. Sepulveda, Artemio: "El fin del espectaculo," *Playboy*, Chicago, September 2005, p. 114
C. Medina, "Violencia y sublimidad: la reapertura del Carrillo Gil," *Reforma*, Mexico City, August 22, 2001, p. 4c

pp. 189-191: Project for the *TI* catalogue

THE MONSTER INSIDE TELEVISION ATE MY GIRLFRIEND

In *Untitled* (2003), several transformers produce electrical discharges of 9,000 volts in a spare setting. In *Mindfall* (2004), the spectators enter a room in which various functioning Diesel engines (apparently faulty or burned out) fill the air with such noxious fumes that they are in danger of being poisoned if they stay in the room too long. *Untitled – dielettrico* (2002) puts spectators in the path of a blast of air whose force is so powerful that they are unable to approach its source. In *The Brightness of the Morning After* (2005) a single person lives in the exhibition space, as in the "belly of the whale," occasionally reading the texts, watching the films or listening to the music selected by the artist, with the help of experts, on the theme of the Apocalypse. Assaël compares the respective methods of investigation of various disciplines, in order to put them to a new, combined use, which will reveal the psychic component of physical risk on the one hand, and, on the other, will transform our understanding and knowledge into perceptible action. (*AV*)

b. 1979, Rome
Lives and works in Rome

Solo Exhibitions
Free Fall in the Vortex of Time, Galleria Zero, Milan, October 7 – November 14, 2005
Micol Assaël, from the series *La folie de la Villa Médicis*, Académie de France à Rome Villa Medici, Rome, March 25, 2002

Group Exhibitions
First Reykjavik Arts Festival. Material Time / Work Time / Life Time, Reykjavik Art Museum, Hafnarhus/National Gallery of Iceland/Gallery 100°, Reykjavik, May 14 – June 5, 2005
La Zona, L'Esposizione Internazionale d'Arte. La Biennale di Venezia, Giardini, Venice, June 15 – November 12, 2003

Bibliography
M. Gioni, *White Noise*, in *1 МОСКОВСКАЯ БИЕННАЛЕ СОВРЕМЕННОГО ИСКУССТВА / 1 Moscow biennale of contemporary art 2005: dialectics of hope*, ArtChronika, Moscow, 2005, pp. 60-65
C. Christov-Bakargiev, "Micol Assaël," *Artforum*, Vol. XLII, No. 5, New York, January 2004, p.136
M. Gioni, *La Zona*, in *Sogni e Conflitti. La dittatura dello spettatore. L'Esposizione Internazionale d'Arte*, Marsilio, Venice; La Biennale di Venezia, Venice, 2003, pp. 63-67; 74-76

p. 193: Project for the *T1* catalog, courtesy the artist; ZERO, Milan; Johann König, Berlin
pp. 194-195: Jan van Eyck, *The Arnolfini Marriage*, 1434 (detail)

MEMORANDUM

Mr. Malik, Soviet Representative on the Security

Council of the United Nations, recently approached

Mr. Jessup in a private conversation with suggestions

which intimated that the Soviet Government might be

prepared to lift the Berlin blockade if the Western

Powers would lift the counter-blockade and would agree

to a meeting of the Council of Foreign Ministers. Mr.

Malik indicated that the Soviet Government might agree

that the lifting of the blockade could precede the

convening of the Conference of Foreign Ministers, pro-

vided a date was fixed for the latter.

In view of the extreme delicacy and importance

of this matter, I instructed the Secretary of State

to have this approach followed up in further private

discussions between Mr. Jessup and Mr. Malik, with a

view to ascertaining whether it had any real substance.

Mr. Jessup was instructed in particular to obtain con-

firmation of Soviet readiness to lift the blockade prior

to the meeting of the Ministers.

Pending such clarification I instructed the Secretary

of State not to disclose information about this discussion

without my authorization. The British and French Foreign

Ministers were naturally kept personally informed of the

progress of these talks.

The

Fikret Atay makes his films and videos using a fixed camera which registers the scenes in question in an obsessive, domineering manner. *Fast and Best* (2002), shot in Batman, the town where he was born on the border between Turkey and Iraq, shows a group of young people performing a traditional folk dance. The lens is trained on the rhythmic, energetic movements of the dancers' legs for seven minutes twenty-nine seconds, as they move to the beat of the Turkish and Kurdish music that accompanies them. The scenes, and the presence of the dance leader's voice – whose stentorian tones "command" their movements – are reminiscent of military parades and marches, although the unisex clothes of the young dancers, namely jeans and heavy boots, suggest another world entirely, but ruled by rituals that are equally severe. (*CPM*)

b. 1976, Batman, Turkey
Lives and works in Paris

Solo Exhibitions
Sonidos lejanos / Distant Sound, Laboratorio 987, MUSAC – Museo de Arte Contemporaneo de Castilla y León, León, June 22 – August 14, 2005
Fikret Atay, BüroFriedrich, Berlin, January 17 – March 27, 2004

Group Exhibitions
Critical Societies, Badischer Kunstverein, Karlsruhe, March 25 – November 22, 2005
Time Zones: Recent Film and Video, Tate Modern, London, October 6 – January 2, 2005

Bibliography
B. Holmes, C. Menke et al., *La insurrección invisible de un millón de mentes / The Invisible Insurrection of a Million Minds*, Sala Rekalde, Bilbao, 2005, p. 126-128
J. Morgan, G. Muir, *Time Zones: Recent Film and Video*, Tate Publishing, London, 2004, pp. 20-21, 28-31, 40, 110

p. 197: *Tinica*, 2004
p. 198: *Fast and Best*, 2002
p. 199: top, *Bang Bang*, 2003; middle, *Any Time Prime Time*, 2004; bottom, *Lalo's Story*, 2004
Courtesy Galerie Chantal Crousel

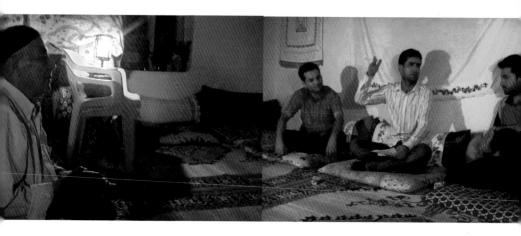

TAMY BEN-TOR

Tamy Ben-Tor is a performer. In her works she embodies different stereotypes as physical characters in real space. She has worked in the medium of live performance, including the musical projects *Electroyiddish* (2002) and *Suspicious Tourists* (2003), as well as in video. "I embody different individuals who embody their own philosophies of life, and try to tear them out of their natural habitat, into a domain of idiocy" (Ben Tor). In order to emphasize the relativity of their "individuality" the artist creates for them "a space of seclusion and nonsense, in which their identity has little to do with reality, and more to do with their need for one." (*RP*)

b. 1975, Jerusalem, Israel
Lives and works in New York

Group Exhibitions
Greater New York 2005, P.S.1 Contemporary Art Center, Long Island City-New York, March 13 – September 26, 2005
First Look, Hudson Valley Center for Contemporary Art, Peekskill, New York, March 6 – September 3, 2005

pp. 201-203: Stills from the video *The Hitler Sisters*, 2003

Since the early 1990s, Fernando Bryce has been building up an archive of photographs, cuttings from newspapers, periodicals and magazines, posters and historical documents. These he copies in the form of thousands of obsessive ink-on-paper drawings. The subjects of most of these revolve around revolutionary political action, and the drawings' incisive style is reminiscent of the political satire and sketches of the radical twentieth-century avant-gardes. *Revolución (Revolution, 2004)* is a series of 219 drawings of various dimensions, with images of the Cuban Revolution and the political and ideological conflicts of the 1960s, to which Bryce has added more contemporary elements and motifs. By recasting these historical images in his own style, he gives a sense of uniformity to his many sources, bringing the spectator more directly in touch with them through a present-day political and artistic sensibility. (*CPM*)

b. 1965, Lima, Perù
Lives and works in Berlin

Solo Exhibitions
Fernando Bryce, Fundació Antoni Tàpies, Barcelona, April 22 – July 10, 2005
The Spanish Revolution & the Spanish War, Konstmuseet, Malmö, February 5 – March 28, 2005

Group Exhibitions
54th Carnegie International, Carnegie Museum of Art, Pittsburgh, October 9, 2004 – March 20, 2005
Poetic Justice / Sürsel Adalet. 8th Istanbul Biennial, Antrepo No. 4, Istanbul, September 19 – November 16, 2003

Bibliography
G. Buntix, K. Power et al., *Fernando Bryce*, Fundació Antoni Tàpies, Barcelona, 2005
C. Tannert, B. Thumm, *Fernando Bryce*, Verlag Thumm & Kolbe, Berlin, 2003

pp. 205-207: Drawings from the series *Revolución (Revolution)*, 2004
Courtesy Galerie Barbara Thumm, Berlin

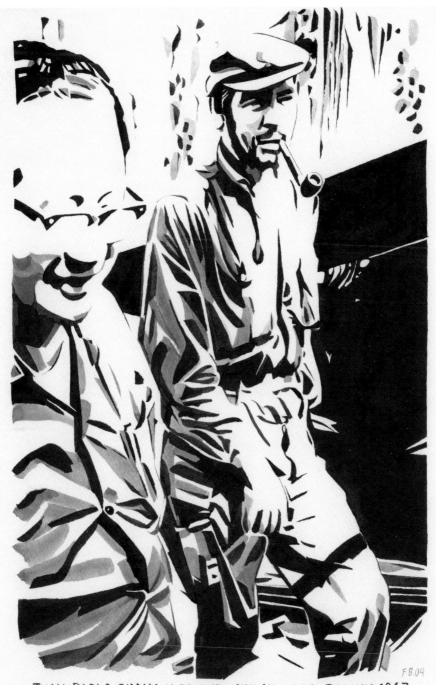

JUAN PABLO CHANG Y ERNESTO CHE GUEVARA - BOLIVIA 1967

In order to distance herself from her own context and gain a fresh perspective on the world, the Polish artist Agnieszka Brzeżańska chose to study in Japan. In her view, the contemporary art scene is suffocated by advertising, and by over-explicit images in which every fragment of reality is accompanied by a proliferation of messages and information. *Impossible is nothing* (2005) – a title with echoes of the famous slogan used by Nike – is a new series of photographs taken by the artist during her travels and then assembled into a slide show, telling various stories and leading the spectator through a complex network of images. Essentially, Brzeżańska's work is a search for transcendence, as revealed in the most banal of everyday objects, and by the frenzied pace of city life. Through her photographs she captures those moments that bring out the links between real and imaginary, between the natural and the artificial world, between the random and the preordained. (*MVM*)

b. 1972, Gdansk, Poland
Lives and works in Warsaw

Solo Exhibitions
Double Happiness, CCA Ujazdowski Castle; Zacheta National Gallery, Warsaw, March 29 – April 28, 2005
FREE DOOM, CCA Ujazdowski Castle, Warsaw, March 14 – April 10, 2005

Group Exhibitions
Under the White and Red Flag. The New Art from Poland, Estonian Art Museum, Tallinn, January 13 – February 15, 2004; CAC Contemporary Art Center, Vilnius, March 19 – May 2, 2004

Bibliography
A. Brzeżańska, *FREE DOOM*, Collegium Helveticum, Zürich, 2004
C. Jolles, "Der Agonie Des Verstehens Entwischt / Escaping the Agony of Understanding," *Meridian*, No. 14, Zürich, Spring 2004, pp. 21-25

pp. 209-211: Images from the slideshow *Freedom to People and Animals*, 2004

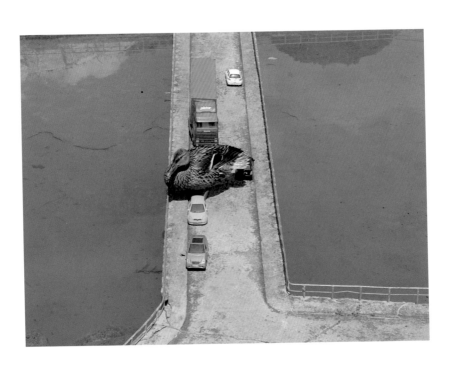

Ian Burns' installations use techniques ranging from puppetry to shadow theatre, as well as kinetic and interactive art. Bringing together various aspects of recent art, always reinterpreted in a parodistic fashion, with movable magnifying glasses in the place of monitor screens, and complex automatic machines, or functional wooden structures and kitsch toys, Burns creates works that are remarkably original and rich in imagery. Cinema and video, painting, sculpture, installations and video games coexist to form a highly inventive whole, in which the revelation of the trick that creates the magic is tantamount to playing with the poetry of objects. (*RP*)

b. 1964, Newcastle, Australia
Lives and works in New York

Solo Exhibitions
Ian Burns, Spencer Brownstone Gallery, New York, September 8 – October 15, 2005
GIGANTIC. Machinery of Surveillance v.2.0, The Soap Factory, Minneapolis, May 7 – June 19, 2005

Group Exhibitions
Greater New York 2005, P.S.1 Contemporary Art Center, Long Island City-New York, March 13 – September 26, 2005
In Practice Project, SculptureCenter, New York, September 12 – November 29, 2004

Bibliography
E. Heartney, "Report from New York I – Return to the Real," *Art in America*, Vol. 93, No. 6, New York, June-July, 2005, pp. 84-89
K. Wilkin, "Not-so-great New York 2005," *The New Criterion*, Vol. 23, No. 9, New York, May 2005, pp. 43-47

pp. 213-215: Project for the *T1* catalog

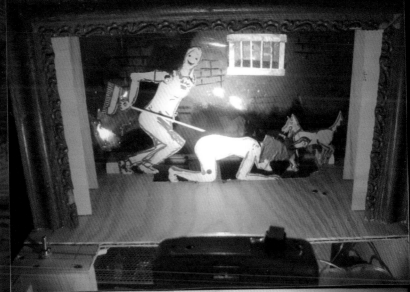

English	Pronunciation	Italian Spelling
digging trenches	*ska-VA-va-no del-lay treen-CHAY-ay*	scavavano delle trincee
laying mines	*kohl-lo-KA-va-no del-lay MEE-nay*	collocavano delle mine
preparing an airfield	*ko-stroo-EE-va-no oon ah-ay-ro-POR-to*	costruivano un aeroporto
laying in supplies	*ahk-koo-moo-LA-va-no ree-for-nee-MEN-tee*	accumulavano rifornimenti
repairing equipment	*ree-pa-RA-va-no eel ma-tayr-YA-lay*	riparavano il materiale
building tank traps	*ko-stroo-EE-va-no TRAHP-po-lay ahn-tee-KAR-ro*	costruivano trappole anti-carro
building dugouts	*ko-stroo-EE-va-no day ree-KO-vay-ree*	costruivano dei ricoveri
Which direction did they go?	*KAY dee-rets-YO-nay AHN-no PRAY-zo?*	Che direzione hanno preso?
Have any mines been planted?	*AHN-no say-mee-NA-to del-lay MEE-nay?*	Hanno seminato delle mine?
Show us where they are	*mo-STRA-tay-chee DOH-vay SO-no*	Mostrateci dove sono

★

ANDREA CARETTO/RAFFAELLA SPAGNA

Nature, and the intellectual and practical systems which regulate its relations with man, is the main theme of the work of Andrea Caretto and Raffaella Spagna: their project E.S.C.U.L.E.N.T.A. envisages a process aimed at the retrieval and use of vegetable organisms which have already become part of the food distribution cycle, in the hope of exploring the domestic and the relationship between wild and cultivated. The presentation, in this context, of another phase of this project envisages the erection, in the museum space, of a small greenhouse in which various fruits and vegetables will be housed and revitalized, using various growing techniques, inverting the cycle which has brought them to the supermarket shelves. Plants grown from such life as still remains in pre-packaged vegetables, and from seeds obtained from the completing of the life cycle of such produce, will serve as the vegetable nucleus for a remarkable new garden. (*COB*)

b. 1970, Turin, Italy
b. 1967, Rivoli-Turin, Italy
Live and work in Moncalieri-Turin

Solo Exhibitions
R-Esistenze, Fabio Paris Art Gallery, Brescia, November 22 – December 20, 2003

Group Exhibitions
Chronos – Il tempo nell'arte dall'epoca barocca all'età contemporanea, CeSAC - Centro Sperimentale per le Arti Contemporanee – Il Filatoio, Caraglio-Cuneo, May 28 – October 9, 2005
Arte nell'era Global. How Latitudes Become Forms, Fondazione Sandretto Re Rebaudengo, Turin, June 6 – September 7, 2003

Bibliography
L. Fassi, in *Chronos – Il tempo nell'arte dall'epoca barocca all'età contemporanea*, CeSAC - Centro Sperimentale per le Arti Contemporanee / Marcovaldo, Caraglio-Cuneo, 2005, pp. 456-457
M. Scotini, *Empowerment / Cantiere Italia*, Museo d'Arte Contemporanea di Villa Croce, Genova; Silvana Editoriale, Cinisello Balsamo-Milan, 2004, pp. 161, 166, 167

p. 217: *E.S.C.U.L.E.N.T.A Lazzaro*, Action for the revitalization of cultivated vegetable organisms, from 2004
p. 218: *E.S.C.U.L.E.N.T.A*, Joint campaign for the gathering and consumption of foodstuffs from natural materials, from 2002
p. 219: *MP_Materie Prime_Sativa – 1.Cerealia*, 2005

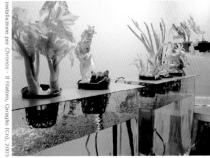

CAAT Mercati generali, Grugliasco (To), 2004

Installazione per Chronos - Il Filatoio, Caraglio (Cn), 2005

Apium graveolens var. rapaleum (sedano rapa)

Allium sativum (aglio)

...radiciola (ravanello)

Raphanus sativus...

QUISTO > RIVITALIZZAZIONE > MESSA A DIMORA > RICRESCITA > FIORITURA > FRUTTIFICAZIONE

TA ORTAGGI RIVITALIZZATI

IACEAE
m graveolens var. *dulce* (sedano)
 var. *rapaleum* (sedano-rapa)
iculum vulgare subsp. *vulgare* var. *azoricum* (finocchio)
cus carota subsp. *sativus* (carota)
ERACEAE
orium intybus (cicoria) var. *foliosum* (catalogna)
cchio rosso di Verona
cchio rosso di Treviso
ria belga
uca sativa (lattuga) var. *longifolia* (lattuga romana)
ASSICACEAE
hanus sativus var. *radicicula* (ravanello)
ssica rapa var. *rapa* (rapa)
ssica oleracea (cavolo)
ar. *capitata* var. *alba* e *rubra* (cavolo cappuccio bianco e rosso,
 sabauda (cavolo verza)
bullata, sottovar. *gommifera,* (cavolini di Bruxelles)
OMELIACEAE
nas comosus (ananas)
NVOLVULACEAE
nea batatas (patata dolce)
UMINOSAE
cine max (soia)
IACEAE
m cepa var. *cepa* (cipolla)
lla rossa di Tropea
olla gialla
olla bianca
um ascalonicum (scalogno)
um sativum (aglio)
m ampeloprasum var. *porrum* (porro)
cari comosum (lampascione o cipollaccio)
LANACEAE
num tuberosum (patata)
GIBERACEAE
iber officinale (zenzero)

Cichorium intybus (cicoria) var. foliosum (radicchio rosso di Verona)

Cichorium Intybus (cicoria) var. foliosum (cicoria)

Brassica oleracea convar. capitata var. alba (cavolo cappuccio bianco)

Allium ampeloprasum var. porrum (porro)

LISTA DEI MATERIALI NATURALI RACCOLTI

Acqua di fonte; Acqua di mare; *Ajuga reptans*: cime; *Alchemilla vulgaris*: foglie; *Alliaria officinalis*: foglie; *Allium schoenoprasum*: foglie; *Allium ursinum*: foglie; *Allium vineale*: bulbi; *Arbutus unedo*: frutti; *Arctium lappa*: radici, foglie e piccioli fogliari; *Asparagus tenuifolius*: turioni; *Betula alba*: corteccia interna; *Borrago officinalis*: foglie; *Castanea sativa*:noci; *Chenopodium album*: cime; *Chenopodium bonus-Henricus*: cime; *Cynara cardunculus*: boccioli floreali; *Corylus avellana*: amenti; *Crataegus monogyna*: boccioli floreali; *Equisetum telmateja*: fusti fertili; *Erythronium dens-canis*: bulbi e foglie; *Fagus sylvatica*: gemme e giovani foglie; *Foeniculum vulgare*: foglie; *Fragaria vesca*: radici, frutti e foglie; *Galium mollugo*: cime; *Helianthus tuberosus*: tuberi; *Humulus lupulus*: giovani getti; *Juniperus communis*: bacche; *Hypochoeris radicata*: giovani piante; *Juniperus communis*: bacche; *Knautia arvensis*: foglie; *Lactuca scariola*: giovani piante; *Lamium maculatum*: cime; *Lamium purpureum*: cime; *Laurus nobilis*: foglie; *Melissa officinalis*: foglie; *Mentha arvensis*: cime; *Mentha sp.*: cime; *Morchella rotunda*: corpi fruttiferi; *Muscari atlanticum*: bulbi; *Muscari comosum*: bulbi; *Nasturtium officinale*: foglie; *Ornithogalum umbellatum*: bulbi; *Oxalis acetosella*: foglie; *Papaver rhoeas*: giovani piante; *Papaver rhoeas ssp strigosum*: petali, boccioli; *Parietaria officinalis*: cime; *Petasites hybridus*: piccioli fogliari; *Phragmites communis*: fusti; *Physalis alkekengi*: frutti; *Phyteuma orbiculare*: foglie; *Pinus pinea*: pinoli; *Pistacia lentiscus*: rametto; *Plantago lanceolata*: foglie; *Polygonatum multiflorum*: rizomi; *Polygonum bistorta*: foglie e rizomi; *Polypodus squamosus*: corpi fruttiferi; *Portulaca oleracea*: cime; *Primula vulgaris*: giovani piante; *Prunus cerasifera*: drupe; *Prunus spinosa*: drupe; *Pulmonaria officinalis*: cime; *Quercus ilex*: ghiande; *Quercus rubra*: ghiande; *Robinia pseudoacacia*: fiori e foglie; *Rosa canina*: cinorrodi, foglie e petali; *Rubus fruticosus*: radici, frutti; *Rubus idaeus*: frutti; *Rumex acetosa*: cime; *Rumex crispus*: foglie, frutti; *Ruscus aculeatus*: turrioni; Sale di miniera; Sale marino; *Salvia officinalis*: foglie; *Salvia pratensis*: foglie; *Sambucus nigra*: getti primaverili; *Satureja calamintha*: cime; *Silene vulgaris*: giovani getti; *Spiraea aruncus*: giovani getti;*Taraxacum officinale*: radice e foglie, boccioli floreali; *Thymus serpyllum*: foglie; *Thymus vulgaris*: foglie; *Tragopogon pratensis*: giovani piante; *Trifolium pratense*: foglie e fiori; *Ulmus campestris*: samare; *Urtica dioica*:cime; *Vaccinium myrtillus*:frutti;*Valerianella locusta*: giovani piante; *Viola odorata*: fiori; *Viola canina*: fiori

Menu' cena E.S.C.U.L.E.N.T.A

29 maggio 2003 c/o bu.net - Torino
La cena è stata preparata utilizzando esclusivamente i materiali naturali provenienti dalle azioni di raccolta.
APERITIVO - Decotto di rosa canina e melissa: Cinorrodi di *Rosa canina*, Foglie di *Melissa officinalis*, Acqua di fonte; **ANTIPASTI - Ventaglio di salamole con asparagi spuri:** Salamole: Piccioli fogliari di *Arctium lappa*, Radici di *Arctium lappa*, Steli di *Foeniculum vulgare*, Boccioli floreali di *Cynara cardunculus*, Boccioli floreali di *Taraxacum officinale*, Bulbi di *Muscari comosum*, Giovani getti di *Silene vulgaris*, Bulbi di *Ornithogalum umbellatum*, Giovani getti di *Humulus lupulus*, Gemme di *Fagus sylvatica*, Sale marino, Acqua di fonte; Asparagi spuri: Turioni di *Ruscus aculeatus*, Sale marino, Rametti di *Thymus vulgaris*; **Antipasto di boccioli con salsa di corbezzolo:** Boccioli floreali di *Taraxacum officinale*, Rametti di *Thymus vulgaris*, Pinoli di *Pinus pinea*, Sale marino; Salsa:Bacche di *Arbutus unedo*; **Coppelle di farina di castagne, ghiande, trifoglio e rosa canina, riplene di crema verde:** impasto: Noci di *Castanea sativa*, Ghiande di *Quercus rubra*, Fiori di *Trifolium pratense*, Semi di *Rosa canina*, Sale marino - Ripieno: Giovani getti di *Silene vulgaris*, Giovani getti di *Humulus lupulus*, Cinorrodi di *Rosa canina*, Foglie di *Oxalis acetosella*, Foglie di *Melissa officinalis*, Frutti di Fragaria vesca, Pinoli di *Pinus pinea*, Sale marino; **PRIMI - Minestrone alle erbe pazze:** Foglie di *Pulmonaria officinalis*, Foglie di *Plantago lanceolata*, Foglie di *Taraxacum officinale*, Foglie di *Alliaria officinalis*, Giovani getti di *Silene Vulgaris*, Bulbi di *Allium vineale*, Farina di ghiande di *Quercus rubra*, Farina di tubero di *Helianthus tuberosus*, Farina di rizomi di *Polygonum bistrorta*, Giovani piante di *Primula vulgaris*, Foglie di *Salvia pratensis*, Foglie di *Oxalis acetosella*, Foglie di *Parietaria officinalis*, Giovani cime di *Chenopodium bonus-Henricus*, Sale marino, Acqua di fonte; **Gnocchetti di castagne al sugo di Morchella rotunda selvaggia:** Gnocchetti: Farina di Noci di *Castanea sativa*, Farina di ghiande di *Quercus rubra*, Farina di fiori di *Trifolium pratense*, Farina di semi di *Rosa canina*, Foglie di *Borrago officinalis*, Sale marino, Acqua di fonte; Sugo: *Morchella rotunda*; **SECONDI - Polpette impanate in granella di castagne:** Cime di *Urtica dioica*, Giovani getti di *Humulus lupulus*, Foglie di *Plantago lanceolata*, Farina di ghiande di *Quercus rubra*, **Sette polpette Sette erbe:** Farina di ghiande di *Quercus rubra*, 1. Giovani getti di *Silene vulgaris*, 2.Foglie di *Polygonum bistrorta*, 3.Cime di *Urtica dioica*, 4.Cime di *Lamium purpureum*, 5.Foglie di *Plantago lanceolata*, 6.Cime di *Ajuga reptans*, 7.Cime di *Parietaria officinalis* e

di *Pulmonaria officinalis*, Sale marino; **Giovani turioni alla besciamella di topinambur e ghiande:** Fusti fertili di *Equisetum telmateja*, Turioni di *Ruscus aculeatus*, Giovani getti di *Sambucus nigra*, Giovani getti di *Spirea aruncus*, Besciamella: Farina di ghiande di *Quercus rubra*, Farina di tuberi di *Helianthus tuberosus*, Sale marino; **Salsa Cren:** Radice di *Armoracia rusticana*, Farina di *Betula alba* (corteccia interna), "Pan grattato" proveniente da pani di castagne trifoglio e ghiande, Sale marino; **Salsa verde all'aglio:** Bulbi di *Allium vineale*, Cime di *Chenopodium bonus-Henricus*, Sale marino, **Salsa di crescione:** *Nasturtium officinale*, *Taraxacum officinale*, Sale marino; **Salsa fresc...** *Borrago officinalis*, *Melissa offici...* *Oxalis acetosella*, Sale marino; **DO...** **Fragoline di Bosco con fr...** **acetosella:** Frutti di *Frag...* Foglie di *Oxalis acetose...* **pura castagna con ...** **e fragoline di ...** *Castanea sa...* *Rosa can...* **BEVA...** *Ox...*

[...]

Tri...
di fo...
ghian...
Quercus ... Macin...
radice di *Taraxacum offic...*
fonte.

LUOGHI DI RACCOLTA

Andrate (To); Tre Pisse, Trive...
Varigotti (Sv); Capo San Donato, ...
Ligure (Sv); Pietra Ligure (Sv); Capra...
Zoppa, Finale Ligure (Sv); loc.
Fiascherino, Lerici (Sp); Bex (Svizzera);
Salina di Pedra di Lume, Isla di Sal,
Capoverde; fraz. Reviglasco, Moncalieri
(To); Issiglio, Val Savenca (To); Inverso,
Val Chiusella (To); Avigliana (To);
Bobbio Pellice (To); Lago Coniglio, Ivrea
(To); Alice Superiore (To); Eremo di
Pecetto (To); Pragelato (To);
Guardavalle Superiore (Cz); Candia
(To); Giave (Ss); rione Bonacina, Lecco;
Ala di Stura (To); fraz. Testona e zona
Colle delle Maddalena, Moncalieri (To);
Caselette (To); loc. La Verna, Cumiana
(To); Sampeyre (To); Valle Varaita;
Golfo Aranci (Ss); Celle (To); Giaveno
(To); La Loggia (To); Piane di Barbato
Trivero, (Bi); Bertesseno (To); fraz. Tetti
Rolle, Moncalieri (To); Chiaverano (To);
Cascinette (To); Noli Ligure (Sv); S.
Teresa di Gallura (Ss); Mondrone (To);
Valli di Lanzo (To); Rosta (To);
Torninparte (Aq), Colle Santa Maria,
Colli Euganei (PD); Monte Calvario, Friuli
Venezia-Giulia; Malesco, Val Loana
(Vb); Parco delle Vallere, Moncalieri (To)

w w w . e s c u l e n t a . o r g
contatti: Info@esculenta.org

E.S.C.U.L.E.N.T.A: *raccolta di materiali naturali, pulitura e traformazione, preparazione della Cena ESCULENTA c/o bu.net, Torino 29-05-2003*

SATIVA - 1.Cerealia, 2005 installazione c/o Munlab Ecomuseo dell'Argilla di Cambiano (To): 3.100 mattoni, telo di juta, terriccio, 17 specie di cereali in fase di crescita, dimensioni 700 x 400 x 80 cm; performance: mietitura, spremitura e offerta al pubblico di succo di cereali

foto di Simone Perolari

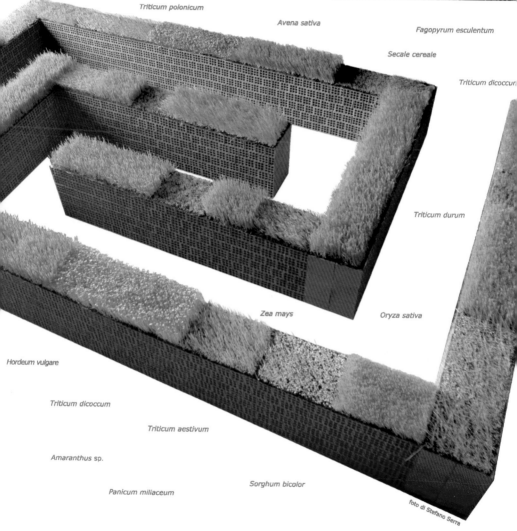

Triticum polonicum

Avena sativa

Fagopyrum esculentum

Secale cereale

Triticum dicoccur

Triticum durum

Zea mays

Oryza sativa

Hordeum vulgare

Triticum dicoccum

Triticum aestivum

Amaranthus sp.

Sorghum bicolor

Panicum miliaceum

foto di Stefano Serra

Alessandro Ceresoli's work is based on various techniques, from photography to drawing and sculpture. *KKK* (an abbreviation of *King Kong Park*, 2005 – in progress) presents a permanently unfinished sculptural space, which changes and grows with each new show and exhibition venue. It is a large, complex, monochrome white structure made of expanded polyurethane, from which animals, objects and the outlines of plants emerge: a room-sculpture created through the assemblage of already existing parts with new components created in each new space and added to it. Highly evocative and dreamlike, it is reminiscent of some imaginary prehistoric cave, where silhouettes of creatures coexist with abstract geometric forms. (*IB*)

b. 1975, Romano di Lombardia-Bergamo, Italy
Lives and works in Berlin

Solo Exhibitions
Geminemuse, Castello Sforzesco, Milan, November 8, 2003 – February 11, 2004

Group Exhibitions
Ticker 9 / Ticker 10, Galerie Carlier | Gebauer, Berlin, July 15 – 23, 2005; July 28 – August 6, 2005
Exit. Nuove geografie della creatività italiana, Fondazione Sandretto Re Rebaudengo, Turin, September 21, 2002 – January 6, 2003

Bibliography
C. Piccoli, *Alessandro Ceresoli*, in *Young Artists in Italy at the Turn of the Millennium. Behind and Beyond the Italian Studio Program at P.S.1/MoMA*, Charta, Milan, 2005, pp. 72-75
F. Bonami, *Alessandro Ceresoli*, in *Exit. Nuove geografie della creatività italiana*, Fondazione Sandretto Re Rebaudengo, Turin; Piccola biblioteca Oscar Mondadori, Milan, 2002, pp. 62-63

pp. 221-223: Project for the *TI* catalog

king kong park

www.infokkk.net

Paolo Chiasera uses video, installation, painting and photography to give an account of the myths and contradictions in contemporary culture. This is exemplified by the ongoing Tupac Project, begun in 2005, a monument to the black panther Tupac Amaru Shaker. Here the artist has placed a hyper-realistic statue, 6.5 metres high, in front of the new MARTa Herford Museum, designed by Frank Gehry, in Herford, Germany. The project is continued through a website, www.tupacproject.it, where Chiasera brings together the hip-hop community, young people at large, and the contemporary art audience. Chiasera presents two photographs of the statue, documenting its installation in Herford, as well as its illegal siting in Bologna on via Libia, an important rallying point for Italy's hip-hop culture. This work reflects on the figure of the contemporary hero, and on the possible transformations of the public monument. (*MVM*)

b. 1978, Bologna, Italy
Lives and works in Bologna

Solo Exhibitions
YDV – Young Dictators' Village, W139, Amsterdam, June 25 – August 21, 2005
20' Livello, GAM Galleria Civica d'Arte Moderna e Contemporanea, Turin, February 8 – April 7, 2002

Group Exhibitions
Il bianco e altro e comunque arte, Palazzo Cavour, Turin, October 21, 2005 – January 22, 2006
(my private) HEROES, MARTa Herford Museum, Herford, May 7 – August 21, 2005

Bibliography
M. Beccaria, *Dangerous Liaisons / Gevaarlijke Liefdes*, in *Forse Italia. Nicoletta Agostini/Paolo Chiasera/Lara Favaretto/Daniele Puppi/Pietro Roccasalva/Corrado Sassi/Donatella Spaziani*, S.M.A.K. Stedelijk Museum voor Actuele Kunst, Gent, 2003
H. U. Obrist, P. Chiasera, "Coup de Cœur, Torino," *Domus*, No. 883, Milan, July-August 2000, p. 17

pp. 225-227: Project by Paolo Chiasera, sculpture by Leonardo Fornito, web site by Enrico Parente, coordination and production by Luca Fontana, photo by Ela Bialkowska
Courtesy MARTa Herford Museum, Herford; Galleria Massimo Minini, Brescia

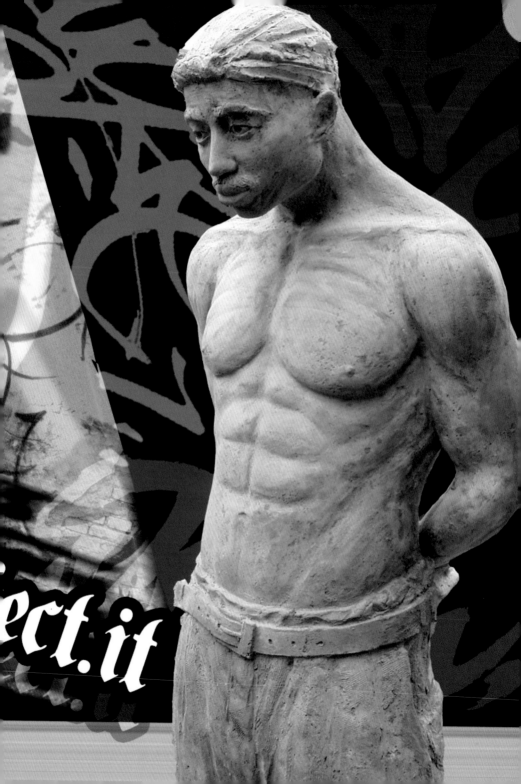

Choi Hochul is a university professor who lectures in the art of the comic strip as well as being one of the most important painters in Korea, which, since the Nineties, has been strongly influenced by comics.

Choi Hochul studied the history of western painting, but soon realized that if he wished to speak for his own culture, he would have to find an expressive form nearer his own world – and this he found in the aesthetic of the comic strip. This led him to create large comic strips representing life in Korea's big cities. *The Ground We Are Living On* (2000) portrays life in a district of Seoul, Daldogne (literally, lunar village), so-called because its inhabitants return from work only when the moon has already risen. Situated on a hill facing the modern city, Daldogne was destroyed after the 1988 Olympics because it was seen as a symbol of urban poverty worsened by industrialization. This outwardly cheerful painting, which in fact contains a hard-hitting social comment on recent Korean history, portrays a vanished world in which people were perhaps poor, but happy. (*IB*)

b. 1965, Tokyo, Japan
Lives and works in Seoul

Solo Exhibitions
Choi Hochul, Seo Nam Art Museum, Seoul, March 2000

Group Exhibitions
AniMate. ANIME in Japanese and Korean Contemporary Art, Fukuoka Asian Art Museum, Fukuoka, February 3 – March 29, 2005
P_A_U_S_E, The 4th Kwangju Biennale, Kwangju, March 29 – June 29, 2002

Bibliography
Choi Hochul, *Korea Fantasy*, in *Comic for Foreign Workers*, Seoul, March 2003
Choi Hochul, *I am All Right*, in *2002 Children Book*, Seoul, November 2002

p. 229: *Labor's Day*, 1995
pp. 230-231: *The Ground We Are Living On*, 2000, courtesy Seoul Museum of Art, Seoul

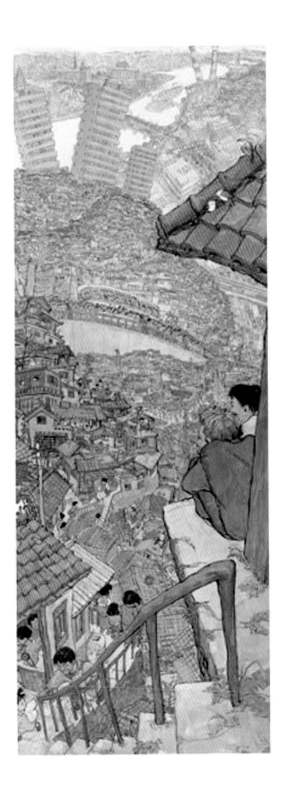

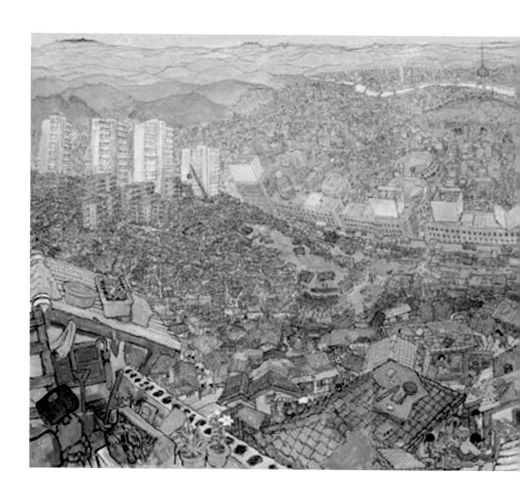

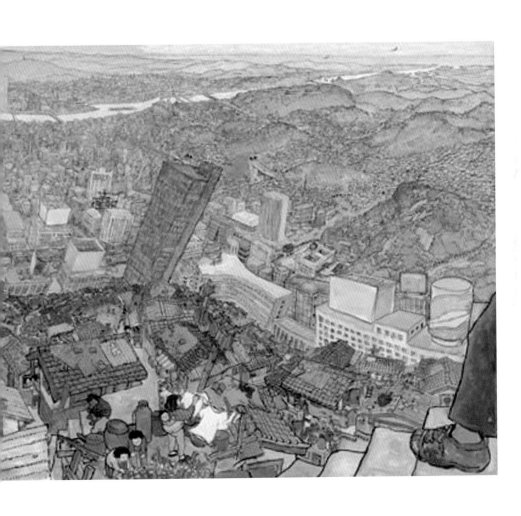

Formed in Milan in 2003, CIBOH is a group made up of Silvia Barna, Natascia Fenoglio and Alessandra Pallotta, three creative artists from the world of fashion, design and the visual arts. In the autumn of 2005 CIBOH opened a space functioning as a workshop, show-room and meeting place for anyone wishing to experience their "life style." The areas covered by CIBOH are fashion and "food architecture," the design of objects linked to food's multifarious manifestations. From Utopian projects to the craft-based production of objects of fashion and design, CIBOH stages events bringing together research into food and considerations of social life styles linked to eating habits. The group does not merely devise creative packaging or unlikely cooking utensils, but also uses food as a sculptural material for the making of edible objects. Its ironic performances are characterized by a bricolage-pop aesthetic, whose sparkling artificiality masks the use of natural substances and ingredients. (IB)

b. 1975, Milan, Italy
b. 1973, Imperia, Italy
b. 1980, Pescara, Italy
Live and work in Milan

Solo Exhibitions
Microclima: CIBOH, Spazio Lima, Milan, February 27, 2004

Group Exhibitions
TIP. Tendenze Idee Progetti, Fondazione Sandretto Re Rebaudengo, Guarene d'Alba-Cuneo and Turin, July 1 – 4, 2004
Dressing ourselves, La Triennale, Milan, January 17 – March 20, 2005

Bibliography
L. Cerizza, Patrick Tuttofuoco / Ciboh, in Dressing Ourselves, La Triennale di Milano / Charta, Milan 2005, pp. 74-75; 115; 110-111
M. Moretti, "Life Style - Belli da mangiare," Marie Claire, No. 9, Milan, September 2005, p. 611

p. 233: Cry Baby, Tokyo, August 2005
pp. 234-235: Biru Snack Dance, Tokyo, August 2005
Drawings by Natascia Fenoglio

Abraham Cruzvillegas creates imaginative installations, whose arrangement and display he transforms according to the site. *Horizontes* (*Horizons*, 2005) is made up of over 400 assorted objects, including a fridge, a teddy bear, a newborn baby's shoe, a man's wedding suit, a shark's jawbone, bits of tortoiseshell, a trombone, golf balls and other items he has collected and housed in his studio in Mexico City. Half of each object is painted in bright, glossy pink enamel, and the other in dull green, the colors of Mangueira in Rio de Janeiro. As in a three-dimensional mosaic, the components are laid out on the floor in a progressively widening spiral with the green half always facing the centre running through several rooms like a wave. (*IB*)

b. 1968, Mexico City, Mexico
Lives and works in Mexico City

Solo Exhibitions
PERSPECTIVES 139: Abraham Cruzvillegas, Contemporary Arts Museum, Houston, October 24, 2003 – January 3, 2004
Abraham Cruzvillegas, MARCO Museo de Arte Contemporáneo de Monterrey, Monterrey, March 11 – July 3, 2004

Group Exhibitions
Universal Experience: Art, Life, and the Tourist's Eye, Museum of Contemporary Art, Chicago, February 12 – June 5, 2005
The Everyday Altered. Dreams and Conflicts. The Dictatorship of the Viewer, L Esposizione Internazionale d'Arte. La Biennale di Venezia, Arsenale, Venice, June 15 – November 2, 2003

Bibliography
S. Gómez, "Extractos de una charla con Abraham Cruzvillegas," *TRAFICO*, Vol. I, No. 3, Mexico City, February-March 2005, pp. 2-8
P. Morsiani, *Perspectives 139: Abraham Cruzvillegas*, Contemporary Arts Museum, Houston, 2003, pp. 3-21

pp. 237-239: *Patriotismo* (*Patriotism*), 2004

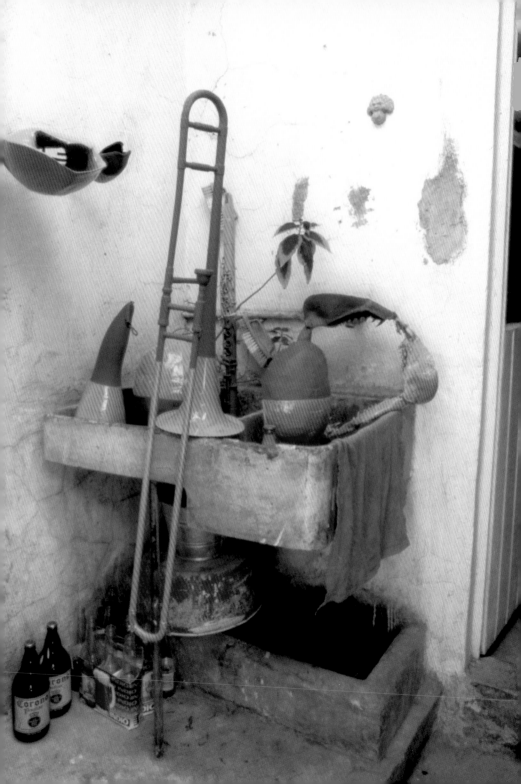

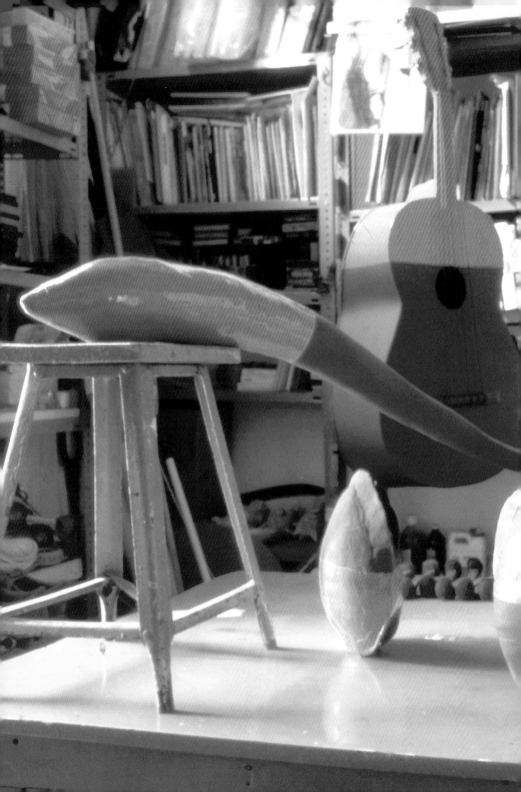

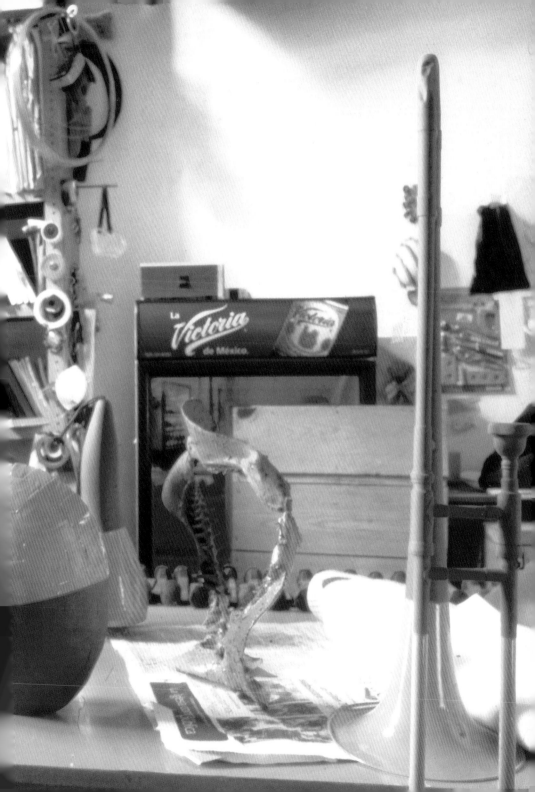

In his repeated transformations, Roberto Cuoghi often goes beyond the traditional limits of the art object to enter the dimensions of lived experience, engaging in humorous reflections on the whys and wherefores, whether real or supposed, of his role as a young contemporary artist. Working directly on his own body – making it look older, then younger again, fatter, then thinner – or on collective icons, from strip-cartoon characters to pictures of VIPS from the art world, Cuoghi reflects on the absurd self-referentiality of all closed systems, collapsing the idea of individuality and coherence in order to explore the hybrid world of intermediary states of knowledge. For this exhibition, the artist has created a new sound artwork based on invented songs and lyrics, *Mbube* (2005). (*AV*)

b. 1973, Modena, Italy
Lives and works in Milan

Solo Exhibitions
Roberto Cuoghi, The Wrong Gallery, New York, March 8, 2005
2003 – Galleria Massimo De Carlo, Milano, I, Galleria Massimo De Carlo, Milan, September 29 – October 29, 2003

Group Exhibitions
I Still Believe in Miracles: Dessins sans papier, ARC Musée d'Art Moderne de la Ville de Paris, Paris, April 7 – May 7, 2005
Vernice. Sentieri della giovane pittura italiana, Villa Manin Centro d'Arte Contemporanea, Passariano-Udine, May 30 – November 7, 2004

Bibliography
A. M. Gingeras, "Roberto Cuoghi," *Artforum*, Vol. XLIII, No. 10, New York, Summer 2005, pp. 316-317
M. Falconer, "Like Father, Like Son," *G2* suppl. *The Guardian*, London, June 29, 2005, p. 10

pp. 241-243: Project for the *T1* catalog

Oskar Dawicki creates performances, video-performances and audio and video installations. Since his aim is to "dissolve art into life," he is ambivalent about his own artistic creations, and adopts an "anti-art" attitude. The use of irony makes it possible to create situations that prove critical to the art system. Dressed in his trademark spangled blue jacket, Dawicki explores the various aspects of performance, from the physical, psychological and theatrical, to those connected to language, the technique of the video, context and the identity of the artist. (*RP*)

b. 1971, Hel, Poland
Lives and works in Warsaw

Solo Exhibitions
Ten Years of Painting, Bunkier Sztuki Gallery, Krakow, January 28 – March 6, 2005

Group Exhibitions
PRAGUE BIENNALE 2. Expanded Painting and Acción Directa, Karlin Hall, Prague, May 26 – September 15, 2005
Under the White and Red Flag. The New Art from Poland, Estonian Art Museum, Tallinn, January 13 – February 15, 2004; CAC Contemporary Art Center, Vilnius; March 19 – May 2, 2004

Bibliography
K. Jagodzińska, M. Ujima, *Dziesięciolecie malarstwa / Ten Years od Painting. Oskar Dawicki*, Galerie Bunkier Sztuki, Warsaw, 2005

pp. 245-247: Project for the *T1* catalog

Hole - Souvenir of Warsaw

MASSIMILIANO E GIANLUCA DE SERIO

The short films made by the De Serio twins bring cinematographic research to bear on a carefully considered choice of subject, often that of immigration and social integration and of identity in contemporary society. The fact that they are documentaries gives added intensity to the stories, which are narrated simply and incisively. By recreating examples of true stories of uprooting, exploitation, loss of all frames of reference and the need to adapt, these works lay bare the difficulties encountered by immigrants, but also the fragility of the host country. (*RP*)

b. 1978, Turin, Italy
Live and work in Turin

Festivals and Awards
Ludwigsburg European Short Film Biennale, Best European Movie 2004-2005 (*Mio Fratello Yang*, 2004), Ludwigsburg-Stuttgart, September 12-18, 2005
Torino Film Festival 2004 - Premio Kodak European Showcase, Best Italian Movie and Special Mention of the Jury (*Mio Fratello Yang*, 2004), Turin, November 12 – 20, 2004

Group Exhibitions
Making Movies, Galleria Francosoffiantino, Turin, September 23 – November 9, 2004
TIP. Tendenze Idee Progetti, Fondazione Sandretto Re Rebaudengo, Guarene d'Alba, Cuneo - Turin, July 1 – 4, 2004

Bibliography
E. Marcheschi, "Corti del contemporaneo," *Il Manifesto*, Rome, May 28, 2005, p. 15
A. Hérran, "Maria Jesus se llevò el Danzante," *Diario de AltoAragòn*, Huesca, June 20, 2004, p. 29
D. Turrini, "Maria Jesus a Torino," *Liberazione*, Rome, November 22, 2003, p. 19

pp. 249-251: *Intervista #1#2* (*Interview #1#2*), 2005

Twin De Serio #1

Massimiliano's questions to Gianluca

1. Do you feel that by now our relationship is almost exclusively linked to our films?
2. What are the terms of our agreement? How important is disagreement?
3. Do you think that making films has brought us closer together?
4. In our work, what do you mean by 'collective', and what by 'personal'?
5. What meaning do you give to the term 'sharing'?
6. Why do you almost always use the same crew?
7. Does working with the same crew mean building a community?
8. Can the filmed image - or the process that goes into it - establish some relationship between different worlds and different identities?
9. How much does your own enviroment count in your films?
10. What do you mean by 'setting' or enviroment, in cinema?
11. Why did you choose cinema as your expressive medium?
12. Did you choose cinema as your expressive medium?
13. What does it mean to make independent films?
14. What importance does the story (or the telling of a personal story) have in your films?
15. Is there an autobiographical element in your work? Or in your actors' work?
16. Which of these terms would you use to describe the conclusions of your films: liberation/denunciation/ information/contact/catharsis/ recollection?
17. Do you think that there is a lack of representation of stories related to clandestine life, of loss of civil and human rights, of identity crises in the contemporary world?
18. Can the film tell the story of what is invisible?
19. Is clandestinity a pretext for telling other stories?
20. Can a film free one's head, free one's soul?
21. What is the soul?

Twin De Serio #2

Gianluca's questions to Massimiliano

1. Do you regard me as your main viewer, your other half, or a collaborator?
2. Don't you feel that shooting a film is really just like looking around yourself?
3. Would you make films without me?
4. What sort of films would you make if you were to work on your own? Would you make the same things?
5. Do you think that working as a couple, with me, counts as collective work?
6. How do you reconcile the collective work of the crew with your own personal expressive needs?
7. Is the end product the result of renunciation, of compromise, or of a process of multiplication?
8. Do you remember that dream we both had the same night, when we were little, about driving the car together?
9. What part does memory play in your films?
10. What particularly connects you to the outskirts of Turin?
11. Do you feel they might represent the genuine stirring of a city which is changing, or are they just one detail among many, illustrating its contradictions, fears, crises - and beauty?
12. Do you think the space we live in has something ritualistic, intimate and collective about it?
13. Why do the titles of your films all have something to do with a sense of religion?
14. Why is Maria Jesus's body 'divided', lost, in its 'moments of crisis' as you say?
15. Why does the last sequence in all your films include some very minor event that transforms or brings out the naturalness of the story as a whole?
16. What, for you, is the meaning of a close-up?
17. And of a camera car?
18. Are you more interested in people's actions, or their gestures?
19. What image would you use to convey the idea of responsibility?
20. Why is making a film, as you say, an act of love? Is it not rather an act of violation?
21. What is love?

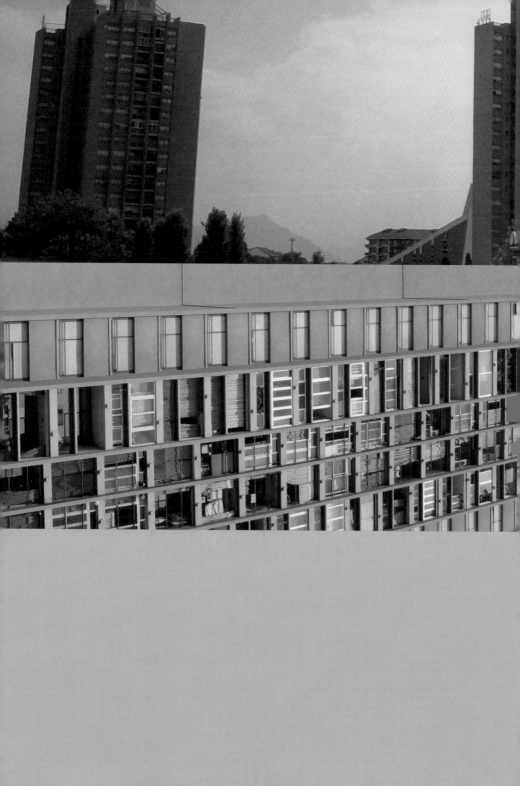

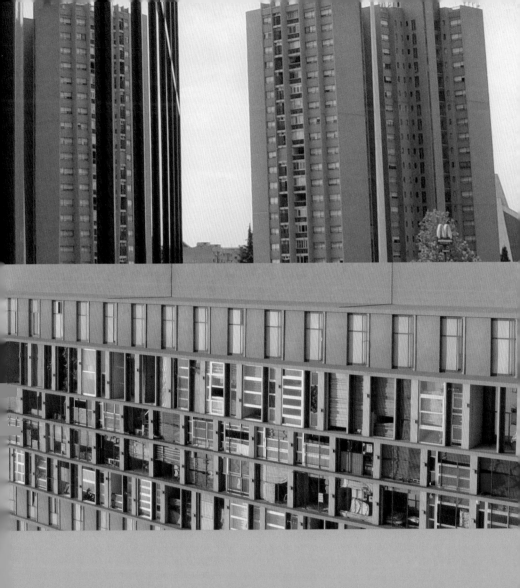

Few Things

Sebastián Díaz Morales creates dream-like atmospheres, in an extreme observation of the difficulties inherent in human action. Often set in Patagonia, his homeland, his videos and video installations present characters in enigmatic and metaphorical situations, sometimes with narrative, sometimes without. The artist sets out to concentrate on a socio-political idea through metaphor and the filtered images, often blurring the boundaries of language. *In a Not So Distant Future* (2003) presents six videos in which the characters, buffeted by a high wind and estranged from the deserted landscape around them, carry out surreal repeated actions, trying to show a future in which human kind is left without any belongings; *Aguante las piedras* (*Seize the Stones*, 2005) is an animated picture illustrating an untranslatable Argentinean expression, "Aguante las piedras," indicating that one is confronting a difficult situation in a constructive way. *Lucharemos hasta anular la ley* (*We Shall Fight Until We Abolish the Law*, 2004) presents the almost abstract silhouettes of a crowd attacking an entrance door, the mood evoking that of a dream – indeed a nightmare or fantasy or possible revolt. (*RP*)

b. 1975, Comodoro Rivadavia, Argentina
Lives and works in Amsterdam and Comodoro Rivadavia

Solo Exhibitions
Sebastián Díaz Morales. Dependencia, attitudes espace d'arts contemporains, Geneva, November 11 – December 17, 2005
In A Not So Distant Future, Stedelijk Museum Bureau, Amsterdam, November 2 – December 31, 2003

Group Exhibitions
Dedicated to a Proposition, Extra City, Antwerpen, November 20 – February 19, 2005
Why if not we...? Surfacing, Ludwig Museum, Budapest, September 16 – October 24, 2004

Bibliography
W. Peeters, *In A Not So Distant Future*, Newsletter n. 77, Stedelijk Museum Bureau, Amsterdam, 2003
C. Medina, "Memorias Letales," *Arco Panorama '04*, Madrid, 2004, p. 2

p. 253: Poem by Pulgarcito, 1997
pp. 254-255: *Untitled*, 2005
Courtesy the artist

IN MY IMAGINATION THE PANIC ASSAULTS ME.
WHERE TO GO? WHERE?
THE PANIC ASSAULTS ME.
SOCIETY, CIVILIZATION, WORLD: THE CAPITAL, THE RELIGION, THE WORK.
WHERE WILL BE A PLACE FOR ME?
IN THAT SOCIETY, IN THAT CIVILIZATION, IN THAT WORLD; WHAT PLACE
 WILL REMAIN, ON EARTH, FOR ME?
IN ONE PLACE, UNITED, THE CAPITALIST MEN OF THE WORLD,
 THE RELIGIOUS MEN OF THE WORLD,
 THE WORKING MEN OF THE WORLD.

HOW CAN THESE LAST THREE LINES BE WRITTEN?
IN ONE PLACE UNITED
THE CAPITALIST MEN, THE RELIGIOUS MEN, THE WORKING MEN.
THE MEN OF THE WORLD ALL UNITED IN ONE SINGLE LINE.
WHERE? WHERE TO FLEE?
WHERE TO FEEL? WHERE TO LIVE? WHERE TO DO? WHERE TO BE?
WHERE?
WHAT PLACE WILL REMAIN ON EARTH TO BE?
IN MY IMAGINATION, UNITED, IN ONE PLACE, THE CAPITALIST MEN,
 THE RELIGIOUS MEN, THE WORKING MEN,
 WILL BUILD A SOCIETY, A CIVILIZATION, A WORLD.

WHERE? WHERE TO FLEE?
 UNITED, IN ONE PLACE, THEY WILL BE THE POWER.
 OF A SINGLE SOCIETY, A SINGLE CIVILIZATION,
 A SINLGE WORLD.

WHERE? WHERE TO FLEE?
IN THE PANIC THAT REACHES ME, WHERE TO FLEE?

Pulgarcito

Rä di Martino's works are parodies of narratives constantly proffered by the media. *The Dancing Kid* (2005) is a double video-installation telling of the adventures of a young cowboy. The choice of the Californian desert projects the public into the landscape of the Wild West. The protagonist, Johnny, reinterprets various scenes from Nicholas Ray's famous film *Johnny Guitar* (1956). The work is a montage of these individual sketches, fragments showing the cowboy engaged in everyday activities such as cleaning his teeth, sleeping or throwing himself into absurd actions such as swimming in sand or pretending to shoot. A prisoner of his own imaginary world, Johnny engages in dialog with a black jacket hanging on a stick, a stand-in for his rival Dancing Kid. At the end of the work Johnny puts on the jacket, thus confirming his complete identification with the "enemy." (*IB*)

b. 1975, Rome, Italy
Lives and works in New York

Solo Exhibitions
Rä di Martino, Galleria monitor video&contemporary art, Rome, April 4 – May 21, 2005
Rä di Martino, Galleria monitor video&contemporary art, Rome, October 20 – November 30, 2003

Group Exhibitions
Premio Furla per l'Arte. V edizione 2005, Villa delle Rose, Bologna, January 29 – April 3, 2005
All Tomorrow's Parties, The Yugoslav Biennial of Young Artists 2004, Galerijia Zvono, Belgrade, Serbia and Montenegro, July 10 – August 11, 2004

Bibliography
R. di Martino, "Self-Portrait/Autoritratto," *Tema Celeste*, No. 105, Milan, September - October 2004, pp. 82-83
C. Canziani, *Rä di Martino*, in *All Tomorrow's Parties. The Yugoslav Biennial of Young Artists*, CCA, Belgrade, 2004, p. 287

pp. 257-259: *The Dancing Kid*, 2005
Courtesy Galleria monitor video&contemporary art, Rome

BRIAN FRIDGE

Brian Fridge is an experimenter, an artist-scientist, an artist-philosopher. His videos, which are silent and unedited, are unstable cosmologies, evoking a range of scales in space and time, yet grounded in a domestic dimension: the swirling of ice crystals and vapor in his freezer or the explosion and implosion of a drop of liquid suggests the cosmic events of outer and inner space. The differences in scale and uncertainty of interpretation suggest a perception of the universe as a single set of ongoing events, in which entropy and regeneration are superimposed and the flux of matter in the flux of duration are brought into a form of simultaneity. (*AV*)

b. 1969, Forth Worth (TX), United States
Lives and works in Dallas

Solo Exhibitions
Brian Fridge, Sheldon Memorial Gallery, Lincoln, April 19 – May 18, 2005
Brian Fridge, ArtPace, San Antonio (TX), March 13 – May 11, 2003

Group Exhibitions
The Random and the Ordered, International Print Center, New York, January 15 – February 28, 2004
Projections: Elemental, Blanton Museum of Art, Austin (TX), February 13 – March 20, 2003

Bibliography
M. L. Anderson, M. Auping et al., *Brian Fridge*, in *Whitney Biennial: 2000 Biennial Exhibition*, Whitney Museum of American Art, New York, 2000, pp. 110-111
L. M. Herbert, *Brian Fridge*, in *Out of the Ordinary: New Art From Texas*, Contemporary Arts Museum, Houston, 2000, pp. 36-43

pp. 261-263: *Sequence 5.1, 5.2*

CHRISTIAN FROSI

Christian Frosi works within an open, changing space with a flow of images that encourage spectators to question what they are seeing. The images and objects he uses are chosen for their residual fascination, capturing the elusive psychological dimension of transformation through slippage and superimposition. *NZ 01* (2005) takes the form of a bench, with a monitor on one end and a glass case on the other. The case contains a fragment of the Mole Antonelliana, a reference that is indirect in formal terms, but concrete and deeply felt as part of the city of Turin. Here its formless and fragmentary presence suggests the idea of building and putting down roots in one specific place. The video, on the other hand, shows a series of fixed shots of the Camargue in France, with various animals visible on its wild, featureless, horizon. The characteristic light and absence of any human presence enable the artist formally to link the marshy landscape with the fragment of the Mole. Frosi frees two places from their natural contexts and brings them together through oblique references. (*IB*)

b. 1977, Milan, Italy
Lives and works in Milan

Solo Exhibitions
Christian Frosi, Isabella Bortolozzi, Berlin, January 22 – March 4, 2005
Christian Frosi, Galleria ZERO, Milan, November 13 – December 20, 2003

Group Exhibitions
Dojo, Via Ventura (Ex Faema), Milan, May 5 – June 10, 2005
We disagree, Andrew Kreps Gallery, New York, January 19 – February 26, 2005

Bibliography
A. Bruciati, *Christian Frosi*, in *TENSIO*, Galleria Comunale d'Arte Contemporanea, Monfalcone, 2003, pp. 32-35
M. Smarrelli, *Intervista a Christian Frosi*, in *Follow Your Shadow: giovani artisti italiani*, Fondazione Querini Stampalia, Venice; Galleria d'Arte Moderna e Contemporanea, Bologna; Charta, Milan, 2005, pp. 60-63, 86-91, 120

pp. 265-267: Project for the *TI* catalog

Ryan Gander's video installation *Is this guilt in you too – (The study of a car in a field)* (2005) plays with the slippage between the world of film and the world that is experienced by its spectator. Entering the installation, the public sees a blank screen, and hears a girl's voice, apparently engaged in dialog with another character. Suddenly a car – motionless, but with its engine running – appears on the screen, having stopped in the middle of a snowy field on a winter morning. As the camera slowly moves down towards the car, the opening sequence of a film is suggested, but just when we would expect the action to begin, the screen goes dark. The narrative events prior or subsequent to this short sequence remain a mystery, as does the fact that the car has made no mark at all upon the snow. *(IB)*

b. 1976, Chester, United Kingdom
Lives and works in London

Solo Exhibitions
Somewhere between 1886 and 2030, Store, London, April 21 – May 28, 2005
The Death of Abbé Faria, Stedelijk Museum Bureau, Amsterdam, March 23 – May 25, 2003

Group Exhibitions
Beck's Futures 2005, ICA Institute of Contemporary Arts, London, March 18 – May 15, 2005
Romantic Detachment, P.S.1 Contemporary Art Center, Long Island City-New York, October 16 – November 7, 2004

Bibliography
M. Beasley, "Ryan Gander," *Frieze*, No. 86, London, October 2004, p. 150
R. Withers, "Ryan Gander – Store," *Artforum*, Vol. XLII, No. 6, New York, February 2004, p. 161

pp. 269-271 : *Selected Works*, 2002-2005: 1. *The Grand National Advertisement*, 2003; 2. *The Boy That Always Looked Up*, 2003; 3. *Portrait of Mary Aurory 1972*, 2002; 4. *It's Like the Spoilt Brat of the Dictionary, but One It'll Never Enter*; 5. *Hergé's realisation that Alph-Art was conceptually flawed, Georges Remi's realisation that Alph-Art was conceptually flawed and Kuifje's realisation that Alph-Art was conceptually flawed*, 2003
Courtesy the artist; STORE, London; Annet Gelink Gallery, Amsterdam

1.

Towards the production of a great work of fiction

THE
GRAND NATIONAL

BY KIERAN AAGARD

A 200-page work of fiction made by a party of 15 writers. The novel will consist of 15 chapters, each one written by a different author. Each author must respond to those chapters previous to their own and, in turn, meet and hand over the manuscript to the subsequent writer. It is not necessary to write an entire chapter; it is also possible to end the previous chapter and begin the next. There is no need to manipulate or change your articulation or style of writing. The diversity of perspectives, pitches and tenses is central to the idea, however the final novel must be viable, meaning all chapters should be written in English and should contain qualities you associate with a good work of fiction. The text must be readable with consistency and continuity of characters, locations and narrative. In terms of its delivery, the final manuscript will be slipped smoothly and silently into the world, in the same way any other young writer would introduce his or her work, copies will be posted to publishing houses with the hope of having an edition printed. The final version will be published as The Grand National *by Kieran Aagard.*

Interested parties should contact: The Grand National, PO BOX 48746, London, E1 8WX.

2.

The Boy Who Always Looked Up
RYAN GANDER

3.

5.

Using salvaged and found materials, the duo GAZEaBOut (Matteo Patrucco and Walter Visentin) construct by improvisation functioning structures which stand erect like genuine contemporary blockhouses; from the top, spectators can let their eyes wander over a tangled heap of garbage. One of their basic aims is to find a suitable place from which to observe the reality that surrounds us; this aim is in fact embedded in the etymology of the word "gazebo," derived from the English "gaze about." These constructions are also islands of "slowness" and are inspired by Schwitters' *merzbau*, structures that offer both a privileged view of contemporary society, and also provide a place for reflecting on the relationship between contemporary society and the individual. (*COB*)

b. 1976, Casale Monferrato, Alessandria, Italy
b. 1969, Turin, Italy
Live and work in Turin

Group Exhibitions
Epi-demia, Palazzo Nuovo, Università degli Studi di Torino, Turin, October 11 – 13, 2004
Luogo: Comune, Artists in Residence (promoted by Kforumvienna), Casale Marittimo-Pisa, May 10-28, 2005

pp. 273-275: *Untitled*

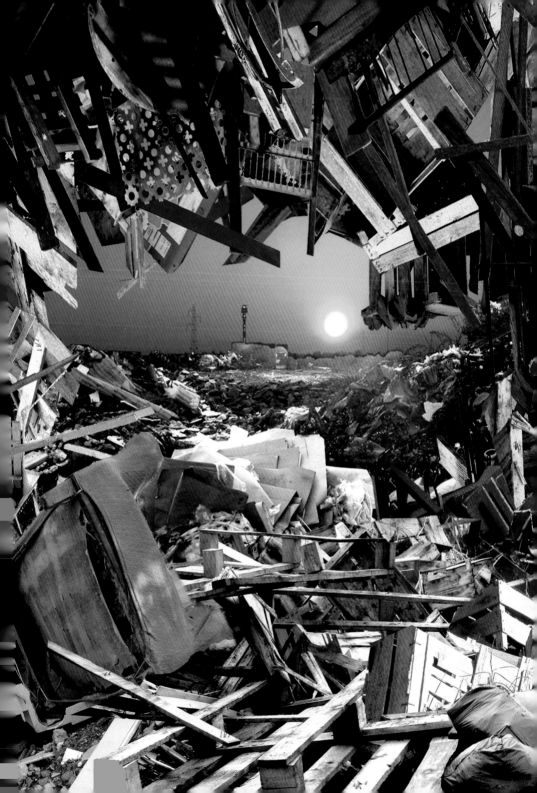

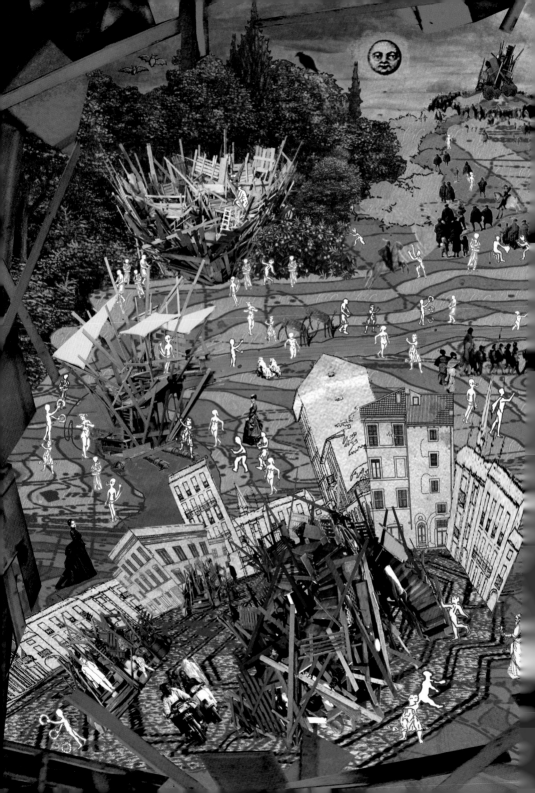

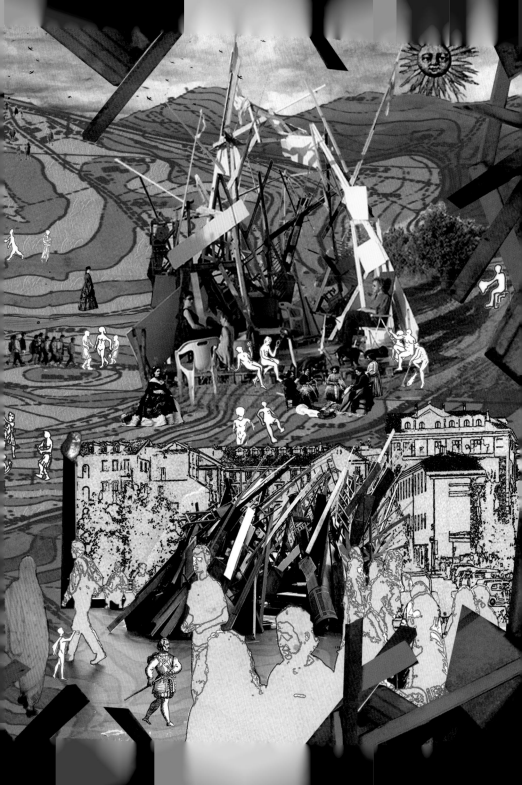

The work of Daniel Guzmán has its origins in the consumer and popular cultures of Mexico, and in the images that can be seen on a daily basis in the streets or in comics. Guzmán uses materials and techniques ranging from drawing to performance, video and sculpture, with particular interest in the world of music and post-punk, to reflect on the way in which we are conditioned by contemporary consumer culture. The installation in the current exhibition is characterized by intense reflection on themes such as these, and is influenced by the "splatter" culture derived from horror movies. Hanging from the ceiling in the exhibition space is a skeleton encased in a house from which various parts of bones stick out, a telling metaphor for the violence of everyday life, characterized by the increasing cannibalism of the individual. (*COB*)

b. 1964, Mexico City, Mexico
Lives and works in Mexico City

Solo Exhibitions
Thieves Like Us, Lombard-Freid Fine Arts, New York, May 1 – June 5, 2004
Hijo de tu Puta Madre (Ya Sé Quien Eres, Te He Estado Observando), kurimanzutto@former
Taquería Saltillo, Mexico City, May 4 – June 15, 2001

Group Exhibitions
Happiness: a survival guide for art and life, Mori Art Museum, Tokyo, October 18 – January 18, 2004
The Everyday Altered. Dreams and Conflicts. The Dictatorship of the Viewer, L Esposizione Internazionale d'Arte. La Biennale di Venezia, Arsenale, Venice, June 15 – November 2, 2003

Bibliography
Armpit for the Mole, Fundación 30km/s, Barcelona, 2005
K. Levin, "The Mexican (Chelsea Remix)," *The Village Voice*, C 74, New York, May 28, 2004

pp. 277-279: *Monsters We Meet*, 2005
Courtesy Kurimanzutto Gallery, Mexico City

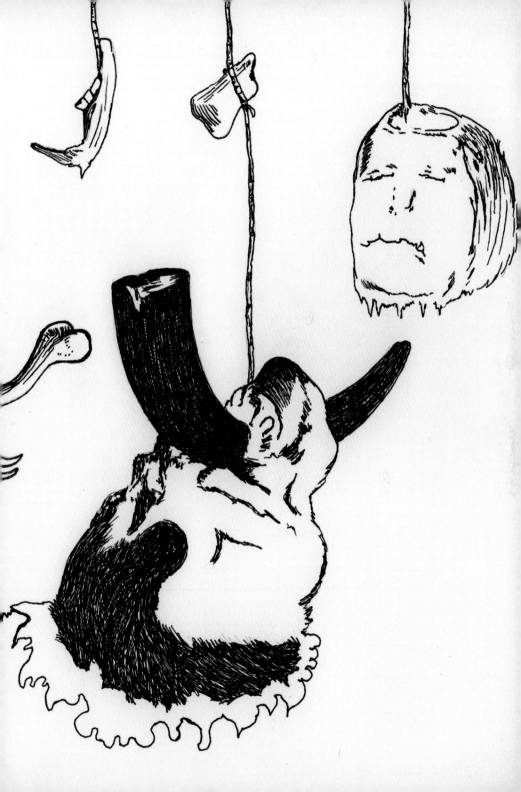

Chala Hadimi's video *Between Prayers* (2001) draws its inspiration from the words of Henri Lefebvre, the French philosopher who claimed that works of architecture create or alter the bodies that inhabit them. The artist, originally from Istanbul, tells of the social life of a mosque between one prayer and another. It is during such intervals of suspended time that the building seems to live through the people who move within it. Spectators have the feeling that they are spying on the intimate life of a building normally closed to tourists, gaining a sense of its complexity through the montage of individual fragments. (*MVM*)

b. 1968, Istanbul, Turkey
Lives and works in Boston and New York

Group Exhibitions
Four by Four, Artists Space, New York, May 7 – June 4, 2005
Group Show, New Works Gallery, Wellington, 1995

Bibliography
Y. Siddiqui, *Four by Four, the Manual. Projected Works by Beatriz Viana Felguerias, Cagla Hadimioglu, Hassan Khan, and Moataz Nasr*, Unpublished Thesis, The Center for Curatorial Studies, Bard College, Annandale-on-Hudson-New York, 2005
C. Hadimi, "Between Prayers: Proscribed Scenes from a Historic Monument," *Thresholds*, No. 25, Boston, Fall 2002, pp. 60-67

pp. 281-283: *Between Prayers*

Between Prayers

by Çağla Hadimi

INT. MOSQUE, YAZD, IRAN – DAY (FLASHBACK)

In a high niche on the *qibla* wall, the tall, erect
figure of a GRANDFATHER CLOCK overlooks the sanc-
tuary like a still sentinel or anachronistic
ghost. TWO OTHER ENTITIES enact a more aggres-
sive guard at ground level, grilled metal masks
slatting their inscrutable gaze. Massive aqua
blue bodies stand on spindly legs fit with
wheels, set for motion but for the electrical
cord that binds each to a wall.

The apparent fierceness of these industrial air-
conditioners belies their dependence: constant-
ly they demand water, and incontinence necessi-
tates the bright plastic buckets between their
legs. Looking again, they resemble nothing more

than apathetic guard-dogs, made torpid by the heat of the afternoon and the energy demands of their industrial innards.

Discretely squatting in a crook of the *iwan,* a plump, pastel green CABINET pullulating with books and pamphlets offers these through glass doors and in loose piles upon its head. Its brood of BOOKS is scattered throughout the mosque. Within niches set into plastered walls they sit with casual perfection, placed there by one with an eye for composition.

WORDS scratched into the plaster crawl upon the surface with a fluidity of movement not afforded the nearby *ALLAHS* imprisoned within a matrix of brick-size units.

CURTAINS congregate in the gallery to the east of the *iwan*, slapping complaints of the wind against carved stucco walls and wooden balustrades. Worked into a sufficient agitation they curl themselves up around their top string. Left in peace they languorously *hang*, sagging toward the ground under their own weight. In the opposite gallery an ample COPPER TEA URN reflects and assembles all activity.

The spaces of the mosque move with the infinite echolalia of MULTIPLE FANS, whose fragile forms strung across the *iwan* resemble frenzied dragonflies captured and hung by malevolent children.

Jeppe Hein's works suspend the physical laws of cause and effect, creating situations in which objects seem to take on a life of their own in the presence of the public. In the work he devised for the garden in front of the Fondazione Sandretto Re Rebaudengo, the artist considers the needs and desires of the people who frequent it. He thus sets about elaborating a "sculptural system" which can reactivate, redefine and characterize this space without altering its particular nature. The light, water and benches of the public park become part of a modular system of sculpture and architecture, whose sculptural "signs" question our normal perception of the place, establishing a direct relationship with the pre-existing structures, transforming the public's movements and creating a space which can trigger off new social interactions. (*IB*)

b. 1974, Copenhagen, Denmark
Lives and works in Berlin

Solo Exhibitions
Jeppe Hein. Invisible Labyrinth, Centre Pompidou, Espace 315, Paris, September 14 – November 14, 2005
Jeppe Hein. Roller Coaster, Dunkers Kulturhus, Helsingborg, June 18 – September 18, 2005

Group Exhibitions
ECSTASY in and about altered states, Museum of Contemporary Art, Los Angeles, October 9, 2005 – February 20, 2006
Connected Presence, Union Gallery, London, September 29 – November 27, 2004

Bibliography
K. Bell, "In the Line of Fire," *Frieze*, No. 81, London, March 2004, pp. 88-91
R. Stange, *The Wall als Welt? Zur künstlerischen Arbeit von Jeppe Hein / The Wall as a World? On the Artistic Work of Jeppe Hein*, in *Jeppe Hein. Take a Walk in the Forest at Sunlight*, Kunstverein Heilbronn, Germany / Snoeck, Köln, 2003

pp. 285-287: *Simplified Mirror Labyrinth*, 2005, installation, Kunstverein Kehdingen
Courtesy Johann König, Berlin

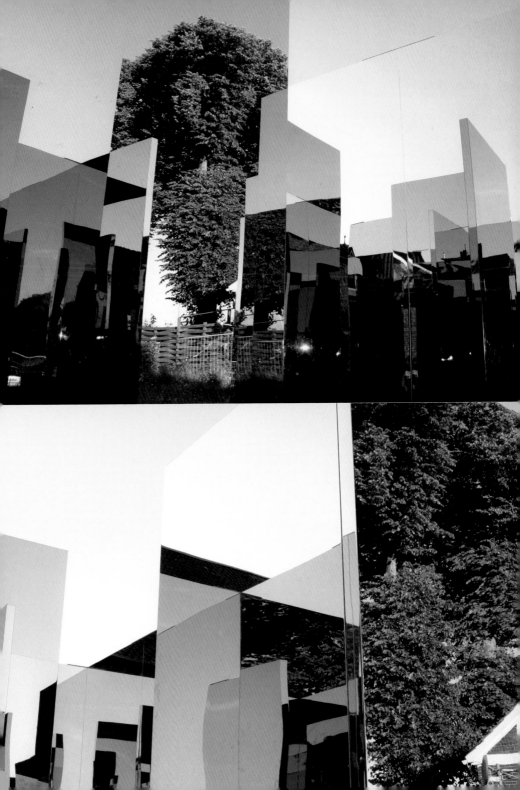

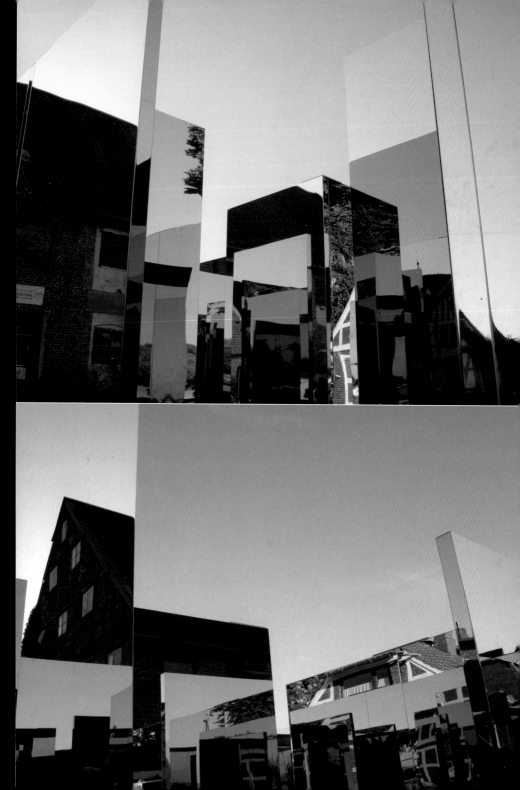

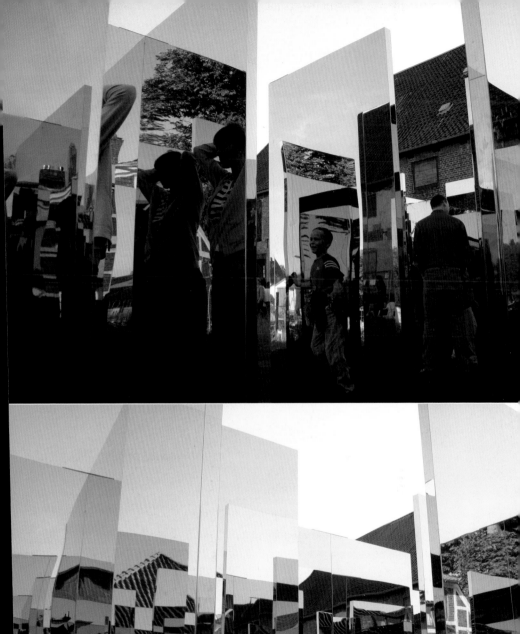
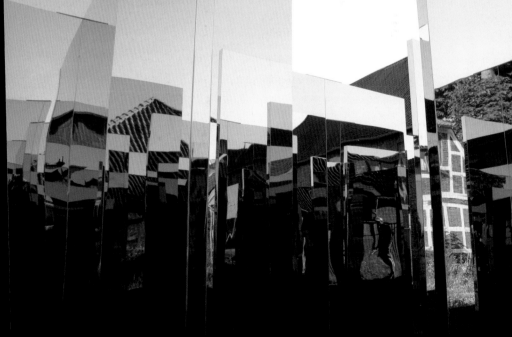

Richard Hughes presents two installations, *Crash My Party You Bastards* (2004) and *I wanna see you sweat* (2005). These works engage in dialogue with one another, summarizing Hughes' thoughts on the slippage between reality and fiction, and on the disorientation caused by the replication of real objects. His work evokes the 'non-places' of the suburbs: by appropriating the various linguistic codes of youth subculture, and fusing them with references from the history of art, he charges the marginalized places of contemporary culture with new meanings. He takes the materials he uses for his sculptural objects from urban refuse, giving his work an apparently unkempt appearance, though in fact the end result is always the fruit of meticulous groundwork. (*MVM*)

b. 1974, Birmingham, United Kingdom
Lives and works in London

Solo Exhibitions
Richard Hughes, The Modern Institute, Glasgow, June 4 – July 15, 2005
The Shelf-Life of Milk, The Showroom, London, October 6 – November 14, 2004

Group Exhibitions
British Art Show 6, BALTIC, Gateshead / Manchester / Nottingham / Bristol, United Kingdom (touring exhibition,) September 24, 2005 – September 17, 2006
Bridge Freezes before Road, Gladstone Gallery, New York, June 24 – August 19, 2005

Bibliography
A. M. Gingeras, "First Take: Richard Hughes," in *Artforum*, vol. XLIII, n. 5, New York, January 2005, pp. 156-157
D. Barrett, "Profile: Richard Hughes," *Art Monthly*, No. 281, London, November 2004, pp. 18-19

p. 289: *Untitled (match)*, 2003
pp. 290-291: *Untitled (flag)*, 2004
Courtesy The Modern Institute, Glasgow

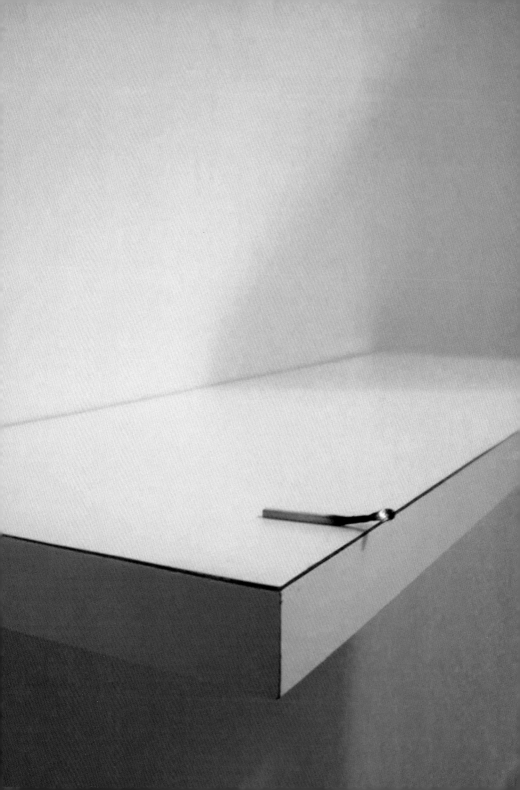

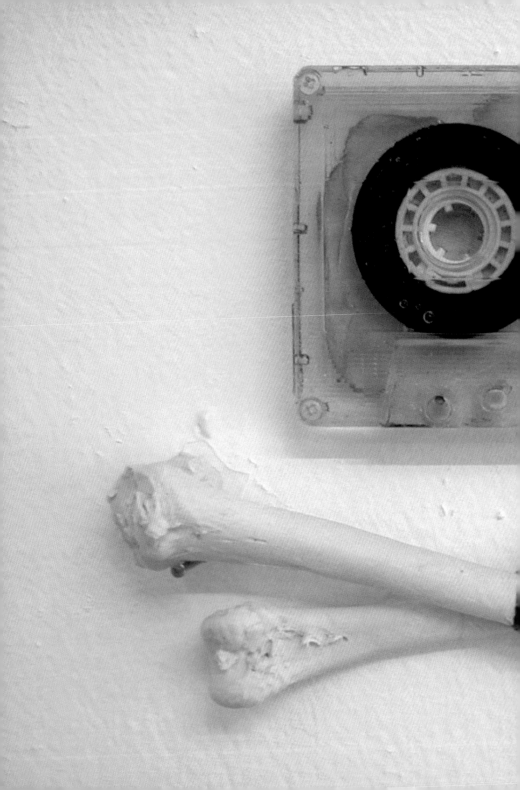

Discovery (Monte Pascoal, Brazil), 2005, consists of an installation with a large photograph lit from above, an effect that recreates the time of the day when Brazil was discovered. Hugonnier went back to the exact point where the Portuguese navigator Pedro Alvares Cabral first saw mainland in 1500. Following the new route to the Indies, Cabral was driven by a hurricane to the coast where he spotted Monte Pascoal, thus discovering Brazil by chance. He first sighted it at night but had to wait for the next morning to confirm what he had seen. By presenting us with Cabral's vision, Hugonnier alludes to those few seconds in history when utopia found ground in reality, when the ideals, beliefs and imagery of the "New World" made their lasting entry into the Western psyche.

b. 1969, Paris, France
Lives and works in London

Solo Exhibitions
Marine Hugonnier, The Center for Curatorial Studies, Bard College, New York, March 6 – 20, 2005
Marine Hugonnier, DCA Dundee Contemporary Arts, Dundee, June 26 – August 8, 2004

Group Exhibitions
British Art Show 6, BALTIC, Gateshead / Manchester / Nottingham / Bristol, United Kingdom (touring exhibition), September 24, 2005 – September 17, 2006
Universal Experience: Art, Life and the Tourist's Eye, MCA Museum of Contemporary Art, Chicago, February 12 – June 5, 2005; Hayward Gallery, London, October 6 – December 11, 2005

Bibliography
S. O'Reilly, *Foreign Correspondences*, in *Modern Painters*, n. 5, London, February 2005, pp. 52-53
Documentary Creations, Kunstmuseum Luzern / Museum of Art Lucerne, 2005, pp. 62-65

pp. 293-295: *The Eiffel Syndrome*, 2005

on
ONIC
tra

er /

tract)

at

I have seen it glowing
everynight.
I have looked at it for
so long that I started
to expect poeple to glitter
in the same way
when midnight comes.
I have been told that I
am not the only one.
If you are one of us,
please contact

Jim@associates.co.uk

THE EIFFEL SYNDROME

Jankowski's artistic projects – which include film, video, photography and actions – combine various media to reflect on the continual superimposition and increasingly blurred boundaries between everyday life and art, reality and invention, the public and private spheres of our lives. In the film *16mm Mystery* (2004) he had himself filmed by the special-effects team The Brothers Strause. In the film, he walks through Los Angeles in the semi-darkness, he sets up a 16 mm projector on a rooftop, while a building collapses in the background. The work alludes to the role played by Hollywood special effects in expressing our innermost urges. (*AV*)

b. 1968, Göttingen, Germany
Lives and works in Berlin and New York

Solo Exhibitions
Everything Fell Together, Des Moines Art Center, Des Moines (IA), June 23 – August 28, 2005
Oops!...I did it again, Centro Galego de Arte Contemporánea, Santiago de Compostela, March 17 – June 12, 2005

Group Exhibitions
Getting Emotional, ICA The Institute of Contemporary Art, Boston, May 18 – September 5, 2005
2002 Whitney Biennial, Whitney Museum of American Art, New York, March 7 – May 26, 2002

Bibliography
B. Arning, J. Fleming et al., *Christian Jankowski: Everything Fell Together*, Des Moines Art Center, Des Moines (IA), 2005
G. Maraniello, *Christian Jankowski*, MACRO Museo d'Arte Contemporanea, Rome; Electa, Milan, 2003

p. 297: *16mm Mystery*, 2004, installation view
pp. 298-299: stills from *16mm Mystery* (*Mistero in 16 mm*)
Photo courtesy Klosterfelde, Berlin; Maccarone Inc., New York

Taking an idea of sculptural space as his starting point, Tom Johnson uses various materials and techniques to make sculptures, videos and performances that range from monologs to dialogs with the viewer. *Standing Date* (2005) consists of a steel surface, the height of a person's neck, placed in a public location. The structure hides and constricts the whole of the artist's body apart from his head, which he uses as the only available means of communication with the people around him. Immobilized in his "den," he is forced to engage in conversation with anyone wanting to talk to him, thus giving rise to a form of public living sculpture. (*CPM*)

b. 1966, New York, United States
Lives and works in New York

Solo Exhibitions
What a Good Boy Wants, MIT Center for Advanced Visual Studies, Cambridge (MA), May 2 – 5, 2005
Better Social Realism, CANADA, New York, December 6 – January 18, 2004

Group Exhibitions
Greater New York 2005, P.S.1 Contemporary Art Center, Long Island City-New York, March 13 – September 26, 2005
Tuckernuck, CANADA, New York, May 25 – June 30, 2003

pp. 301-303: *Standing Date*, performance, P.S.1 Contemporary Art Center, Long Island City-New York, 2005

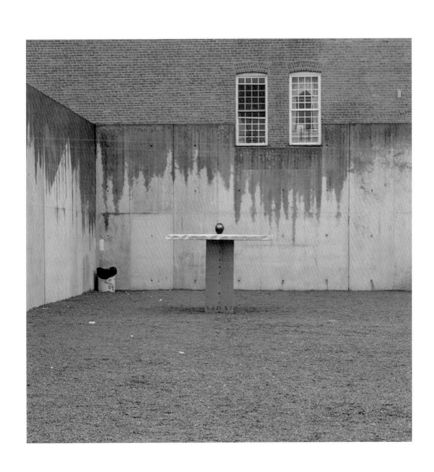

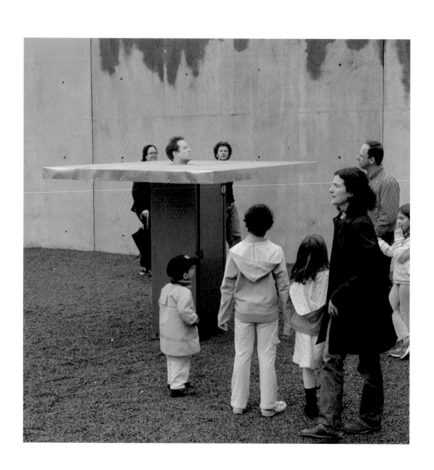

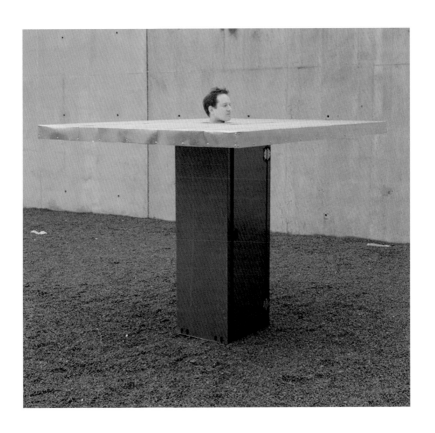

Hassan Khan makes video installations which reflect upon urban life in Cairo, a Middle-Eastern megalopolis in a state of constant flux, where television and religion, tablas and electric guitars come together to form a relentlessly rhythmic language. For the exhibition he presents a project in which the intensity of the light varies in time with the notes of a *shaabi* composition. *Shaabi* music, literally "of the people," is a popular urban type of music – rowdy and rousing, but also melancholy – which tells of class consciousness, love of life and the lot of the ordinary Egyptian.

Regarded as 'vulgar' by intellectuals, it is performed with the greatest enthusiasm by the masses. Alternating composition, production and montage, Khan has devised a form of adulterated *shaabi* from which the emotional element has been removed, creating a connection between contrasting categories and values, between the traditional and the contemporary. (*IB*)

b. 1975, London, United Kingdom
Lives and works in Cairo

Solo Exhibitions
Hassan Khan, Galerie Chantal Crousel, Paris, September 18 – October 30, 2004
I am a hero/you are a hero, Gezira Art Center, Cairo, September 23 – October 8, 1999

Group Exhibitions
Four by Four, Artists Space, New York, May 7 – June 4, 2005
Poetic Justice / Sürsel Adalet. 8th Istanbul Biennial, Antrepo n. 4, Istanbul, September 19 – November 16, 2003

Bibliography
L. U. Marks, *Performance and its Other Side: Hassan Khan's The Hidden Location*, A Space Gallery, Toronto, 2005
N. Azimi, "The Video Work of Hassan Khan," *Bidoun*, No. 1, New York, June 2004, p. 4

p. 306: Album covers of Khaled El Kashef, Abdoh El Iskandarany, Arabey El Soghayar, Shaaban Abd El Rehim, Ahmed Addawiyya, Ali Salheen and Abd El Baset Hamouda stacked on top of each other using Photoshop.
p. 307: Cinema accessories storage house. Photographed by the artist using a Kodak wideshot automatic camera.

shouting out the names of districts and streets marking them
or marking something else?

the basis might be simple or as Ali Salheen's album title puts it
if you play with me i will play with you it might be thus
necessary to discover an imaginary archive to be able to
conceptualise a history with a cognitive dimension

somewhere in the depths of the city there is a music studio
where the soundproofed walls are covered in geometrical
patterns of different colours and photographs of babies and
saxophones cover the walls of the corridors

a process of production can be both unconscious and highly
planned the twitch of a muscle might be automatic but
our perceptions might not

Working at the interface between video and sound installation, Thomas Köner analyzes the combined areas of visual and aural experience. In his images of suburban landscapes, moulded with the help of an incessant flow of barely perceptible noises, the boundaries between movement and stasis, between sound and image, appear to be suspended, giving rise to dreamlike scenarios that are ill-defined in terms of mass and color. Sensory perception is heightened by the interposition of technology, with the viewer-listener appreciating the result in all its physical and mental complexity. (*AV*)

b. 1965, Bochum, Germany
Lives and works in Dortmund

Solo Exhibitions
PROJECTIONS. *Thomas Köner: Untitled (part one: Anicca)*, Musée d'art contemporain de Montréal, February 8 – March 5, 2006
Arrabales del Vacío. Una topografía sonora de Thomas Köner, Espacio Fundación Telefónica, Buenos Aires, September 16 – October 23, 2005

Group Exhibitions
Climax-the Highlight of Ars Electronica, National Taiwan Museum of Fine Arts, Taichung, July 2 – August 28, 2005
CyberArts 2004 - Prix Ars Electronica Exhibition, O.K. Centrum für Gegenwartskunst, Linz, September 2 – 19, 2004

Bibliography
A. Zimmermann, "Banlieue du Vide," *Revue URBANISME*, No. 343, Paris, July-August 2005, p. 11
C. Metzger, *Thomas Köner, Akustische Spuren und gefrorene Perspektiven/ Acoustic Traces and Frozen Perspectives*, in *Katalog zum Deutschen Klangkunst-Preis in Marl 2004*, Skulpturenmuseum Marl, 2004, pp. 42-43, 73

pp. 309-311: Stills from the video *Suburbs of the Void*, 2003
Courtesy GIMA gallery for international media art, Berlin

Jin Kurashige makes video-performances that might be described as part enquiry into, part reflection on, the nature of the image. They are based on situations inspired by the idea of the game, veering between irony and a more minor key. *Billy* (2004), filmed from the viewpoint of someone looking down into a courtyard where children are playing, was originally conceived as a depiction of both Utopia and entropy. While the video was being edited, however, the chance discovery of one particular child, quite on his own, standing still among the others, led the artist to consider the contrast between movement and immobility. Kurashige drives home the point that chance is of the essence in video, sometimes actually shaping the artist's intentions. (*RP*)

b. 1975, Kanagawa, Japan
Lives and works in Paris

Solo Exhibitions
Old Holborn, Mizuma Art Gallery, Tokyo, August 24 – September 10, 2005
Jin Kurashige, Galerie Tripode, Nantes, April 2003

Group Exhibitions
Retour de Athenes, Atelier d'Artiste de la Ville de Marseille, Marseille, February 18 – April 3, 2004
Cosmographies, cosmopolitanism and digi-cosmos in the imagination of young artists. XI Biennial of Young Artists from Europe and Mediterranean, Ilios' Tower Park, Athens, June 5 – 16, 2003

Bibliography
N. Aono, C. Staebler, "Brave New World," *VOGUE*, Japanese edition, No. 74, Tokyo, October 2005, p. 83
J. A. Álvarez-Reyes, "Global Uniformity: Down With Difference!," *ABC de ARCO*, No. 3, Madrid, February 12, 2005, pp. 12-13

p. 313: Das *Kunstwerk im Zeitalter seiner Technischen Reproduzierbarkeit* (*The Work of Art in the Age of Mechanical Reproduction*), 2002
pp. 314-315: *Billy*, 2004
Courtesy the artist and Mizuma Art Gallery

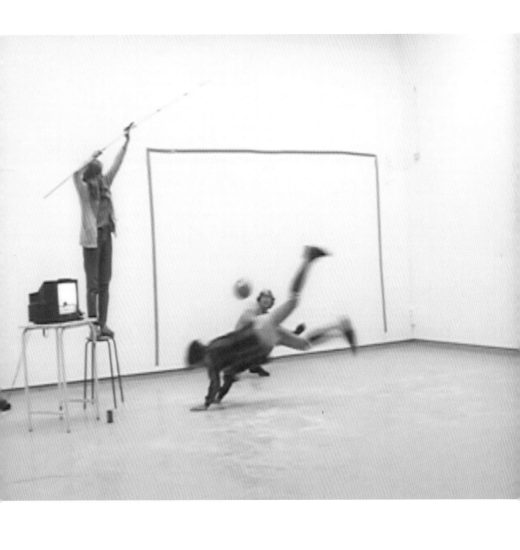

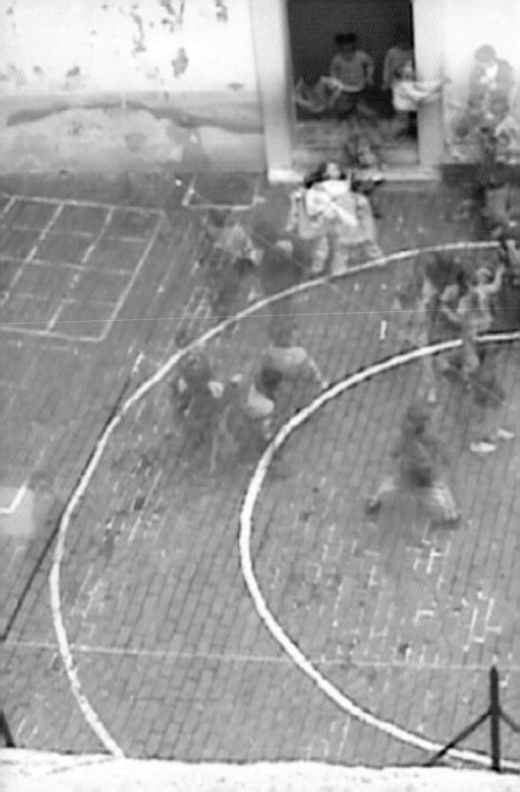

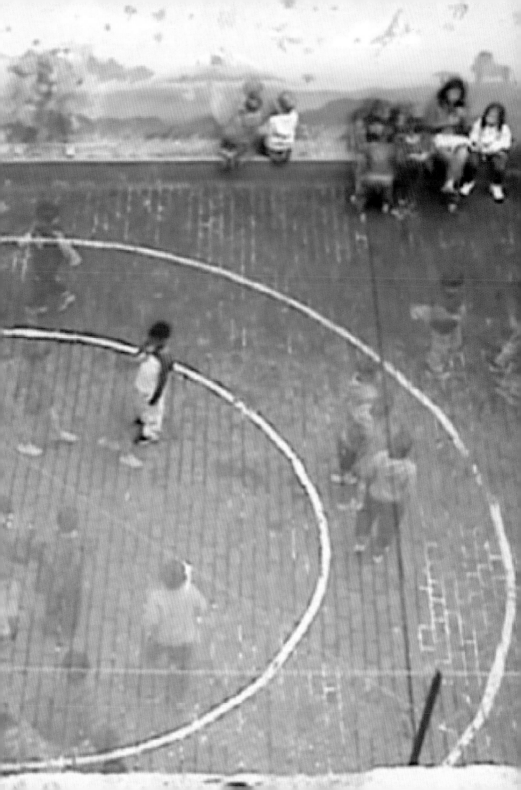

An-My Lê's *Small Wars* (1999 – 2002) is a "Vietnam of the soul." The historical events of the Vietnam War are reconstructed with the collaboration of 're-enactors' and photographed not in their real setting, but in Virginia and North Carolina. The participants in these simulations are rarely war veterans but young civilian men who are fascinated by military history and are keen collectors of military paraphernalia. The scenarios created for *Small Wars* were inspired by the artist's childhood memories, family snapshots, photos from newspapers and Hollywood film stills. These images thus superimpose a very personal viewpoint upon the aesthetic of documentary photography, giving the work an ambiguous intensity.

29 Palms (2003 – 2004) is a cycle of photographs devoted to recent US military operations in Iraq and Afghanistan. It involves US Marines training in the Californian desert in preparation for deployment. Rather than being an objective recording of specific historical events, the photographs strike the viewer as an exploration of the repertoire of images associated with war, and of the psychological reasons underlying our fascination with such images. (*AV*)

b. 1960, Saigon, Vietnam
Lives and works in New York

Solo Exhibitions
29 Palms, Murray Guy Gallery, New York, September 10 – October 16, 2004
An-My Le: Small Wars, P.S.1 Contemporary Art Center, Long Island City-New York, June 30, 2002 – January 28, 2003

Group Exhibitions
The Art of Aggression, Reynolds Gallery, Richmond, January 14 – March 20, 2005; The Moore Space, Miami, April 14 – July 1, 2005
New Photography 13, MoMA The Museum of Modern Art, New York, October 24, 1997 – January 13, 1998

Bibliography
A.-M. Lê, R.B. Woodward, H. Als, *An-My Lê: Small Wars*, Aperture Foundation, New York, 2005
A.-M. Lê, photographic project, *Blindspot*, No. 28, New York, Fall 2004

pp. 317-319: *29 Palms (Mortar Impacts; Debriefing; Mechanized Assault; Security and Stabilization Operations, Graffiti; Colonel Greenwood; Night Operations)*, 2003-04
Courtesy Murray Guy, New York

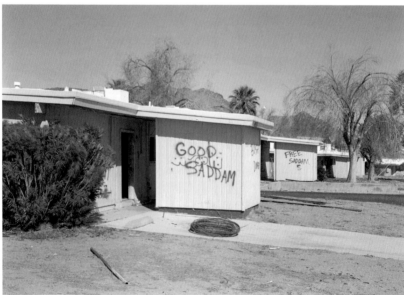

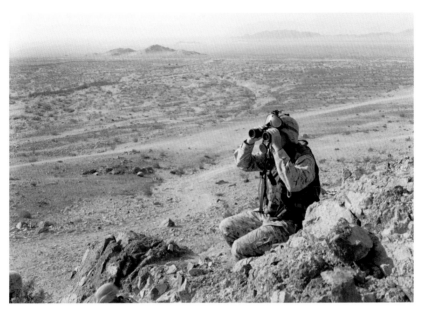

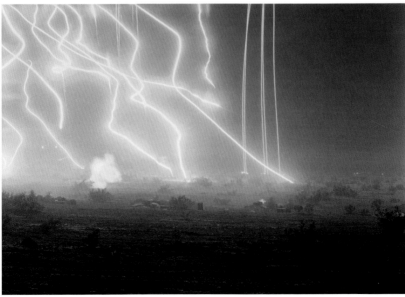

CHRISTELLE LHEUREUX AND APICHATPONG WEERASETHAKUL

The video installation *Ghost of Asia* (2005) is a collaboration between two film-makers, Apichatpong Weerasethakul and Christelle Lheureux, taking the recent tsunami in Asia as its starting point. In a life-affirming gesture, the directors invited local children to direct the film for them, suggesting and filming the movements of the actor-ghost who is seen wandering along the rocky coastline of a Thai island. By projecting their own ideas on to this spectral creature, half real, half imagined, the children's fantasies are given substance, their childish game mediated by the adult 'game' of shooting a film. (*AV*)

b. 1972, Bolbec, France
Lives and works in Paris

Solo Exhibitions
Christelle Lheureux, Galerie Blancpain Stepinsky, Geneva, November 5 – January, 2006
L'expérience préhistorique, crac, Valence, January 26 – February 29, 2004

Group Exhibitions
BMW The 9th Baltic Triennial of International Art, CAC, Contemporary Art Center, Vilnius, Lithuania – ICA Institute of Contemporary Arts, London, September 23 – November 20, 2005
Multipistes, argosfestival 2005, Bruxelles, October 13 – 22, 2005

Bibliography
J.-C. Royoux, *Christelle Lheureux*, in *Un remake Multipiste*, Point Ligne Plan, Paris, 2004, p. 8
C. Lheureux, *Que des mensonges*, onestarpress, Paris, 2003

b. 1970, Bangkok, Thailand
Lives and works in Bangkok

Solo Exhibitions
A Retrospective, KunstenFESTIVALdesArts, Bruxelles, May 6 – 28, 2005

Group Exhibitions
EindhovenIstanbul, Van Abbemuseum, Eindhoven, October 1 – January 29, 2006
2004/Taipei Biennial: Do You Believe in Reality?, Taipei Fine Arts Museum, Taipei, October 10 – January 23, 2005

Bibliography
J. Quandt, "Exquisite Corpus: the Film of Apichatpong Weerasethakul," *Artforum*, Vol. XLIII, No. 9, New York, May 2005, pp. 226-231

pp. 321-323: *Ghost of Asia*, 2005
Courtesy Christelle Lheureux & Kick the Machine

Justin Lowe's polymorphic installations are built up on a relationship between improvisation and a playful use of salvaged materials. Interested in the aesthetics of the 1960s, his desire is to create spaces and architecture that surprise the viewer, environments that can be moved through to the accompaniment of music, as if they were the scenes of festive events. This has led Lowe to create a space that is organic and hallucinatory, in which the spectator is immersed in the "ready-made" colors of old carpets, clothing, cushions and cast-off furniture. Various soft forms intermingle, creating optical and intellectual effects that bring the artistic vocabulary into the everyday, prompting a subtle and nostalgic critique of present-day consumerism. (*RP*)

b. 1976, Dayton, United States
Lives and works in New York

Solo Exhibitions
Justin Lowe, in the series *In Practice. Special Project Series*, SculptureCenter, Long Island City-New York, January 16 – April 10, 2005
Cabinessence, Hampshire College, Amherst (MA), December 16, 1999

Group Exhibitions
Greater New York 2005, P.S.1 Contemporary Art Center, Long Island City-New York, March 13 – September 26, 2005
The Melvins, Anton Kern Gallery, New York, May 15 – June 21, 2003

Bibliography
D. Rimanelli, "Greater NY Review," *Artforum*, Vol. XLIII, No. 9, New York, May 2005, pp. 239-240
L. Gillick, "Fenced, Unfenced, Referenced," *Yard Magazine*, Los Angeles, Fall 2004, p.46

pp. 325-327: Project for the *T1* catalog

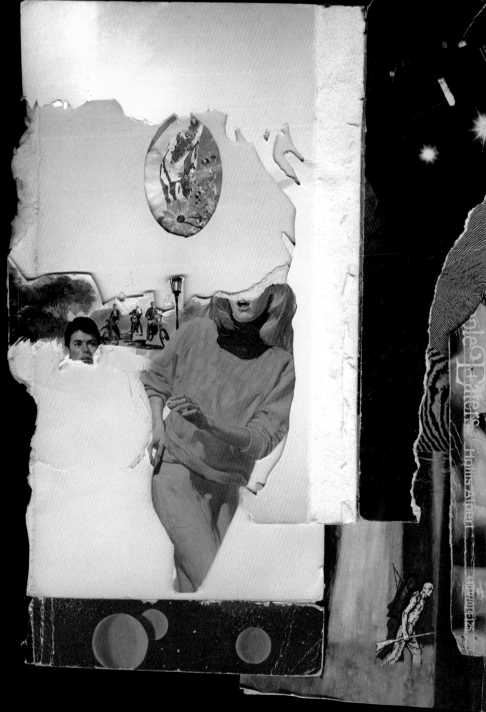

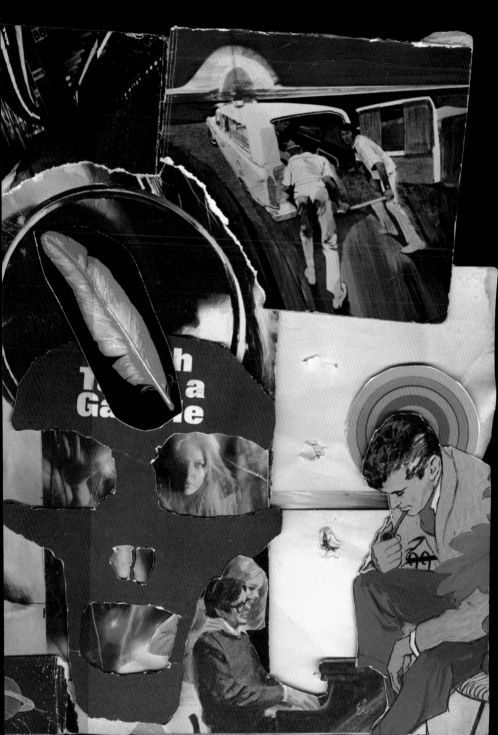

Nalini Malani's "video-plays" are sound and video installations with strongly theatrical components. With considerable lyrical and political sensibility, the artist incorporates historical and allegorical references into her work, with narratives, texts and quotations alluding to the more painful aspects of contemporary India, with particular reference to the female condition and to India's ambivalent and contradictory attitudes to women. *Mother India: Transactions in the Construction of Pain* (2005) is a "video-play" made up of five videos, two of which are projected on to the floor of the room. Malani conjures up India – the Motherland – from the social, economic and political view point, with special emphasis on the troubled relations between Hindus and Muslims, whose sparring ground is often this same female body. Her reflections, which include images of the violent process of the Partition of India and Pakistan (1947), and genocide in Gujarat (2002) are accompanied by the words of the sociologist Veena Das. (*CPM*)

b. 1946, Karachi, Pakistan
Lives and works in Bombay

Solo Exhibitions
Stories Retold, Bose Pacia Gallery, New York, September 8 – October 30, 2004
Nalini Malani: Hamletmachine, New Museum of Contemporary Art, New York, November 12 – January 12, 2003

Group Exhibitions
iCon India, LI Esposizione Internazionale d'Arte. La Biennale di Venezia, Convento dei SS. Cosma e Damiano, Refettorio d'Inverno, Venice, June 9 – July 31, 2005
Poetic Justice / Sürsel Adalet, 8th Istanbul Biennial, Yerebatan Cistern, Istanbul, Turkey, September 19 – November 16, 2003

Bibliography
A. Huber-Sigwart, "Nalini Malani: Political Metaphors," in *n.paradoxa: international feminist art journal*, Vol. 13, London, January 2004, pp. 67-74
T. McEvilly, "Nalini Malani at the New Museum," in *Art in America*, No. 11, New York, November 2003, pp. 169-170

pp. 329-331: Stills from the video *Mother India: Transactions in the Construction of Pain*, 2005
Courtesy Bose Pacia Gallery, New York

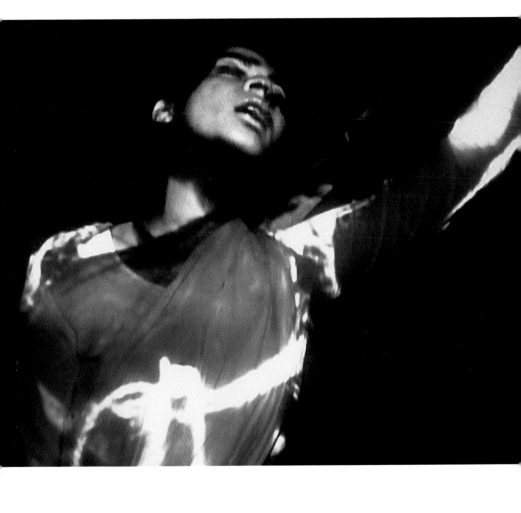

Intrigued by the abnormal concealed within the normal, Angelika Markul creates video-installations that examine the atrocity inherent in the most banal images. Using a voyeuristic system in which the spectator is caught between disquiet and curiosity, she creates personal worlds of her own, telling of madness, weirdness, uncertainty and loss of identity. The subjects she highlights establish connections between objects, while installations and stage sets enveloped in living material take on psychological values, playing on the internalized symbols of the monstrous, the surreal and the abnormal in fairy tales, a metaphor for the artist's own condition. In the video *My nature* (2005), a luxuriant forest grows at breakneck speed, half fantasy, half nightmare. *(RP)*

b. 1977, Szczecin, Poland
Lives and works in Paris

Solo Exhibitions
Szkola nr 17, Spazio culturale LA RADA, Locarno, July 23 – August 20, 2005

Group Exhibitions
J'en rêve, Fondation Cartier pour l'art contemporain, Paris, June 24 – October 30, 2005
I Still Believe In Miracles. Derrière l'horizon, ARC /Musée d'Art Moderne de la Ville de Paris, Paris, May 19 – June 19, 2005

Bibliography
C. Boltanski in *J'en rêve*, Fondation Cartier pour l'art contemporain, Paris; Actes Sud, Arles, 2005, pp. 128-129
J. Truong, *Le ventre de l'artiste*, in *I Still Believe in Miracles. Derrière l'horizon*, Musée d'Art Moderne de la Ville de Paris / ARC, Paris, 2005

pp. 333-335: Stills from the video *Ma nature* (*My Nature*), 2005
Courtesy the artist

Melissa Martin's works explore the present-day neuroses connected with food, and the mechanisms governing its acceptance or rejection. *Little Pig* (2004) is a sculpture of a pig entirely made from chewing gum, chewed by the artist, sectioned and laid out on a butcher's slab. Anatomically accurate both externally and internally, the image is a violent one, which gives the pig something of the status of a sacrificial victim. The video *Seconds* (2004), on the other hand, presents the artist taking various foodstuffs out of a fridge and tipping them into her trousers one by one, in a series of mechanically repeated gestures that, apart from expressing an obvious feeling of unease, also seems to suggest the metaphorical feeding of a sexual appetite. (*COB*)

b. 1975, Indianapolis, United States
Lives and works in New York

Solo Exhibitions
Melissa Martin, Art In General, New York, October 1 – December 23, 2005
Melissa Martin, Rare Gallery, New York, March 5 – April 2, 2005

Group Exhibitions
Spark Video: New Video from the Skowhegan School of Painting and Sculpture, Spark Contemporary Art Space, Syracuse-New York, October 1 – November 1, 2004
SculptureCenter Winter Gala 2003, SculptureCenter, Long Island City-New York, December 11, 2003

p. 337: *Seconds*, 2004, photo: Courtesy the artist and Rare Gallery, New York
pp. 338-339: *Little Pig*, 2004, George Lindemann Jr. Collection, Miami

Jesús "Bubu" Negrón is a 'conceptual romantic' who creates objects, sculptures and public installations which scrutinize the social dimension of our time through highly personal reflection. His works often take the form of 'ensemble' actions which communicate political ideas and prompt reflection on the social reality in which we live, as though they were a form of visual poetry. For this exhibition he is presenting *Rosa Tekata* (*Junkie Rose*, 2005), a gigantic rose of huge folded palm leaves, made by drug addicts from San Juan. Negrón's rose is a contemporary version of one of Michelangelo Pistoletto's *Minus Objects*, the *Rosa bruciata* (*Burned Rose*, 1965) by which it was overtly inspired. At the same time, *Rosa Tekata* is a monumental version of the little roses that Puerto Rico's pushers and addicts make by hand out of palm leaves while waiting to sell, or buy. By manipulating a symbol and referring to an iconic work of Arte Povera, this sculpture creates an unexpected and powerful link between art and life, transforming a moment from Italian art history into a symbol of the complexities of life in Puerto Rico. (*IB*)

b. 1975, Arecibo, Puerto Rico
Lives and works in San Juan and Barceloneta

Solo Exhibitions
Jesús "Bubu" Negrón [2001-2004], Galería Comercial, San Juan, September 14 – October 8, 2004

Group Exhibitions
Tropical Abstraction, Stedelijk Museum Bureau, Amsterdam, July 10 – August 21, 2005
pr 04. tribute to the messenger. // 2004 olympics (Puerto Rico 2004), M&M Proyectos, San Juan, May 27-30, 2004; Rincón, May 31 – June 6, 2004

Bibliography
J. Gonzáles, "San Juan - Jesús (Bubu) Negrón - Galería Comercial," *Flash Art International*, Vol. XXXVII, No. 239, Milan, November-December 2004, pp. 121-122

pp. 341-343: *July 2, 2004*

Humor, satire and criticism come together in the videos and performances of
Yoshua Okon, characterized by strong images that recycle symbols and
situations found in society in general. Often centered on some improvised
action, his videos show people in real-life situations, albeit manipulated by the
artist, and thus retaining a documentary character with a distinctly subversive
feel. *Coyoteria* (*Coyotery*, 2003) is a Mexican version of Joseph Beuys' historic
action of 1974, when he spent a week in a cage with a coyote. In this
contemporary rereading of the relationship between man and nature, of social
relations in general, and of power and corruption, an elegantly attired human
coyote attacks Okon on all fours, biting at him as he tries to fend it off with a
police baton. (*RP*)

b. 1970, Mexico City, Mexico
Lives and works in Mexico City and Los Angeles

Solo Exhibitions
Lago Bolsena, The Project, New York, April 7 – 29, 2005
Cockfight, Galleria Francesca Kaufmann, Milan, September 25 – November 10, 2003

Group Exhibitions
Poetic Justice / Sürsel Adalet, 8*th* *Istanbul Biennial*, Antrepo n. 4, Istanbul, September 20 –
November 16, 2003
Mexico City: an Exhibition about the Exchange Rate of Bodies and Values, P.S.1 Contemporary Art
Center, Long Island City-New York, June 30 – September 2, 2002; Kunstwerke, Berlino, September
22 – January 1, 2003

Bibliography
J. Welchman, "Yoshua Okon: Crying Wolf," *Flash Art International*, Vol. XXXVII, No. 234, Milan,
January-February 2004, pp. 96-97
Strangers: The First ICP Triennial of Photography and Video, International Center of Photography,
New York; Steidl Verlag, Gottingen, 2003, pp. 60-63, 88-91

pp. 345-347: *Coyoteria*, 2003
Courtesy francesca kaufmann, Milan; The Project, New York; Galería Enrique Guerriero, Mexico
City

Damián Ortega's environmental sculptures and installations transform the traditional notion of sculpture as static and solid into something dynamic, comparable to the transformation of a word into a pun, or an image into a performance. By means of allusive or suggested movements, or by revealing the interconnections in the inner structure of everyday objects, as well as leaving the uncertain moments of transition between one state and another in abeyance, Ortega presents an action in progress, rather than its outcome, such as in the progressive decomposition of a Vespa in *Miracolo italiano* (*Italian Miracle*, 2005). His sculptures thus represent a penetrating exploration of the entropic chaos of contemporary objects, suggesting a point of view that is humorous but at the same time lucidly critical and political. (*AV*)

b. 1967, Mexico City, Mexico
Lives and works in Mexico City

Solo Exhibitions
UNTITLED: Damián Ortega The Uncertainty Principle, Tate Modern, London, April 23 – June 12, 2005
Damián Ortega, Kunsthalle Basel, Basel, September 19 – November 14, 2004

Group Exhibitions
The Everyday Altered. Dreams and Conflicts. The Dictatorship of the Viewer, L Esposizione Internazionale d'Arte. La Biennale di Venezia, Arsenale, Venice, June 15 – November 2, 2003
Arte all'Arte 7. Architettura e Paesaggio, Associazione Arte Continua, Enopolio Granducato, Poggibonsi-Siena, September 13, 2002 – January 6, 2003

Bibliography
M. Godfrey, "Image Structures: Mark Godfrey on Photography and Sculpture," *Artforum*, Vol. XLIII, No. 6, New York, February 2005, pp. 146-153
D. Ortega, P. Berenstein Jacques, A. Szymczyk et al., *Damián Ortega*, Kunsthalle Basel; Schwabe Verlag, Basel, 2004

pp. 349-351: *Miracolo italiano (Italian Miracle)*, 2005

MIRACOLO ITALIANO·I

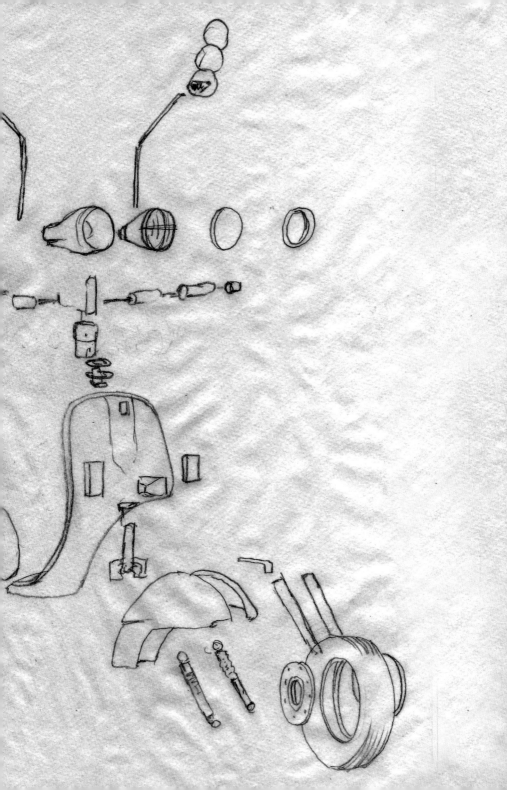

Ulrike Palmbach is a sculptor who transforms banal living forms into mysterious ones, and ordinary objects into almost surreal ones, serving no purpose. Playing with illusion, estrangement and reality and piecing together bits of fabric she creates sculptures which speak to us of everyday objects, and thoughts.

Cow (2004) is a representation of a cow whose distinctive features have been suppressed: it is larger than life, has no ears or horns, and its spotted coat has a dreamlike pallor. Yet even in the absence of such details, the animal's presence is quite simply enhanced.

As we approach the work we realize that the sculpture is a patchwork of muslin whose stiching is suggestive of wounds staunched by suturing. *Cow* leads us to reflect on the possibilities for the transformation of present-day sculpture as an art form which is becoming more open and less monumental. (*MVM*)

b. 1963, Sindelfingen, Germany
Lives and works in San Francisco

Solo Exhibitions
Ulrike Palmbach, Shasta College Art Gallery, Redding (CA), October 3 – November 10, 2005
Sculpture, Stephen Wirtz Gallery, San Francisco, March 2 – April 16, 2005

Group Exhibitions
Fantastical Topographies: Sculpture by Ulrike Palmbach and Genevieve Quick, Montalvo Arts Center, Saratoga, November 17 – January 26, 2003
Bestiary, Armory Center for the Arts, Los Angeles, July 2 – August 27, 2000

Bibliography
AA.VV., *Ulrike Palmbach*, Stephen Wirtz Gallery, San Francisco, 2005
A. Miller, "Ulrike Palmbach: Stephen Wirtz Gallery," *Sculpture*, Vol. 20, No. 6, Washington D.C., July-August 2001, pp. 60-61

p. 353: *Cow*, 2004
pp. 354-355: Study for *Cow*, 2004
Courtesy Stephen Wirtz Gallery, San Francisco

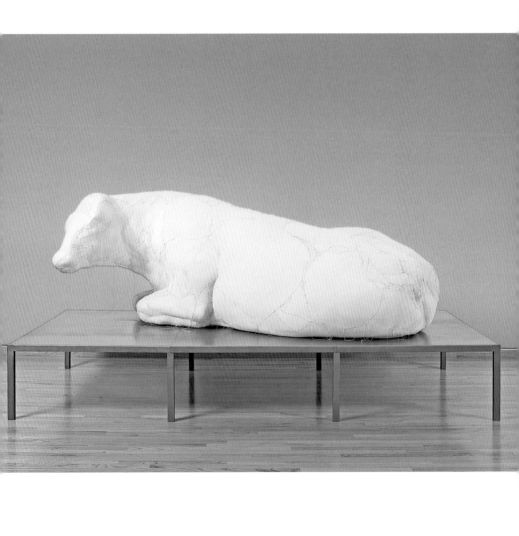

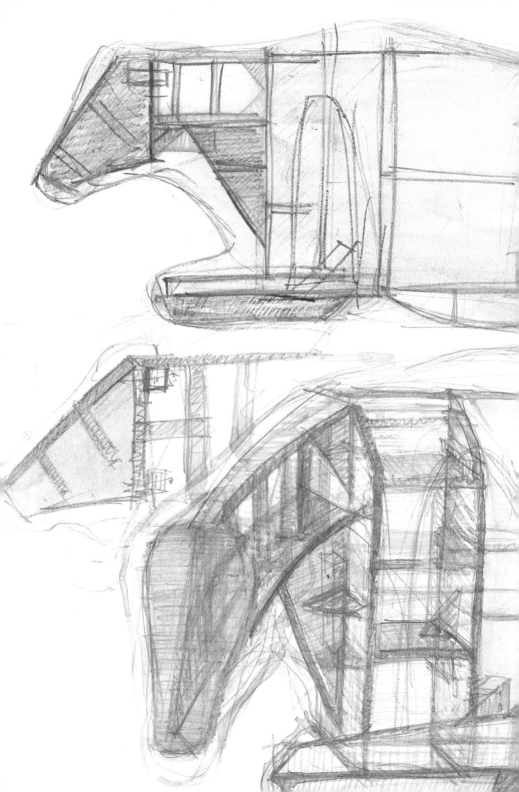

The year 2003 started with the US preparing for war, which to me was a frightening outlook.

Growing up in Germany, I was taught that the most terrifying thing that could happen in one's lifetime is a war. Since my parents were children in World War II, my own childhood was filled with their stories and images, telling of what it means to be caught in such a disaster.

One of the images that struck me particularly was that of screaming cows. When the bombers were flying over the villages, people would crouch in their basements so the cows often could not be milked. This caused them to "scream" in agony, for their udders were bursting. As a child I found this description particularly frightening, because in a child's understanding of the world, cows don't cry.

This primal outcry of a large animal was the first thing that came to my adult mind as the US began the Iraq war, an outcry not over the animal's agony but for the human terror it expresses.

I don't see myself as a political artist, yet I do feel a certain urgency to express my concern about world events that are so large in scale that I can't possibly address them adequately. What I can do is reduce all the information and observations to what I can understand and find a form for it. In this case, I could only voice my concern in the form of a cow, using its voice as a human expression.

PARK SEJIN

Park Sejin is a young Korean painter working in the ancient tradition of landscape painting, featuring transparent marks, light traces of pigment and small hyper-real figures. All her pictures show distant horizons, as though she hoped to capture the space beyond the visual boundary, to show what happens beyond. The objects and figures represented seem to migrate from one painting to another, producing a fragmentary but continuous narrative, apparently existing in parallel time-space universes. Park Sejin tells improbable stories, such as that of doctor Kim, turned to stone by too much solitude as he attempts to create a cyborg; or of the cyborg itself which, failing in its mission, finds that its head is sprouting donkeys' ears. (*IB*)

b. 1977, Gwangju, Korea
Lives and works in Seoul

Group Exhibitions
Secret Beyond the Door, Korean Republic Pavilion, LI Esposizione Internazionale d'Arte. La Biennale di Venezia, Giardini, Venice, June 12 – November 6, 2005
Art Spectrum 2003, Leeum, Samsung Museum of Modern Art, Seoul, December 19 – February 29, 2004

Bibliography
S. Ahn, *Landscapes for the Space of Escape*, in *Art Spectrum 2003*, Samsung Museum of Modern Art, Seoul, 2003, pp. 44 - 53
S. Yim, "Intellectual Jouissance of Sense," *Space*, No. 39, Seoul, September 2004, pp. 162-167

p. 357: *Dr. Kim's One Day*, 2004, courtesy the artist
pp. 358-359: *The Helipad*, 2001, Private Collection, Korea

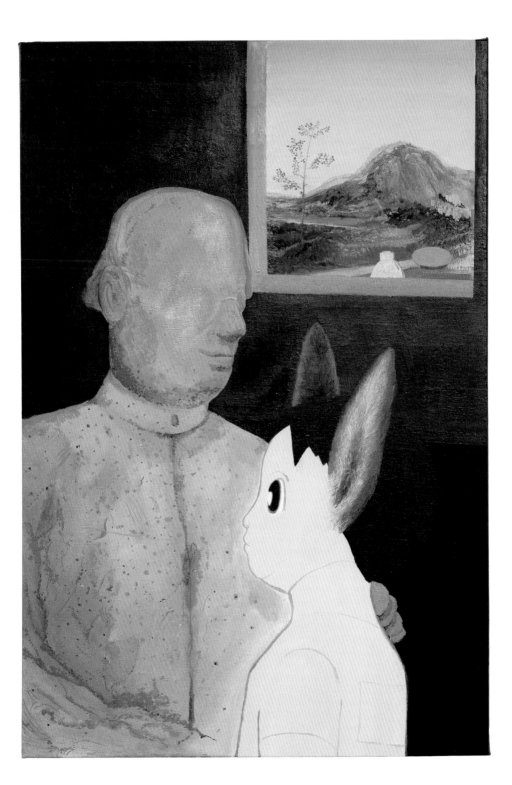

Jorge Peris uses his work – and the movements of the figures who pass through it – to transform and modify space. His project *Kursk* (2004) takes its name from the Russian submarine that sank off the Barents Sea in 2000. This installation takes the form of a ravaged space, with pieces of iron and metal structures conveying a general sense of danger, while spurts of water continually threaten to soak the viewer. The work recreates the phase of a shipwreck when the capsule, completely surrounded by water, becomes transformed into an independent microcosm in which various forms of life, such as mildew and bacteria, self-generate spontaneously, emerging as the masters of a space that is now their own. (*IB*)

b. 1969, Alzira, Spain
Lives and works in London

Solo Exhibitions
Jorge Peris, Le Creux de l'Enfer Centre d'Art Contemporain, Thiers, April 10 – May 31, 2005
Jorge Peris, Galleria Giorgio Persano, Turin, May 3 – July 29, 2000

Group Exhibitions
Tank.TV, ICA Institute for Contemporary Art, London, August 5 – September 5, 2004
Jammed, Smart Project Space, Amsterdam, October 19 – December 7, 2003

Bibliography
F. Gavin, "Small films. Big ideas," *BBC Collective* (on-line magazine), No. 161, London, 20 August 2004, www.bbc.co.uk/dna/collective/A2931743
T. Conti, "Jorge Peris – Galleria Giorgio Persano, Torino," *Tema Celeste*, No. 82, Milan, October-December 2000, p. 94

p. 361: image from the website www.aids-info.ch/bilder/schule_aids/jpg_bilder/koch14_2.jpg
Courtesy the artist
pp. 362-363: *Kursk*, 2004

Susan Philipsz records her unaccompanied *a cappella* voice and plays back the results in a variety of different sites. Her songs belong to a known repertoire, but in view of the concentration and thoughtfulness she puts into them, the flaws in her untrained voice and the absence of accompaniment, the resulting work conveys a particular sense of intimacy, causing us to feel deeply involved in the space and time in which we find ourselves. In *Stay With Me* (2005), first performed in the empty, light-filled space of the Konsthall in Malmö, Philipsz sings three songs, *Watch With Me* (1972), *Nothing Lasts Forever* (1997) and *Pyramid Song* (2001), each of which, in their different ways, tells of our journey from life to death, giving us glimpses of something beyond everyday reality and intensifying the transcendent qualities of the space in which they are heard. A new version of this installation was created for the Baroque Santa Croce church in Rivoli. (*AV*)

b. 1965, Glasgow (Scotland), United Kingdom
Lives and works in Berlin

Solo Exhibitions
Stay With Me, Malmö Konsthall, Malmö, April 30 – August 14, 2005
Susan Philipsz, Ellen De Bruijne Projects, Amsterdam, April 17 – May 22, 2004

Group Exhibitions
Beck's Futures 2004, ICA Institute for Contemporary Art, London, March 26 – May 16, 2004; CCA: Center for Contemporary Art, Glasgow, June 12 – August 1, 2004
Days Like These: Tate Triennial of Contemporary British Art 2003, Tate Britain, London, February 26 – May 26, 2003

Bibliography
P. Albrethsen, W. Bradley, C. Christov-Bakargiev et al., *Susan Philipsz*, Malmö Konsthall, Malmö; CA Anderson, Malmö, 2005
C. Mac Giolla Leith, *Susan Philipsz*, in *The Glen Dimplex Artists Award Exhibition 2001*, IMMA Irish Museum of Modern Art, Dublin, 2001, pp. 18-19

pp. 365-367: Project for the *T1* catalog

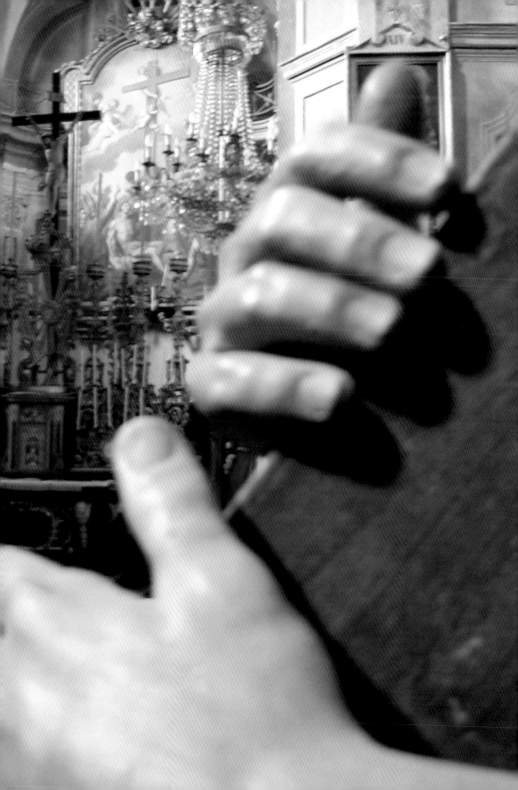

ne hour with me stay just a way by my side when my hallel

stre

Under skin is where I hide The love that alw

s

blues and greys be my guide stay awhile watch with me

my lovers were there with me All my past and futures

gets me on my knees

Wit Pimkanchanapong's works range from VJ performance events to music, videos and elaborate one-channel video installations, his main preoccupation being the animation of the still image. Through Photoshop manipulations, he produces minute, almost imperceptible animated effects, giving movement to urban spaces or familiar scenes and portraits. In the latter, a sense of strained tension is evident. In the urban landscapes, on the other hand, we are made aware of extremely slow changes to tourist sites of Bangkok, his native city. These animated photographs, or "travel notes," are observations of contemporary urban civilization, with its various infrastructures and city plans. (*CPM*)

b. 1976, Bangkok, Thailand
Lives and works in Bangkok

Solo Exhibitions
My Map, The Odyssey Visual Loft, Bangkok, February, 2004
Still Animation: Family Portrait Series, All Season Place, Bangkok, December, 2002

Group Exhibitions
Space and Shadows. Contemporary Art from South East Asia, Haus der Kulturen der Welt, Berlin, September 30 – November 20, 2005
SOI Project / Yokohama Triennale 2005, Warehouse n. 3, Warehouse n. 4, Yamashita Pier, Yokohama, September 28 – December 28, 2005

Bibliography
P. Yoon, *Now We Met*, in *Have We Met, Bangkok?*, The Japan Foundation, Bangkok, 2005, pp. 13-22
Z. Butt, B. Dean, *Mirror Worlds. Contemporary Video from Asia*, in *Mirror Worlds. Contemporary Video from Asia*, Australian Center for Photography, Paddington, 2005, p. 2

———
pp. 369-371: Project for the *T1* catalog

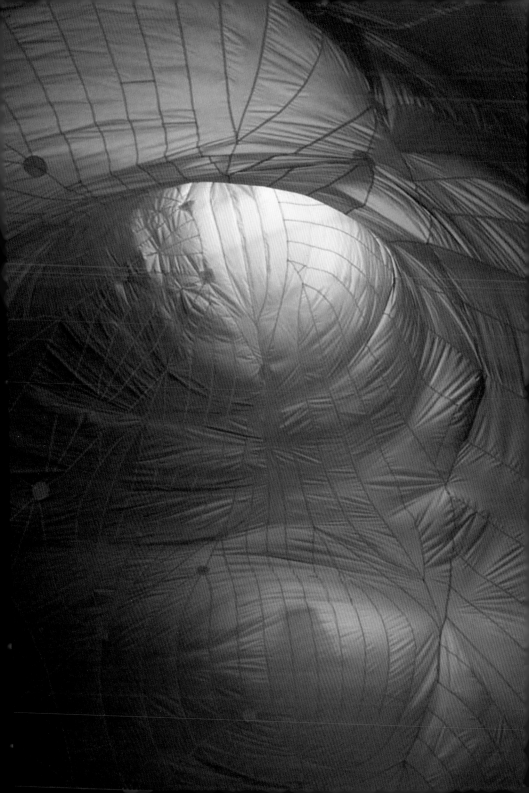

Shannon Plumb's videos are based on a stock of images borrowed from the silent films of the last century. An actor by training, she films herself in short, humorous sequences, creating anachronistic parodies of earlier films and advertisements, with the help of simple props and set in everyday situations. Her up-dated version of pantomime, dated images and the imitation of behavioral and social prototypes refer back to long-established patterns belonging to the culture of TV, in the tradition of the purest American creative satire. (*RP*)

b. 1970, Schenectady-New York, United States
Lives and works in Brooklyn

Solo Exhibitions
Shannon Plumb: Behind the Curtain, Aldrich Contemporary Art Museum, Ridgefield, January 23 – June 22, 2005
Black and White, Sara Meltzer Gallery, New York, September 9 – October 16, 2004

Group Exhibitions
Greater New York 2005, P.S.1 Contemporary Art Center, Long Island City-New York, March 13 – September 26, 2005
Between You and Me, Art House, Austin (TX), March 12 – April 17, 2005; SculptureCenter, Long Island City-New York, September 12 – November 29, 2004

Bibliography
B. Genocchio, "The Artist as the Star of a Silent Comedy," *The New York Times*, New York, March 6 2005, section 14CN, p. 7
R. Smith, "Art in Review; Shannon Plumb – 'Black and White'," *The New York Times*, New York, October 8, 2004, p. E37

pp. 373-375 Project for the *T1* catalog

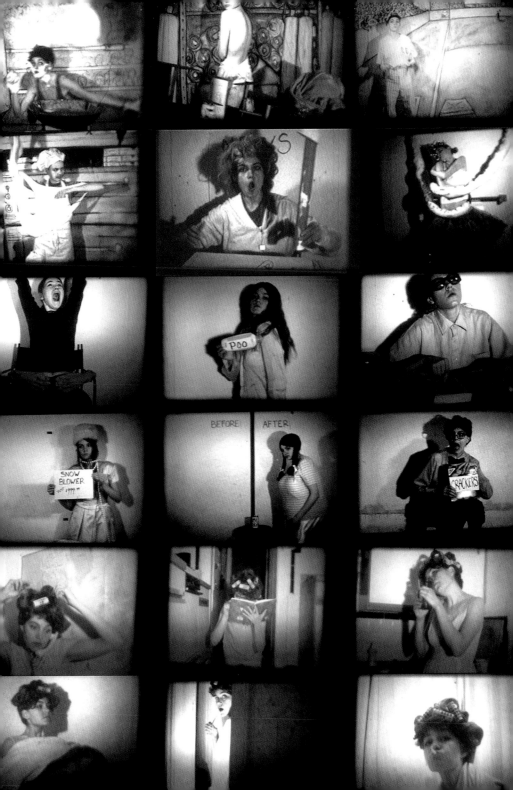

PRIVATE INVESTIGATOR
HIRE A P.I.
HIRE A DIK

Sherlock Holmes feel
 but not quite as slick

CAN'T FIND IT
LOOK IN THE YELLOW PAGES

CLUE

FAN
~~SHOEBOX~~
A ~~STOOL~~ or A stool

selling any product
"~~BUY~~ call NOW and RECEIVE
____ FREE
All for just $19.95"

+ little table
+ little ottoman
 shoeboxes

Sell a thing. Any thing. Make it have multi
functions. THE HAND HELD FAN

PROJECT

SPEED READING

LeaRN how

NEWSPAPER,
MAGAZINE,
BOOKS

tossing away
whenfinished

quickly happy + sad
emotions happen very
fast

GOOD COFFEE
~~DEPETHE DRINK PIKK~~ ?

SEWING
WIRED ON
COFFEE

NEUROTIC behavior
folding + unfolding
jacket
REORGANIZING bag-
nothing fits
folding papers
putting them in
different compartments

needs to be darker
than other films. Sort of a homeless character. But emphasize
drinking a large coffee It has to be gulped, over and
over. maybe have more than one cup.

In Riccardo Previdi's works, borders are blurred: they strike a supple balance between sculpture, installation, video, photography and performance. The structures he uses are open-ended and modular, and may be adapted to different contexts and modes of viewing. His frequent references to architecture create undulating geometries, evocative atmospheres whose rational elements are subtly merged with more personal insights. For his *Non Stop* (2005), a reworking of Archizoom's *Non-Stop City* (1970), centered on a limitless Utopian metropolis, Prevedi sets up two viewing areas in which the images of the final scene of George Lucas's movie *Star Wars* (1977) are projected on to one filtering surface and two reflecting ones, endlessly taking on new life. The neutral space of the exhibition, together with the futuristic space suggested by *Star Wars*, become the platform for a comparison enabling us to recreate their codes and symbols. (*AV*)

b. 1970, Milan, Italy, 1970
Lives and works in Berlin

Solo Exhibitions
Es ist nur eine Frage der Zeit, Galleria Massimo Minini, Brescia, January 12 – March 11, 2006
SML, PresentFuture, Artissima 10, Turin, November 5 – 9, 2003

Group Exhibitions
Lichtkunst aus Kunstlicht / Light Art from Artificial Light, ZKM | Museum Für Neue Kunst, Karlsruhe, November 19, 2005 – April 23, 2006
Dojo, Via Ventura (Ex Faema), Milan, May 6 – June 10, 2005

Bibliography
L. Cerizza, *Riccardo Previdi*, in *Young Artists in Italy at the Turn of the Millennium. Behind and Beyond the Italian Studio Program at P.S.1/MoMA*, Charta, Milan, 2005, p. 231
F. Lunn, *Riccardo Previdi*, in *Interior View*, De Zonnehof centrum voor moderne kunst, Amersfoort, 2004, p. 64

pp. 377-379: *50% Radical*, 2005, project for the *T1* catalog

Ana Prvacki's conceptual art is one continuous outpouring of ideas and projects. Her work is fuelled by an interest in architecture, design, advertising and collaboration with the public, for which purpose she set up a company, Ananatural Production, with its website, www.ananatural com, which produces at least two catalogs a year of new ideas, creative 'recipes' for do-it-yourself objects and activities. During the exhibition the artist will distribute a free bilingual edition, with yet more novel and absurd ideas; at certain set times, she will also be offering the public free consultations and demonstrations. (*IB*)

b. 1976, Pancevo, Serbia and Montenegro
Lives and works in Singapore and New York

Group Exhibitions
A Migration of Energies – part 1: Clouding Europe, Gandy Gallery, Bratislava, September 16 – November 26, 2005
Toys, Earl Lu Gallery, Singapore, November 13 – December 29, 2003

Bibliography
The BMW Book, CAC – Contemporary Art Center, Vilnius; Revolver. Archiv für aktuelle Kunst, Frankfurt am Main, 2005, p. 22
New Labor, Columbia University Press, New York, 2005

pp. 381-383: A special excerpt from the Ananatural Production catalog for *The Pantagruel Syndrome*, 2005

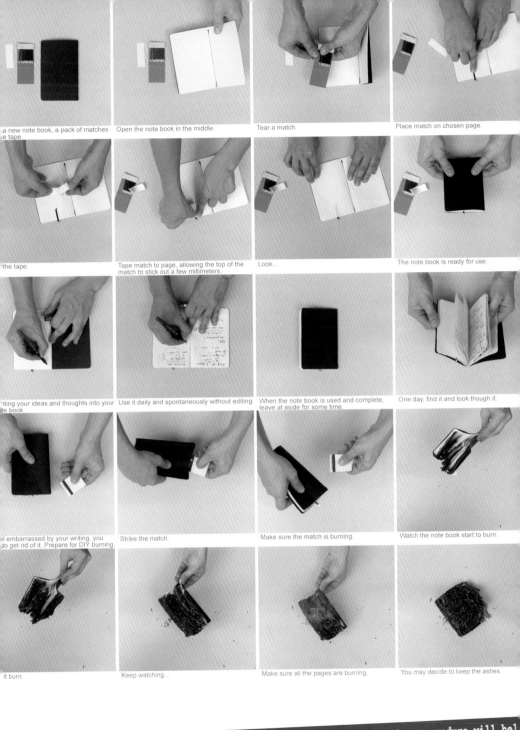

a new note book, a pack of matches e tape.

Open the note book in the middle.

Tear a match.

Place match on chosen page.

the tape.

Tape match to page, allowing the top of the match to stick out a few millimeters.

Look...

The note book is ready for use.

iting your ideas and thoughts into your te book

Use it daily and spontaneously without editing.

When the note book is used and complete, leave at aside for some time.

One day, find it and look though it.

l embarrassed by your writing, you to get rid of it. Prepare for DIY burning.

Strike the match.

Make sure the match is burning.

Watch the note book start to burn.

it burn.

Keep watching...

Make sure all the pages are burning.

You may decide to keep the ashes

In case you worry about history...This DIY book burning, step by step procedure will hel you deal with posterity related anxiety. Be prepared and use caution with matche

GULLIVER TRAVELS AND ALICE IS OUT OF FASHIO
DEFY OLD AGE AND DEATH. WHAT TO PACK and HOW TO TRAVEL like Gulli
At the age of 139, Alice finds herself an old maid stuck in Wonderla
while Gulliver, 278, feels alive, active, and keeps fit traveling arou

ize and weather can change so keep it simple and wear modular outfits, after breakfast r
apaya skin on your face and let dry. wash off. always keep foot to mouth, hand on food a
our money where your art is. follow control and generosity regulations. if pleasant please
lease. travel light and homeless. do not eat everything that flies. avoid baroque cuisine.
olor coordinate as often as possible. practice good intentions and avoid bad taste. to
npress, laminate. MOISTURISE and avoid electric lipsticks. do not be afraid to masturbat
void the melodramatic moderate center. join the weather modification organization. practi
on-hurtfulness and truthfulness. take only planes with olympic size swimming pools. go t
ed early. sample often and be as transdisciplinery as possible. always stop when you see
URFACE WORKS sign. tip without thinking or twitching.avoid growing or shrinking too fas
e proportionally patient. use buoyancy pills only when diving.avoid public gatherings.
evelop syllabus for funny theories and ideas. avoid purgatory. never eat heterogeneous n
n a bar. to be more aerodynamic keep your hair short. enjoy artificial good looking space
llers in moderatio.use anti-frost eye ball cream only when under zero. install light at the
ottom of your bags so you can see what you are doing.......

After acquiring Jesus's foreskin, we will be proceeding in a similar fashion as one would with a skin graft, a porcine xenograft skin or a cultured autograft keratinoctes (in this case it would be a cadaveric allograft skin).

Using the initial biopsy specimen, we will be able to grow enough skin for the production of exclusive, luxurious and unique garments made of Jesus's dermis. DERMESUS is an Ananatural Production subsidiary.

- Dolce vita (the turtle neck

This genetically cultured fabric couture is available in olive oil color ███. Besides the custom made line, the following cuts are available in S,M, L and XL:

- Hooded T

ou find the above mentioned idea terribly upsetting, these glossy, sticky, smooth, mess
e and easy to use tomato, egg and paint stickers can be thrown in anger and disgust.
s demonstration of demonstration is a convenient and controlled act of expression and
ellion is tested, safe and fun.

aprox. 30x30cm colour vinyl stickers.works on any flat, dry surface.

Michael Rakowitz expresses himself in the field of 'social sculpture' with works in which poetry and pragmatism create suggestive parallels. The works often take shape in urban space, through the 'free' element that binds us all together, namely air. As something shared, as a sculptural, architectural and political medium, air is at the heart of *Dull Roar* (2005), in which drawings and sculptures provide the spectator with views of Pruitt-Igoe, a modernist residential complex in St Louis, demolished in 1972. A model of the building is rhythmically inflated and deflated, rising up and then collapsing as a metaphor for the exploding of both buildings and ideas. (*RP*)

b. 1973, Great Neck-New York, United States
Lives and works in New York

Solo Exhibitions
Dull Roar, Lombard-Freid Fine Arts, New York, April 21 – March 28, 2005
Special Project – Winter 2000: Climate Control, P.S.1 Contemporary Art Center, Long Island City-New York, November 19 – January 31, 2001

Group Exhibitions
Safe: Design Takes On Risk, MoMA The Museum of Modern Art, New York, October 16 – January 2, 2006
The Interventionists, Mass MoCA, North Adams (MA), May 30 – March 21, 2005

Bibliography
C. Christov-Bakargiev, *Michael Rakowitz. Circumventions*, onestar press / Dena Foundation for Contemporary Art, Paris, 2003
J. Drobnick, "Platefuls of Air," *Public*, No. 30, Toronto, Winter 2004, pp. 175-193

pp. 385-387: *Dull Roar*, 2005
Courtesy the artist and Lombard-Freid Projects

*Modern Architecture died in St. Louis Missouri on July 15, 1972 at 3:32
pm (or thereabouts) when the infamous Pruitt-Igoe scheme, or rather several
of its slab blocks, were given the final coup de grâce by dynamite.*

-Charles Jencks, The Language of Post-Modern Architecture

*The hush, like that of a football crowd awaiting the outcome of a crucial
place kick in the last seconds of a bowl game, was ended by sharp
explosions. As the reinforced steel and concrete building crumbled into
rubble a spontaneous shout arose from the spectators.*

-St. Louis Post-Dispatch, April 22, 1972

October 28, 1963: New York's Pennsylvania Station, designed by McKim, Mead & White, is demolished to make way for Charles Luckman's Madison Square Garden. Amid a sea of protesters, architect Phillip Johnson is seen holding a sign reading: "Don't Demolish It, Polish It."

1956: Pruitt-Igoe opens to tenants. Lack of federal funding forced Yamasaki to severely compromise his original plan, eventually leading to the deterioration and disappearance of public features like playgrounds, gyms, and landscaping. Spaces were frequently vandalized and the projects quickly fell into disrepair.

1951: Minoru Yamasaki, of the architecture firm Leinweber, Yamasaki & Hellmuth, designs the Pruitt-Igoe housing projects in St. Louis.

September 11, 2001: Minoru Yamasaki.s World Trade Center buildings are destroyed in a terrorist attack.

July 15, 2001: The defunct Brooklyn Union Gas Towers, two identical 40-storey structures in Greenpoint, Brooklyn, are imploded. Residents from throughout the city view the public event.

March 17, 1974: Modernist architect Louis I. Kahn is found dead in the men's lavatory in the Amtrak terminal of New York City's new Penn Station. Bankrupt and without any identification on his person, he lay in a morgue unidentified for three days. Kahn's death occurs on the anniversary of the first implosion of Yamasaki's Pruitt-Igoe housing project.

February 11, 1968: Madison Square Garden
opens atop the new Pennsylvania Station,
reduced to a subterranean transit hub.

1971: St. Louis city officials meet to discuss
the problematic situation of the Pruitt-Igoe
housing project and its future.

March 16, 1972: The Dore Wrecking Company
of Kawhawklin, Michigan, implodes the first of
Pruitt-Igoe's 33 buildings, an experiment meant
to determine what, if anything, of the housing
project could be rescued.

April 21, 1972: The first public destruction
of the buildings occurs, the dynamite tearing
through the concrete amid a sea of spectators,
many of whom lived in Pruitt-Igoe.
The implosion becomes a media event,
broadcast nationally.

July 15, 1972: Complete demolition of Pruitt-Igoe commences
in earnest, the process lasting more than one year. Reached
for comment while working on a new project in Lower
Manhattan, Yamasaki states: "I didn't think human beings
could be so destructive." The rubble is carted off to serve as
landfill for luxury homes being built in the suburb of Ladue,
Missouri — the wealthiest and most expensive
neighborhood in North America.

October 1972: Henry Dreyfuss, an industrial designer
whose products included the Hoover Constellation, a
spherical vacuum that hovered on a cushion of its own
air, commits suicide with his wife Doris.

Araya Rasdjarmrearnsook's work is permeated by a nostalgic sense of loss, but a loss which can be made good, thanks to the dignity of the artistic gesture, through a sincere and thorough dialogue with matters of life and death. In *The Class* (2005), performed at the Institute of Pathological Anatomy of the University of Turin, the artist takes on the role of a teacher addressing a class of corpses with a lesson on the mystery of death. In a world which tends to repress the idea of death, and to avoid all contact with the dead body, as well as to "prettify" death in order to make it more socially acceptable, this demure conversation emerges as an attempt to re-establish an honest and respectful relationship with the feelings of desperation linked to loss, emphasizing all our vulnerability and suggesting the importance of reinstating death in our everyday consciousness. (*COB*)

b. 1957, Trad, Thailand
Lives and works in Chiangmai

Solo Exhibitions
Lament, Tensta Konsthall, Stockholm, August 30 – October 26, 2003
Why Is It Poetry Rather than Awareness?, The National Gallery, Bangkok, December 21 – 28, 2002

Group Exhibitions
Chi muore desidera restare, chi vive si prepara a partire, Thai Pavillion, LI Esposizione Internazionale d'Arte, La Biennale di Venezia, Giardini, Venice, June 12 – November 6, 2005
Poetic Justice / Sürsel Adalet, 8th Istanbul Biennial, Hagia Sophia Museum, Istanbul, September 19 – November 16, 2003

Bibliography
B. Mertens, "Death in Venice: Montien and Araya," *ArtAsiaPacific*, No. 45, New York, Summer 2005, pp. 40-41
Those dying wishing to stay, those living preparing to leave, Office of Contemporary Art and Culture, Bangkok, 2005, pp. 10-13

pp. 389-391: Project for the *T1* catalog

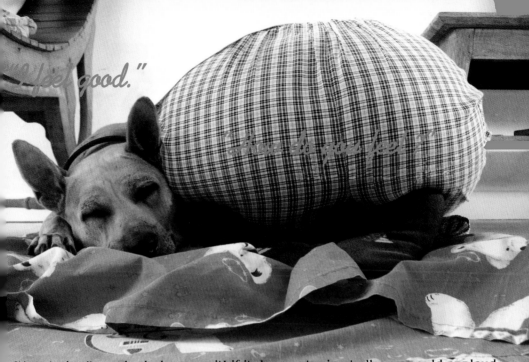

"I feel good."

"How do you feel?"

It's art, don't you look down on it! if it does not rain at all, you could applaud or do whatever you want, simply because it is art.

The dog I keep walks over to press itself against my thigh. The friction of the fresh thigh of the young Thai bitch rubbing against the withering white calf of the middle-aged Thai female generates the realization that this is its mealtime.

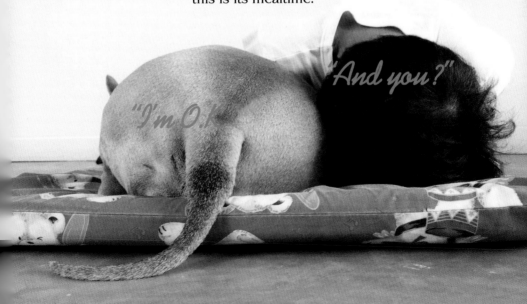

"And you?"

"I'm O.K."

Last night I woke up in the middle of the night with a thought.....that I ought to magically change a crippled dog into a king. The bedside lamp douses its light, distrusting my idea of changing the rashes and wounds on the skin of the dog into a gorgeous cloak.

Oh, my Lord Buddha......not tonight. That the moon shone in beauty through the throng of dark clouds was a glory in itself! Let nothing ruffle my mood tonight, with everything so fair and fine.

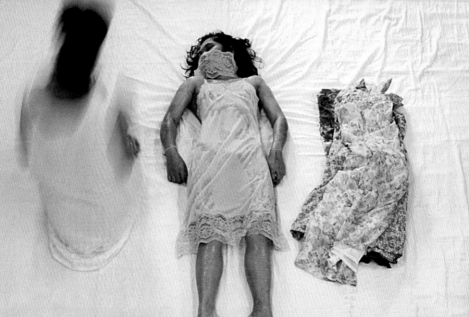

One night, I went there again. The bodies stretched out stiffly, as always.
The bodies allow themselves to be covered by brightly colored drapes
knowing perfectly well that it is unbecoming. "Death should be
dressed in black," a body reflects. "But, well, just for tonight."
Late night wind wafted past, fresher and cooler than in that dark hall.
Mist, oh, mist have you stopped breathing?

In his large, two-colored photographs, the Californian artist David Ratcliff manipulates images taken from pornography, sales catalogs, Yellow Pages, magazines of interior design and the internet. They take the form of large digital collages which he prints on paper, cuts up and places like masks onto the black painted canvas, and then works on them with a colored spray. This, while still damp, leaves the canvas untouched behind the masks, but runs, blurring the outlines of the superimposed images.

The result – a sort of home-made tracing/carbon copy – is reminiscent of Andy Warhol's silkscreen; using a mix of abstraction and figuration, conceptual rigor and punk, Ratcliff creates a catalog of contemporary images, a cosmology within which man is reduced to a purely decorative element. Like that of Brett Easton Ellis, also from Los Angeles, his work has an elegant formal violence, and reflects a passion for lists of symbols which become an inexhaustible source of cultural critique. (*IB*)

b. 1970, Los Angeles, United States
Lives and works in Los Angeles

Solo Exhibitions
I find a Burberry scarf and matching coat with a whale embroidered on it (something a little kid might wear) and it's covered with what looks like dried chocolate syrup crisscrossed over the front, Team Gallery, New York, April 7 – May 7, 2005

Group Exhibitions
5 X U, Team Gallery, New York, June 24 – July 22, 2005

Bibliography
K. Johnson, "The Listings: April 22 – April 28," *The New York Times*, New York, April 22, 2005, p. E23
R. C. Baker, "Spring Preview: David Ratcliff," *The Village Voice*, New York, March 2 2005

pp. 393-395: Project for the *T1* catalog

Charm Bracelets

BLACK CAKE

Horses & Ribbons

BLACK LEATHER SOFAS AND CATTAILS

PORCELAIN

Fireplaces

Kimono Forest

Mirrors

Embroidery

Tack & Gentry

FLOATATION

Stereo Remotes

Venetian Blinds

ABSTRACT PAINTING (FLOOR)

Television

Abstract Painting (Burberry)

CHEERS

6-12

Man With No Name

Rocky Mountain High

Humor and fantasy characterize the work of the Thai artist Porntaweesak Rimsakul, who uses his imagination to transform ordinary household objects into fantastical beings or places. *The Dinosaurs* (2002) are in fact teapots with added paws and ponytails. Inside each is a battery that propels the 'little creatures' through the exhibition space, following the drift of the artist's imagination. Rimsakul's works are not just full of energy and humor; they also make an overt critique of urban life, as it becomes invisibly more complex behind its visible structures. In *Pet* (2005), he creates a series of small interactive aggressive and humorous objects to indicate our Pantagruel syndrome. (*CPM*)

b. 1979, Udonthani, Thailand
Lives and works in Bangkok

Solo Exhibitions
Feeling, Bangkok University Art Gallery, Bangkok, March 13 – April 2, 2003

Group Exhibitions
Fool's Paradise / La Fête 2005, The Art center Chulalongkorn University, Bangkok, June 9 – July 9, 2005
Have We Met, The Japan Foundation Forum, Tokyo, December 11 – January 30, 2005

Bibliography
M. Nakamura, "A collaborative exhibition by Asian curator sought to explore the relationship of people from across of Asia," *Asia-Pacific Perspectives: Japan* +, Vol. 3, No. 1, Tokyo, May 2005, pp. 28-29
Arin Rung Chang, "Recycled Art," *ESQUIRE*, Thai edition, Vol. 10, No. 1, Bangkok, January 2004, pp. 32-37

pp. 397-399: Project for the *T1* catalog

พรทวีศักดิ์ ริมสกุล
PORNTAWEESAK RIMSAKUL

Website : www.Pontaweesak.com
Email : Tee_bangkok@yahoo.com, Porntawesak@hotmail.com
Born : 14-02-1979
Education
2002 : B.F.A. VISUAL ARTS, Bangkok University, Bangkok, THAILAND

Lives and works in Bangkok

Solo Exhibitions
2003 : "Feeling", Bangkok University Art Gallery, Bangkok, THAILAND
Residency Program
2004 : École nationale Supérieure des Beaux-Arts, Paris, FRANCE

Selected Group Exhibitions

2005 : "Fool's paradise/ La Fête2005", The Art center Chulalongkorn University, Bangkok, THAILAND
: "Have We Met,Bangkok?", The Japan Foundation Art Space, Sermmit Tower10F, Bangkok, THAILAND
: "The Mosaic of Genius:M.A.P", Art center of Silpakorn University, Wang thapra, Bangkok, THAILAND
: "The Way to Art", Gallery of The Faculty of Painting Sculpture and Graphic Arts, Silpakorn University, Bangkok, THAILAND
: "Have we met", The Japan Foundation Forum, Tokyo, JAPAN
2004 : "à la G.G./At galerie Gauche", École nationale Supérieure des Beaux-Arts, Paris, FRANCE
: "Thailand in August: welcome to soi sabai", Curate by FUMIYA SAWA,Graf media gm, Osaka, JAPAN
: "Here&Now", Curate by NATHALIE BOUTIN, Blue building, pomprab, Bangkok, THAILAND
: "Oh!", Old factory, Rama4 ,Klongteuy, Bangkok, THAILAND
: "Vitalistic Photography3", The National Gallery, Bangkok, THAILAND
: "3Finnish Artist", Art center of Silpakorn University, Wang thapra, Bangkok, THAILAND
2003 : "Bangkok-Bremen", Bangkok University Art Gallery, Bangkok, THAILAND
: "ASSORTED ASIAN TIGERS", Curate by FUMIYA SAWA, Proud Gallery10 Greenland street, London, ENGLAND
: "POINT", Space contemporary art, Bangkok, THAILAND
: "Art for all", Muaglek Paradise and resort, Saraburi, THAILAND
: "Thailand to you", Giarolli Optik, Stephansdom, Heidentürme, Wein, AUSTRIA
: "Actes de Fe I de Generositat D'Empordà ", La bisbal, Girona, SPAIN
: "ปัญญา/La sagesse", Atelier art gallery, Bangkok, THAILAND
2002 : "จินตภาพจากพระพุทธศาสนา/ IMAGES OF DHARMA", Le Toit de La Défense, Paris La Défense, FRANCE
: "ปัญญา /La sagesse", Le Toit de La Défense, Paris La Défense, FRANCE
2001 : "ข้างใน-ข้างนอก / Inside-Outside / Dedans-Dehors", Galerie Crous-Beaux Arts, Paris, FRANCE
: "เอเลี่ยน/ALIEAN (Gener)Ation: E-san Version", The Art Gallery, Faculty of Fine Arts, Khonkean University, Khonkean, THAILAND
2000 : "NEAREST DISTANCE", COLLABORATED 5 UNIVERSITY, SRINAKHARINWIROT Fine Arts Hall, Srinakharinwirot University, Silpakorn University, Bangkok, THAILAND
: "ต่างตา /Tang-Down", Si-Am Art Space, Bangkok, THAILAND
: "กาลเทศะ /Social Grace", Curate by PRAPON JOE KUMJIM, BANGKOK UNIVERSITY ARTGALLERY, Bangkok, THAILAND
1999 : "Snow", COLLABORATED with SASKIA BREITENICHER, BANGKOK UNIVERSITY ART GALLERY, Bangkok, THAILAND

Miguel Ángel Ríos' video installations address complex geopolitical issues through a poetic lens that focuses on the daily life, the cultures and histories of marginal societies. *A Morir ('Til Death)*, 2003 makes use of the popular game of spinning tops in Mexico. Filmed from close to, so that they take on gigantic, anthropomorphic proportions, dozens of booming tops spin off on random courses, each with its own dynamic, as metaphors for life as a game, of the struggle for territory and the futile elegance of chance. "As a quasi- abstract video ballet, *A Morir* is pure pleasure to watch, but the little points to the piece's serious metaphorical message: existence is continual struggle, fate is unpredictable and frequently unjust, and the game of life must be played to its inevitable end." (R. Rubinstein) (*RP*)

b. 1953, Catamarca, Argentina
Lives and works in Mexico City and New York

Solo Exhibitions
A morir ('Til Death), Hirshhorn Museum and Sculpture Garden, Washington DC, June 2005
A morir ('Til Death), LACE Los Angeles Contemporary Exhibition, Los Angeles, October 15 – December 10, 2004

Group Exhibitions
Marking Time: Moving Images, MAM Miami Art Museum, Miami, May 13 – September 11, 2005
ECO: Arte contemporáneo Mexicano, Museo Nacional Centro de Arte Reina Sofía, Madrid, February 8 – May 22, 2005

Bibliography
R. Rubinstein, "A Serious Game," *Art in America*, No. 6, New York, June-July 2005, pp. 170-171
O. Sanchez, *ECO: arte contemporáneo mexicano*, Museo Nacional Centro de Arte Reina Sofía, Madrid; Turner, Madrid, 2005, pp. 86-87

pp. 401-403: Stills from the video *A Morir ('Til Death)*, 2003
Courtesy Marco Noire Contemporary Art, Turin

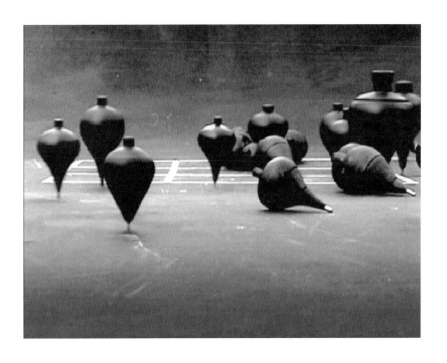

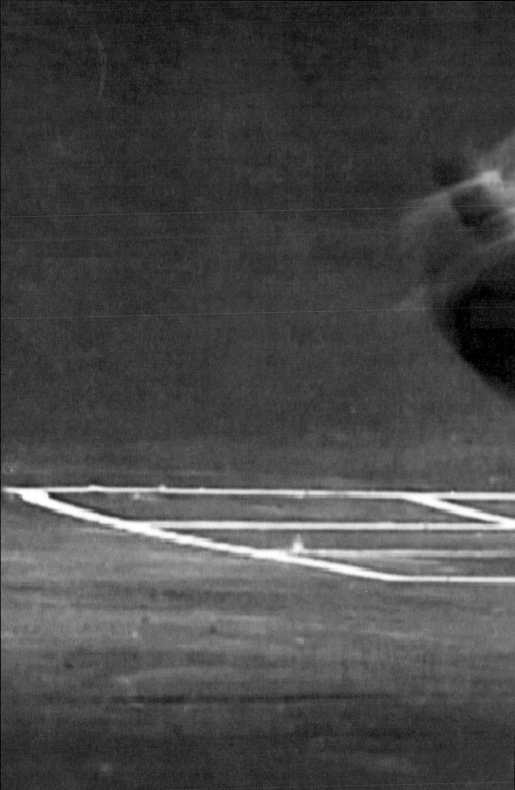

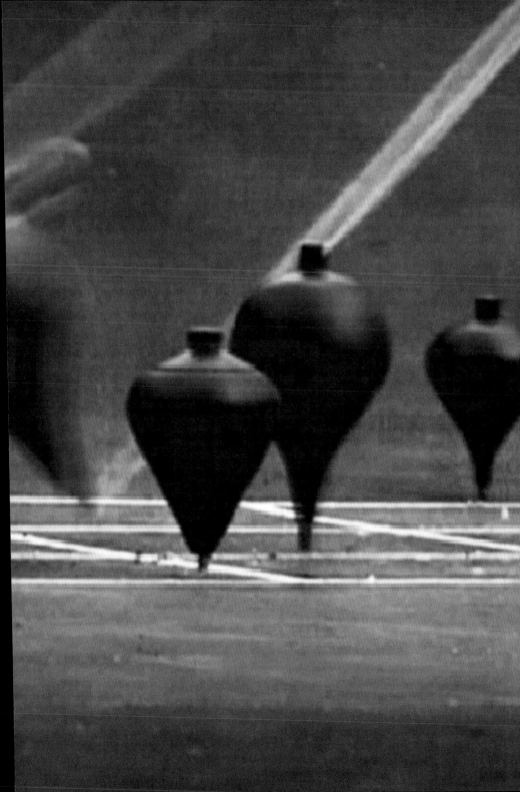

Sterling Ruby elaborated his complex language through the combination of various techniques – photography, collage, video, drawing, sculpture and performance. Like so many parallel universes, his works make use of salvage, and instinctive gestures, through which he investigates the amorphous nature of the spaces and activities of city suburbs. These eerie, vandalized industrial landscapes provide material for a crude and fluid creativity, also open to popular elements, which are manipulated and assembled, together with references to art history, psychology and politics. Through a process of cross-fertilization, the artist takes the spectator into a world of strong emotions, born of the clash between freedom and repression, expression and frustration, individuality and the collective spirit. The materials, and gestures, from which Ruby creates his installations underline his interest in an underground dimension characterized by violence, drugs and frenetic sex. Intensely expressionistic and physical in their use of material, his installations seem to self-generate from a sheer explosion of violence. (*IB*)

b. 1972, Bitburgh, Germany
Lives and works in Los Angeles

Solo Exhibitions
This Range, Guild & Greyshkul, New York, May 28 – June 25, 2005
New Work, Foxy Production, New York, April 14 – June 4, 2005

Group Exhibitions
5 X U, Team Gallery, New York, June 24 – July 22, 2005
Resonance. Contemporary Performance Art, Nederland Instituut voor Mediakunst. Montevideo;
Time Based Arts, Amsterdam, February 4 – May 6, 2005

Bibliography
C. LaBelle, "Behind the Pedestal - 'Kirsten Stoltmann and Sterling Ruby'," *Frieze*, No. 81, London,
March 2004, pp. 102-103
H. Cotter, "Art in Review; 5 x U," *The New York Times*, New York, July 22, 2005, p. 32

p. 405: *Figure in Kiln*, 2005
Transient Bed of John, 2004
pp. 406-407: *Transient Trilogy*, 2005
Courtesy the artist; Foxy Production, New York; MARC FOXX, Los Angeles; Galerie Christian
Nagel, Köln – Berlin

Aïda Ruilova's tightly edited video montages are multifaceted: jewels, falling somewhere between the montage of Sergei Eisenstein and the hysteria of Andrzej Zulawski. Fracturing sound and image, her single-channel videos collapse an intense amount of information into a short frame, since these psychologically charged scenes appear for mere seconds as brief glimpses. Her work reveals a strong interest in music (she previously performed with the band Alva,) creating sequences that combine disturbing staged visual imagery with exaggerated vocals and other sounds. "Through her well-aimed, lightning-fast edits, Ruilova summons forth a mysterious shut-in world that emerges from the cracks of a splintered mise-en-scène. These are gasped, spit and hyperventilated shots. Pulverizing real time, then stringing it back together..." (John Kelsey)

b. 1974, Wheeling, United States
Lives and works in New York

Solo Exhibitions
Lets Go, Greenberg Van Doren Gallery, New York, May 4 – June 4, 2005
Aïda Ruilova: Endings, Franklin ArtWorks, Minneapolis, April 9 – May 28, 2005

Group Exhibitions
Uncertain States of America - American Art in the 3rd Millennium, Astrup Fearnley Museet for Moderne Kunst, Oslo, October 8 – December 11, 2005
Greater New York 2005, P.S.1 Contemporary Art Center, Long Island City-New York, March 13 – September 26, 2005

Bibliography
M. Kimmelman, "Youth and the Market: Love at First Sight," *The New York Times*, New York, March 18, 2005
P. M. Lee, "Crystal Lite," *Artforum*, Vol. XLII, No. 9, New York, May 2004, pp. 174-175

pp. 409-411: Project for the *T1* catalog

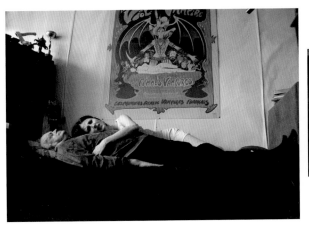

In his work – linked to the experience of space – Hans Schabus sets himself a series of daunting challenges. His sculptures and installations, made by hand with simple, economic means, stem from the artist's own physical and psychic context. Taking his studio as his focal point, together with the work done there, Schabus seems to reflect on the creative act itself. *Astronaut* (2002) shows him digging a narrow tunnel into the floor of his studio in an attempt at escape. Once inside it, he begins to run madly; then, reaching what seems to be the other end, he starts digging again. "The idea of the shaft and escape tunnel was to fill up the whole space of the studio with excavation material. Then I would have the entire studio – space – volume in the form of an escape tunnel" (Schabus.) The film takes the spectator on a journey through the unknown world of underground Vienna, and seems to compare the contemporary artist to an astronaut, locked into a ceaseless and laborious search for the unknown. *(IB)*

b. 1970, Watschig, Austria
Lives and works in Wien

Solo Exhibitions
Das Letze Land (The Last Land), Austrian Pavilion, LI Esposizione Internazionale d'Arte. La Biennale di Venezia, Giardini, Venice, June 12 – November 6, 2005
Das Rendezvousproblem (The Rendezvousproblem), Kunsthaus, Bregenz, November 11 – January 16, 2005

Group Exhibitions
Blickwechsel, Museum Moderner Kunst Kärten - MMKK, Klagenfurt, November 25 – February 20, 2005
White Spirit, 49 NORD 6 EST - Frac Lorraine, Metz, May 15 – 30, 2004

Bibliography
Das Letze Land (The Last Land), Austrian Pavilion, 51st International Art Exhibition, Schlebrügge Editor, Wien, 2005
Hans Schabus. Das Rendezvousproblem, Kunsthaus Bregenz; Eckhard Schneider, Bregenz, 2004

p. 413: *Schacht von Babel (Babel Pit)*, 2002
pp. 414-415: *Schacht von Babel (Bergwerk - Atelier) (Babel Pit – Bergwerl – Studio)*, 2003
Courtesy ZERO, Milan and Engholm Engelhorn Galerie, Wien

A. DŁUGOSZA SAURAU MODENA

KRAJ

RUSSEGGER MARIA TERESA

The work of the Austrian artist Markus Schinwald is based on a fusion of various disciplines, including theatre, fashion and photography. His images, dense with historical, artistic and cinematic references, create a world in which personal experiences and collective memory meet and merge. His interest centers on the many-sided historical and cultural representations of the body, seen as a physical 'place' and also as an interface between public and private. His works' theatrical settings recall the splendor and decline of Viennese history, as well as the city's position as the birthplace of psychoanalysis. The protagonists of his films – often actors and dancers – move like puppets, imprisoned in their clothing, which hinders their movements like so many prostheses, turning them into automata. Schinwald's fragmentary narratives create a disturbing sense of suspension, in which unconnected sound and images seem to run in parallel. (*MVM*)

b. 1973, Salzburg, Austria
Lives and works in Wien

Solo Exhibitions
Tableau Twain, Frankfurter Kunstverein, Frankfurt am Main, September 1 – October 24, 2004
(Moderna Museet Projekt) MMP: Markus Schinwald, Moderna Museet, Stockholm, May 31 – September 2, 2001

Group Exhibitions
I Still Believe In Miracles. Derrière l'horizon, Musée d'Art Moderne de la Ville de Paris / ARC, Paris, May 19 – June 19, 2005
Manifesta 5, Kubo Kutxa Kursaal, San Sebastian, Spain, June 11 – September 30, 2004

Bibliography
M. Heinzelmann, N. Schafhausen, *Markus Schinwald: Format 190 x 260 mm 242 pages incl. poster*, Frankfurter Kunstverein, Frankfurt am Main; Lukas & Sternberg, Berlin - New York, 2004
S. Rollig, "Im Labyrinth der Sehnsüchte/Puzzling the Connoisseur," *Parkett*, No. 61, Zürich, May 2001, pp. 199-201, 202-205

pp. 417-419: Stills from the video *1st part conditional (#1-3)*, 2004
Courtesy Giò Marconi, Milan

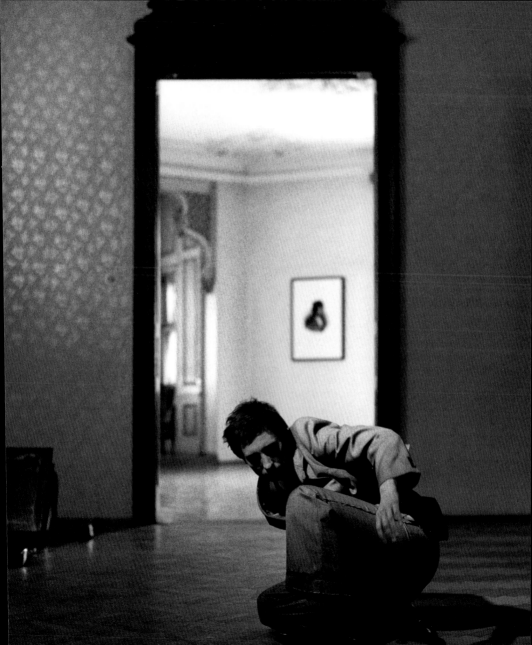

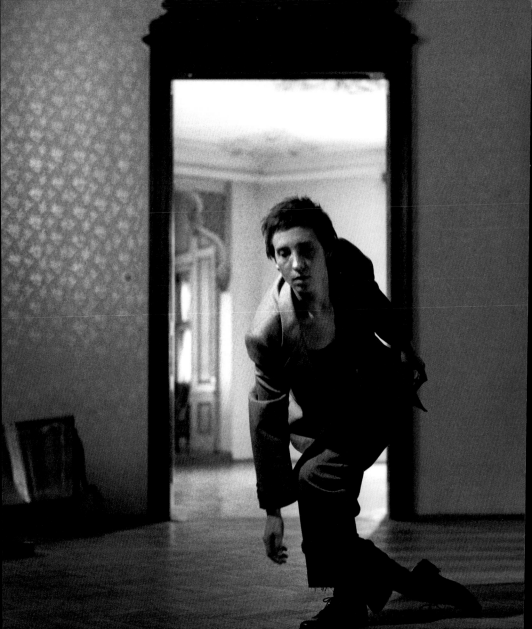

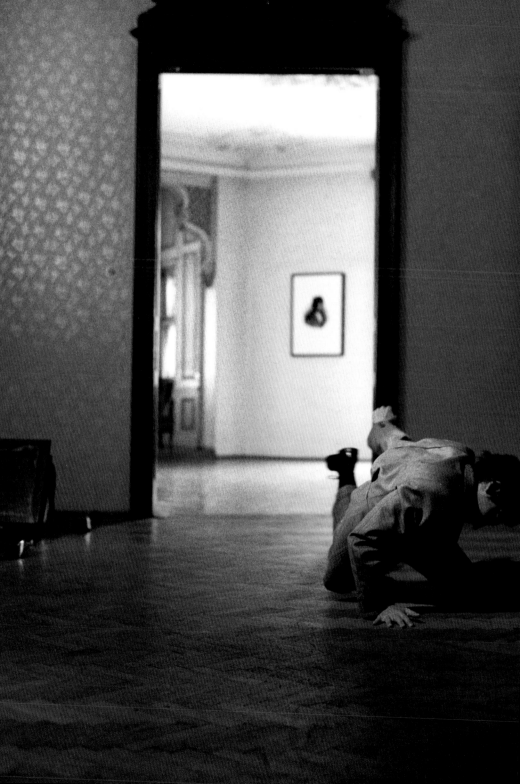

Ahlam Shibli was born in a Palestinian village in the Galilee. Wishing to come to an understanding of her own living conditions, she has dealt in several recent projects with the situation of the Palestinian population under Israeli rule.

Scouts is a series of photographs taken in 2005. For *The Pantagruel Syndrome*, Ahlam is showing part of this series which is concerned with the Palestinians of Bedouin descent who served or are serving as volunteers in the Israeli Army. According to the artist, "the project researches the price a minority is forced to pay to the majority, maybe to be accepted, maybe to change its identity, maybe to survive, or maybe all of this and more." (*MVM*)

b. 1970, 'Arab al-Shibli, Palestine
Lives and works in Haifa

Solo Exhibitions
Lost Time, Ikon Gallery, Birmingham, September 24 – November 9, 2003
Goter, Tel Aviv Museum of Art, Tel Aviv, April 25 – July 3, 2003

Group Exhibitions
Istanbul, 9. Uluslararasi Istanbul Bienali / 9th International Istanbul Biennial, Antrepo n. 5, Istanbul, September 16 – October 30, 2005
NON-SECT RADICAL: Contemporary Photography III, Yokohama Museum of Art, Yokohama, July 17 – September 20, 2004

Bibliography
T. Amano, *The Locus of Gaze*, in *NON-SECT RADICAL: Contemporary Photography III*, Yokohama Museum of Art, Yokohama, 2004, pp. 1-39, 170-171, 174-178, 188, 199-200
J. Berger, U. Loock et al., *Lost Time. Ahlam Shibli*, Ikon Gallery, Birmingham, 2003

pp. 421-423: from the series *Scouts* (*Scout*, 2005): Toba-Zangareia (Palestinian village in Israel) – new road to the soldier quarter, 2.7.2005; al-Laqiya (Palestinian village in Israel) – soldier house, 01.6.2005; Beer al-Maksor (Palestinian village in Israel) – soldier house, 1.7.2005; Israeli army camp – Grenade training area, 1.6.2005; Israeli army camp – Grenade training area – waiting room, 1.6.2005; Israeli army camp – sleeping tent, 1.6.2005, Courtesy the artist

In Katrín Sigurðardóttir's works architecture, landscape and complex psychological areas are brought together through the creation of meticulous models of spaces. They speak to us of her particular way of perceiving space, both physical and metaphorical, evoking the architecture of dreams and memories. The fact that she grew up in the empty landscapes of Iceland has clearly influenced her sense of space. The main themes of her art are 'memory and distance, spaces of elusion, nostalgia and deception, spaces that are at once compelling and repulsive, evoking the desire to escape, but "whether that escape is towards or away from, remains ambiguous" (Sigurðardóttir.) Her most recent installations appropriate and transform common architectural features such as walls, shelves, rooms and cubbyholes, into so many disquieting spaces. (*IB*)

b. 1967, Reykjavik, Iceland
Lives and works in New York and Reykjavik

Solo Exhibitions
Katrín Sigurðardóttir a Private Exhibition, Hafnarhus, Reykjavik Art Museum, Reykjavik, August 21 – October 3, 2004
Katrín Sigurðardóttir. D-segni, Fondazione Sandretto Re Rebaudengo, Turin, April 22 – May 16, 2004

Group Exhibitions
Odd Lots: Revisiting Gordon Matta-Clark's "Fake Estates", White Columns, New York, September 9 – October 15, 2005; Queens Museum of Art, New York, September 11 – January 22, 2006
The Here and Now, The Renaissance Society at the University of Chicago, Chicago, January 16 – February 20, 2005

Bibliography
E. Heisler, "Of Landmarks and Birthmarks: the work of Katrín Sigurðardóttir," *n.paradoxa*, Vol. 15, London, 2005, pp. 80-87
G. Volk, *Near and Far: On Katrín Sigurðardóttir's sculptures*, in *Katrín Sigurðardóttir*, The Reykjavik Art Museum, Reykjavik, 2004

pp. 425-427: Project for the *T1* catalog

The interior of Guðbjartur Sigurðssons 1956 Desoto Fireflite sedan, in front of Langahlíð 11, Reykjavík, Iceland, at midnight on June 28th, 2005.

A maquette made from drafts of the proposed residence [...] Reykjavík (designed by Guðmundur Þorláksson in 1926, but never bu[...] [...] May [...] throwing it off the roof of 475 Keap Street, Brooklyn, New York, on April 24th, 2005.

A vagabond turtle, found at Via Modane,16, outside of the Fondazione Sandretto Re Rebaudengo on June 7th, 2005.

Mikhael Subotzky is a South African artist whose medium is documentary photography. *Die Vier Hoeke* (*Four Corners*, 2004) is a series of panoramic photographs taken in the prison at Pollsmoor, near Capetown. A detention center whose prisoners have included the leader of the African National Congress and first president of South Africa after the end of Apartheid, Nelson Mandela, Pollsmoor is the largest high security prison in South Africa, with 1,000 staff and 8,000 detainees.

By documenting the conditions in which these latter live, Subotzky draws attention to the problem of the prison, an institution which is deeply rooted in South African culture, a symbol of the racism and oppression which have characterized the history of his country. During the time he spent in the cells – teaching the prisoners about photography – Subotzky took a series of snapshots which he then brought together digitally into panoramas, providing a novel insight into a place which is usually locked away from the public's view. (*MVM*)

b. 1981, Cape Town, South Africa
Lives and works in Cape Town

Solo Exhibitions
Mikhael Subotzky, The Goodman Gallery, Johannesburg, February 18 – March 11, 2006
Die Vier Hoeke, Pollsmoor Maximum Security Prison, Cape Town, April 27, 2005

Group Exhibitions
Click. Photographic Show, The Goodman Gallery, Johannesburg, July 23 – August 27, 2005
Vyf Kurators, Vyftien Kunstenaars (Five Curators, Fifteen Artists), KNK National Art Festival, Klein Karoo, March 25 – April 2, 2005

Bibliography
S. O'Toole, "Cape Town Prison Blues," *ID Magazine*, New York, September-October 2005, pp. 64,71
C. Greeff, "Inside Out," *Sunday Times Magazine*, Johannesburg, April 17, 2005, pp. 9-11

p. 429: *Johnny Fortune*, 2004, Pollsmoor Maximum Security Prison
pp. 430-431: *Cell 508*, 2004, A Section, Pollsmoor Maximum Security Prison; *Cell 508b*, 2004, A Section, Pollsmoor Maximum Security Prison; 360 degree panoramic photograph
Courtesy The Goodman Gallery

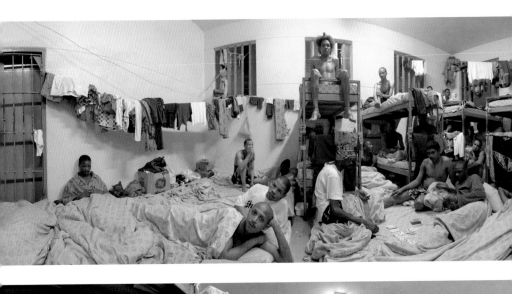

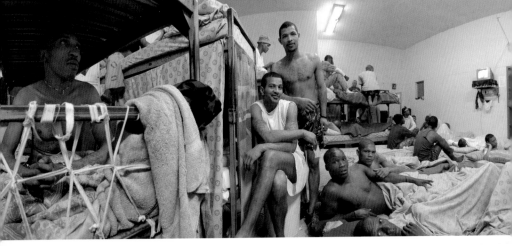

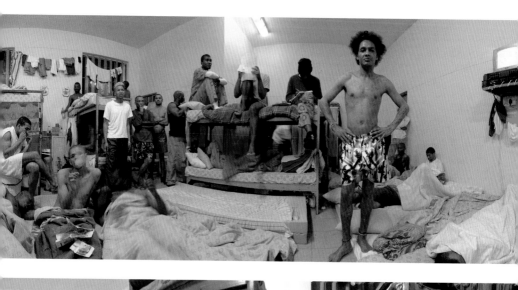
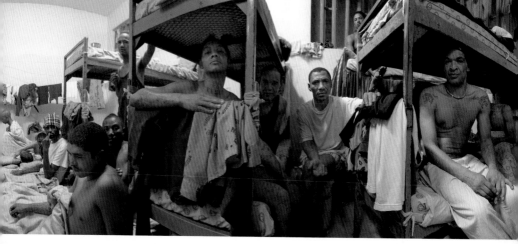

Javier Téllez's installations investigate notions of normalcy and pathology. His works establish links between marginal conditions, such as mental illness or immigration, and the systems set up to cure or control them. The video installation *The Greatest Show on Earth* (2005) consists of a circus tent, inside which we see a video-screening of a public event that Téllez organized for *inSite 05*, with the collaboration of the patients of CESAM, a Mexican Psychiatric Hospital. The event was conceived as a mini circus, with patients wearing costumes and animal masks, and included as its main act the launching of David Smith, the world record-breaking human cannon ball, across the Mexico/USA border. Transgressing the frontier between Mexico and the United States – a gesture as dazzling as it is symbolic – the work reflects on the tensions triggered off by divisions and borders, and on the tactics used by illegal immigrants, as paradoxes of our time. (*AV*)

b. 1969, Valencia, Venezuela
Lives and works in Long Island City-New York

Solo Exhibitions
S-t-e-r-e-o-v-i-e-w, Bronx Museum of the Arts, New York, February 3 – June 5, 2005
A Hunger Artist, Museo Carrillo Gil, Mexico City, February 28 – March 5, 2004

Group Exhibitions
Biennale of Sydney - On Reason and Emotion, Museum of Contemporary Art, Sydney, June 4 – August 15, 2004
Emotion Eins Gruppenausstellung in Kooperation mit der Ursula Blickle Stiftung, Frankfurt Kunstverein, Frankfurt am Main, June 8 – July 18, 2004

Bibliography
R. Zamudio, "Javier Téllez: Institutionalized Aesthetics," *Flash Art International*, No. 225, Milan, July-September 2002, pp. 96-97
G. Brett, *Learning from Spiders*, in *Plateau of Humankind*, XLIX Esposizione Internazionale d'Arte. La Biennale di Venezia, Venice; Electa, Milan, 2001, pp. 248-251

pp. 433-435: Project for the *T1* catalog

JAVIER TÉLLEZ

&

THE PATIENTS OF CESAM

CENTRO DE SALUD MENTAL DE MEXICALI

PRESENTING

THE GREATEST SHOW ON EARTH

FOR THE FIRST TIME FLYING OVER THE US - MEXICO BORDER

1 ONLY PERFORMANCE

PLAYAS DE TIJ

SAT. A

THE HUMAN CANNONBALL
DAVID SMITH

A LIVING PERSON SHOT THROUGH SPACE WITH VIOLENT VELOCITY FROM THE MOUTH OF A MONSTER CANNON

THE SENSATION OF THE CENTURY!

NA
G 27

3 PM
RAIN
OR
SHINE

Avdei Ter-Oganyan's work aims to set up a direct dialog with the spectator. His work for TI, *The Receptionist* (2005), is an installation whose subject is the people who work in exhibition spaces. This work, to be shown at the entrance to the Fondazione Sandretto Re Rebaudengo, consists of two large colored photographs reminiscent of advertisements, together with 20 other black and white images of the female staff working in the museum. Ter-Oganyan has also installed a camera showing the museum staff about their daily business, in real time, thus transforming the work of the Reception staff into a work of art. Avdei's son, David, is also an artist and author of provocative and radical works such as sculptures/bombs which, instead of exploding, transform the spectator's experience into a moment of anxiety. (*MVM*)

b. 1961, Rostov-na-Donu, Russia
Lives and works in Prague and Berlin

Solo Exhibitions
Project of Assertion of the New School of Contemporary Art and Some Other Works by Avdei Ter-Oganyan 1982 – 2005, Solvberget StavangerKulturhus, Stavanger, June 2005

Group Exhibitions
Russia 2. Special Projects, 1st Moscow Biennial of Contemporary Art, Central House of Artists, Moscow, January 1 – February 28, 2005
Le Fou Dédouble, Central House of Artists, Moscow, December 7 – January 11, 2000 (touring)

Bibliography
M. Nemirov, *A.S. Ter-Oganyan: Life, Fate and Contemporary Art*, GIF, Moscow, 1999

b. 1981, Rostov-na-Donu, Russia
Lives and works in Moscow

Solo Exhibitions
David Ter-Oganyan, Marat Guelman Gallery, Moscow, November 11 – December 4, 2004

Group Exhibitions
Dialectics of Hope, 1st Moscow Biennial of Contemporary Art, Moscow, January 1 – February 28, 2005

Bibliography
I. Budraitskis, *David Ter-Oganyan*, in *1 МОСКОВСКАЯ БИЕННАЛЕ СОВРЕМЕННОГО ИСКУССТВА / 1 Moscow biennale of contemporary art 2005: dialectics of hope*, ArtChronika, Moscow, 2005, pp. 198-201

p. 437: *Young Atheist*, 1998
pp. 438-439: *Toward the Object*, 1992, photo I. Mukhin: p. xxx: *Drunk*, 1996, photo A. Erofeev

YOUNG ATHEIST. 1998
During the non-profit program of Art-Manege art fair in Moscow, Ter-Oganian organised the workshop "Blasphemy" with his pupils from the School of Contemporary Art. Russian icons were publicly destroyed with an axe and the icons were desecrated with inscriptions like "God is shit", etc. After this performance the author was accused blasphemy and was compelled to flee to the Czech Republic where he applied for exile.

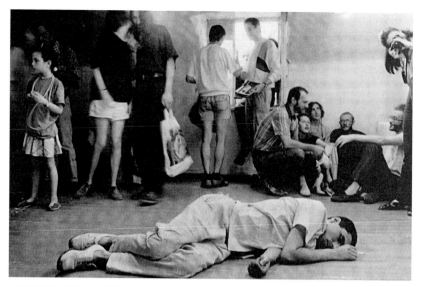

TOWARDS THE OBJECT. 1992
The body of the drunken author, fallen asleep on the floor. Exhibition in Trechpudny
Gallery.

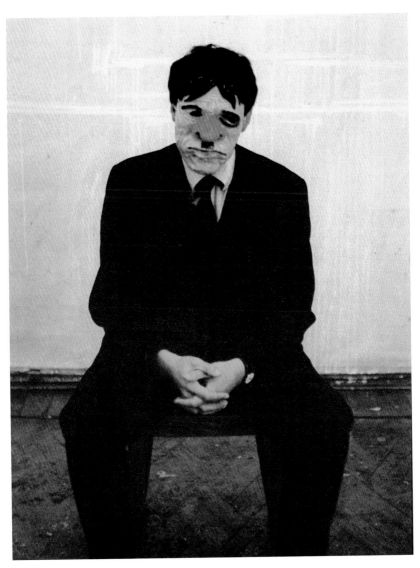

THE DRUNK MAN. 1996
Performance. The sober author pretended to be drunk.

TV Moore's videos and films are made up of eclectic subjects and images, focusing on a range of archetypes and "disconnections." Combining various tropes of the cinema, theatre, video and television, Moore's images enter into a dialog with a medley of genres. He is interested in the space between the staged and the real, the documentary and the directed. *The Neddy Project* (2001–04) was inspired by two Australian bushrangers, who coincidently share the same name. Here, cardboard props and sets stand in for simple digital effects. From mountaintop battles to smokey "ballets," Moore sets up intense and hallucinatory situations in which the narrative is continually re-established. (*RP*)

b. 1974, Canberra, Australia
Lives and works in Los Angeles and Sydney

Solo Exhibitions
The Dead Zone, roslyn oxley9 gallery, Sydney, May 27 – June 26, 2004
The Neddy Project, Artspace, Sydney, March 4 – May 27, 2004

Group Exhibitions
MCA Collections: New Acquisitions in Context, Museum of Contemporary Art, Sydney, August 19 – November 13, 2005
OSAKA 05. Osaka Art Kaleidoscope 2005, Art Intertwining: Kaleidoscopic Thoughts and Imagery, CASO Contemporary Art Space Osaka, Osaka, March 5 – 24, 2005

Bibliography
K. Rhodes, "TV Moore: I am somewhere in the city," *Eyeline: Contemporary Visual Arts*, No. 55, Brisbane, Australia, Spring 2004, pp. 36-38
F. Armstrong, "TV Moore's Long Takes," *Art & Australia*, Vol. 42, No. 1, Sydney, Spring 2004, pp. 80-83

pp. 441-443: Project for the *T1* catalog

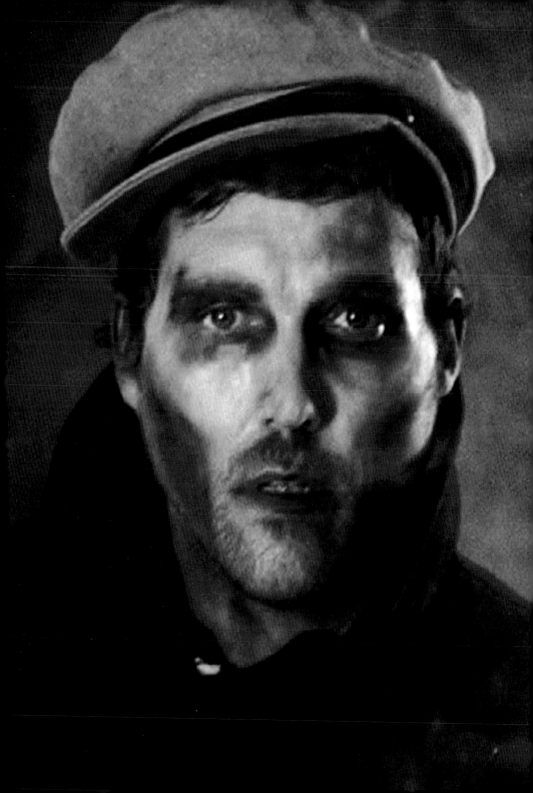

Clemens von Wedemeyer's work moves in the space between cinema and video, producing hypnotic narratives which cause the spectator to adopt new viewpoints, arousing strong emotions and a subtle feeling of suspense. Concentrating on the relationship between the space of the cinema itself, the audience and the making of the single film, the artist reflects upon cinema as a system along the lines of the Situationist tradition of shifting and deconstructing space. According to him, under the reflecting cinema screen could be a lake which accumulates the memories of all the films and all the sensations which the cinema arouses in every spectator... The aim of his work is metaphorically to draw the audience away from the screen (and sometimes push them back into it.) For this exhibition, von Wedemeyer will present a new film in 16 mm, giving a portrayal, in black and white, of a nervous movement performed by one solitary figure. (MVM)

b. 1974, Göttingen, Germany
Lives and works in Berlin and Lipsia

Solo Exhibitions
Big Business, Plattform, Berlin, July 2003
Cinema Divisible – Clemens von Wedemeyer, Galerie Jocelyn Wolff, Paris, October 2 – November 8, 2003

Group Exhibitions
Dialectics of Hope. 1st Moscow Biennial of Contemporary Art, Former Lenin Museum; Schusev State Museum of Architecture; metro station Vorobyevy Gory (Sparrow Hills), Moscow, January 1 – February 28, 2005
Projekt Migration / Project Migration, Rudolfplatz; Friesenplatz; Kölnischer Kunstverein, Köln, October 1, 2004 – January 15, 2005

Bibliography
C. von Wedemeyer, *Filmmaterial 1 (Otjesd)*, Revolver Verlag, Frankfurt am Main, 2005
S. Ravini, "Mellanvärldar," *Paletten*, No. 259, Stockholm, May 2005, p. 3

pp. 445-447: *To the Redundant Population*, 2004
Dedication translated into five languages [of the first translations of the communist manifesto.]

"My mistake arose from the supposition that whenever the net income of a society increased, its gross income would also increase; I now, however, see reason to be satisfied that the one fund, from which landlords and capitalists derive their revenue, may increase, while the other, that upon which the labouring class mainly depend, may diminish, and therefore it follows, if I am right, that the same cause which may increase the net revenue of the country, may at the same time render the population redundant, and deteriorate the condition of the labourer."

From: David Ricardo (1817) "On The Principles of Political Economy and Taxation", Chapter 31: On Machinery

TO THE REDUND
БЕСПОЛЕЗНО
DER ÜBERFLÜSSI
ZBĘDNEJ
ALLA POPOLAZ

NT POPULATION

У НАСЕЛЕНИЮ

EN BEVÖLKERUNG

UDNOŚCI

NE SUPERFLUA

Chen XiaoYun's subjects include an investigation into the painful relationship between the individual and a society that is expanding rapidly and constantly changing, as in today's China. Mainly through video films, he emphasises the importance of the role of the artist in the search for possible ways in which the individual can escape. He uses strong, apparently meaningless, almost anarchic gestures. His video *Lash* (2004) features a naked man dragging a large branch of a tree to the top of a mountain. The images are interrupted by flashes of light and accompanied by a pounding, repetitive soundtrack, whose nervy, ceaseless rhythm disturbs the spectator's vision. Interspersed between the troubling images of the naked man are brief, dreamlike flashes – the muzzle of a white horse or the wings of a butterfly, images that seem intended to suppress for a moment the violence of what appears to be a personal pilgrimage of expiation for the whole of humanity. (*COB*)

b. 1971, Hubei, China
Lives and works in Hangzhou, Zhjiang, China

Solo Exhibitions
Chen XiaoYun, Material Living Space, Shenzhen, March 8-11, 2002

Group Exhibitions
Archaeology Of the Future. The Second Triennial of Chinese Art, Nanjin Museum, Nanjin, June 11-25, 2005
Shanghai Biennial. Techniques of the Visible, Shanghai Art Museum, Shanghai, September 28 – November 27, 2004

Bibliography
C. Higgins, "Fast Forward," *Contemporary*, No. 72, London, 2005, p. 28
C. XiaoYun, "Alchemy On Bad," *Vision 21*, No. 1, Hunan, 2000, pp. 14-15

p. 449: *Lash*, 2005
p. 450: *Several Moments Extending To A Night*, 2003
p. 451: *Shears, Shears*, 2002; *Who Is Angel*, 2002

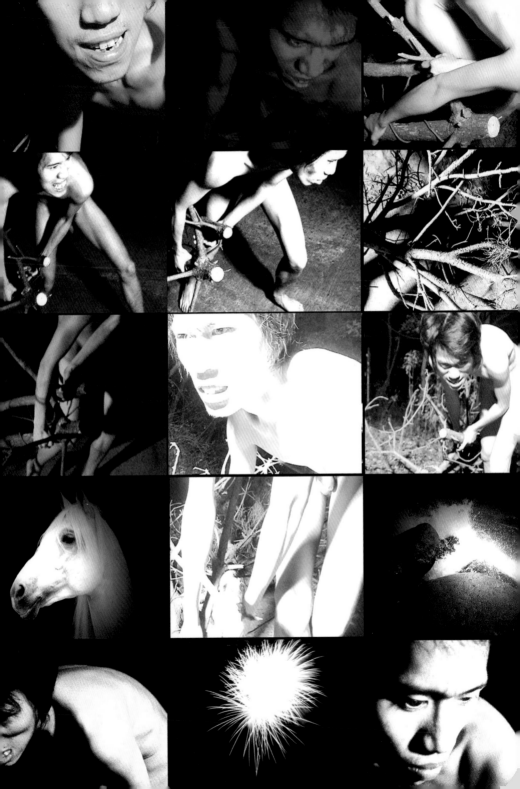

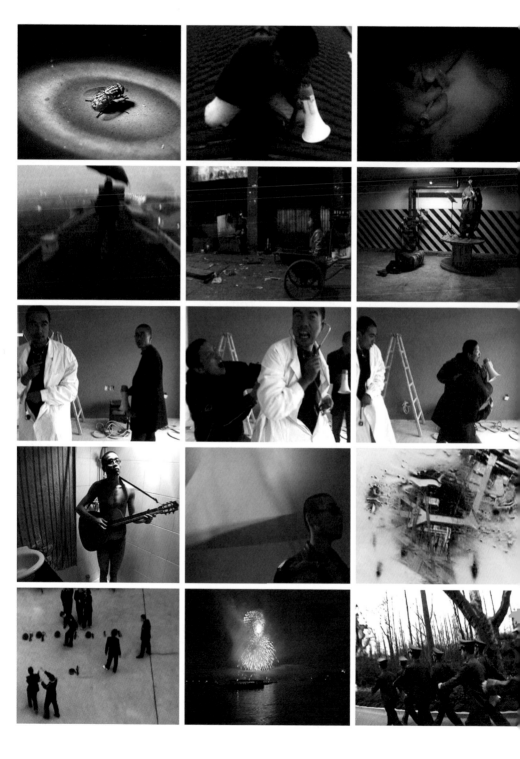

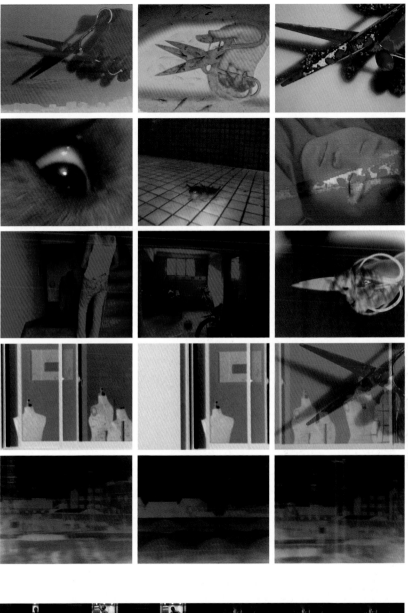

JAMES YAMADA

James Yamada's work is centered on the contrast between the natural landscape and the digital landscape typical of the post-industrial period.
He works like an archaeologist-scientist, seeking out and analyzing various aspects of reality, creating installations, sculptures, videos and photographs which lead the spectator to reconsider the limits of his or her own perception. Yamada's constantly evolving works are made to interact with one another, and with the public, by electronic and mechanical means, or atmospheric changes. He creates minimal, poetic objects, whose subtle irony suggests a playful probing of reality. Interested as he is in the relationship between nature and the technological aspects of culture, Yamada analyzes the influence which the various forms of contemporary technology have on both the individual and the environment. The fragmentary nature of his works may be explained by his conviction that only through eclecticism can we attain the coherence needed to survive in a globalized world. (*IB*)

b. 1967, Bat Cave, United States
Lives and works in Brooklyn-New York

Solo Exhibitions
We Are What We Eat or Why We Have Screens, Galleria Raucci/Santamaria, Naples, February 14 – March 25, 2005

Group exhibitions
Greater New York 2005, P.S.1 Contemporary Art Center, Long Island City-New York, March 13 – September 26, 2005
Some New Minds, P.S.1 Contemporary Art Center, December 17 – February 28, 2001

Bibliography
C.-S. Rabinowitz, "James Yamada," *Boiler*, No. 04, Milan, January 2004, pp. 6-13
Birdspace, New Orleans Center for Contemporary Art, New Orleans, 2003

p. 453: *Currently untitled* (detail), 2005
pp. 454-455: *Currently untitled* (detail), 2005

Fertilizantes Agrícolas

UREA

46 % N

50 Kg Neto

Nº79

The starting point for Ed Young's videos and performances is a desire to subvert social and artistic codes. Playing fast and loose with both the history of art – from which he borrows ideas and strategies that have long since hardened into theories – and with linguistic conventions, he creates situations in which the spectator is led to ask questions about the boundaries between the prank and the work of art. 'Playing the fool' is thus revealed as both implicit cultural criticism and a distinctive hallmark of the figure of the artist. Full of black humor, the video entitled *Killing Teddy* (2001) shows the artist destroying an assortment of soft toys with weapons, stones and cars, thus investigating the nature of deviant behavior. (*RP*)

b. 1978, Welkom, South Africa
Lives and works in Cape Town

Solo Exhibitions
Asshole, Bell-Roberts, Cape Town, January 14, 2004
Bruce Gordon, South African National Gallery, Cape Town, March 29, 2003

Group Exhibitions
Printtttt, AVA - Association for Visual Arts, Cape Town, May 30 – June 18, 2005
Grasduinen 01.S.M.A.K. at the Sea, Bredene, April 3 – June 13, 2004

Bibliography
10 Years 100 Artists. Art in a Democratic South Africa, Bell-Roberts, Cape Town, 2004, pp. 418-421
C. Bierinckx, interview with the artist, in *Grasduinen 01*, S.M.A.K. Stedelijk Museum voor Actuele Kunst, Gent, 2004, pp. 41-46

pp. 457-459: Project for the *T1* catalog, photo curtesy the artist

You'd have
to be fucking
desperate
to be on this

Crap
Show

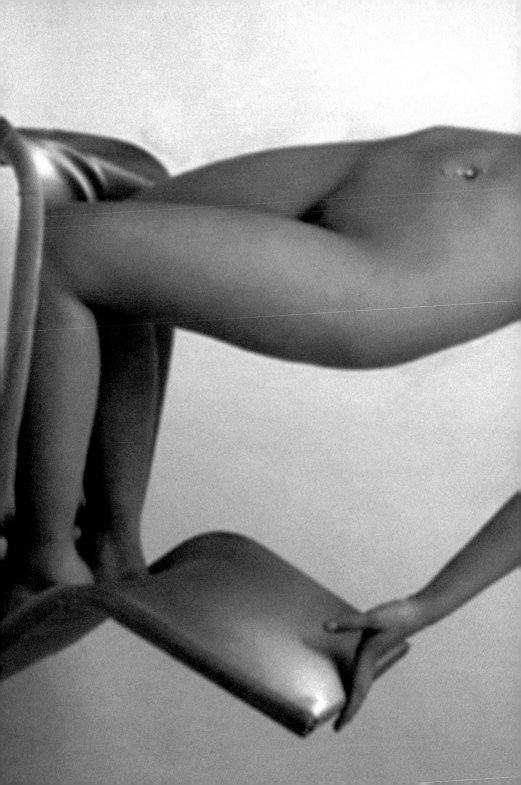

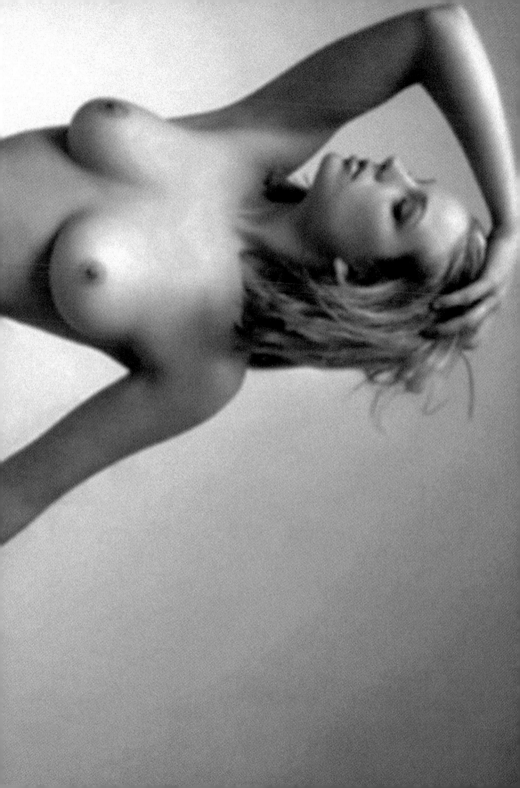

List of Exhibited Works in "Pantagruelisms"

Saâdane Afif
Laffs in the Dark, 2005
Installation
Variable dimensions
Courtesy the artist and Galleria Maze, Turin

Allora & Calzadilla
Ruin, 2005
Metal
Variable dimensions
Courtesy Galerie Chantal Crousel, Paris

Carlos Amorales
Dark Mirror, 2005
Two channel video projection over floating
screen, 6' 1"
Animation, André Pahl, original score and
piano performance, José Maria Serralde;
Photograph, Fernando Maquieira
Courtesy Kurimanzutto Gallery, Mexico City

Armando Andrade Tudela
The Song Remains the Same, 2005
Two channel video projection, 2' 10", loop
Courtesy Counter Gallery, London and Annet
Gelink, Amsterdam

Andreoni_Fortugno
*IMHO – Manifesti elettorali (IMHO – Electoral
Posters)*, 2004
Lambda print
Installation, 78 ³/₄ x 315 in.
Courtesy the artists and Nepente Art Gallery,
Milan

Magnús Árnason
Detritus, 2005
Mixed media installation
Dimensions determined by the space
Courtesy the artist

Sveinbjörn Jónsson, 2003
Ice, fabric, paper
23 5/8 x 70 7/8 x 23 5/8 in.
Courtesy the artist

Artemio
Untitled, 2005
Video installation, 4 plasma screens, 10',
loop
Courtesy the artist

Micol Assaël
Untitled, 2005
Sound installation
Dimensions determined by the space
Courtesy the artist, ZERO, Milan and Johann
König, Berlin

Fikret Atay
Fast and Best, 2002
Color video transferred to DVD, 7' 29"
Courtesy Galerie Chantal Crousel, Paris

Tamy Ben-Tor
Amerikanische Schweinerei, 2004
Video, 3'
Courtesy the artist and Zach Feuer Gallery
(LFL), New York

Women Talk About Hitler, 2003
Video, 8'
Editing: Anat Ben-David
Courtesy the artist and Zach Feuer Gallery
(LFL), New York

My name is Adolf Hitler, 2003
Video, 2'
Courtesy the artist and Zach Feuer Gallery
(LFL), New York

Exotica. The Rat and The Liberal, 2005
Performance, Castello di Rivoli Museo d'Arte
Contemporanea
Courtesy the artist

Fernando Bryce
Revolución (Revolution), 2004
Ink on paper
153 drawings, 11 ¹¹/₁₆ x 8 1/4 in. each; 63
drawings, 16 ⁹/₁₆ x 11 ¹¹/₁₆ in. each; 3
drawings, 23 ⁷/₁₆ x 16 ⁹/₁₆ in. each
Courtesy Galerie Barbara Thumm, Berlin

Agnieszka Brzeżańska
Impossible is Nothing, 2005
Slideshow, 9'
Music, Marek Raczkowski and Maciek
Sienkiewicz
Courtesy the artist

Ian Burns
The information process, 2005
Kinetic interactive sculpture, mixed media
(wood, metal, rubber, resin, motors, video
cameras, monitors, lights)
3150 x 6063 x 173 in. ca.
Courtesy the artist and Spencer Brownstone
Gallery, New York

andrea caretto / raffaella spagna
*E.S.C.U.L.E.N.T.A. Lazzaro - Azione di
rivitalizzazione di organismi vegetali coltivati
(E.S.C.U.L.E.N.T.A. Lazzaro - Action for the
revitalization of cultivated vegetable
organisms)*, 2005
Wooden boxes, vegetables, soil, lights, fan,
iron greenhouse for agriculture, hydroponic
pool, slides on LCD monitor, documentation
157 ¹/₂ x 236 ¹/₄ x 236 ¹/₄ in.
Courtesy the artists

Alessandro Ceresoli
KKK – King Kong Park and drawings, 2005
Mixed media installation
Variable dimensions
Courtesy the artist

Paolo Chiasera
www.tupacproject.it, 2005
Lambda print
68 ⁷/₈ x 49 ³/₁₆ in.
Photo, Ela Bialkowska
Courtesy MARTa Herford Museum and
Galleria Massimo Minini, Brescia

www.tupacproject.it, 2005
Lambda print
67 x 49 ³/₁₆ in.
Photo, Ela Bialkowska
Courtesy Galleria Massimo Minini, Brescia

www.tupacproject.it, 2005
Concrete sculpture
70 ⁷/₈ in. h.
Courtesy the artist and Galleria Massimo
Minini, Brescia

Choi Hochul
The Ground We Are Living On, 2000

Acrylic on canvas
153 ⁹/₁₆ x 63 in.
Collection Seoul Museum of Art, Seoul

Labor's Day, 1995
Mixed media on paper
31 ¹/₂ x 78 ³/₄ in.
Courtesy the artist

CIBOH
One Shot, 2005
Mixed media installation, performance video
documentation
Courtesy the artists

Abraham Cruzvillegas
Horizontes (Horizons), 2005
Acrylic enamel paint on objects
Variable dimensions
Courtesy the artist and Kurimanzutto Gallery,
Mexico City

Roberto Cuoghi
Mbube, 2005
Sound work, 3'
Hardware: Edirol PCR-1, Eventide Eclipse,
Akg/Behringer Eurorack UB 802, Mac G5 -
Software: Cubase SEVoce, balafon, claves,
shaker, jingling, vibraslap, guiro, djambe,
Basque tambourine, flûte à coulisse, Budrio
ocarina, cuckoo call, nut-shells
Courtesy the artist and Massimo de Carlo,
Milan

Oskar Dawicki
Quotation Snowman, 2005
Refrigerator, snow, buttons
77 ³/₁₆ x 29 ¹/₂ x 33 ⁷/₁₆ in.
Courtesy the artist and Raster Gallery,
Warsaw

Massimiliano e Gianluca De Serio
Lezioni di Arabo (Arab Class), 2005
Film 35mm transferred on DVD, color, 10'
30"
Courtesy the artists, self production g&m
and Antiloco with the contribution of Film
Commission Torino, Piemonte, Fondazione
Torino Musei, Città di Torino – Assessorato
alle Pari Opportunità, Regione Piemonte –
Assessorato alle Pari Opportunità e
Assessorato al Welfare, Associazione
Pratocinema – Festival Pratometraggi,
Festival La Cittadella del Corto, Piero Basso,
La bottega dell'immagine – Giorgio Mari

Sebastián Díaz Morales
*Lucharemos hasta anular la ley (We Shall
Fight Until We Abolish the Law)*, 2004
Video projection on black screen, 10' 39"
Courtesy Galerie Carlier I Gebauer, Berlin

Rä di Martino
The Dancing Kid, 2005
Two channel video projection, 13'
Courtesy the artist and Monitor
video&contemporaryart, Rome

Brian Fridge
Vault Sequence, 1997
Video, silent, 6', loop
Vault Sequence no. 2, 1998
Video, silent, 5' 30", loop
Vault Sequence no. 4, 1999

deo, silent, 6', loop
ault Sequence no. 5, 1999
deo, silent, 2' 30", loop
ault Sequence no. 10, 2000
deo, silent, 4', loop
videos on monitors on table
ourtesy the artist, Art Pace, San Antonio
X) and Down and Brown Contemporary,
allas

hristian Frosi
Z 01, 2005
stallation
ourtesy the artist, ZERO, Milan and Galerie
abella Bortolozzi, Berlin

yan Gander
this guilt in you too - (The study of a car in field), 2005
udio/Video installation, 17' 20"
ourtesy the artist

AZEaBOut
AZEaBOut #4, 2005
nvironment, scraps
36 $^1/_4$ x 236 $^1/_4$ x 236 $^1/_4$ in.
ourtesy the artists

aniel Guzmán
Monsters we meet, 2005
astic, wood
ariable dimensions
ourtesy the artist and Kurimanzutto Gallery,
Mexico City

ew Face in Hell, 2005
crylic on wood
paintings, 19 $^{11}/_{16}$ x 23 $^5/_8$ in. each
ourtesy the artists and Kurimanzutto
allery, Mexico City

Darkness On The Edge Of The Town, 2005
k on paper
drawings, 55 $^1/_2$ x 42 $^1/_2$ each; 8 drawings,
4 x 18 $^1/_2$ in. each
ourtesy the artists and Kurimanzutto
allery, Mexico City

hala Hadimi
etween Prayers, 2001
ideoprojection, 30'
ourtesy the artist

eppe Hein
Illuminated Benches, 2005
tainless steel benches
7 $^{11}/_{16}$ x 78 $^3/_4$ x 25 $^3/_{16}$ in. each
Courtesy Johann König, Berlin

Richard Hughes
it, 2004
and-dyed and stitched fabric, polyester
tuffing, plywood, spray paint, lacquer
5 $^3/_{16}$ x 49 $^5/_8$ x 55 $^7/_8$ in.
Courtesy the artist and The Moderne
nstitute, Glasgow

ll Be Having A Word With Someone From The Council About This, 2004
olyester resin, fiberglass
5 $^3/_{16}$ x 87 x 26 in.
Courtesy The Showroom, London

Wanna See You Sweat, 2005

Black puffa coats, table, coat hooks, mild
steel, epoxy resin, emulsion, acrylic
Variable dimensions
Courtesy the artist and The Moderne
Institute, Glasgow

Marine Hugonnier
Wednesday (Monte Pascoal, Brazil), 2005
Light jet print, 6 fluorescent tubes
Variable dimensions
Courtesy the artist and Max Wigram Gallery,
London

Thursday (Monte Pascoal, Brazil), 2005
Light jet print, fluorescent tubes
Variable dimensions
Courtesy the artist and Max Wigram Gallery,
London

Christian Jankowski
16mm Mystery, 2004
35mm film transferred on DVD, 5'
Courtesy Klosterfelde, Berlin and Maccarone
Inc., New York

Tom Johnson
Standing Date, 2005
Performance with metal structure
structure, 86 $^1/_2$ x 67 x 118 in.
Courtesy the artist

Hassan Khan
DOM-TAK-TAK-DOM-TAK, 2005
Sound installation (mixer, amplifier,
speakers, programmable lights, computer
controller, vinyl text on wall)
134 x 578 $^3/_4$ x 224 $^1/_2$ in.
Courtesy the artist and Galerie Chantal
Crousel, Paris

Thomas Köner
Suburbs of the Void, 2004
Video projection, 14' 13"
Courtesy the artist

Jin Kurashige
Billy, 2004
Video projection, 9'
Courtesy Mizuma Art Gallery, Tokyo

An-My Lê
29 Palms – Mechanized Assault, 2003-2004
Gelatin silver print
27 $^1/_4$ x 38 $^3/_4$ in.
Courtesy the artist and Murray Guy Gallery,
New York
29 Palms – Embassy #17, 2003-2004
Gelatin silver print
27 $^1/_4$ x 38 $^3/_4$ in.
Courtesy the artist and Murray Guy Gallery,
New York

29 Palms – Infantry officers brief, 2003-2004
Gelatin silver print
27 $^1/_4$ x 38 $^3/_4$ in.
Courtesy the artist and Murray Guy Gallery,
New York

29 Palms – Infantry Platoon (retreat), 2003-
2004
Gelatin silver print
27 $^1/_4$ x 38 $^3/_4$ in.
Courtesy the artist and Murray Guy Gallery,
New York

29 Palms – Marine palms, data
Gelatin silver print
27 $^1/_4$ x 38 $^3/_4$ in.
Courtesy the artist and Murray Guy Gallery,
New York

Small Wars – Tall Grass #1, 1999-2002
Gelatin silver print
27 $^1/_4$ x 38 $^3/_4$ in.
Courtesy the artist and Murray Guy Gallery,
New York

Small Wars – Cots, 1999-2002
Gelatin silver print
27 $^1/_4$ x 38 $^3/_4$ in.
Courtesy the artist and Murray Guy Gallery,
New York

Small Wars – Rescue, 1999-2002
Gelatin silver print
27 $^1/_4$ x 38 $^3/_4$ in.
Courtesy the artist and Murray Guy Gallery,
New York

Small Wars – Smoking, 1999-2002
Gelatin silver print
27 $^1/_4$ x 38 $^3/_4$ in.
Courtesy the artist and Murray Guy Gallery,
New York

Small Wars – Stars and Stripes, 1999-2002
Gelatin silver print
27 $^1/_4$ x 38 $^3/_4$ in.
Courtesy the artist and Murray Guy Gallery,
New York

**Christelle Lheureux and Apichatpong
Weerasethakul**
Ghost of Asia, 2005
Two channel video projection, 9' 15"
Courtesy the artists, Produced by Cité Siam,
Alliance Française, Bangkok, Thailand;
French Embassy of Thailand / Ministry of
Culture, Bangkok, Thailand - Part of The
Tsunami Project

Justin Lowe
If You've Got Ghosts, You've Got Everything,
2005
Volvo Polar, mattresses, sound, cloths,
wood, mixed media
236 $^1/_4$ x 472 $^7/_{16}$ x 236 $^1/_4$ in.
Music, Saleem Dhamee
Courtesy the artist and Oliver Kamm 5BE
Gallery, New York, production Fondazione
Torino Musei

Nalini Malani
*Mother India:Transactions in the
Constructions of Pain*, 2005
Five channel video projection, 5' 9"
Courtesy the artist and Bose Pacia Gallery,
New York

Angelika Markul
Pantagruel, 2005
Video installation, 10' 42"
Courtesy the artist

Melissa Martin
Little Pig, 2004
Chewing gum
33 x 80 $^1/_2$ x 34 in.
Collection George Lindemann Jr., Miami

Seconds, 2004
Video, 5' 54"
Courtesy the artist and Rare Gallery New York

Jesús "Bubu" Negrón
Rosa Tekata (Junky Rose), 2005
Palm tree leaves, trinitarian flower, thread
55 $^1/_8$ x 55 $^1/_8$ x 39 $^3/_8$ in.
Courtesy the artist and Galeria Comercial,
San Juan, Puerto Rico

Yoshua Okon
Coyoteria, 2003
Video, 30', loop
Courtesy the artist and francesca kaufmann,
Milan

Damián Ortega
Miracolo Italiano (Italian Miracle), 2005
3 Vespa Piaggio PX 150
146 $^7/_8$ x 543 $^5/_{16}$ x 181 $^7/_8$ in.
Courtesy the artist and Kurimanzutto Gallery,
Mexico City

Ulrike Palmbach
Cow (Mucca), 2004
Muslin, polyester fibrefill, wood, thread
Sculpture, 36 x 94 $^1/_8$ x 48 1/16 in.; base, 17
x 114 $^3/_{16}$ x 57 $^1/_{16}$ in.
Courtesy Stephen Wirtz Gallery, San
Francisco

Park Sejin
Property-tech, 2002
Tech, acrylic, cactus extracts, mixed media
on canvas
46 $^7/_{16}$ x 58 $^{11}/_{16}$ in.
Courtesy Arario Gallery, Cheonan (Korea)

The Helipad, 2001
Grape, mixed media on paper
59 x 62 $^3/_{16}$ in.
Courtesy Arario Gallery, Cheonan (Korea)

*Falling Bird (Hit by a Sketchbook that
Someone has Thrown)*, 2000
Oil on canvas
35 $^{13}/_{16}$ x 46 in.
Courtesy Arario Gallery, Cheonan (Korea)

Dr. Kim's One Day, 2004
Acrylic on canvas
23 $^5/_8$ x 16 $^1/_2$ in.
Courtesy Arario Gallery, Cheonan (Korea)

Jorge Peris
Kursk, 2005
Mixed media installation
Variable dimensions
Courtesy the artist

Susan Philipsz
Stay with me, 2005
Sound installation, voice
Dimensions determined by the space
Courtesy the artist

Wit Pimkanchanapong
Still Animation: Family Portrait Series, 2002
Three videoprojections, 1', loop
Courtesy the artist

Michelangelo Pistoletto
Rosa bruciata (Oggetti in meno) (Burned

Rose – Minus Objects), 1965
Undulated cardboard, enamel paint
55 $^1/_8$ x 55 $^1/_8$ x 39 $^3/_8$ in.
Collection Fondazione Pistoletto, Biella

Shannon Plumb
Commercials, 2001
Video, 25'
Courtesy the artist and Sara Meltzer Gallery,
New York

Olympics – Track and Field, 2005
Video, 18'
Courtesy the artist and Sara Meltzer Gallery,
New York

Riccardo Previdi
Non-Stop, 2005
Video projection on screen, metal, mirror, 3',
loop
Screen, 94 $^1/_2$ x 70 $^7/_8$ in.
Courtesy the artist

Ana Prvacki
*Ananatural Production Catalogue (The
Pantagruel Syndrome Issue)*, 2005
Publication
4000 catalogs, 7 $^1/_{16}$ x 10 $^1/_4$ in. each
Courtesy the artist

Michael Rakowitz
Dull Roar, 2005
Installation (wood, inflatable structure,
plastic, motor), pencil on vellum
Inflatable sculpture
144 x 84 x 96 in.
15 drawings, 8 $^1/_2$ x 11 in. each
Courtesy the artist and Lombard-Freid
Projects, New York

Positive Agitation, 2005
Hoover 150 vacuum cleaner (vintage, Henry
Dreyfuss), exhaust pipe, motor with timer,
pencil on vellum
Sculpture
48 x 60 x 60 in.
1 drawing, 24 x 43 $^1/_2$ in.
Courtesy the artist and Lombard-Freid
Projects, New York

Last Gasp, 2005
Electric hand dryer, handmade inflatable
sculpture, pencil on vellum
Sculpture
48 x 18 x 7 in.
2 drawings, 24 x 43 $^1/_2$ in. each
Courtesy the artist and Lombard-Freid
Projects, New York

Araya Rasdjarmrearnsook
The Class, 2005
Video, 16' 20"
Courtesy the artist

The Class, 2005
Performance, Sala Settoria, Anatomia
Patologica dell'Università,
Dipartimento di Scienze Biomediche
e Oncologia Umana, Turin
20'

David Ratcliff
Charm Bracelets, 2005
Acrylic on canvas

72 x 66 in.
Private Collection

Tack and Gentry, 2005
Acrylic on canvas
72 x 66 in.
Courtesy the artist and Team Gallery, New
York

Abstract Painting (Floor), 2005
Acrylic on canvas
72 x 66 in.
Libra Art Collection, Milano

Porntaweesak Rimsakul
Pet, 2005
22 plastic elements, 1 torso guide on table
Variable dimensions
Courtesy the artist

Miguel Ángel Rios
A Morir, 2003
Three channel video projection, 4' 54"
Courtesy the artist and Marco Noire
Contemporary Art, Turin

Sterling Ruby
Soft Sculpture: Found Cushion with Bleach,
2005
Fabric, polyfil, zippers
26 x 66 x 22 in.
Private Collection
Courtesy MARC FOXX, Los Angeles

Found Cushion Act, 2005
Video, single projection, 11' 26"
Courtesy Foxy Production, New York

*Found Fabric Print: True Love Always/Trans
Los Angeles #1*, 2005
Lambda print mounted with sintra and
Plexiglass
70 $^9/_{16}$ x 40 $^5/_{16}$ x 2 in.
Courtesy MARC FOXX, Los Angeles

*Found Fabric Print: True Love Always/Trans
Los Angeles #2*, 2005
Lambda print mounted with sintra and
Plexiglass
70 $^9/_{16}$ x 40 $^5/_{16}$ x 2 in.
Courtesy MARC FOXX, Los Angeles

*Found Fabric Print: True Love Always/Trans
Los Angeles #3*, 2005
Lambda print mounted with sintra and
Plexiglass
70 $^9/_{16}$ x 40 $^5/_{16}$ x 2 in.
Courtesy Foxy Production, New York

*Found Fabric Print: True Love Always/Trans
Los Angeles #4*, 2005
Lambda print mounted with sintra and
Plexiglass
70 $^9/_{16}$ x 40 $^5/_{16}$ x 2 in.
Courtesy Foxy Production, New York

Aïda Ruilova
I Have to Stop, 2001-2002
Video, 34"
Courtesy the artist and Greenberg Van
Doren Gallery, New York

3-2-1, 2001-2002
Video, 15"

ourtesy the artist and Greenberg Van
oren Gallery, New York

ey, 1999-2000
deo, 31"
ourtesy the artist and Greenberg Van
oren Gallery, New York

eat and Perv, 1999
deo, 45"
ourtesy the artist and Greenberg Van
oren Gallery, New York

he Stun, 2000
deo, 2' 28"
ourtesy the artist and Greenberg Van
oren Gallery, New York

ans Schabus
stronaut, 2003
deo, 8' 30"
ourtesy the artist and Engholm Engelhorn
alerie, Wien

ergwerk – Atelier (Bergwerk – Studio), 2003
opy on paper, pencil
4 ⁵/₈ x 53 ⁹/₁₆ in.
ourtesy the artist, Engholm Engelhorn
alerie, Wien and ZERO, Milan

arkus Schinwald
ntitled, 2005
ood, polyester, oil paint, electric motor,
all paper
imensions determined by the space
ourtesy the artist

hlam Shibli
couts, 2005
hotographs
9 photographs, 23 ⁵/₈ x 31 ¹/₂ in. each
ourtesy the artist, supported by Lottery
ouncil For Culture and Arts, Israel

atrín Siguraardóttir
tage, 2005
stallation
imensions determined by the space
ourtesy the artist

likhael Subotzky
oter X, 2004
rom the photographic series *Die Vier Hoeke*
rchival pigment ink on cotton rag paper
2 x 92 ¹/₈ in.
ourtesy the artist and The Goodman
allery, Johannesburg

*ell 508, A Section, Pollsmoor Maxiumum
ecurity Prison*, 2004
rom the photographic series *Die Vier Hoeke*
rchival pigment ink on cotton rag paper
2 x 92 ¹/₈ in.
ourtesy the artist and The Goodman
allery, Johannesburg

ell, Voorberg Prison, 2004
rom the photographic series *Die Vier Hoeke*
rchival pigment ink on cotton rag paper
2 x 92 ¹/₈ in.
ourtesy the artist and The Goodman
allery, Johannesburg

Grave, Noar Encobo, Eastern Cape, 2004
rom the photographic series *Die Vier Hoeke*

Archival pigment ink on cotton rag paper
22 x 92 ¹/₈ in.
Courtesy the artist and The Goodman
Gallery, Johannesburg

Preacher, Dwarsriver Prison, 2004
From the photographic series *Die Vier Hoeke*
Archival pigment ink on cotton rag paper
22 x 92 ¹/₈ in.
Courtesy the artist and The Goodman
Gallery, Johannesburg

*Burnt Cell, Pollsmoor Maximum Security
Prison*, 2004
From the photographic series *Die Vier Hoeke*
Archival pigment ink on cotton rag paper
22 x 92 ¹/₈ in.
Courtesy the artist and The Goodman
Gallery, Johannesburg

Abbatoir, Voorberg Prison, 2004
From the photographic series *Die Vier Hoeke*
Archival pigment ink on cotton rag paper
22 x 92 ¹/₈ in.
Courtesy the artist and The Goodman
Gallery, Johannesburg

*Reception, Pollsmoor Maximum Security
Prison*, 2004
From the photographic series *Die Vier Hoeke*
Archival pigment ink on cotton rag paper
22 x 92 ¹/₈ in.
Courtesy the artist and The Goodman
Gallery, Johannesburg

Javier Téllez
The Greatest Show on Earth, 2005
Video installation inside a tent, mixed media
275 ¹/₂ x 275 ¹/₂ in. Ø
Courtesy the artist and InSite San Diego -
Tijuana

Avdei Ter-Oganyan
The Receptionist, 2005
Installation
Variable dimensions
Courtesy the artist

David Ter-Oganyan
It Is Not a Bomb, 2005
Various materials, food, cables, timers
Variable dimensions
Courtesy the artist and XL Gallery, Moscow

TV Moore
Across the Universe, 2005
Two channel video projection, 17'
Courtesy the artist and roslyn oxley9 gallery,
Sydney

Clemens von Wedemeyer
Untitled, 2005
16mm film transferred to DVD, 2'
Courtesy the artist

Chen XiaoYun
Lash, 2005
Video, 4'
Courtesy the artist

Who is Angel, 2002
Video, 3'
Courtesy the artist

Shears Shears, 2001

Video, 3'
Courtesy the artist

Several Moments Extending To A Night - 1,
2003
Video, 11'
Courtesy the artist

James Yamada
Untitled, 2005
Chromed steel, watercolour on paper, cold-
cathode fluorescent lamps, misc hardware
and electronics
Courtesy the artist

Currently Untitled, 2005
Enamel paint on aluminum
47 ¹/₄ x 24 in.
Courtesy the artist

Currently Untitled, 2005
Glass solar panels, aluminum, steel,
concrete
70 ⁷/₈ x 47 ¹/₄ in.
Courtesy the artist

Ed Young
Damn those bitches represent, 2003
Video, 1' 20", loop
Courtesy the artist

Bruce Gordon, 2002
Found object (Concept)
Variable dimensions
Courtesy IZIKO The South African National
Gallery, Cape Town

Do Nothing, 2004
Performance
Courtesy the artist

Texts which appear in "Pantagruelisms" in their original language

andrea caretto / raffaella spagna

E.S.C.U.L.E.N.T.A.-Lazzaro – Action for the revitalization of cultivated vegetable organisms – from 2004

ACQUISITION>REVITALIZATION>LOCA-TION>GROWTH>FLOWERING>FRUITING

LIST OF REVITALIZED VEGETABLES

APIACEAE
Apium graveolens var. *dulce* (celery) var. *rapaleum* (celeriac)

Foeniculum vulgare subsp. *Vulgare* var. *azoricum* (fennel)
Daucus carota subsp. s*ativus* (carrot)

ASTERACEAE
Cichorium intybus (chicory) var. *foliosum*
Catalonian or asparagus chicory
Radicchio – rosso di Verona
Radicchio – rosso di Treviso
Belgian endive

Lactuca sativa (lettuce) var. *longifolia* (Roman lettuce)

BRASSICACEAE
Raphanus sativus var. *radicicula* (radish)

Brassica rapa var. *rapa* (turnip)

Brassica oleracea (cabbage)
Brassica capitata var. *alba* and *rubra* (red and white cabbage)
var. *sabauda* (Savoy cabbage)

var. *bullata* subvar. g*ommifera* (Brussels sprouts)

BROMELIACEAE
Ananas comosus (pineapple)

CONVOLVULACEAE
Ipomea batatas (sweet potato)

LEGUMINOSAE
Glycine max (soya)

LILIACEAE
Allium cepa var. *cepa* (onion)
Red onion
Yellow onion
White onion

Allium ascalonicum (shallot)

Allium sativum (garlic)

Allium ampeloprasum var. *porrum* (leek)

Muscari comosum (tassel hyacinth)

SOLANACEAE
Solanum tuberosum (potato)

ZINGIBERACEAE
Zingiber officinale (ginger)

E.S.C.U.L.E.N.T.A .- joint campaign for the gathering and consumption of foodstuff from natural materials – from 2002

LIST OF THE NATURAL MATERIALS GATHERED
Spring water; Sea water; *Ajuga reptans*:

tips; *Alchemilla vulgaris*: leaves; *Alliaria officinalis*: leaves; *Allium schoenoprasum*: leaves; *Allium ursinum*: leaves; *Allium vineale*: bulbs; *Arbutus unedo*: fruit; *Arctium lappa*: roots, leaves and baby leaves; *Asparagus tenuifolius*: root buds; *Betula alba*: inner cortex; *Borrago officinalis*: leaves; *Castanea sativa*: chestnuts; *Chenopodium album*: tips; *Chenopodium bonus-Henricus*: tips; *Cynara cardunculus*: flower buds; *Corylus avellana*: catkins; *Crataegus monogyna*: flower buds; *Equisetum telmateja*: stalks; *Erythronium dens-canis*: bulbs and leaves; *Fagus sylvatica*: buds and young leaves; *Foeniculum vulgare*: leaves; *Fragaria vesca*: roots, fruit and leaves; *Galium mollugo*: tips; *Helianthus tuberosus*: tubers; *Humulus lupulus*: young shoots; *Hypochoeris radicata*: young plants; *Juniperus communis*: berries; *Knautia arvensis*: leaves; *Lactuca scariola*: young plants; *Lamium maculatum*: tips; *Lamium purpureum*: tips; *Laurus nobilis*: leaves; *Melissa officinalis*: leaves; *Mentha arvensis*: tips; *Mentha sp.*: tips; *Morchella rotunda*: fruiting parts; *Muscari atlanticum*: bulbs; *Muscari comosum*: bulbs; *Nasturtium officinale*: leaves; Ornithogalum umbellatum: bulbs; Oxalis acetosella: leaves; Papaver rhoeas: young plants; *Papaver rhoeas ssp strigosum*: petals, buds; *Parietaria officinalis*: tips; *Petasites hybridus*: tiny leaves; *Phragmites communis*: stalks; *Physalis alkekengi*: fruit; *Phyteuma orbiculare*: leaves; *Pinus pinea*: pine kernels; *Pistacia lentiscus*: small branches; *Plantago lanceolata*: leaves; *Polygonatum multiflorum*: rhizomes;

Polygonum bistorta: leaves and rhizomes; *Polyporus squamosus*: fruiting parts; *Portulaca oleracea*: tips; *Primula vulgaris*: young plants; *Prunus cerasifera*: fruits; *Prunus spinosa*: drupes; *Pulmonaria officinalis*: tips; *Quercus ilex*: acorns; *Quercus rubra*: acorns; *Robinia pseudoacacia*: flowers and leaves; *Rosa canina*: hips, leaves and petals; *Rubus fruticosus*: roots, fruit; *Rubus idaeus*: fruit; *Rumex acetosa*: tips; *Rumex crispus*: leaves, fruit; *Ruscus aculeatus*: root buds; *Rock salt*; Sea salt; *Salvia officinalis*: leaves; *Salvia pratensis*: leaves; *Sambucus nigra*: spring shoots; *Satureja calamintha*: tips; *Silene vulgaris*: young shoots; *Spiracea arancus*: young shoots; *Taraxacum officinale*: roots and leaves, flower buds; *Thymus serpyllum*: leaves; *Thymus vulgaris*: leaves; *Tragopogon pratensis*; *Trifolium pratense*: leaves and flowers; *Ulmus campestris*: winged fruits; *Urtica dioica*: young shoots; *Vaccinium mirtyllus*: fruit; *Valerianella locusta*: young plants; *Viola odorata*: flowers; *Viola canina*: flowers.

DINNER MENU, E.S.C.U.L.E.N.T.A
29 May 2003 c/o Bu.Net - Turin

The dinner was prepared using exclusively ingredients provided by the gathering campaign

APERITIF – Decoction of dog rose and lemon balm: Rose hips; leaves of *Melissa officinalis*; Spring water;

HORS D'OEUVRES – Fan of pickles with asparagus tips: Pickles: Small leaves of *Arctium lappa*; Roots of *Arctium lappa*; Stems of *Foeniculum vulgare*; Flower buds of *Cynara cardunculus*; Flower buds of

Taraxacum officinale; Bulbs of *Muscari comosum*; Young shoots of *Silene vulgaris*; Bulbs of *Ornithogalum umbellatum*; Young shoots of *Humulus lupulus*; Buds of *Fagus sylvaticus*; Sea salt; **Antipasto of flower buds with arbutus sauce**: Flower buds of *Taraxacum officinale*; sprigs of *Thymus vulgaris*; Pine kernels from *Pinus pinea*; Sea salt; Sauce: Berries of *Arbutus unedo*; **Small cups made with chestnut, acorn, clover and dog rose flour, filled with green cream**: Pastry: nuts from *Castanea sativa*; acorns from *Quercus rubra*; Flowers of *Trifolium pratense*; Seeds of *Rosa canina*; Sea salt; filling: Young shoots of *Silene vulgaris*; Young shoots of *Humulus lupulus*; Rose hips from *Rosa canina*; Leaves of *Oxalis acetosella*; Leaves of *Melissa officinalis*; Fruits of *Fragaria vesca*; Pine kernels from *Pinus pinea*; Sea salt; **First courses – Minestrone with crazy herbs**: Leaves of *Pulmonaria officinalis*; Leaves of *Plantago lanceolata*; Leaves of *Taraxacum officinale*; Leaves of *Alliaria officinalis*; Young shoots of *Silene vulgaris*; Bulbs of *Allium vineale*; Flour made from the acorns of *Quercus rubra*; Flour made from the tubers of *Helianthus tuberosus*; Flour made from the rhizomes of *Polygonum bistorta*; Young plants of *Primula vulgaris*; Leaves of *Salvia pratensis*; Leaves of *Oxalis acetosella*; Leaves of *Parietaria officinalis*; Young tips of *Chenopodium bonus-Henricus*; Sea salt. **Chestnut *gnocchetti* with a sauce of wild Morels**: Gnocchetti: Chestnut flour from *Castanea sativa*; Flour made from the acorns of *Quercus rubra*; Flour made from the flowers of *Trifolium pratense*; Flour

made from the seeds of *Rosa canina*; Leaves of *Borrago officinalis*; Sea salt; Spring water; Sauce: *Morchella rotunda*; Leaves of *Borrago officinalis*; Bulbs of *Allium vineale*; **Second courses – Rissoles rolled in ground chestnuts**: Tips of *Urtica dioica*; Young shoots of *Humulus lupulus*; Leaves of *Plantago lanceolata*; Flour made from the acorns of *Quercus rubra*; Sea salt; **Seven rissoles, seven herbs**: Flour made from the acorns of *Quercus rubra*; 1 Young shoots of *Silene vulgaris*; 2 Leaves of *Polygonum bistorta*; 3 Tips of *Urtica dioica*; 4 Tips of *Lamium purpureum*; 5 Leaves of *Plantago lanceolata*; 6 Tips of *Ajuga reptans*; 7 Tips of *Parietaria officinalis* and of *Pulmonaria officinalis*; Sea salt; **Young root buds in a white sauce of artichokes and acorns**: Fertile stems of *Equisetum telmateja*; Root buds of *Ruscus aculeatus*; Young shoots of *Sambucus niger*; Young shoots of *Spirea aruncus*; White sauce: Flour made from the acorns of *Quercus rubra*; Flour made from tubers of *Helianthus tuberosus*; Sea salt; Spring water; **Sauces – Horseradish sauce**: Root of *Armoracia rusticana*; Flour made from *Betula alba* (internal cortex); "*Breadcrumbs*" from bread made of chestnut, trefoil and acorn; Sea salt; **Green garlic sauce**: Bulbs of *Allium sp*; Tips of *Chenopodium bonus-Henricus*; Sea salt; **Watercress sauce**: *Nasturtium officinale*; *Taraxacum officinale*; Sea salt; **Fresh sauce**: *Borrago officinalis; Melissa officinalis; Oxalis acetosella*; Sea salt; **Desserts – Wild strawberries with wood sorrel leaves**: Fruits of *Fragaria Vesca*; **Boxes made of pure chestnut gar-**

nished with a purée of Rosa Canina and wild strawberries: Flour made from chestnuts, *Castanea sativa*; purée of rosehips from *Rosa canina*; Fruits of *Fragaria vesca*; **Beverages**: Spring water; Decoction of *Oxalis acetosella*; Decoction of the flowers of *Robinia pseudoacacia*; **Bread made from acorn, chestnut and trefoil flour**: Flour made of chestnuts, *Castanea sativa*; Flour made of acorns from *Quercus rubra*; Flowers of *Trifolium pratense*; Sea salt; **Dandelion and acorn coffee:** roasted bran from the acorns of *Quercus rubra*; the root of *Taraxacum officinale* roasted and ground; Spring water.

GATHERING SITES

Andrate (To); Tre Pisse, Trivero (Bi); Capo San Donato, Finale Ligure (Sv); Pietra Ligure (Sv); Capra Zoppa, Finale Ligure (Sv) 03/05/03 – loc. Fiascherino, Lerici (Sp); Bex (Switzerland); Salina di Pedra di Lume, Isla di Sal, Capoverde; fraz. Revigliasco, Moncalieri (To) – Issiglio, Val Savenca (To); Inverso, Val Chiusella (To); Avigliana (To); Bobbio Pellice (To); Lago Coniglio, Ivrea (To); Alice Superiore (To); Eremo Di Pecetto (To); Pragelato (To); Guardavalle Superiore (Cz); Candia (To); Giave (Ss); rione Bonacina, Lecco; Ala di Stura (To); fraz. Testona and zona Colle della Maddalena, Moncalieri (To); Caselette (To); loc. La Verna, Cumiana

(To); Sampeyre (To); Valle Varaita; Golfo Aranci (Ss); Celle (To); Giaveno (To); La Loggia (To); Piane di Barbato Trivero (Bi); Bertesseno (To); fraz. Tetti Rolle, Moncalieri (To); Chiaverano (To); Cascinette (To); Noli Ligure (Sv); S. Teresa di Gallura (Ss); Mondrone (To); Valli di Ianzo (To); Rosta (To); Torninparte (Aq); Colle Santa Maria, Colli Euganei (Pd); Monte Calvario, Friuli Venezia-Giulia; Malesco, Vel Ioana (Vb); Parco delle Vallere, Moncalieri (To).

www. Esculenta.org
contact: info@esculenta.org

Sativa - 1.Cerealia, 2005

Installation c/o Munlab Ecomuseo dell'Argilla di Cambiano (To): 3,100 bricks, jute, soil, 17 species of cereals in their growing season, dimensions 700x400x80cm; performance, reaping, pressing and cereal juice served to the public.

E.S.C.U.L.E.N.T.A. gathering natural materials, cleaning, processing, preparation of the E.S.C.U.L.E.N.T.A. dinner c/o bu.net, Turin 29.05.2003